EYE OF THE SIXTIES

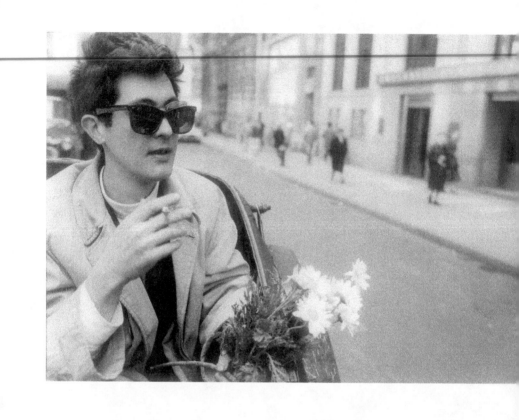

EYE OF THE SIXTIES

RICHARD BELLAMY AND THE
TRANSFORMATION OF MODERN ART

JUDITH E. STEIN

FARRAR, STRAUS AND GIROUX NEW YORK

Farrar, Straus and Giroux
18 West 18th Street, New York 10011

Printed in the United States of America
Published in 2016 by Farrar, Straus and Giroux
First paperback edition, 2017

Grateful acknowledgment is made for permission to reprint the following material:
Excerpt from "A Primitive Like an Orb," from *The Collected Poems of Wallace Stevens* by Wallace
Stevens, copyright © 1954 by Wallace Stevens and copyright renewed 1982 by Holly Stevens.
Used by permission of Alfred A. Knopf, an imprint of the Knopf Doubleday Publishing
Group, a division of Penguin Random House LLC. All rights reserved.
Excerpt from "Corsons Inlet" copyright © 1963 by A. R. Ammons, from *The Selected Poems,
Expanded Edition* by A. R. Ammons. Used by permission of W. W. Norton & Company, Inc.

The Library of Congress has cataloged the hardcover edition as follows:
Names: Stein, Judith E., author.
Title: Eye of the sixties : Richard Bellamy and the transformation
 of modern art / Judith Stein.
Description: First edition. | New York : Farrar, Straus and Giroux, 2016. | Includes
 bibliographical references and index.
Identifiers: LCCN 2015036468 | ISBN 9780374151324 (hardback) |
 ISBN 9780374715205 (e-book)
Subjects: LCSH: Bellamy, Richard. | Art dealers—United States—Biography. |
 Art and society—United States—History—20th century. | BISAC: BIOGRAPHY &
 AUTOBIOGRAPHY / Artists, Architects, Photographers. | ART / History /
 Contemporary (1945–). | HISTORY / United States / 20th Century.
Classification: LCC N8660.B38 S74 2016 | DDC 709.2—dc23
LC record available at http://lccn.loc.gov/2015036468

Paperback ISBN: 978-0-374-53699-2

Designed by Jonathan D. Lippincott

Our books may be purchased in bulk for promotional, educational, or
business use. Please contact your local bookseller or the Macmillan Corporate
and Premium Sales Department at 1-800-221-7945, extension 5442,
or by e-mail at MacmillanSpecialMarkets@macmillan.com.

www.fsgbooks.com
www.twitter.com/fsgbooks • www.facebook.com/fsgbooks

P1

Frontispiece: Dick on a publicity carriage ride for *Pull My Daisy*, 1959
(Photograph by John Cohen, courtesy of L. Parker Stephenson)

FOR JONATHAN

Jeepers, Creepers, where'd ya get those peepers?
Jeepers, Creepers, where'd ya get those eyes?
—Johnny Mercer, 1938

CONTENTS

PREFACE

Richard (Dick) Bellamy was one of the most influential and enigmatic American art dealers of the sixties. The artists he was the first to champion—pop luminaries such as Claes Oldenburg and James Rosenquist, and minimalists such as Dan Flavin and Donald Judd—are today shown in museums from Paris to Des Moines, Sydney to Düsseldorf. Their names are well known. Dick's isn't. I met Dick in 1986, when I was a curator at the Pennsylvania Academy of the Fine Arts. It was hard to believe that this charming, waifish man with frayed cuffs and eyeglasses mended with tape was the legendary art dealer I'd heard about from artists. And I was fuzzy on the details. Most people were. Intrigued, I began to research Dick's career and discovered that there was almost nothing in print about him. I decided to remedy this, though the path forward was hardly clear.

The American art critic and philosopher Arthur Danto was particularly encouraging when I shared my intention to document Dick's accomplishments. But when Dick heard about it, he asked his friend Alfred Leslie to convey his discomfort at the prospect. Deferentially, I let go of the idea. Five years later, in 1995, Leslie himself urged me to reconsider, Dick's distress notwithstanding. "Isn't there anything I can say to make you stop?" Dick said without rancor when he phoned to dissuade me again. This time, I respectfully stood my ground, and he tacitly agreed not to put up roadblocks. By

the time he died, in 1998, this biography was under way. As I trekked into Dick's past, interviewing hundreds of his contemporaries, I learned that there was more to him than met the eye, and it would require guile and resourcefulness to match the subject.

Dick ran the Green Gallery on Fifty-Seventh Street between 1960 and 1965 with the covert support of Robert and Ethel Scull, who became the country's first celebrity art collectors. The remarkable talent he unearthed was jaw-dropping, but what really sustained my attention for what became a twenty-year journey was Dick's singular attitude toward money. He simply wasn't interested in making it, even as the market for contemporary art exploded all around him. A latter-day Bartleby, he preferred not to profit from the opportunity. The best art dealers have a fictional quality, the cartoonist Saul Steinberg once observed.[1] Dick called to mind Sir Gawain, Huckleberry Finn, and Miniver Cheevy. He performed life with tragedy and farce as templates.

The puzzle pieces I gathered didn't all fit together at first. Some of his friends described his dark side; others thought him a bodhisattva or lay Jesuit. Gradually a picture of this extraordinary, contradictory man emerged, a picture, in Nabokov's words, "the finder cannot unsee once it has been seen."[2] In the end, I found Dick to most resemble Coyote, the culture-giving trickster in Native American mythology—eccentric, delightful, and gross, a shadowy figure with a capacity for intense pain and the rare gift of intuition.

EYE OF THE SIXTIES

INTRODUCTION

Dick and Sheindi lived downtown on Cherry Street, a street on the way to nowhere. She remembered it from her childhood, when the fragrance of spices rode in on the breeze from the East River warehouses a few blocks away. Her Orthodox Jewish background was as foreign to Dick as the shape of his eyes and his shock of black hair were to her. She'd been charmed by his voice, a resonant baritone mellowed by smoke and alcohol. A onetime radio announcer, Dick read aloud all his beloved writers, especially Wallace Stevens. "The lover writes, the believer hears, / The poet mumbles and the painter sees, / Each one, his fated eccentricity / . . . living in change." He might teasingly append "and the art dealer droolingly sells."[1]

He could make a game out of anything. "Dick-foolery," his friends called it. On the evening of October 20, 1959, he helped Sheindi on with her coat with the politesse of a medieval knight. They were heading to the grand opening of the Guggenheim Museum, a black-tie affair. No one there would be dressed as Sheindi was. A thrift shop maven, like all her friends, Sheindi had found a handkerchief-silk sheath in rich autumnal colors that needed only a few repairs. She teamed it with a white slip Dick had bought for her in Chinatown, now light brown after a dip in tea. At a distance, the otherwise demure Hebrew school teacher seemed to be wearing nothing underneath.

Dick and Sheindi were getting by on her salary and the little he made from odd jobs. He'd been director of the artists' cooperative Hansa Gallery until it folded in May. He had more time now to visit studios and the new, seat-of-the-pants galleries downtown. He dreamed of a gallery of his own, a place to show the art he found that baffled and unsettled him. At thirty-one, Dick was a man with few possessions—a seemingly humble figure, never taking nor being taken. He was like the Fool in a deck of Tarot cards, signifying change and new beginnings, life existing to be enjoyed.

Robert and Ethel Scull lived in Kings Point, Great Neck, Long Island, in a house Robert built for her on Blue Sea Lane. It overlooked a small cove on Manhasset Bay, as if nature had nibbled a recess in the coastline just for them. On the afternoon of the Guggenheim gala,[2] Ethel skirted Bob's desk and his Eames chair and called him from her Princess phone. He greeted her as Spike,[3] the unlikely moniker Bob preferred to "Ethel." He planned to leave his taxi garage in the Bronx with just enough time to pick her up in a quick turnaround. The housekeeper would ready his tux, and the cook would fix dinner for their three sons. Bob doodled as he talked, sketching his name in bold, slanted letters in his daybook.[4]

Ethel took her time deciding what to wear—she had such wonderful options. She appreciated the way a pink Balenciaga cocktail dress rose playfully at the front and trailed to the back, and she loved the fluidity and grace of a lace strapless designed by Yves Saint Laurent. Her closets were full of haute couture purchased abroad, all the more prized because she had paid no duty on her return. Before she left her Paris hotel, she delicately removed the French designers' labels and stitched in American ones.[5]

With his share of his father-in-law's taxi business, Bob had built a thriving cab company. In the past few years he and Ethel had begun to buy art—Renaissance bronzes—until prices turned dear. They moved on to art of their own time, newcomers such as Jasper Johns, and the abstract expressionists Willem de Kooning, Franz Kline, and Mark Rothko. But not Jackson Pollock. The market for Pollock, who had died in a car crash in 1956, already outpaced

them.[6] Growing the collection with "safe" investments required more money than they had or were willing to pay. It was getting too expensive to buy artists vetted before they became aware of them.

As the Sculls' chauffeured Cadillac pulled up in front of the Guggenheim, the No. 6 train jolted to a halt at Eighty-Sixth Street and Lexington Avenue. Dick and Sheindi stepped off and strolled toward Central Park. They turned uptown at Fifth, the dark expanse of the park on their left. Like the Cheshire cat, the museum materialized all at once, disembodied bands of light set against the night sky. Frank Lloyd Wright's design seemed an exhilarating preview of what the future would look like. New Yorkers hadn't been so eager to experience an interior space since the early thirties, when Radio City Music Hall opened the largest indoor theater in the world. Unlike the Museum of Modern Art's modernist box, which slid into place beside Gilded Age brownstones, the Guggenheim sat back on its lot like an imperious turbaned pasha.

Dick and Sheindi joined the soigné crowd pooling under the cantilever at the museum's entrance. They funneled through revolving doors into a squat foyer and stepped into the bright cavity at its heart. They paused near Constantin Brancusi's towering wood sculpture *King of Kings*[7] and gazed up at the immense expanding spiral of space, as vast as the Pantheon or the Hagia Sophia.[8] Dick took its measure and, as usual, kept his thoughts to himself. Somewhere in the throng, B. H. Friedman, a collector and writer, felt as if he were inside an enormous seashell,[9] with an oceanic din in his ears. "Wouldn't it be fun to roller-skate down the ramp?"[10] the impish writer Pati Hill joked with her fiancé, Paul Bianchini, a gallerist who found it hard to be flippant. For Bianchini, the curlicue shape called to mind the Circles of Hell as diagrammed by William Blake.

"It reminds me of the dome of St. Peter's,"[11] said a voice just behind Dick. He turned to find Richard Brown Baker, one of the few collectors he knew who bought contemporary art. The two had a jocular, flirtatious friendship. Dick addressed him as Brown Bunny, who in turn called him George. It was a mark of intimacy when Dick identified himself as George, his favorite alter ego. He loved

pseudonyms. He was "Finlay" in high school; "Mooney Peebles" on the radio; and, most recently, "Gogo" to his friend Miles Forst's "Didi,"[12] names of the two vagrants at the center of *Waiting for Godot.*

Dick and Sheindi walked up the coiling ramp, past bays of such modern masters as Cézanne and Picasso, along with abstract works by lesser-known artists from Japan, Spain, and the United States, sequenced visually, not chronologically. The enfilade of MoMA's historical galleries had one route in and one way out, but at the Guggenheim, people could start at the bottom, the top, or anywhere in between. Sheindi stood at the low wall edging the center, dizzied by the visual plunge into open space. She saw the promenade of tuxedo-suited swells, *le tout Paris* of the art elite. It seemed an illicit thrill to watch people looking at art, unaware that they were under surveillance.[13]

"Mr. Berremy, I presume?"[14] said the ebullient Ivan Karp, stepping close. "Ah, Missy Kup," Dick responded in kind. Play-talking Pidgin was one of the shticks the two had perfected when they worked together at the Hansa. Although Dick's Chinese mother spoke unaccented English, he occasionally spoke Pidgin, critiquing a stereotype by embracing it. On days of few chores and fewer visitors, the Hansa's codirectors toyed with language and concocted satiric labels for people and things. In their lexicon, the widely read *Art News* became "The Watchtower," also the name of the Jehovah's Witnesses sentinel publication, and Thomas B. Hess, *Art News*'s quick-thinking editor, was "the fastest gun in the West" for rushing one of Jasper Johns's target paintings onto the front cover of *Art News* in January 1958, the very month of the artist's debut at the Castelli Gallery. As the *Village Voice*'s first art critic,[15] Ivan met Dick when he came to the Hansa to review shows. Dick would be sitting on the floor, reading.[16] The co-op members liked what Ivan had to say about them, and they hired him to buttress their lackadaisical manager, who'd sooner quote poetry than prices to prospective buyers.

After the Hansa closed in May 1959, Ivan worked at the posh Martha Jackson Gallery until Leo Castelli wooed him away to become the Castelli Gallery's first director. In the weeks following the Guggenheim's opening, Ivan would see Dick again at the pre-

miere of *Pull My Daisy*, the grainy black-and-white film by their friends Alfred Leslie and Robert Frank, who'd cast Dick as a sanctimonious bishop in this quintessentially Beat film starring Allen Ginsberg, Gregory Corso, and Peter Orlovsky as themselves. Jack Kerouac wrote and read the voice-over, a text suffused with bebop poetics. "Early morning in the universe . . ." it began.

A few floors away at the Guggenheim, Bob and Ethel Scull paused to inspect a de Kooning[17] and admired its fleshy pink passages and electrifying swaths of red, turquoise, and chrome yellow. They owned a de Kooning—Bob had bought it from the artist.[18] It wasn't the Guggenheim's collection they coveted as much as its cultural authority. They well understood art's alchemy, its magical ability to transform mere gold into social standing. Bob was already visiting studios in addition to galleries, intent on sidestepping middlemen dealers.[19] Aggressive, unfamiliar art excited him. He'd recently bought a scrap metal sculpture by an unknown John Chamberlain.[20] The growing buzz about the young sculptor, who was now in Castelli's stable, confirmed Bob's prescience, but he didn't have enough time to track down more talents like him. It was Ivan who'd sold him the Chamberlain when he worked for Martha Jackson. What Bob needed, he was coming to realize, was a gallery of his own, a gallery he wanted Ivan to direct.

Sometime after the gala, Bob put his proposition to Ivan. But Ivan had already had a taste of the collector's abrasive personal style and loathed him for it. "I knew we wouldn't last ten minutes working together,"[21] he later reflected. So Ivan suggested that he approach Dick Bellamy—"somebody who was the exact opposite of himself." It was a very odd combination of personalities, Ivan knew, "this classic American capitalist and successful entrepreneur, and this curious, offbeat, eccentric, even spiritual character." It would take Bob a while to warm to Dick, a whimsical, disorderly type in a secondhand suit, a drink never far out of reach, but he recognized in him a man like himself, happiest in the company of artists.

Nearly a year to the day after the Guggenheim opened, the Green Gallery debuted on West Fifty-Seventh Street, with Bob's covert support. If the museum's design seemed to foretell the future, so too did the opening show Dick chose for the Green—monumental

scrap wood and metal sculpture by Mark di Suvero, an artist in his twenties. Other artists used found materials, but di Suvero added scale and emotion to the mix and dispensed with pedestals. Here was an artist, one reviewer said, who "stepped beyond our immediate experience into history."[22] With Dick as its director, the Green would introduce many artists who stepped into history. Yet Dick himself would artfully dodge posterity. Acclaimed in the sixties as the country's first celebrity collectors, Bob and Ethel Scull would become best known in the future not for owning art, but for selling it.

GUSTS OF
GREAT ENKINDLINGS

HIS FATED ECCENTRICITY

In 1929, the first year of the talkies, an astounding 110 million Americans—one out of three—went to the movies.[1] One popular film was *Welcome Danger*, set amid a San Francisco Chinatown tong war. The comic Harold Lloyd played an endearing bungler who chases a pigtailed ruffian into a building and ends up decking an entire roomful of similarly attired Chinese men. The champ explains that he KO'd the lot because "they all look alike."

Richard Townley Bellamy, the man everyone in the art world called "Dick," was born to a Chinese mother and Caucasian father on December 3, 1927, in Wyoming, Ohio, a suburb of Cincinnati. The year of *Welcome Danger*'s release, Dick was a beguiling toddler with coal-black hair and epicanthic eyelids. No one in Wyoming had eyes like his except his mother, Lydia Blome Hu Bellamy. The boy's looks "didn't sit right with some people,"[2] an empathetic neighbor sighed to recall. When polled for "dislikes" by his high school yearbook, Dick would write "people who ridicule me."[3]

Twenty-six-year-old Dr. Lydia Hu gave "San Francisco"[4] as her birthplace when she and her American fiancé, Dr. Curtis Bellamy, applied for a marriage license in 1926. This wasn't true—Lydia was born in China. She arrived as a teenager, so full of patriotism for the United States that classmates dubbed her "Little Miss George Washington."[5] When the Immigration Act of 1924 pulled shut the nation's golden door, foreign-born Chinese such as Lydia found

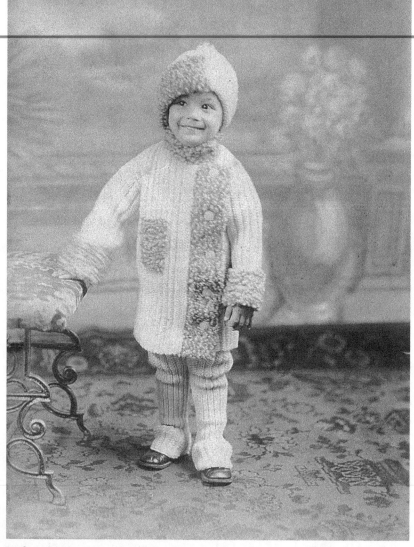

Dick, age two, 1930 (Courtesy of Miles Bellamy)

themselves locked out. Perjury was the only way a "permanent for-eigner," as Lydia was newly classified, could become a citizen. Her false claim regarding San Francisco was never questioned. Eighteen years earlier, the city's earthquake had destroyed all municipal rec-ords, including birth certificates. For Lydia and countless other Chinese, an affidavit was proof enough of native-born status.

Dick would never meet his mother's parents, C.P. and Shiu Wing Hu. In photographs, his grandmother holds her head at a slight tilt, as Dick did. He inherited his grandfather's elegantly long neck, the one part of his body he never liked.[6] C.P. went by his initials— his real name is today unknown. He was born in Jiujiang (formerly Kiukiang), a Yangtze River port city more than four hundred miles west of Shanghai. During China's devastating civil war, roughly contemporary with the American Civil War, Jiujiang was a strong-hold of the Taiping rebels fighting against the corrupt rulers of the Qing Dynasty. By the time C.P. was born, in 1872,[7] the impe-rial forces had won, and the once populous city was left in ruins.

Tradition and superstition dominated the China of C.P.'s boy-hood. Infanticide and polygyny were everyday occurrences, and foot binding was the rule, not the exception. Girls didn't go to school. Evangelical Anglo-American missionaries, whose presence in the country expanded after 1860, were vocally opposed to these practices. They found receptive ears in C.P. (possibly in his parents as well), who converted to Christianity. Never more than a tiny por-tion of China's population, converts typically held progressive ideas about their country's future. C.P. must have impressed Jiujiang's Southern Methodist missionaries, who in 1888 arranged for the sixteen-year-old to be educated in Germany.[8] He returned five years later, a modern-thinking idealist with a doctor of divinity degree and a taste for Wagner. His fluency in German was then a rare skill in his homeland. According to family lore, warlords once approached him to negotiate on their behalf with German munitions compa-nies. To do so, he told them, was incompatible with his religion, and he turned them down.[9]

Fresh from abroad, C.P. taught in a Methodist school in Zhen-jiang (Chinkiang), a Yangtze River port close to Nanjing (Nanking). It was there, within Zhenjiang's small Christian community, that

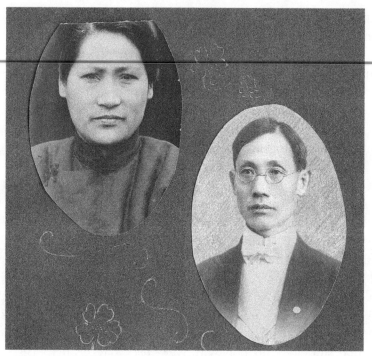

Dick's maternal grandparents, Dr. C. P. Hu and Shiu Wing Hu (née Kung), circa 1900, Zhenjiang, China (Courtesy of Miles Bellamy)

C.P. met the teenage Shiu Wing Kung, who sang in the church choir. Her family had come to Zhenjiang from Yangzhou (Yangchow), another of the Yangtze's ports, and were likely Christian converts, as they left their daughter's feet unbound. Zhenjiang was also home to a little American girl who would grow up to be the Nobel Prize–winning writer Pearl S. Buck. Her celebrated novel *The Good Earth* (1931) is set in the China of her youth, a land of wealthy landowners and poverty-stricken farmers fated to endure the cyclical catastrophes of flood, drought, and famine. Buck's parents, Absalom and Caroline Sydenstricker, were Southern Presbyterian missionaries and may have been among the wedding guests when, in 1896, the twenty-six-year-old C.P. married Shiu Wing, age seventeen.

In 1899 C.P. and his young wife returned to his hometown, Jiujiang. Lydia, their firstborn, arrived with the new century. Eight of their ten children survived infancy.[10] The Hus likely stayed in

touch with the Sydenstrickers—the Hus' youngest child, Rebecca, born in 1923, recalled that when she and her brothers complained that their father was too strict, he would remind them that Pearl's father, Absalom, a zealous evangelist, was even worse.[11] Eight years younger than Pearl, Lydia was a baby during the Boxer Rebellion, a peasant uprising that targeted westerners and Christian converts. Just how the Hus got through those lawless times is unrecorded, but when Lydia would have been old enough to understand, she likely heard stories about those horrific few years. Dick's cousin Jack Davies, who was close to him in age, remembered a visit to the Bellamys when Lydia made a point of sitting down with the boys to talk about the Boxers and that moment in Chinese history.[12]

In 1905 C.P. again left China to study, this time in the United States, and the stalwart Shiu Wing stayed behind with the children. Lydia was eight when her father returned three years later with degrees in theology and liberal arts[13] and joined the faculty at William Nast College, a Methodist school in Jiujiang. He was still teaching there in 1912 when China's last emperor abdicated and Sun Yat-sen became president of the new Republic of China. Sun was a hero to forward-thinking Chinese like the Hus. Lydia would later talk about Sun to Dick and his cousin.[14] Sun's successor, Chiang Kai-shek, was a Methodist, as was his wife, May-ling Soong, and the Hu children counted Madame Chiang Kai-shek and her two sisters as friends.[15] Whatever reservations the Hus may have had about Chiang's vision of China's future, they supported the nationalists when they split with the Communists in the late twenties.

Dick's grandparents were part of China's new educated elite, proud to send their daughters as well as their sons to university. Everyone at home played an instrument,[16] and music was integral to their lives. C.P. and his wife read English newspapers and spoke German to each other when they didn't want to be overheard.[17] Their oldest girls, Lydia and Hannah, trained as doctors in the United States. Their parents took it for granted that the two would return to minister to their people, as C.P. had done. Lydia arrived in the United States in the fall of 1916[18] and enrolled in the Northern Arizona Normal School in Flagstaff, a high school with a primarily occidental and Native American student body.[19] An editor of her

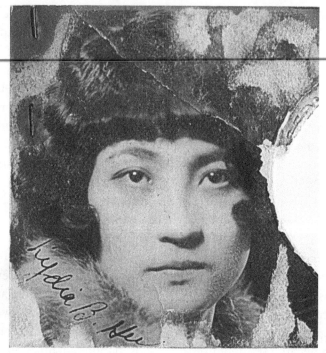

Dick's mother, Lydia Hu, 1918 (Courtesy of Miles Bellamy)

yearbook,[20] she excelled in Latin, math, and science and earned her highest grade—99—in music.[21] She adored music, a passion her son would share.

Smart, genteel, and strikingly beautiful, Lydia earned her B.A. in 1921 at Western College for Women in Oxford, Ohio, and was the only woman in the class of 1925 at the University of Cincinnati College of Medicine. She met Curtis Franklin Bellamy—two classes ahead of her at the medical school—at a dance, and they were engaged before she graduated. Lydia's choice of a husband and her decision to remain in the States wounded her parents, who expected her to marry a countryman and to practice medicine in her homeland. Chinese prejudice against non-Chinese[22] differed little from the bias they themselves faced outside of China—Lydia Bellamy's in-laws didn't take to her either.[23] Strong enough to reject the life her parents outlined for her, Lydia nonetheless carried her guilt for a lifetime.[24]

Determined that Hannah would not follow in her elder sister's footsteps, the Hus called her back to China.[25] She married Shiu Kee Yee, today known by his initials, S.K.[26] Yee was an undercover operative for the Nationalist Chinese secret service, as was the Hus' charismatic youngest son, Daniel. Dick was ten in 1937, when an anguished Lydia learned of the Japanese occupation of Shanghai, where her parents then lived. Perhaps in retaliation for the clandestine activities of the extended Hu family, the Japanese targeted them, first requisitioning C.P.'s prizewinning rosebushes, then destroying their house. The Hus watched helplessly as his treasured library and Wagner recordings went up in flames. Not long after, he died of dysentery, and his widow and daughters Hannah and Rebecca joined S. K. Yee in Hong Kong. Weeks after Pearl Harbor, when the Japanese closed in there, Lydia's mother and sisters made harrowing getaways, as did Yee, who fled separately in a daring Christmas Day escape by sea with compatriots and several British soldiers.[27]

"It used to be said of my father that one leg was shorter than the other from walking down the hill from the one-room log cabin, of course, to the out-house—the path had a rut in it," Dick wrote to a collector friend in the 1960s.[28] "Did you know that I was half-breed Kentuckian? Hill-Billy Chinese, as it were." When Dick was a boy, his paternal relatives had a family farm in Portsmouth, Ohio, on the northern banks of the Ohio River, just across the water from Kentucky. His grandfather Townley Hannah Bellamy was a dignified but rough-hewn tobacco farmer and justice of the peace whom everybody called "Judge." It wasn't until after Dick's death that his cousin Joe David Bellamy researched the family's complete genealogy.[29] Likely Dick was unaware that the earliest Bellamy/Bellomys arrived in the New World as early as the 1630s and possibly sooner, or that he was a direct descendant of New Englanders John and Samuel Adams.[30] It would have tickled him to learn that he was related to the famed circus master, Phineas T. Barnum.[31]

Dick's father, Curtis—"Doc" to family and friends—was born in 1899, the fourth of Townley and Sarah Edith Lawhorn Bellamy's

nine children, the third of their five gregarious and athletic[32] sons. After Sarah Bellamy died, in 1934, her youngest child, fifteen-year-old Victor, lived with Doc and his family until he finished high school. Doc bankrolled his brother "endlessly and way beyond good sense," as Joe David Bellamy saw it.[33] Doc paid for Victor's operatic study at Juilliard—expensive training not technically necessary for his subsequent career as a country-and-western singer. He had a beautiful bass voice and made it onto Ted Mack's *Original Amateur Hour*—a national TV show with the prestige of *American Idol*. Billed as Vic Bellamy, Dick's young uncle was a regular on the televised *Midwestern Hayride*, a Cincinnati version of the *Grand Ole Opry*.

There was to be only one Dr. Bellamy in the family after Lydia and Doc wed in 1926. Although she briefly interned at the Women's Medical College of Pennsylvania,[34] Lydia never practiced medicine. She had conservative views about married women as wage earners, Dick later told a friend;[35] besides, Doc didn't want his wife to work. The young couple bought a house in Wyoming, just past the northern boundary of Cincinnati—a Tudor revival with snug window seats and a fireplace flanked by blue- and pink-flowered Rookwood tiles. The house had a shoulder-high hedge and a Chinese (lacebark) elm that Lydia planted in the front yard.

Dick grew up amid Chinese furnishings and artifacts. Later in life he would tell friends that he first understood beauty by handling Lydia's collection of jade carvings.[36] Chairs that once belonged to her parents sat in the Bellamys' living room near Chinese porcelains Lydia used as accent pieces;[37] a large Oriental rug with a dragon motif covered the floor. A marble Buddha sat in a small niche near the hearth.[38] Dick's school friends marveled at the oil painting of his mother above the mantel. Dressed in a Chinese embroidered robe and ornate headdress, Lydia seemed every bit a princess, a rumor Dick himself may have started.[39]

He was seven when his young uncle moved in. Prohibition had only recently been repealed. Vic arrived well acquainted with hooch,[40] and perhaps became Dick's unwitting role model. A prankster, Vic once painted rings around the eyes of the family's bull terrier, Pete, making it look as if the dog were wearing glasses.[41] On another occasion he brushed the treads of an old tire with paint and

Dick in the front yard of his family home, Wyoming, Ohio, 1931 (Courtesy of Miles Bellamy)

Dick and his mother, Lydia, circa 1933 (Courtesy of Miles Bellamy)

rolled it over poor Pete's side. When the pet lay down in the middle of West Mills Avenue, as he liked to do, it appeared he'd been run over by a car.

The Bellamys' parcel of land on Springfield Pike in the affluent village of Wyoming was close to Hartwell, a working-class neighborhood. Their home was the biggest in the immediate vicinity.[42] They lived comfortably during the Great Depression, with a maid, and radios in every room.[43] Doc operated a private emergency clinic[44] in Cincinnati's West End, a poor, quasi-industrial area whose manufacturing plants had no facilities to treat job-related injuries. People who lived and worked nearby kept Doc's waiting room full. He cared for them regardless of their ability to pay,[45] charitable acts likely subsidized by his surgical privileges at major hospitals. He also dabbled in real estate and could have been a very wealthy man,[46] his nephew Jack said. "But he was not interested in money; I think he taught Dick to be that way." A few months before Dick died, his son, Miles, asked him to name Doc's most admirable trait. "He treated all people equally,"[47] Dick replied, a precept he too lived by.

Dick was about to enter first grade when the infant son of the aviation pioneer Charles A. Lindbergh was kidnapped and later found dead, one of the most highly publicized domestic crimes of the century. Mothers everywhere hugged their children tighter. Lydia did not allow her little boy to leave their front yard, even to get candy at the general store with kids in the neighborhood.[48] But sometimes the world came to him. The American-born movie star Anna May Wong, the most famous Asian performer of her generation, was a friend of Lydia's and on one occasion stayed with the family when she was filming nearby.[49] To the end of his life Dick treasured the memory of his dandle on the beautiful actress's knee.

Dick saw many movies as a boy—Doc owned most of a block of businesses in nearby Hartwell, including the Vogue movie theater. His cousin Jack laughed to recall Dick's spot-on mimic of Charlie Chaplin's comic walk.[50] There were Chinese characters in movies, but the parts almost never went to Chinese actors. Anna May Wong

Dick and his parents, 1932 (Courtesy of Miles Bellamy)

was considered "too Asian" for the starring role in the 1937 film based on Pearl Buck's *The Good Earth* and was passed over in favor of a white woman in yellowface.[51] Chinese evildoers appeared in several films popular in the thirties, artifacts of "the yellow peril" of the last century. The sinister, made-to-look-Asian Boris Karloff commanded, "Kill the white man and take his women!" in *The Mask of Fu Manchu* (1932), a film based on pulp fiction that had been around for years. The wicked Ming the Merciless, Flash Gordon's nemesis, first appeared in comics of the twenties and survived for decades on celluloid. The honorable Charlie Chan may have been the sole Chinese screen character with whom Dick felt kinship. The impeccably polite, benevolent detective with a sense of humor outsmarted bad guys in nearly fifty films between 1926 and 1949.[52] Played by a succession of occidental actors, Charlie Chan was given to cryptic aphorisms spoken in ungrammatical Pidgin English.

The Bellamys' only child was an exotic presence in the homogeneous Anglo-Saxon community of Wyoming, Ohio. Over the years, Dick attended school with only a handful of black children and likely fewer Jews.[53] "I thought from his appearance he might be Jewish,"[54] remembered a schoolmate who first saw Dick at the Vogue Theater. "I didn't like him, and I told him to go back where he came from." People didn't know what a Jew was, Dick once told Sheindi,[55] recounting a time when he and his friends hid in the bushes to see if they could spot horns on the head of a Jewish man.[56]

Lydia originally wanted several children,[57] but after seeing what Dick endured as he grew up, she had second thoughts.[58] Even if people were not openly hostile, they might scan his face for a few seconds longer than was polite. Dick was unusual looking for many reasons—in addition to his mother's distinguishing Chinese features, an illness at age five had permanently darkened his teeth.[59] He was widely liked yet ribbed and taunted and was "very unhappy at times,"[60] a school friend acknowledged. Kids called him "Chink."[61] Friends who were with him when they heard the news about Pearl Harbor remembered kidding around, pretending he was Japanese. Dick "didn't seem to mind,"[62] or at least didn't let on, knowing full well that a reaction would only make things worse.

From first grade until puberty—when he shot up to six feet—

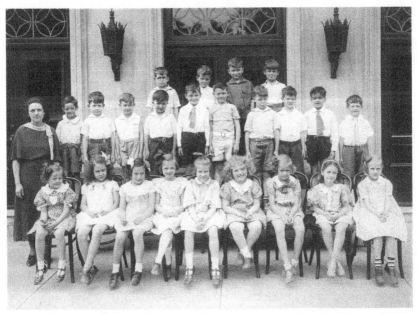

First grade, Wyoming Public School, 1933 (Dick in second row, next to teacher)
(Courtesy of Miles Bellamy)

Dick was the smallest of the cohort progressing together through Wyoming's public schools. "He was frequently teased, mainly because he seemed to invite it with his clowning,"[63] one classmate recalled, confessing, "I don't think I ever knew him in spite of sharing classrooms with him for twelve years." Wyoming High's yearbook editors jokingly tagged Dick "most prosaic," a condition they knew to be contrary to fact. He had numerous nicknames, assigned "mainly by himself,"[64] including Finlay, Somerset, Cup Cake, and Moon Glow.[65] Here and there in the yearbook he's identified as "George Bellamy," notably in the cast list for *One Mad Night*, the junior class farce he may have had a hand in drafting. Dick played the part of a Chinese valet named Wing. He did not seem to need friends in the same way that others did, said the classmate who played the master to Dick's servant in the play.[66] He was "popular with his peers, although he didn't want to be,"[67] observed his cousin Jack. "People gravitated to him. He had a certain mystery, an aura about him. He was ambivalent about the attention—he liked it and didn't like it.

At times he was entertaining and outgoing, and then at other times he was inward, withdrawn." He would be little different as an adult.

Throughout his life Dick treated clothing as costume and disguise. In high school he pulled off a madcap stunt at an elite Cincinnati tennis club,[68] convincing the management that he was from Afghanistan and playing several rounds of tennis draped in sheets and a turban.[69] A singular presence in his teens, he wore sneakers and torn jeans to class[70] decades before it was the fashion. The elegant, Chaplinesque physicality he cultivated as a boy never left. "He'd dress in the most outrageous rags," commented an artist who knew him later in life, "but then he'd pour you tea as if you were in the garden of the Frick."[71]

For Dick's high school crowd, social gatherings usually involved alcohol, and about half of the young men would go on to become problem drinkers.[72] On some Sundays the gang picked up a keg of beer and headed to the country to play softball.[73] Wyoming didn't allow the sale of liquor, but nearby Woodlawn did. At three thirty on school days, they might head to Utrecht's Tavern, a Woodlawn bar they cheekily dubbed "the office,"[74] which turned a blind eye to patrons under eighteen, then the legal drinking age.

A master at high jinx, Dick was known to jump out of the school's first-floor windows to get cigarettes or take off for a bar.[75] Sometimes he reversed the route, scaling an exterior wall and startling his friends by peering in through the classroom window.[76] Known to cut classes to attend matinees of the Cincinnati orchestra,[77] he also took friends to the outdoor operas staged on the grounds of the zoo,[78] where "animals would often roar, screech, or jabber when the soprano sang,"[79] recalled the writer Thomas Berger, a friend of the Bellamys'. Cincinnati was a culturally progressive city in the mid-forties. Nearly a half century after moving away, Dick would remember a 1946 exhibition of Brancusi, Calder, Lipchitz, and Moore, one of a series of shows that the innovative Cincinnati Modern Art Society sponsored that year at the Cincinnati Art Museum.[80] Unusually for a teenager, he decorated his room with reproductions of abstractions by Matisse and Georgia O'Keeffe.[81] One yearbook photo caught him cutting up in the art room—paintbrush in hand, Dick flings his arms wide in mock triumph near an easel with an abstract

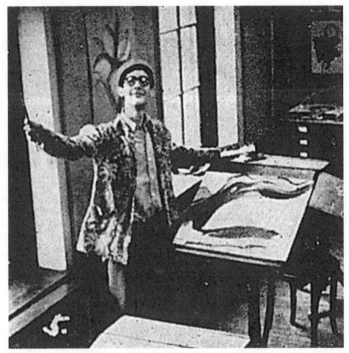

Dick in the art room, in a photograph from the Wyoming High School
yearbook, 1944 (Courtesy of Wyoming, Ohio, Historical Society)

composition, presumably his. Its emphatic, floating shapes are one
part Wassily Kandinsky, one part O'Keeffe. He grins broadly, chin
raised, his myopic eyes barely visible behind chunky lenses.

When the yearbook polled the senior class about their aspira-
tions, Dick was one of several who deflected the question with hu-
mor. "Sheriff," he replied, a masculine fantasy straight out of the
movies. "I never had any ambition. I didn't ever think of being any-
thing," Dick confided later in life to a friend who asked what he'd
been like as a kid.[82] If he envisioned his future at all, he once told an
interviewer with likely irony, it was to sit at a desk with a green visor
on his head.[83] In the movies, old-timey editors, accountants, and
people doing vision-intensive work might wear eyeshades to reduce
glare from overhead lights. But such visors were out of fashion by
Dick's day and had come to symbolize excessive concern for pecu-
niary matters and small details.

•

The social hierarchy of Wyoming largely shut out Doc and Lydia Bellamy.[84] One of Dick's school friends remembered learning from her parents that in the thirties, a local bridge club pointedly excluded Lydia.[85] Even those who admired Lydia felt that she had married beneath her and found Doc's rough charm and accent "too country."[86] The neighborhood kids, though, thought the world of Doc, who made house calls when they were ill and dropped by when they needed checkups.[87] In the forties, the community may have warmed to Lydia when she energetically aided the war effort, selling bonds[88] and helping out with paperwork at Doc's office.[89]

Doc Bellamy belonged to that rare fraternity of men who served in both world wars.[90] An army private and bugler in 1918, twenty-six years later he served as a navy lieutenant commander, assigned to San Francisco. In the fall of 1944 his wife and son joined him in California during the first semester of Dick's senior year in high school. In a photo from this time, they gather in bright sunlight at the entrance to a building. Lydia rests on the steps, a sable coat thrown over her shoulders in the chill air. Her husband and son stand like flanking pillars. Doc is a dashing middle-aged officer in navy blues; Dick wears stylish light-colored clothes Lydia must have helped him choose. No one smiles.

The Bellamys returned from the West Coast in the early months of 1945, and Dick rejoined the senior class at Wyoming High. Lydia's health began to decline in her early forties, eroded by congenital heart disease.[91] As doctors, she and Doc knew that it was only a matter of time before her leaky heart failed. In the months before she died, Lydia spent her days resting on the Chippendale couch in the living room, and Doc put in a bathroom on the ground floor. Literature, music, and art were mother and son's common ground. Afternoons after school, Dick and Lydia read poetry aloud and sat together listening to records, especially Tchaikovsky.[92] When Cousin Jack visited, they'd talk about books, such as *Between Tears and Laughter* (1943),[93] a bestselling critique of Western racism and imperialism by Lydia's friend the Chinese American writer Lin Yutang. Dick graduated from high school in late spring, and Lydia may have found the

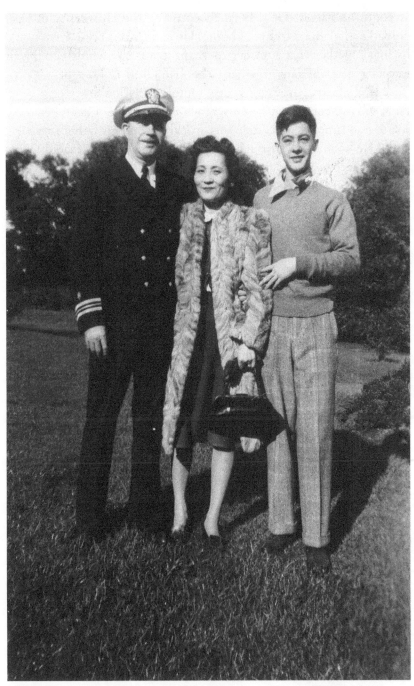

Dick and his parents, 1944 (Courtesy of Miles Bellamy)

strength to attend. He'd been accepted by the University of Cincinnati and planned to live at home. He and Lydia pored over course listings together that summer; perhaps it was she who steered him into German, the language her father had loved and taught.

Lydia's heart gave out in early October 1945, a few weeks after Dick started college. It was a wrenching loss. She'd been her son's solace and support, his guide to a world beyond his father's experience. He sobbed all through the funeral and then retreated to his room, where he stayed for a day and a half.[94] Then, oddly, he popped back to life, resuming his studies with no outward sign of sorrow.[95] As a grown man, he would behave similarly when someone close died, a coping strategy of shutting off feelings that his partners found "unsettling and incongruous." [96] After his mother's death his drinking increased, as did his father's. "You knew you could get a drink at his dad's house," [97] a friend recalled. "No questions asked."

In his first semester Dick squeaked by with passing grades in German and English but flunked ancient history and biology.[98] The second semester was a rout, with Fs in English, public speaking, aesthetics, and "Philosophical Ideas in Contemporary Literature." Still, he must have paid attention to some of it. As had Lydia, Dick loved to share what he valued, once urging a friend from high school to give William Faulkner a go.[99] Perhaps his college lit course curriculum included Franz Kafka's consequential *The Castle*, a book Dick would introduce in 1946 to Thomas Berger, the future author of *Little Big Man*, whose uncle was a friend of Doc's.[100] "It was Kafka who taught me that at any moment banality might turn sinister," Berger revealed decades later, "for existence was not meant to be unfailingly genial."[101]

Dick's pseudonym "George" gained a new dimension after Lydia died. The Bellamy men began to call each other "George" and "Lennie," the names of the two forlorn and alienated outsiders in John Steinbeck's Depression-era novella *Of Mice and Men*.[102] George is small, quick, dark, and restless, as Dick was as a boy. Like Lennie, Doc was a large man, although the resemblance ended there. All too

soon for Dick's comfort, Doc began to date. His succession of girl-friends embarrassed his sensitive eighteen-year-old, and Dick was made all the more uncomfortable when his father tried to bring home girls for him as well.[103] By mid-1946, Gay Cain, a stylish di-vorcée twenty years Doc's junior, edged up in his favor.[104] Gay was a good-looking beautician from the tiny town of Albany, Kentucky, near the Tennessee border. Doc owned the hair salon where she worked. To Cousin Jack, Gay resembled Lydia in appearance if not demeanor—the two attractive women were both short, with black hair and very pale skin.[105]

Dick disliked Gay even before she moved in, carting with her a mundane collection of bisque ceramics. One ploy he found to defy her was to refuse to clean his room. She tried bringing in a clergy-man to talk sense into him.[106] The preacher found Dick upstairs in the offending bedroom and admonished him for disrespecting his elders. Then the man dropped to his knees to pray for him, a shock-ing gesture Dick never forgot. Not surprisingly, the entreaties did not work. Likely with Doc's encouragement, Dick gave higher education another try, this time far from home. In the fall of 1947 he enrolled at Columbia University's School of General Studies. Doc wanted him to go into medicine, but Dick wasn't interested.[107] He thought about the Foreign Service,[108] perhaps an idea his civic-minded mother had nurtured. At Columbia he piled on a heavy course load: two philosophy courses, a beginning class in economics, and one in Chinese.

Chinese. An ambitious and freighted choice. By then Dick must have read Ezra Pound's translations from the Chinese, poems Lydia would have praised for their delicacy and economy. But studying Chinese might have revived the irremediable ache of her absence. Before the end of the term, he dropped the course, as well as the one in economics. He managed a B plus in introductory philosophy, but failed the department's "human nature and conduct," a turn of events that may have amused him. When Dick cut classes in Cin-cinnati, he usually went drinking. In New York he likely found his way to the West End Bar on Broadway near 114th Street, a magnet for boozy Columbia students. A few years before Dick arrived in

Morningside Heights, the Beat Generation stalwarts Jack Kerouac, Allen Ginsberg, and Lucien Carr were regulars at the venerable West End.

That semester Doc Bellamy paid tuition for his son and for his youngest brother, Vic, a student at nearby Juilliard.[109] Dick's high school friend Albert Richardson occasionally came up from Princeton to see him. Once, they had dinner in a Chinese restaurant with Dick's aunt Hannah, in New York on a visit from Hong Kong, and she gamely taught Albert to use chopsticks.[110] After World War II, she and her husband, S. K. Yee, had returned to the British colony, where he entered banking, in time becoming one of Hong Kong's wealthiest citizens. Hannah greatly valued family bonds[111] and stayed in touch with Doc and his sisters for the rest of her life. She struggled to understand her nephew Dick, who lived by a different set of rules. In a 1981 letter to Doc's sister Beulah, written years after her brother-in-law died, she talked about Dick, pointing to his biracial identity as a possible explanation for his unfathomable behavior: "What a disappointment [Dick] is to me, and I feel so hurt for Lydia's sake. He is a good for nothing fellow! . . . I understand he [is] penniless most of the time. Psychologically, his strange behavior might be attributed to his mixed blood heritage, but there are many people of this category and they have made great names for themselves in finance and politics."[112] Hannah had untold resources and no children of her own[113] and hoped to pay for Dick's son's college education,[114] but Dick neglected to keep Hannah up to date on his whereabouts, and her efforts to reach him were in vain. Dick wanted no part of finance or politics, strange behavior indeed to Aunt Hannah.

"I am the embodiment of our generation's cliché of the dope-fiend Oriental resigned to the last bitter dregs of this 'strange business,'"[115] Dick wrote facetiously to the collector Vera List in the 1970s, taking the unusual step of footnoting his quotation's source: a 1928 essay by Robert Graves on "the future of humor."[116] That future, Graves posits, "was inevitably Chinese,"[117] and he recounts "a classical Chinese jest" about an influential mandarin, reduced by his enemies from affluence to misery, who retreats to a rude mountain cell and repeatedly writes on its walls with a burnt stick, "Oh, oh! Strange business!"

Dick with his father and his father's second wife, Gay, at their wedding, 1948 (Courtesy of Miles Bellamy)

As an adult, Dick rarely talked about race. Yet some of his friends understood him through the prism of Chinese culture. The enigma of his mind was "charming" to the photographer and filmmaker Robert Frank: "He played very well on that, as the mysterious Chinese."[118] The Japanese American artist Kunié Sugiura remembered agonizing with Dick over a romance, theorizing that her lover did not find her as beautiful as white women. "You have a national disease you are carrying in your body!" Dick remonstrated with a rare flare of anger. "You should be very proud of who you are!"[119]

December 1947 must have been a particularly difficult time for Dick. As New York shopkeepers geared up for the holidays, festooning Broadway with wreaths and poinsettias, Dick sharpened his solitude alone at the bars. It is not known how he spent his twentieth birthday, December third. After finals week, the desultory young man returned to Ohio. It was a grim homecoming. Doc and Gay married on January 14, 1948.[120] A photograph probably taken on their wedding day shows Dick and the couple posing in Sunday finery. His guileless father has one arm wrapped around Gay's waist, peering ahead with a look of slight surprise. Dressed in a dark suit with matching hat and veil, his bride turns slightly away from the camera, narrowing her eyes in a tense smile. Dick stands with them in profound discomfort, with pursed lips and unfocused eyes. As

soon as he was able, he left home for good. He first stopped at the Oak Hill Cemetery and followed its neat pathways to the Bellamy family plot. His mother's gravestone was flush with the grass, "Lydia" its sole inscription. He crumpled across it and wept.[121]

He left soon after for Mexico City. Perhaps his desire to choose this destination came from F.S.C. Northrop's *The Meeting of East and West*,[122] a book he'd read in college whose very title seemed to define him. Northrup believed that Mexico's multicultural sites and artifacts provided "a tie and a bridge to Asia,"[123] a postulation that Dick may have wanted to test for himself. Northrop had lived through both world wars and believed that world peace would endure only through the reconciliation of the distinct cultures of the East and the West. The former apprehends experience as a totality, Northrop generalized, a characteristic he called "aesthetic." For westerners, on the other hand, experience was a theoretical construction. Dick may or may not have found clues to his Asian heritage in Mexico, but it was there he met one of the two people who set him on course to find his life's work.

The American decorator and antiques dealer Peter Hunt[124] happened to be in Mexico at the same time as Dick. It is not known where and how they met, but perhaps the two gringos fell into conversation in a bar. Of all the intriguing young men a gay aesthete like Peter Hunt would have come across in Greenwich Village or in Provincetown, his hometown, few would have matched this unworldly, unconventional, straight young man who carried his body with an androgynous grace. Dick must have listened attentively as Hunt described Provincetown, the live-and-let-live community of fishermen and artists right on the Atlantic Ocean. Not only did this stranger predict that Dick would find it to his taste, but he promised him a job should he ever find himself there.

From Mexico, Dick traveled to Baltimore, where he knew someone who was a seaman based there.[125] Dick planned to jump-start manhood by shipping out as a merchant marine. It was an adventurous scheme for a skinny kid from landlocked Ohio who had once spent a few happy weeks with schoolmates boating on Lake Huron.[126] But Dick was enamored with Herman Melville[127] and the romance of doing man's work in the watery equivalent of the Foreign Legion.

To prepare for the life of a tar, he bought a black turtleneck sweater, the memory of which made him laugh when he shared it as a sixty-three-year-old.[128] He must have imagined himself plying the seas in watch cap and peacoat, collar turned up against the salty wind. His seaman's papers were going to take weeks to be processed, and rather than wait around in Baltimore, Dick decided to see what Provincetown was like.

PROVINCETOWN, 1948–49

Provincetown was a drowsy fishing village when twenty-year-old Dick Bellamy hitched there in 1948. Located on the tip of Cape Cod, it is a place where "geography runs out," as Norman Mailer once said.[1] The Pilgrims made first landfall in Provincetown and wrote the Mayflower Compact in the shelter of its snug harbor.[2] But by the time of the Revolutionary War, the out-of-the-way town was a destination for pirates and smugglers who counted on the residents to mind their own business. Many locals were descendants of the Portuguese crews who hunted for whales when blubber was a valued fuel. By the 1870s, tourists began arriving by railroad. Painters from Boston and New York discovered its picturesque fishing boats and working wharf,[3] and they were followed by writers and political progressives who were enticed by its cheap digs and casual atmosphere. Gay men and lesbians came as well, attracted by the town's tradition of tolerance, if not acceptance, of difference. After trekking out to this artistic enclave, most visitors were smitten for life. Dick Bellamy was, just as Peter Hunt foresaw.

Hunt himself had turned up in "Ovince," as he called it, in the early 1920s.[4] He told later admirers that he first learned of Provincetown when a yacht he shared with Zelda and F. Scott Fitzgerald sought refuge there from a storm. He described how he strolled down the narrow thoroughfare of Commercial Street wearing a black cape and broad-brimmed hat, two Afghan hounds and a

redheaded dwarf by his side. Like a camp Vasco de Gama, Hunt surveyed his surroundings and proclaimed, "This is a wonderful place. I must stay." Listeners were enthralled. But the story was as fanciful as his account of his origins. A charmer with a talent for self-invention, Hunt confided to friends that he was descended from Russian aristocracy, though in truth he was born Frederick Schnitzer, the son of German immigrants who raised him in the tenements of Jersey City, New Jersey. His father, Edward C. ("Pa") Hunt, was a self-taught artist.[5] A sensitive, artistic teenager and queer to boot, Hunt was all eyes and ears during his European service in the ambulance corps during the First World War. After returning to the United States, he gravitated toward the bohemian subculture of Manhattan, hoping to support himself as a painter.

He proved an unremarkable artist, and he struggled to keep up financially with his cohort and its wealthy patrons. At the suggestion of the playwright Eugene O'Neill and the journalist Mary Heaton Vorse, he opened an antique shop in Provincetown in the late twenties.[6] When he moved there permanently during the Depression, Hunt advanced from "wash-ashore" to "year-rounder," in the local parlance. With limited funds to purchase stock for his business, he trolled dumps and thrift shops to rescue forlorn wooden furniture. Cleverly removing any outmoded elements, he might cover the reclaimed piece with ivory paint and rich blue trim.[7] Then he would decorate it with the folksy ornamentation that soon became his trademark: swags of chubby hearts and flowers, and figures in quaint garb, reminiscent of the peasant art he had seen in Europe. The trendsetting, well-connected Helena Rubenstein was one of several of Hunt's city friends who liked his handiwork and talked it up. New York department stores began to carry his gaily painted "whatnots," and orders flowed in. He was well positioned when recycling became a patriotic duty during the Second World War; *Transformagic*, a widely circulated pamphlet on "the art of making old things new" that he wrote for the DuPont paint company, prompted articles about him in *National Geographic*, *Life*, and *House Beautiful*. With the publication of *Peter Hunt's Workbook* at the war's end, the verb "to Peter Hunt" entered the American vocabulary.

Hunt gave Dick a room in one of the apartments he owned,

trading rent for houseboy services.[8] Dick assisted at cocktail parties and dinners, serving the wealthy decorator's wide circle of friends, including the painter Maurice Sterne, who as a young man in Paris had known Rodin and Degas. Hunt found a paying job for Dick as an apprentice at Peasant Village, his store and atelier, which was then housed in a loose confederation of chintz-draped showrooms and studios linked by flagstone courtyards directly off Commercial Street. Dick worked with as many as a dozen young people,[9] helping to transform the outmoded cabinets and tables that Hunt brought in from Boston by the truckload. Hunt encouraged his helpers to tap into their sense of whimsy as they painted these castoffs with his signature flowers and fruits. In *Paintbox Summer* (1949), Betty Cavanna's young adult novel based on her experiences as an apprentice, she described the easy camaraderie of the youths who would begin their workday by tearing out pages from back issues of glossy magazines to use as makeshift palettes.[10] Dick never returned to Baltimore to claim his seaman's papers.

Provincetown artists aligned themselves in two camps at mid-century—the "modernists" and the "traditionalists." It was easy to spot the latter working outdoors, their portable easels planted in front of the classic vistas of pier, dunes, or bay. Many were former students of the late Charles Hawthorne, an American impressionist who opened the first summer art school there in the late nineteenth century. He taught his pupils to follow Monet's practice of painting directly in front of the subject, or *le motif*, as the Frenchman called it, the better to observe the effects of sunlight on the natural world. Traditionalists dominated the juries of the venerable Provincetown Art Association, the town's only exhibition venue. William Baziotes, an avant-garde abstractionist, found the Art Association an easy target in 1949 when he lampooned their *retardataire* tastes and dreary exhibitions by imagining prizes awarded to "Agnes Mayberry Sputterbutt's 'Callow Lilies by My Window' . . . or John Woof's turbulent watercolor 'Provincetown Fishermen Playing Bingo on a Whale's Back.'"[11]

The modernists didn't paint scenes. They absolved color, line,

light, and space from the responsibilities of representation and usu-
ally worked in their studios. Although such pioneering American
modernists as Stuart Davis, Charles Demuth, and Marsden Hartley
had been drawn to Provincetown as early as the teens and the twen-
ties, it was only when the renowned European teacher Hans Hofmann
opened his own summer school there in 1935 that modernism
gained an enduring presence. Hofmann, a German émigré who had
known Picasso, Braque, and Matisse when he was a student in Paris
before the First World War, embodied a direct link to the most ad-
vanced painters in the world. (It was rumored that he picked Province-
town as a base because it resembled the summer resorts of the French
impressionists.)[12] Hofmann was an expressionist who took joy in
unfettered brushwork and exuberant color, and he spoke of making
a painting as "almost a physical struggle."[13]

During the winters Hofmann operated a school in Manhattan.
When the weather turned warm, he shifted to Provincetown, and
many of his students followed him north. Enrollment increased after
the war ended, in 1945, as former servicemen and women resumed
their education under the GI Bill. Theirs was a generation impatient
to get beyond literal, earthbound images, the social realism and
nativist landscapes of the thirties. Hard-edged, geometric abstrac-
tion likewise seemed irrelevant to the times. Some had firsthand
experience of the horrors of war and found in Hofmann's teachings
nonobjective ways to express spiritual truths.

Postwar American painting, variously called abstract expression-
ism, action painting, and New York school painting, became a vis-
ceral record of each artist's own creative process. To Hofmann,
color and shape could convey the illusion of space, depth, and even
movement on a canvas, a phenomenon he famously called "push and
pull." It made no difference to him if the final artwork was natural-
istic or abstract, for he believed that "every visual expression follows
the same fundamental laws."[14] Nature was the starting point, he
told his students, the source from which all abstractions began. As
a visual point of departure, he would set up a still life or pose a live
model in the front of the class.

Hans Hofmann was a significant, if indirect, influence on Dick.
On Friday afternoons Hofmann held celebrated critiques against

the exterior wall of his Provincetown school, which fronted Commercial Street. Students would lean their paintings up against the former barn, and he commented on them in his heavily accented English.[15] As did many of his friends, Dick came to eavesdrop from time to time. For years, Dick regarded Hofmann as "a negligible painter but a great teacher,"[16] but in time he came to appreciate his greatness: "When Hofmann used to talk about color to his students, he would use this word 'interval' to describe what happens when two colors meet and a light flash is created. This never made any sense to me until I had a revelation while looking at one particular painting of his at the Metropolitan Museum in New York. I actually saw color in a different way."[17]

Hans Hofmann and Peter Hunt belonged to different social circles in Provincetown yet found common cause as supporters of Forum 49, a historic series of lectures, panels, and readings, plus one exhibition, held in July 1949.[18] For Dick to find himself in Provincetown during Forum 49 was the first manifestation of his karmic propensity to be in the right place at the right time. That summer, his art education began in earnest. Had he tried, Dick could not have come up with a more apt curriculum. One evening, attendees listened to recordings of James Joyce and T. S. Eliot reading their own work;[19] on another, they watched avant-garde films by Joseph Cornell and Helen Levitt, including In the Street, Levitt's new film of Harlem street culture that was shot with hidden cameras. Other programs focused on psychoanalysis, American jazz of the twenties, and modernist architecture, as well as "America's Responsibilities in the New World" and other current topics.

Forum 49 activities took place at Gallery 200, a former garage on Commercial Street. The opening event on July 3—a debate on "What Is an Artist?"—attracted so many people that several hundred were turned away for lack of space. Hans Hofmann ended his talk that night by toasting the American Constitution, "a great work of art."[20] He, the painter and sculptor Fritz Bultman, the poet Cecil Hemley, and Hemley's cousin, the painter Adolph Gottlieb, all helped organize Forum 49, but it was Weldon Kees, a highly talented

writer, painter, jazz pianist, and songwriter, who supplied its guid-
ing energy.

The exhibition they installed at Gallery 200 may have been the
first-ever group show[21] of what Baziotes described in 1949 as "this
abstract thing . . . so much in the air and so American."[22] Abstract
expressionism was little known beyond the community of artists
who lived on Manhattan's Lower East Side. Kees and his friends bor-
rowed work directly from the artists—or from galleries, for those
lucky enough to be represented by dealers. Their exhibit saluted
Provincetown history with the work of seventy-one-year-old Blanche
Lazzell, an important if infrequently shown abstractionist of an
earlier generation, and included recent paintings by Mark Rothko,
Franz Kline, Robert Motherwell, Barnett Newman, and Jackson
Pollock, who only two years before had begun dribbling and flick-
ing his colors from the end of a stick. When Pollock and the painter
Lee Krasner, his future wife, spent the summer in Provincetown
in 1944,[23] she arranged for her former teacher Hans Hofmann to
visit his studio. When Hofmann suggested that Pollock might try
working from nature, the younger painter famously replied, "I am
nature."[24]

Pollock's paintings in the late forties were typically on a colossal
scale. But in keeping with the limited wall space in Forum 49, his
dealer Betty Parsons lent one of his best small-scale works, *Number
Seventeen*, made with drizzled and brushed aluminum paint and
ordinary household enamels.[25] Pollock told interviewers that he
numbered his paintings rather than naming them because he didn't
want people bringing preconceived notions of subject matter to their
experience of his work. If *Number Seventeen* was about anything, it
was the sensuous complexity of space and the time it took to fathom
its intricate tangle of light and dark pigments.

The painting made a strong impression on Dick, who later des-
cribed it laconically as "a very great picture."[26] Except for a few art
world insiders, the general public was oblivious to Jackson Pollock.
All that would change when the August 8, 1949, issue of *Life* maga-
zine reached newsstands and subscribers. Halfway through was a
photograph of the artist, standing with head cocked and arms
folded protectively across his chest. Pollock had a quizzical look on

his face. It seemed as if the balding thirty-seven-year-old were pondering the question embedded in *Life*'s provocatively titled feature: "Jackson Pollock: Is He the Greatest Living Painter in the United States?"[27] The photographer had backed Pollock up against the horizontal flow of *Number Nine*, an eighteen-foot-long canvas. If its undulating lines and sprays of color didn't telegraph a specific meaning to *Life*'s readers, his paint-spattered dungarees and denim shirt did, signaling Pollock's allegiance with the working class.

Although Forum 49's groundbreaking exhibit had already closed when *Life*'s article appeared, Pollock's *Number Seventeen* was still on the premises of Gallery 200—the Betty Parsons Gallery was in no particular hurry to have it back during the summer. Recognizing a publicity windfall when he saw it, the owner of Gallery 200 took the painting out of storage, put it in the front window, and jerry-rigged a ballot box for the sidewalk, with a sign that asked passersby to vote: *Was* Pollock the greatest living painter in the United States? When the more than seven hundred responses were tallied, "No" ballots outnumbered "Yes" six or seven to one.[28]

THIS CALLING OF ART

At some unremembered party[1] during his first season in Province-town, Dick had his second fated encounter when he met the dazzling Nancy Christopherson, the person he'd later describe, with Poundian grammar, as "her who brought me to this calling of art."[2] "A mission-ary with no particular affiliation,"[3] Nancy had a formative impact on nearly everyone she met. A self-taught painter, she was passionate about the visual world, and she talked about "color irony,"[4] extolling the beauty of rust and pink for example, colors that weren't supposed to go together. "Aesthetic economy" was another precept she lived by, finding visual delight in the patterns created by shattered glass and water-stained walls.[5] Nancy's "other way of looking" was eye-opening to friends, who regarded it as an "ongoing gift." With her three-year-old daughter, Poni, in tow, in 1947 Nancy "exiled her-self"[6] from Manhattan, as Dick put it. The snapshots she took of her languorous new lover playing with Poni seem to picture an entirely different person from the anguished young witness to his father's wedding. Perhaps she colluded in Dick's new look: a gondolier-striped muscle shirt, jeans, and heishi bead choker, with sideburns and a haircut she may have styled with a soup bowl.

Nancy grew up in Lakewood, Ohio, a suburban farming com-munity five miles west of Cleveland, along the shores of Lake Erie.[7] Her mother, Iris Evans, attended Wellesley; her father, Chris, was an authoritarian high school teacher. She and her brother Edmund

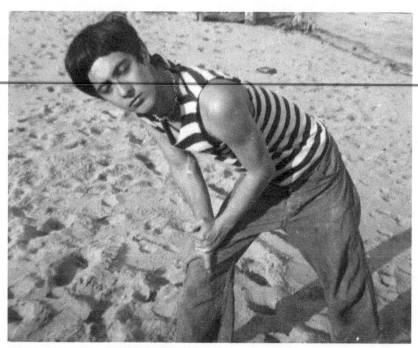

Dick in Provincetown, 1948 (Courtesy of Miles Bellamy)

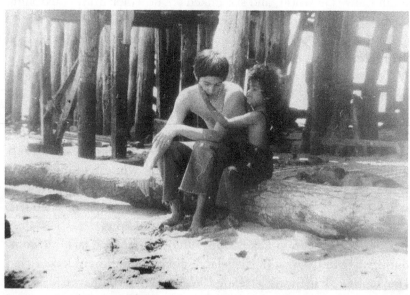

Dick and Poni in Provincetown, 1948—49 (Courtesy of Miles Bellamy)

had political views considerably to the left of their Republican parents. Nancy was part of an arty crowd in high school, a member of the drama and poetry clubs.[8] She graduated in 1941, six months before the attack on Pearl Harbor. In the next few years she studied at Cleveland College, a downtown branch of Western Reserve University. Early in 1944 she began to date Donald Banks, a former pupil of her father's then studying chemical engineering at Western Reserve, one of the first African American students they admitted.

When the Christophersons learned that Nancy was pregnant, they sent her to a home for unwed mothers in New York. Sometime after she gave birth to Poni, in 1944, she and Don married. They lived in a flat near the Hudson River, with "hardly any furniture but books and records and much love in the air," Anaïs Nin described in her diary after a visit.[9] Her short story "A Child Born Out of the Fog"[10] is based on their lives. Nin's thinly veiled portrait conveys the raw hostility Don and Nancy faced as an interracial couple with a biracial child. Married for the sake of their child, they divorced by the time Poni was three.

Although Provincetown was generally accepting, it was never a bias-free zone. Already familiar with the receiving end of prejudice, Dick experienced it freshly after teaming up with Nancy. Some Provincetown property owners were "none too happy,"[11] he later recalled, to rent to a couple with a mixed-race child. Dick, Nancy, and Poni must have been an eye-catching threesome in Provincetown. A deft seamstress, Nancy sometimes dressed them all in matching outfits, with romantic, flowing capes.[12] Poni was an "exceptionally good-looking," café au lait–colored little girl.[13] Nancy did not believe in pomade or barrettes[14] and kept her daughter's hair untamed decades before Afros were fashionable.

When Nancy first met Pati Hill, she and Poni were living nearby in a condemned house on Manhattan's West Tenth Street, a house Nancy personalized by painting a different color on "every step of the staircase and every spoke in every banister and every wall and baseboard of every room from first to third floors."[15] Pati introduced her beautiful neighbor to Diane Arbus, a dear friend who had recently opened a fashion photography studio with her husband, Allan. Pati hoped they could find a modeling job for Nancy,

who was perennially broke.[16] But it didn't pan out. Although Nancy had the looks, she lacked "the worldliness to don the *role* of a model," Pati later reflected. Nancy was incapable of creating a fac-simile of the self as a barrier, the exact opposite of Dick, a master craftsman of protective masks.

Nancy literally wore her vulnerability on her sleeve, dressing in eccentric ensembles of her own design. She hated "fashion," recalled Pati, and "judged clothing by feel or a relationship to something quite other than wearability. Velvet and cardboard gave you goose-flesh. Feathers, linoleum and fly paper were all to be considered before moving on to isinglass, tar from a nearby street and wax."[17] When she could find the work, Nancy created costumes for avant-garde theatrical productions.[18] They were like nothing else. She scoured thrift shops for evocative clothes and then deconstructed them, reassembling pieces from different garments, fastening them with safety pins.[19]

Nancy and Diane became the closest of friends. "Our friend-ship was metaphysical, rapturous," Nancy later effused. "We were mothers to each other; we were daughters to each other."[20] In July 1950 Nancy brought Dick to meet the Arbus family, who were then vacationing at Lake Champlain. Diane took photos during their visit, catching Dick at the breakfast table, tousled-haired, pensive, a knee hugged to his chest, a cigarette idling in his fingers. The filmmaker Emile de Antonio, who knew both Diane and Dick in the fifties, recognized an affinity between the two and re-garded them both as extraordinarily private and self-contained people.[21]

Nancy loved to paint in the middle of the night.[22] Her only sur-viving work is a portrait of Dick, for which she chose a tall, skinny canvas that echoed his lanky proportions. It's a striking image—lemon-yellow shirt, blue pants, and eggplant-purple background. She framed his face with a jagged cap of black hair and confined him within boundaries that knife through his body on three sides. He swivels to meet our gaze with a wide-eyed, impassive stare. Like the sitter himself, the image would have a pseudonymous identity. She'd painted Dick's portrait not long after she met him, and unearthed it in 1979 when her friend Albert Poland needed an arresting

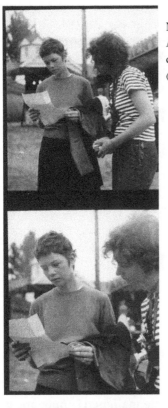

Nancy Christopherson (left) with Diane
Arbus, Lake Champlain, New York,
circa 1950. Contact strip by Allan Arbus
(© 2003 The Estate of Diane Arbus LLC)

poster for his production of Dennis McIntyre's play *Modigliani* at
the Astor Place Theatre.[23] Although the real-life Dick did not par-
ticularly resemble the brooding, handsome Italian, Nancy's version
of him did.

Nancy, five years his senior, tutored Dick in countless ways. She
made sure he met her friend Maya Deren, the Russian-born Amer-
ican avant-garde filmmaker.[24] She'd introduced the Arbus family to
yoga,[25] and now taught Dick. Nancy believed in reincarnation and
drew daily guidance from the *I Ching*, the ancient Chinese wisdom
and divination manual. An exceptional cook, she ritualized the quo-
tidian act of eating with unique bowls and serving pieces. She had a
feel for the flavor and texture of food, delighting in its inherent
sensuality. Dick would adopt as his own Nancy's emphasis on food
presentation and her interest in unexpected combinations. He en-
joyed peanut butter sandwiches with mayonnaise and raw onion,[26]

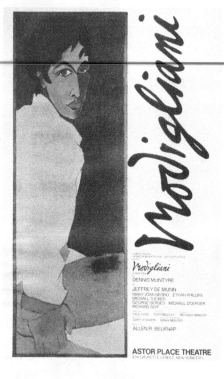

Theater poster with Nancy
Christopherson's 1948 portrait of
Dick, 1979. (Courtesy of Albert Poland)

as well as grape jelly with bacon and eggs.[27] It may have amused Nancy that he continued to eat Spam,[28] the maligned canned meat of his childhood, a wartime staple.

"The only way to make a picture of Nancy is with mosaic," suggested Pati Hill.[29] James Baldwin might have given dimension to any portrait of Nancy, but he never wrote about his next-door neighbor and good friend, whom he knew in the few years before she moved to Provincetown and he to Paris.[30] Nancy had a "very, very soft voice,"[31] with an "edge of steel" inside the softness, her niece Jeanne Christopherson detected, "as if she granted you an audience and you couldn't leave until she said so."[32] She created magical environments with draped rags and colors rubbed into the wall, transforming railroad flats into "a South American hacienda or a fifteenth-century Italian palazzo," recollected Alfred Leslie, a fan of her "imaginative resourcefulness."[33]

Faced with unfriendly landlords in Provincetown, Dick rented a ramshackle cabin for the three of them in the Province Lands,

which he did his best to winterize.[34] Night never seemed as black, the stars as close, or the wind as fierce as on this insular stretch of the state beach, miles from the nearest road. Their neighbors were seagulls, plover, and spadefoot toads; mice and weasels came to call after dark. The turn-of-the-century rustic shack had no electricity or running water. Perhaps Dick knew that Henry David Thoreau found such beach shacks useful for naps during long walks along the Cape, or perhaps he heard about the one that Eugene O'Neill and his wife lived in until it toppled over, felled by waves. There was a romance to life in the dunes. Mailer worked on *The Naked and the Dead* in a dune shack, and Jack Kerouac wrote a chunk of *On the Road* in similar isolation.

Dick and Nancy roughed it, pumping water from a well, cooking on a camp stove, and lighting kerosene lamps after nightfall. The sight, sound, and smell of the Atlantic Ocean were ever present. Daily they swept out the sand that blew in through the shack's uneven slats. To earn what he needed to supplement the check for thirty-seven dollars Doc sent him monthly,[35] Dick washed dishes at a restaurant just off the Provincetown pier,[36] an arduous trek across silting sand. "Corsons Inlet," a poem by A. R. Ammons describing the experience of walking across sand, would later be one of Dick's favorites.[37] "The walk liberating, I was released from forms, / from the perpendiculars, / straight lines, blocks, boxes, binds / of thought / into the hues, shadings, rises, flowing bends and blends / of sight . . ."

The couple made several forays into Manhattan early in 1949. While still in Ohio, Dick had seen reproductions of de Kooning's black-and-white abstractions in the *Partisan Review*, images that so impressed him, they "just went into the back of my skull."[38] On one of his trips to New York, Dick got to rub shoulders with de Kooning himself. He went to hear him give a talk,[39] only to discover that the painter was sitting in the row behind him. Oddly, Robert Motherwell came to the podium and announced, "I don't know why, but Bill de Kooning has asked me to read this to you."[40] Despite Motherwell's "very neutral, dull, uninspired" delivery, de Kooning's relayed comments left Dick "perfectly astonished." In art, de Kooning proposed that evening, "one idea is as good as another . . . Art should

not have to be a certain way."[41] His inspiring, open attitude would have a lasting impact.

Nancy introduced the new man in her life to her friends the painters Miles and Barbara Forst, who recognized Dick as a kindred spirit. All four were children of the Depression who survived in comfort. All spurned the bourgeois world of their parents—Barbara came from a family of Virginia newspaper publishers;[42] Miles's family owned a large hardware store. There was an anarchic, wild streak in Dick that met its match in Miles Forst.[43] The two had an instant rapport. To their friend Mary Frank, they seemed like "cultural spies" who whispered to each other in codes they devised for each other's amusement.[44] Four years older than Dick, the Brooklyn-born artist had been a rebellious, dandified teenager in pegged trousers when he first discovered the jazz clubs of Manhattan.

In the late forties one could walk up and down both sides of Fifty-Second Street between Fifth and Sixth Avenues and pass through successive strains of music that filtered out to the pavement, performed by such legendary figures as Billie Holiday, Art Tatum, Coleman Hawkins, Lester Young, and Hot Lips Page.[45] The good-looking bad boy from Brooklyn got to know them all. According to his son Jesse, Miles hung around with Charlie Parker, at times scoring drugs together.[46] When Miles moved to Greenwich Village, the two lived on the same block. In one of Miles's most treasured memories, Parker sits on his front stoop with his saxophone, sending bebop threads out into the night.

Just as sarcastic and funny as the musicians he adored, Miles spoke their slang and smoked their reefer. For a time he was Billie Holiday's boy toy, Barbara Forst would tell Jesse, and reportedly the singer's drug connection. Miles was "very bright, sardonic, and outrageously daring," recalled his former sister-in-law, "with a wild willfulness and readiness to try anything once, and some things twice."[47] To an acquaintance who met Miles in the fifties, he was "a past master at feigning indifference, at keeping emotion to a minimum."[48] The Forsts radiated an alluring air of rebellion. Barbara was an exquisite redheaded beauty and Miles "immensely handsome, very physical."[49]

In the summer of 1949 Barbara and Miles were staying in the

Dick seated at a table in a cabin, Lake Champlain, New York, circa 1950 (Photograph by Diane Arbus, © 2003 The Estate of Diane Arbus LLC)

Province Lands, helping Nancy make a movie. That summer was "pure fun, thoughtless joy,"[50] Miles recalled. The two-story dune shack, "bereft of material goodies," became an informal hostel for Nancy and Dick's friends. The men bunked together upstairs on a "shelf" overlooking the only room: "We could look down and hear all the girls talking about the guys." The gang practically lived on the beach. "We all were nude as much as we could—why wear anything when you're out in the sand dunes with nobody there?" One day the extraordinary-looking quartet was strolling on the Province-town pier when they stopped to talk with a curly-haired man they took to be a Portuguese fisherman. But they soon learned that the ebullient stranger was Alfred Leslie, a rising star in New York's avant-garde. Leslie was drawn to Dick, "the lean, interiorized fellow wearing a string of beads," who would become his lifelong friend.

Nancy based her summer film on Claude Debussy's *Pelléas and Mélisande*, an opera fittingly set near the sea. She cast Miles as

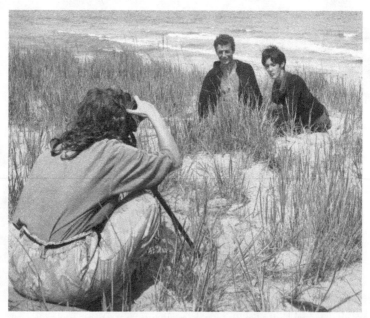

Nancy Christopherson filming Miles Forst and Dick as characters in Debussy's *Pelléas and Mélisande*, Provincetown, 1949 (Courtesy of Miles Bellamy)

Golaud, a man driven by jealousy to murder his half brother Pelléas, and Dick, wryly nicknamed "Mr. Beauty" by Miles, played the part of his victim. Miles was a "show-off,"[51] Nancy remembered years later, and had an appealing way of going "past the point of reasonableness, beyond the tenable. He acted out himself." The same was true of "Richard," as Nancy always called him, who performed with "a sense of decorum and of rightness." In a photo taken that summer, Nancy squats on a rise behind her tripod, training her lens on the two men sitting low in the sand. They wear dark costumes, their faces blackened with charcoal. Miles looks up, bemused. But Dick, with a grave expression and lowered lids, seems in a different world. In another shot, they take a smoking break. Miles unwinds, but Dick stays in character, dignified, remote, and absorbed in thought. That fall, when the friends gathered to screen the unedited footage of Nancy's opera, she was devastated to discover a long scratch running through every frame, nullifying her work.[52] Short of funds, she'd used cheap, expired film bought on Canal Street.

Some of Dick's later friends regarded his life as an ongoing performance, as if he never relinquished the role he'd perfected in grade school of the strange, enchanted boy who disarmed ridicule by anticipating it. He "seemed to do nothing not contrived for its effect,"[53] observed Jill Johnston, who met him in the early sixties, attracted by his "absurdly posturing attitudes of chivalry and executive charm." Dick was "the first self-conscious stylist, calculated personality" she ever encountered. "The space he occupied was always the site of ceremonious happening—I never saw him when he wasn't put on. The real Richard, whatever that was, was maddeningly inaccessible, yet delightfully concealed by the ruse of personality."

Dick, Nancy, and Poni left their refuge on the Cape in the fall of 1949 and settled where their friends lived, on the Lower East Side.[54] Later they moved to a top-floor apartment on Amsterdam Avenue and 107th Street, a largely Hispanic neighborhood where Poni's skin color was not uncommon. Dick had been a morose college student when he first lived in New York. He returned as the head of a household, a favorite role he would revisit again and again. The couple wed on September 1, 1952, at Nancy's parents' farm in

Ohio. He was twenty-four, she twenty-nine. They had been to-
gether for four years. As husband and wife, they would not last that
long, and their decision to marry took some friends by surprise.
"Oh, you're kidding!" Allan Arbus exclaimed when Nancy showed
off her ring at an Arbus family dinner.[55] For an individualist un-
governed by middle-class morality, Nancy's switch from lover to
wife seemed an odd choice. "I don't know why I did that,"[56] she
confided years later.

Most of the artists, actors, writers, and musicians in Dick and Nancy's
circle lived in downtown Manhattan, where rents were low. Alfred
Leslie was an exception. He and his then wife, Esta Teich, had a
loft overlooking the Hudson River in Hoboken, New Jersey. Dick
and Nancy visited there nearly every weekend in the early fif-
ties.[57] When Dick bought a collage from Alfred's first one-man
show in 1951, it cemented their friendship. Alfred's debut nearly
hadn't happened. To cover his portion of expenses, the ingenious
artist arranged to be a "randomly selected contestant" on *Strike It
Rich*,[58] one of the earliest reality shows on television.

Alfred was a seductive mix of street smarts and intellectual
acumen, a largely self-taught artist who began painting, sculpting,
writing, and making movies all before he was out of his teens. Born
and raised in the Bronx, he came from a hard-pressed working-class
family. He was a well-muscled gymnast and a hand-balancer whose
ability to control his body from his hands and wrists likely informed
the expressive brushwork of his abstract paintings. Alfred and Dick
shared a love of literature, particularly the work of Ezra Pound,[59] a
poet whose daring, unexpected transitions seemed to find a visual
corollary in the conjunctions of the artist's collages.

No one in their crowd had any money, but they gave parties
anyway. Get-togethers required little more than cheap wine, plenti-
ful spaghetti, and a radio or record player. For one party, Mary Frank
painted a fantasy of flowering trees, birds, and exploding stars on
photographic paper that her husband Robert put up on the walls.[60]
As far as Dick was concerned, perhaps the most memorable bash
was the one given by Norman Mailer and his Spanish-Peruvian wife,

Adele, on July 27, 1951,[61] a party that left both men with head wounds.[62]

The Mailers had a top-floor commercial loft on Monroe Street, in the great ethnic stew of the Lower East Side. Predominantly unfurnished—they never got around to fixing it up—the 2,500-square-foot space was perfect for parties. It was illegal to have beds in places like theirs, yet they and their friends often rented them as studios and then quietly moved in. A summons for unlawful occupancy was an all too frequent expense on top of the rent. For some tenants, dismantling the bed and hiding the bedding was a daily chore;[63] others disguised their sleeping areas behind a sliding bookcase.[64]

Adele Morales Mailer, a Hofmann student, used the couple's long, narrow loft as a studio. The Mailers had many friends—fledgling actors, established writers, and people Adele knew from Provincetown, including the Franks, the Forsts, and the Bellamys, who lived nearby. It was a neighborhood in transition, "with Jews moving out and the Puerto Ricans and some hippies moving in," recalled Tuli Kupferberg,[65] the American counterculture poet.[66] Their building was special, Kupferberg said, one of the first on the Lower East Side taken over by bohemians, "like a premonition of what the culture of the sixties was going to be like." Allen Ginsberg approvingly described Mailer's cold-water flat on Monroe Street as one with a "Dostoevskian man-of-the-underground quality."[67]

In Miles and Dick's wry lingo, Norman was "Normal,"[68] a man who was anything but. The two friends were among the guests the Mailers invited to their party that muggy July evening. Nancy planned to arrive late with several friends. Adele's bohemian crowd mingled with Norman's tuxedo-wearing pals. Louis Auchincloss taxied down from uptown. Lillian Hellman,[69] who wrote the screenplay for Norman's *The Naked and the Dead*, arrived toting a hip flask. The actress Rita Moreno brought along Marlon Brando, who stood in front of the fireplace and scrutinized the other guests, saying nothing.[70] Montgomery Clift came alone.

It was after midnight by the time Nancy and her friends neared the building's entrance. Along the way, one of them found a stray

kitten and walked cradling it in her hands. "Hey baby, let me pet your pussy," a kid on the street taunted her, and suggestively reached out to fondle the cat. She kicked him hard in the shin, and he dropped with a yowl. As the women bolted toward the Mailers' door, he leaped up and made a running jump on top of her. His friends pried him off, and the women fled to the safety of the party on the fifth floor. They had just caught their breath when the hoodlums burst through the door. The one with the sore shin was still in a rage. A congenial host, Norman stepped forward to offer placatory drinks, but they would not be appeased, and they began to menace the guests. Miles Forst picked up a hammer in a futile gesture to intimidate them. One of the roughnecks wrenched it out of his grip and attacked Norman, repeatedly hitting him on the head.

Dick was his second target. The writer Calder Willingham saw the events unfolding as the thug turned on the "dreamy-eyed poet . . . with glasses that magnified his eyes like the bottom of a Coca-Cola bottle," knocking him to the floor "like a steer."[71] When the police finally showed up, they refused to arrest the troublemakers and issued a summons to Norman for having an illegal bed in his loft.[72]

Dick took his role as household head seriously and worked a variety of odd jobs, many involving physical labor. His one extant résumé[73] lists without dates the arduous work of brick cleaning, carpentry, house painting, and construction. The when and where of "salesman for dance bands" remains a mystery. At some point after he and Nancy settled in New York, Dick returned to Cincinnati to work for his uncle Orin Bellamy as a "TV salesman," a job that also entailed installing aerials on rooftops.[74] In the early days, when sales of television sets were increasing exponentially, his uncle had the foresight to found Television Stores, Inc., an enterprise that burgeoned into a chain of TV stores and became the largest retail outlet for TV sets in Greater Cincinnati. Kindly Uncle Orin was committed to helping give Dick a start in life, "on an ongoing basis," his son Joe David Bellamy quipped.[75]

Soon enough, Dick was back in New York, and he continued to cast about for a steady source of income. His resonant voice and his

knowledge of music made radio a natural choice. In the early fifties he trained for a career in broadcasting at SRT, a school of radio and television.[76] For about a year he worked for WCNX in Middletown, Connecticut, near the campus of Wesleyan University, and lived apart from his family on weekdays.[77] On Monday mornings he became a reverse commuter, passing the parade of gray flannel suits and calf-length day dresses arriving at Grand Central Station just as he was leaving. Those months in Connecticut, he would later tell a friend, were some of the happiest of his life.[78]

In Middletown, Dick lodged in a boardinghouse at the end of Main Street.[79] On a few occasions Nancy and Poni came to visit.[80] Like all the staff at WCNX, Dick worked on a variety of programs, announcing the news and creating fifteen-minute segments of pop music, including the Top 40, the McGuire Sisters, Tony Bennett, Glenn Miller, and the big bands.[81] He also hosted a children's program called *Mayor for the Day*. Many young listeners wanted to come to the station just to see the man who did unusual things on the air.[82] "Mooney Peebles" was the hillbilly-sounding pseudonym he created for himself when announcing the country music program. In all likelihood it derived from "Moon Glow," a nickname bestowed by high school friends as a gentle jibe at his poetic riffs on natural beauty.[83] He was known to read poetry on the air[84] and once learned a few words in Italian to announce the station's Italian-language hour by saying "And now for your snake in the grass."[85]

His former colleagues remember him as "a nice young man with a soft, gentle voice that really came across, who did an admirable job as a disc jockey." Dick would show up on time, usually dressed in cutoff jeans. The staff at WCNX had never met anyone like Dick, who could relax anywhere. He might sit cross-legged with his head down, "off in another world"; slide down the wall and sit on the floor in the station office; or fall asleep underneath the office manager's desk.[86] The story later circulating in the art world that Dick was fired for reading T. S. Eliot's *Waste Land* on the graveyard shift isn't true—the station didn't have late broadcasts. But one day while on the air, Dick fell into an awkward silence, at a loss for words.[87] The station owner, who happened to hear the segment, berated him for the gap in the program. Soon thereafter Dick gave two weeks' notice

and left, to the dismay of the manager, who particularly admired his voice and whimsicalities.

The Broadway actor Robert Brown met Dick in the early fifties through his Upper East Side neighbors Allan and Diane Arbus, and remembered him decades later as "a romantic drifter trying to find a profession where you didn't have to work too hard."[88] After Dick left WCNX, he tried to break into broadcasting in New York, and Brown tried to help, sending him to see a friend from acting school, then the chief announcer at NBC. The fellow reported back to Brown that Dick was not at all the type of person who would fit in at NBC; he didn't know of any station that would hire "a bohemian."

In 1953 Dick and Nancy enrolled Poni in the fourth grade at the progressive Rudolph Steiner School in Manhattan.[89] In all likelihood they heard about it from the Arbuses, whose elder daughter, Doon, began third grade there at the same time. While still in grammar school, Poni fell in love with dance and trained at the School of American Ballet.[90] Dick and Nancy had little money for nonessentials, and it may have been Poni's Cleveland grandparents who paid her tuition. Her performance as a toy soldier in *The Nutcracker* at the New York City Center was one of the high points of Poni's young life.[91]

During the year Dick commuted to Connecticut, his marriage soured. Perhaps his out-of-town job was a sign of change already in progress. The staff at WCNX don't recall that alcohol was a problem for Dick, but he did drink, and its probable effect on their sex life may have stirred Nancy's discontent.[92] With Dick so often away, she took as a lover her next-door neighbor Luis, a pleasant-faced Puerto Rican.[93] Not one for confrontation, if Dick came back on a weekend and found Luis in their bed, he curled up on the tile floor outside their apartment door and spent the night sleeping in the common hallway.[94] At various points later in life Dick would repeat this abject behavior when under duress, his seeming indifference to creature comfort tantamount to a hair shirt worn close to the skin, a self-imposed reminder of failure.

Dick was like a father to Poni, and he was actively engaged in her life.[95] But his concept of parenthood was closer to Peter Pan's than

to Ozzie Nelson's. Dick's friend Jill Johnston considered him a stereo-typical "*puer aeternus*" (eternal boy),[96] one of those mythological child-gods whose provisional lives were characterized by disorder, intoxication, and whimsy. Nancy's style of mothering was little different. She and Poni had a turbulent relationship, and as her daughter grew older, the two often communicated via notes left on the refrigerator door.[97] Poni's closest friend in the fourth grade was Wendy Clarke, who had a similar latchkey childhood.[98] She remembered that Nancy rarely supervised her daughter. "Poni really brought herself up," she said. Also a problem drinker, Nancy vindictively severed Dick's contact with Poni after she and Dick finally separated in 1955.[99] They never divorced, a legal technicality that would frustrate his future loves, who hoped to become the second Mrs. Richard Bellamy.

As Dick's marriage unraveled, so did his father's. Doc's relationship with Gay "lasted longer than anyone but Doc suspected," Joe David Bellamy wrote about his uncle in his novel *Suzi Sinzinnati*, a fictionalized account of his life.[100] Doc "doted on her and idolized her and was so wounded when she sought to divorce him (older and sicker and getting a little foolish) that he let her have everything she wanted—which was nearly everything he owned." Doc was already diagnosed with Parkinson's in 1954, when "he walked away leaving Gay everything but his [car] and the clothes on his back." He gave her title to the Tudor revival house on Springfield Pike that had been his home for thirty years.[101] Gay had little interest in its contents, and she organized a tag sale, selling off everything belonging to Lydia,[102] including her Chinese treasures.

Doc bought back the house in 1960 and flipped it. By then, urban renewal had claimed his clinic building, putting an end to whatever was left of his medical practice. Parkinson's is a disease that "lowers a man's morale clear to the bottom of despondency, and often to the point of suicide,"[103] Doc later wrote to his son. But he reassured Dick that "thanks to the supreme power of God, I have not come near to that cowardly act . . . I can laugh and joke much more easy [*sic*], and I can find humor in anything that has any humor in it." He was almost penniless[104] when he died, in 1969, a few days shy of seventy.

HANSA DAYS

Late in 1951 three young artists sat in one another's East Village studios and compared notes about their prospects. No uptown art gallery considered them worthy of attention.[1] If they had a space of their own, they envisioned, critics, curators, and their friends could see what they were doing. As a first step, Wolf Kahn, Felix Pasilis, and Jan Müller organized an ad hoc exhibition in the skylight-lit top-floor loft at 813 Broadway, where Kahn and Pasilis had studios.[2] Dick made a point to catch the show,[3] *813 Broadway*, as it came to be called,[4] as did hundreds of others undaunted by the steep climb.

"How artists deal with the economic challenges inherent in an unforgiving society is surely the most interesting aspect of art history,"[5] Pasilis later reflected. Encouraged by the response, the *813 Broadway* organizers recruited nine other artists interested in founding a cooperative gallery. Theirs would be the second group of its kind downtown, designed to reach audiences directly by jumping the hurdle of dealers. Their working name, Dodeca, alluded to the number of founders and the gallery's location on Twelfth Street.[6] But Kahn and Müller, both refugees from Hitler's Germany, soon proposed a different name, Hansa. It dually referenced the Hanseatic League, a medieval confederation of free cities joined together for mutual benefit (*Hansa* means "fellowship" in medieval German), and cleverly honored their teacher and friend, Hans Hofmann.

Miles Forst and the Swiss émigré painter Jacques Beckwith,

both skilled carpenters, took charge of converting the dark, dusty loft at 70 East Twelfth Street into an appropriate exhibition space.[7] Everyone helped clean and paint the walls white, sand the floor, and install light fixtures. Without the financial help of Allan Kaprow, "there would have been no Hansa," Pasilis recalled. Kaprow, whose friendship with Kahn dated from their student days at New York's High School of Music and Art, loaned the gallery $1,000 in its "birth pang days," which they used for rent, furnishings, and their grand opening.[8] The painter Paul Brach declined their invitation to join; he wanted to produce art with no responsibility for showing it. Brach regarded the Hansa and the many similar co-ops that followed in its wake as "farm team(s) for the commercial galleries . . . no one wanted to *stay* in those collectives."[9] The members themselves considered their gallery as "provisional."[10]

During the week, the Hansa attracted few visitors.[11] The painter Jane Wilson's husband, John Gruen, the only founder who was not a visual artist, served as program director. He understood the tactical importance of "bringing bodies into the gallery," and he devised three public events with small entrance fees.[12] Dick was there on the evening in 1953 when the influential tastemaker Clement Greenberg came to speak.[13] A man with near-papal status for artists, Greenberg was the first critic to champion New York school painters in the forties; Dick loved his phrase for it—"American-type painting."[14] A former Hans Hofmann student, Greenberg would exhibit one of his own watercolors at the Hansa the following year.[15]

"To sell is to sell out," the members postured in the early days.[16] Jean Follett's friends were incredulous when she put astronomical prices ($5,000) on her drawings in the Hansa's first year,[17] a quixotic gesture likely calculated to discourage sales so the unprolific artist could hold on to her work. Money was not then a marker of success. "Making it" meant the respect of peers and the attention of critics and curators. Gruen's strategy began to pay off when the Guggenheim Museum's curator came to the Hansa for the first time to deliver an invited lecture on Antonio Gaudí's sculpture, and not long after, the Guggenheim's 1954 landmark exhibition *Younger American Painters* included the work of Miles Forst and Jean Follett.[18]

There were more artists per square foot in the vicinity of the

Hansa than in any other neighborhood in New York. It was an intimate social climate, the architect Cynthia Navaretta recalled. "We all lived in the same area—Tenth Street was the center. You saw everyone you knew walking around in the streets."[19] Afflicted by rising rents in the traditional bohemian enclave of the West Village, artists were shifting eastward, drawn to the impoverished neighborhood around St. Mark's Church in the Bowery, sulking in the shadows of the Third Avenue El.[20] As its founders hoped, Hansa shows elicited the interest of their little-known contemporaries along with such respected elders as de Kooning and Kline.

De Kooning's nearby studio, at 88 East Tenth Street, was around the corner from 34 Third Avenue, where Robert and Mary Frank lived in a loft one floor above Miles and Barbara Forst's. For a time, Alfred Leslie lived next door, at number 36. Everyone had windows that faced a common yard. De Kooning liked to paint into the small hours of the night, and when Leslie looked out his rear window, he might catch sight of his revered friend at work—"kinda like the Hitchcock film," he kidded.[21] The Franks and the Forsts could also see the master painter's well-lit workspace after dark. They might observe his creative process from the vantage of the fire escape or the roof, watching as he stroked on a color and then sat back in a chair to spend hours contemplating his next move.[22]

The Hansa artists (or the men's girlfriends)[23] took turns gallery-sitting from 1:00 to 6:00 p.m. every day except Sunday. But the minders sometimes arrived late or left early, and as a result, the Hansa was too often closed when it should have been open. They needed a dedicated manager. Through the *Art News* editor Tom Hess, who had many social connections, they found Anita Coleman, a tall, comely, and sweet-natured Sarah Lawrence graduate who was willing to take on the undemanding job of business director. They paid her seven dollars a week.[24]

During the Hansa's first two years in the Tenth Street area, the poet Frank O'Hara and other influential art writers covered their exhibitions.[25] Nonetheless, some members felt that they would be better positioned to attract the notice of prestigious dealers if they were located closer to them. They moved their base uptown in October 1954, the same month that the Whitney Museum left its home

in Greenwich Village for expanded quarters on West Fifty-Fourth Street. Hansa members may have hoped for the same proximity to MoMA that the Whitney had, but rents in the immediate area of Fifty-Third Street were an unaffordable $400 or $500 a month.[26] Instead they found a parlor-floor studio apartment in a ramshackle brownstone on Central Park South, near Columbus Circle and the future home of Lincoln Center, then just a gleam in Robert Moses's eye. Their new space accommodated "a rather small gallery," Dick recalled, although at the time it seemed "very spiffy to everybody."[27]

O'Hara reviewed their opening show uptown, the work of the now-forgotten artist Hedi Fuchs, who painted eerie faces on boxes fished out of the trash.[28] Before long, Fuchs added her most treasured possessions, including a tree trunk encrusted with a huge leathery fungus.[29] Then she installed *herself*, haunting the rooms by day and sleeping there by night. People didn't know what to expect when they walked in from the street. By literally moving up in the world, the Hansa unplugged from the do-it-yourself energy source of Tenth Street. There were compensatory advantages. They were not far from the prestigious Stable Gallery on Seventh Avenue and West Fifty-Eighth Street, housed in a renovated wooden livery stable that still smelled of horse piss on damp days.[30] But attendance was little better than on Twelfth Street. Most midtown gallery-goers did not put the Hansa on their walking rounds. The feeling in the gallery was "quite pastoral," Dick remembered, reaching for a line from Wordsworth to describe the rare day when a sole visitor might wander in, "lonely as a cloud."[31] But however vacant the gallery may have been on weekdays, its Tuesday-night openings[32] were mobbed. "Everybody in the art world used to go to their openings," remembered the art dealer Leo Castelli.[33]

Although he was never a member, the photographer Robert Frank was an integral part of the Hansa's history. Documents from its planning stage were handwritten on his personal stationery.[34] The gallery was "inspiration and influence," he wrote in an inscription on his photo-collage tribute to the Hansa.[35] In one shot an insouciant Miles Forst stands painting a portrait of Dick; handsome Felix Pasilis, who later described himself as a "lunar (as was Dick Bellamy) in the orbit of Miles Forst," is in another.[36] In a third, there's a

trio of blurred beauties, artists all, barely recognizable as Robert's wife, Mary, and her friends Dody Müller and Barbara Forst.

Of the three women among the Hansa's founders, Barbara was the only one to juggle a career, motherhood, and marriage to another painter. Her intensely colored expressionist abstractions were part of the opening show on Twelfth Street, and in 1953 she had her solo debut. Fernande, the Forsts' first child, was born just before the co-op moved to Central Park South. As a mother, she could no longer sequester herself at will in her studio. Although she occasionally participated in exhibitions, Barbara never had another one-woman show. For a time, she and Miles lived communally with the Franks[37] and experimented with an open marriage. She was seeing the avant-garde composer Morton Feldman,[38] and Miles became involved with Mary, a situation so hurtful to Barbara when she eventually found out that she didn't speak to her friend for years.[39] "Everybody was screwing everybody else compulsively,"[40] Barbara later reflected. "We [women] all thought that sex was very important; that our bodies were a source of power—maybe our *only* source of power."

When the Hansa's manager married and resigned in the fall of 1954, the members hired a director with more art world savoir faire. Anneta Duveen,[41] a sculptor and divorced mother, was the former sister-in-law twice over of the famous art dealer Sir Joseph Duveen—over time, she had married two of his brothers.[42] Despite her legendary name, Duveen needed to support her family. Somehow the gallery members talked her into an unsalaried job with a promised commission of 25 percent on sales.[43] Although Duveen had the wit and charm to court potential buyers, she had trouble closing sales, and the Hansa let her go after six months. It's unknown whether Dick's name came up when they hired Duveen, but faced with another vacant directorship, Miles proposed him for the job.[44] Most members knew Dick from downtown openings, parties, and his visits to their studios. The co-op had taken advantage of Duveen, but they offered Dick better terms, twenty-five dollars a week in addition to a 25 percent commission on sales.[45] It was still a pittance—in 1955, the average worker earned $4,418 a year.[46]

It took Dick all summer to make up his mind,[47] and he turned to the *I Ching* for guidance,[48] a practice he'd learned from Nancy.

He accepted the job only after the manual suggested that it was a well-omened choice. "When the question of my working [at the Hansa] came up, I never conceived of it as a career, but rather as giving a hand to some friends who were short of help," he said later.[49] "I wanted to get a decent job that would allow me to buy my friends' art every once in a while, but in those ragged times, art dealers were thought of as people who were always turning artists away."

In Dick's thinking, money sullied what mattered about art and spurred people to collect for "the wrong reasons." He must have been revolted by the article on the international art market that *Fortune* magazine published late in 1955 touting contemporary art as a speculative investment. Among the "growth stocks" they boosted were the American abstract expressionists Baziotes, Kline, de Kooning, Motherwell, Pollock, Reinhardt, Rothko, and Still.[50] To Dick's countercultural value system, it was bizarre to acquire art for its potential to appreciate. You bought art because you loved it, pure and simple. "The essence of money is in its absolute worthlessness," the philosopher Norman O. Brown would write in *Life Against Death: The Psychoanalytical Meaning of History,* a book Dick read and discussed with friends following its publication in 1959.[51] Brown, who derived his ideas from Marx, Nietzsche, and Freud, interpreted the pursuit of capital as "an attempt to find God in things."

Dick was homeless in 1955 when he started at the Hansa. Whatever semblance of family life he had with Nancy and Poni, however faint, was gone. His minuscule income may have covered the support he regularly sent them, but he didn't make enough to pay rent for himself. He crashed on Alfred Leslie's studio couch[52] or stayed overnight at the Hansa after the members reluctantly agreed to let him sleep there.[53] He made friends with the college students who moved in upstairs a few years later, the future critic Barbara Rose and her roommate, Terry Brook, a poet. Dick liked to have a nightcap with them, and he often passed out. "He was drunk ninety-nine percent of the time,"[54] Barbara recalled. When the Hansa opened for business after midday, he would stow his sleeping bag and hot plate in the closet. In the coming decades Dick would reprise his practice of camping out in his galleries whenever financial blues or domestic storms required it.

Jan Müller, *Faust I* (1956), oil on canvas, 68⅛ in. × 10 ft. (173 × 304.7 cm). Collection of MoMA (Digital image © The Museum of Modern Art / Licensed by SCALA / Art Resource, N.Y.)

There were advantages to living at the gallery, unique experiences that exceeded Dick's need for mere shelter: "The crystallization of the work of my lifetime took place during Jan Müller's exhibition . . . when I was sleeping at the gallery and would wake up in the morning surrounded by the paintings. I felt I was seeing what the artist was putting down, his life going on in the work. I was able to see these paintings in an unguarded moment that art dealers rarely have."[55] One day Allan Kaprow dropped by to check on how things were going. As he reached for the doorknob, a bemused woman came rushing out and said, "That was the best show you ever had."[56] Kaprow murmured, "Thank you," and stepped into the gallery. There in the middle of the floor was the recumbent Dick Bellamy, asleep, an inadvertent "living sculpture," *avant la lettre.*

In the fall of 1955 Dan Wolf, Ed Fancher, and Norman Mailer launched the *Village Voice*, a free weekly newspaper. Ivan Karp recalled that its earliest writers were volunteers,[57] content enough just to see their names in print. Although the *Voice* initially circulated only in Greenwich Village, its cultural coverage included a broader

swath of New York. As the *Voice*'s first art critic, Ivan made a point of seeing the exhibitions[58] at the Hansa cooperative on Central Park South, which he considered "an important little iconoclastic spot."[59] On his initial visit, he found the attendant—Dick—sitting on the floor, reading a book of poems by Howard Nemerov, Diane Arbus's brother.[60] Ivan was charmed. But when he asked for information about the art on view, he discovered that "there was no documentation, there were no photographs—it was basically a very primitive operation. If the artist supplied material, there was material; if it wasn't supplied, it wasn't there."[61] Nonetheless, the gallery's "beautiful anarchy"[62] appealed to him.

On subsequent visits Ivan lingered to talk with Dick. "I found him a very attractive personality,"[63] he remembered. "It was unusual, I discovered, for people running galleries to take an interest in poetry. I felt some comfort, some identity there, and we made friends." Ivan was a Brooklyn boy, bright, well-read, and, like Dick, largely self-educated—he never finished high school.[64] A flâneur in his twenties, Ivan wandered through Manhattan streets at a time when renewal projects were flattening whole blocks.[65] If he saw a demolition ball aimed at buildings with richly ornate trim, he became a self-declared "rubble rouser,"[66] rescuing doomed carvings by means of charm, bribes, or cover of darkness.

The Hansa's artists regarded Dick as one of their own, but they would never feel that way about Ivan, who became their codirector in September 1956. During the previous year Dick had belatedly realized that he didn't want to work six days a week. His lack of managerial experience and his touch-and-go relationship with sobriety must have become more apparent—and problematic—over time. Dick was smart, funny, and extremely knowledgeable about the members' art, but by his own admission he "just sat there, answering the phone. I never knew what it was to run a gallery, or how to sell the work. My title, 'gallery director,' always amused me."[67] It was Dick who proposed that they bring in Ivan,[68] whose writings the members all admired.[69] Dick and Ivan were an unlikely team: one wiry and reticent, the other short and voluble, they "looked like Laurel and Hardy when they walked down the street."[70]

The two divvied up the workweek and split the weekly salary

of twenty-five dollars—not including commissions on sales, which
were rare events.[71] Dick subsidized his wages painting houses at
night, on weekends, or on his days off. Ivan's then wife, Lois, had a
full-time job, which freed him to work for such low pay. Shortly
after he began at the Hansa, Ivan wrote one final piece for the *Voice*,
a memoriam for the volatile Jackson Pollock.[72] Six weeks earlier,
the drunken painter had run his car off the road, killing himself and
one of his passengers.

The Hansa continued to double as Dick's base. As a result, he and
Ivan were often at the gallery at the same time. Besides, they enjoyed
each other's company. One pastime of these two hearty heterosexu-
als was to draw up lists, including one of the "most wanted" women
they fancied.[73] The autumn of 1956 was a busy time for Ivan and
the many Hansa members who were supporting Adlai Stevenson's
presidential bid.[74] Dick most likely did not take part in campaign-
ing.[75] He "didn't take stands,"[76] one of his partners remembered.
"There was something missing in him," she felt. It was "a scandal" in
their liberal circle, Dick remembered years later, when the former
Hofmann student Robert Goodnough came out for Eisenhower.[77]

A man who loved language, Dick must have had a soft spot for
Ivan's corny puns. "It will all come out in the gouache, as Goya used
to say," was a quip Ivan later slipped into his one published novel,
set in the art world.[78] Ivan's offbeat joviality evoked startled laughter
from those unfamiliar with his particular sense of humor. One earthy
shtick he would use in the sixties but likely perfected at the Hansa
was to proclaim, "The paintings are all twenty percent less on
Wednesdays,"[79] as if he were a suit salesman on the Lower East Side.

One stress of Dick and Ivan's job, shared by all who run art
galleries, was the pressure to reach collectors and curators who had
purchasing power. The two men were terrified by the prospect and
would dare each other to do it. "I'd say to Dick, 'Why don't *you* call
her? She's not my type; she scares me.' I would call the lady that he
was afraid to call, and he would call the man I was afraid to call."[80]
Dick usually wrote the letters, "beautiful, elegant, poetic letters
that nobody ever answered."[81] One of the people whose attention
they sought was Dorothy Miller, the busy and influential curator at
MoMA, six blocks away. "Florence Nightingale" was the code name

they assigned to her on their list of art world personalities, "because she was a generous and good person."[82]

It was Dick who wrote to her about *Contemporary Americans*, their 1956 season opener. He began traditionally enough, enumerating the artists. But with disarming candor he went on to confess that "although two of the seven works ravage the total quality we sought (in these instances, even by dispute, we were unable to get the specific works we wanted), the exhibit as a whole is nevertheless of a quality to be remarked."[83] Using hilariously quaint locution, he importuned her to stop in: "Therefore, if you happen to be in the vicinity, I would not suffer any distress should that occasion implement a few minutes of your presence here—the implication is correct that distress might prevail at another time or two—that is, I do not think you would find the exhibition without interest." It's not known whether the redoubtable Dorothy Miller took the bait.

In spring 1957 the Hansa received attention[84] when five current and former members[85] were included in *Artists of the New York School: Second Generation*,[86] a historic and, to *The New York Times*, "ebullient"[87] survey exhibition at the Jewish Museum. (The museum had begun to mount shows of contemporary art unrelated to Jewish culture.) "No use pretending that the work of these 23 younger New York painters is easily understood," the art historian Leo Steinberg pointed out in his essay for the show's catalogue.[88] "It is not. With few exceptions, it is deliberately recondite, uncompromising and exclusive; we are meant to break our teeth on it."

Nearly all the artists in the show came to maturity after abstract expressionism changed prevailing assumptions of how to paint. Yet Alfred Leslie, for one, chafed at the designation "second generation." They were all so different from one another. The curator Meyer Schapiro, a Columbia University art history professor, chose artists as well known as Jan Müller and as obscure as Jasper Johns. Dick remembered being present at the Hansa when Allan Kaprow, already tapped to participate, made a very strong pitch to Meyer Schapiro for Johns's inclusion. " 'Meyer, you've *got* to put Jasper Johns in that exhibition.' It certainly impressed me that Allan was being a little discourteous, a little too sure of his oats. There was definitely a tone in Meyer's voice, a kind of supreme patience."[89]

When Dick saw Jasper Johns's *Green Target* in the show, he "didn't get it. It certainly didn't offend me. But I didn't get it."[90] The painting was a readable image of a bull's-eye, with a choppy, encaustic surface that here and there revealed legible bits of newsprint and waxy tears, the accidental drips so cherished by abstract expressionists. But the overall effect had none of the emotional heat of the Hansa's figurative expressionists. If the unfamiliar qualities of *Green Target* failed to engage Dick, they did arrest the attention of another visitor, an art dealer who lingered in front of the wall label. "I looked at the name," Leo Castelli later recalled. "The name didn't mean anything to me. It seemed almost like an invented name—Jasper Johns."[91]

A month before coming across *Green Target* at the Jewish Museum, Leo Castelli had opened a two-room art gallery in his father-in-law's elegant town house on East Seventy-Seventh Street. Its very location near Madison Avenue connoted luxury, as did "Butterfield 8," its telephone exchange. Castelli was fifty years old. Urbane, cultured, and fond of fine haberdashery, the European-born gallerist and his then wife, Ileana, arrived in New York shortly after the United States entered the Second World War. Following his military service, he and Ileana befriended many of the abstract expressionists: "I wanted to be a part of it," he recollected; "*was* a part of it. There was a real hero worship of artists, or some artists in particular, and of that world in general . . ."

Castelli's inaugural show in February 1957 brought together such blue-chip European modernists as Léger and Mondrian, and the Americans David Smith and de Kooning. A thoughtful strategist, Castelli wanted to instill collectors' trust with familiar names before venturing to launch the young artists he had every expectation he'd discover. As Ileana later commented, Leo "was more interested in what was coming up, than in what had already bloomed."[92] Days after he stood puzzling in front of *Green Target*, Castelli went to see Robert Rauschenberg, an artist he deliberated taking on.[93] When Rauschenberg needed a hand with some heavy canvases—in another retelling, he lacked ice cubes—he called on his artist friend and lover who lived downstairs, Jasper Johns. On hearing Johns's name, the dealer immediately asked to visit his studio. Twelve years

later Castelli described what he saw when he walked into the artist's workspace: "There were all those great masterpieces. There was about a million dollars' worth of paintings that were worth nothing [then], just there."[94] Stunned and impressed, Castelli asked him on the spot to join his gallery: "It was as simple as all that," the dealer later said of one of the best decisions of his life.

A year would pass before Johns debuted at Castelli's. During that time, interest quickened for a few Hansa artists, including Richard Stankiewicz and Jean Follett. The two were at the tail end of a relationship begun in the late forties during their student days with Hans Hofmann. Jean had been a memorable presence at the Hofmann school,[95] known for both her paintings and her person. Her former classmate Allan Kaprow remembered that Hofmann often corrected student work during a critique by drawing on it, but when he got to Jean's, he would just look at it and almost invariably say, *"Ja, das ist*

Jean Follett, *Gulliver* (1956), location unknown, photographer unknown (Courtesy of Deborah VanDetta)

sehr gut, sehr gut."[96] Most Hofmann students dressed in clothes "that dirt wouldn't get noticed on,"[97] said Larry Rivers, another class-mate. But "Jean wore a white-powdered face, a long, clean skirt, and chunky high-heeled shoes." She usually wore black in the win-ter, and white in the summer.[98]

Jean and Stank, as Stankiewicz's friends called him, appeared to have equally promising careers. Both used found materials, he in the round, she in relief. Initially he worked with wire and plaster, until she awakened him to the possibilities to be found in Parisian rubble piles.[99] *Gulliver* (1956), present location unknown, is Jean's witty ar-rangement of pipes, tools, and machine parts that resembles a hori-zontal figure pinned down by small creatures. The Whitney Museum's jovial *Lady with the Open-Door Stomach* (1956) also evokes a human form, this time with a womblike chamber. A fragile, fascinating woman, Jean captivated Robert Frank, who regarded her as his "fa-vorite artist."[100] She was like a dark version of Dick's wife, Nancy, and Dick too found her work and her strange complexes compelling. He was attracted to her "as an entity," the artist Lucas Samaras remem-bered. "It was always a big event for Dick to go to Follett's studio."[101]

By the late fifties, major museums in New York acquired work by Jean and Stank. Dick obliquely acknowledged her influence on several artists by describing her imagination as "very infective at a certain point."[102] Jim Dine, James Rosenquist, and George Segal would all be in her debt,[103] even perhaps the French artist Jean Dubuffet, who lived near Jean and Stank in New York for several months in 1951.[104] Yet as the sixties advanced, only Stankiewicz sustained the limelight.[105] Bad luck accounted for part of it: Jean suffered a studio fire that destroyed nearly all her stored work. She supported herself as a mechanical draftsman, close work that in time ruined her eyes. She was as hard-drinking as the men around her, and it took its toll on her health.[106] Although she wanted to re-turn to New York after what was supposed to be a short respite at her home in Minneapolis in the early sixties, she never did. She was broke,[107] and her temporary absence became permanent. As the decade progressed, Jean's career slipped into invisibility when her surrealist-inflected sensibility fell out of style.

PROVINCETOWN, 1957

On sweltering summer nights in Manhattan, the artists who lived downtown chased breezes out on the fire escape or up on the roof—dubbed "tar beach." Or they sweated in their studios, windows open, radio on as honey-voiced Patti Page crooned about the "sand dunes and salty air" of old Cape Cod. In the summer of 1957, when the Hansa shut down until the fall, Dick headed for the Cape as soon as he could, as did many of his friends.

Provincetown branches uphill from the central nerve of Commercial Street. Its quaint lanes, alleys, and passages bear such names as Pleasant Street and Captain Bertie Way. There were many rentals along these byways, and the farther away from the harbor, the lower the price. Tasha's Hill was a wooded area of paths and small cottages built by the matriarch Sunny Tasha on the property her family owned. This sprawling compound of charming shanties with no heat or hot water was like a "fantastic movie set depicting ur-Provincetown, a three-dimensional expression of the old town's spirit: dense, communal, primitive and modest; improvised and eccentric."[1] The Franks rented the last house at the end of Tasha's Road, larger than the rest.[2] Dick and the Forsts had places nearby. Sunny Tasha encouraged tenants to weed her "community garden" and take what they needed.[3] There was usually a pot of beans on her stove and bread in the oven.[4] With wild blueberries to pick and

mussels and clams to dig, none of Tasha's tenants went hungry. That summer Dick ate one meal a day, mostly hot dogs.[5]

Bourgeois dos and don'ts little interested the Hansa crowd back in the city, and their behavior relaxed even further on the Cape. To the Hansa member George Segal, Provincetown summers were like "a sunburst of ease and sexuality and pleasure."[6] Ivan and Lois Karp's apartment in town had modern conveniences, niceties they shared with their friends on Tasha's Hill. On returning to Provincetown one Friday from her job in the city, Lois's eyes boggled at the scene awaiting her when she stepped into her bathroom.[7] There was Ivan at the sink, shaving, and Dick on the floor with his head in a book, the two unfazed by a blissful Mary Frank partially submerged in the bathtub as her six-year-old son, Pablo, scattered rose petals on the water.

Over the years, Dick worked an assortment of jobs on the Cape, from fishing scallops to waiting tables at Ciro & Sal's,[8] a popular artists' hangout. In 1957 he assisted at the H.C.E. Gallery,[9] whose initials stood for "Here Comes Everyone," a phrase from *Finnegans Wake*.[10] A commercial gallery, not a co-op, H.C.E. showed such well-known painters as Motherwell and Milton Avery, as well as several of Dick's Hansa friends, including Miles Forst. Dick wore the same pair of shorts to work all summer, a garment that became increasingly darker as the weeks went by.[11] He preferred to go topless, a penchant that pushed against even Provincetown's informal standards of business attire. Whenever the gallery owner came by, he would rush to put on a shirt.

On some Saturday mornings Dick and his twenty-two-year-old coworker, Jim Bumgardner, played softball on a dusty, forsaken field on the edge of town.[12] The writer Hubert Selby Jr.—Cubby to his friends—was often the umpire. Cubby's flow of quick-witted, scabrous humor made batting a trial. One morning, shortstop Emilio Cruz, a Bronx-born art student, noticed that the guy on second base had become the butt of jokes in the prevailing schoolyard mentality. The best athlete on that motley team, Emilio did all he could to encourage Dick, the self-conscious, disconcerted second-base player he had yet to meet. Their enduring friendship began that day.

Dick and Jim, a student at the Hofmann School, sometimes biked down Commercial Street to have a drink with Motherwell. Five years earlier, Dick had experienced a *coup de foudre* when he happened to see the painter's fiercely emotional *Elegy* series of lamentations for the Spanish Republic. "Stunned in the glory of the occasion—for his work on my first seeing something from his hand went directly to my quick."[13] Over drinks with Motherwell at the Ship, Dick and his young friend may have talked with the artist about his figurative drawings, then on view in town. Most artists occasionally drew from the model, but it became national news that July that an abstract expressionist of Motherwell's stature exhibited nude figure drawings, a "lighthearted deviation from orthodoxy."[14]

For those with "orthodox" views about the teleology of art, abstraction, not figuration, was modernity's cutting edge. Yet several of Dick's Hansa friends were figurative expressionists[15] who painted recognizable imagery in a gestural, emotionally charged style. The topic of abstraction versus figuration may have come up when Dick and Jim stayed closer to Tasha's Hill and sat in Cookie's Tap talking and drinking with seventy-seven-year-old Hans Hofmann. If Provincetown was an "oasis of abstract painters,"[16] as *Time* declared that summer, then the lush date palm at its center was Hofmann, the master teacher who'd been seeding the Cape with modernists for nearly a quarter of a century. Dick had never formally enrolled in Hofmann's classes, but he once worked at the school as a model[17] and learned a good deal by listening while holding a pose. He gradually advanced his art education at Hofmann's semipublic critiques, from time to time jotting notes on artists' conversations.[18] "I was always kind of listening, and wasn't really a participant in any real discussions on issues,"[19] he recalled.

Apostates as well as abstractionists thrived on the "oasis." Hofmann's abstractions seemed academic to young Turks such as Val Falcone, a poet, and his wife, the painter Yvonne Andersen, who were eager to find their own way to be modern. Together the husband and wife founded Provincetown's Sun Gallery, one of Dick's regular haunts. "As outsiders you can do anything you want,"[20]

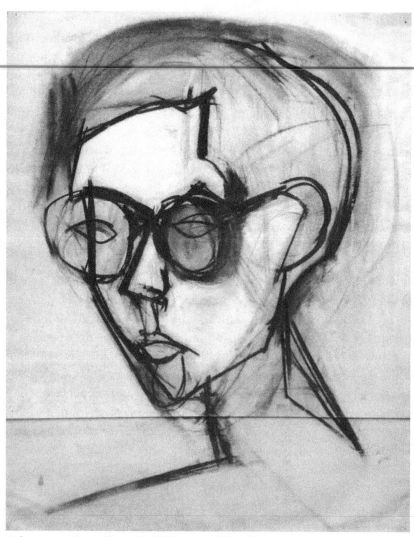

Miles Forst, *Dick Bellamy* (1957), drawing, 26 × 20 in. (66 × 50.8 cm) (Courtesy of Miles Bellamy)

Yvonne said, a simple truth Dick lived by. Unlike the H.C.E., the Sun couldn't afford to hire help. Val and Yvonne worked a variety of jobs to cover the rent for a small Commercial Street storefront.[21] The Sun wasn't a co-op, although the couple's "I've got a barn, let's put on a show" esprit synced with the galleries on Tenth Street. Their solo or group exhibitions ran for seven days, opening on a Monday at 9:00 p.m. and closing at midnight on Sunday. Dick must have seen all of them—many of the artists who interested Val and Yvonne had ties to the Hansa. "Magical stuff was going on at the Sun, the opposite of the abstract people," remembered the artist Red Grooms,[22] who came to Provincetown in 1957 to study with Hofmann.

Charismatic Jan Müller, the vital nucleus of Dick's world, was a figurative expressionist. One of Hofmann's most cherished protégés, Müller was overheard at the Sun heatedly arguing with his mentor on the subject of figuration.[23] Raucous rouged women and covens of ghostly tarts populated Müller's recent literary-themed paintings, the scary granddaughters of the early twentieth-century German expressionists. As a boy in postwar Europe, Müller had contracted rheumatic fever, which damaged his heart. He was one of the first people in the world implanted with a plastic heart valve.[24] Müller's technology-assisted heartbeat kept pace for nearly four years. It was audible to all in his vicinity, a constant and poignant memento mori, like the ticking clock inside Captain Hook's crocodile. At about the time of his surgery, in 1954, he shifted from mosaic-like abstractions to the literary-themed figurative paintings. For one majestic work, Müller borrowed a title from Lionel Trilling, whose short story "Of This Time, of That Place" centers on a man who resists undeniable realities. In Müller's painting of that name, an erect, deathly white figure steps over a pile of featureless bodies.

In the summer of 1957 there were many parties. A snapshot of one of Mary Frank's festive gatherings—held under the trees, with crepe paper streamers and Cézannesque still lifes arranged here and there—captured a shirtless Dick stretched out in the shade, disengaged and probably hung over. "The late fifties were my hangout, late-twenties summer days in Provincetown,"[25] Dick

Sheindi, Dick, and Andy, Provincetown, circa 1960–62
(Courtesy of Miles Bellamy)

remembered. "Everybody met each other at the Sun Gallery, at the AC [Atlantic Club], the bars, beaches—what a time!"

Beaches. Hansa artists gravitated to the beaches. "Provincetown was important,"[26] said Robert Frank. "You were relaxed; you could go to the beach." Most mornings, mothers brought their children to the placid bay beach. Arty women easily spotted one another— they were the only ones wearing bikinis, a semaphore of counter-cultural affiliation.[27] Genial Walter Gutman, one of the most unique personalities in Dick's world,[28] often sat near them in a folding chair. The middle-aged stock analyst, collector, and philanthropist was a scopophiliac with a passion for big-muscled female bodies—a fact Dick's women friends took in stride. The beach was an ideal setting for Gutman, who smiled amiably at the sight of a cut bicep or a muscular calf.

Beaches were the settings for bonfires and bacchanalian clam-bakes,[29] with wild dancing, nude dips in the ocean, and sometimes fights.[30] In photos of one party tucked into the slope of a dune, Müller and his wife, Dody, and Miles and Barbara Forst are among the merry celebrants drinking gin from Dixie cups. The Sun Gallery founders, Val and Yvonne, didn't have time for nighttime revels—

they had to be up early for their jobs. Privately, they jokingly dubbed their more freewheeling acquaintances "The Orgy School."[31] "People were outrageous," mused the artist Mimi Gross, an old Province-town hand.[32] "You slept with one another randomly; people liked living in that kind of way—but it was hard." Couples sometimes lived apart for weeks, one on the Cape, the other in the city, and took advantage of their temporary freedom. Yet an infidelity was felt as an infidelity. The resulting fury, despair, and jealousy would throw friendships completely askew.[33]

One Sunday morning early that summer, Jim Bumgardner brought Dick to a pancake brunch cohosted by his current flame, the sculptor Jackie Ferrara,[34] and her housemate, Charlotte Tokayer, whom everyone called Sheindi. Jim had met them at a Hofmann School critique. Jackie and Sheindi, whose name derived from the Yiddish word for "little beauty," rented a converted barn just off Commercial Street,[35] not far from Tasha's Hill, and hosted regular outdoor parties. Their landlady was the elderly Mary Heaton Vorse, a renowned figure in Provincetown. Forty years earlier, Vorse had encouraged her artist and writer friends from Green-wich Village to spend summers there and had helped launch Eugene O'Neill and the Provincetown Players.

Sheindi Tokayer, the fourth of seven children of an Orthodox Jewish rabbi and his wife, had grown up in a Lower East Side tene-ment on the corner of Henry and Clinton streets. Nearby was the Hester Street Park, the first permanent playground for children ever built in an American city. As their parents were observant Jews, the Tokayer children did not play in the park on the Sabbath and might pass the time walking back and forth to Brooklyn across the Williamsburg Bridge. One day in the early forties, eleven-year-old Sheindi set out from her home in search of "the village" she overheard people talking about. In her mind's eye it was like the mysterious old-world settlements she imagined from folk legends, rounded by a rustic fence. After crossing the intimidating width of Delancey Street, she eventually came to Greenwich Village. The expedition revealed a crucial truth: the inscribed circle of her girlhood was not a physical boundary. There were multiple ways to live life.

As a nineteen-year-old Hebrew school teacher, Sheindi made the irrevocable decision to leave home. She found a one-room sublet on East Sixth Street near Avenue A, with an icebox in lieu of a refrigerator and a shared toilet in the hall. Rabbi Tokayer tracked her down and came to ask Sheindi if she still observed the Sabbath. "I do not," she answered truthfully. Sheindi watched as he dramatically cut his coat lapel as a symbol of loss and declared, "I have no daughter." He chanted Kaddish, the traditional Jewish prayer for mourners, and left.

At Ratner's, the Lower East Side's landmark Jewish dairy restaurant, Sheindi met Jack Tatarsky, a law student turned carpenter. He wasn't Jewish. In the early fifties Ratner's was the favorite gathering place for Sheindi and her group of impoverished, like-minded leftists. There, one could order such vegetarian delicacies as cheese blintzes, potato latkes, or split pea soup[36] and sit for hours nursing a cup of coffee as waiters kept refilling bread baskets with hot onion rolls.[37] Sheindi and Jack's first child, Laurie, was born in 1953, and Andy in 1955. By the time the boy was six months old, the couple had gone their separate ways. Sheindi and Jack were Reichians,[38] as the followers of the émigré psychoanalyst Wilhelm Reich were called. The doctor championed the liberating power of orgasms, a force he believed was heightened when a person sat inside an "orgone" box, a therapeutic device of his invention. The couple owned one of these metal-lined, steel-wool-insulated chambers, which was equipped with a seat, a light, and a door. According to Reich, the box accumulated vitalizing energy and cosmic life forces, and people who sat inside it enhanced their "orgastic potency."[39] Reich's theories on the importance of sexual energy for human well-being had many adherents in the bohemian community,[40] including Allen Ginsberg, Paul Goodman, and Norman Mailer.[41] During the Red Scare of the fifties, when federal agents imprisoned Reich and burned his books, papers, and equipment, Sheindi and Jack got rid of their orgone box.[42] But she retained Reich's teachings and the comfort with her body that became part of her charm and underlined her skill as a method actor.

She was twenty-eight when she met Dick in Provincetown.

Sheindi didn't know any Midwesterners, and on this point alone he must have seemed exotic. A stunningly handsome man with thick glasses and unusual eyes, Dick was amiable, attentive, and very funny, at times intensely present, at times removed. Sheindi—as down-to-earth as his estranged wife, Nancy, was ethereal—radiated warmth and sensual ease and was all in all "adorable,"[43] a friend described. Like Nancy, she was a self-reliant woman who'd rejected the life her parents had mapped out for her. Sheindi and Dick shared a love of books. She had no experience of the art world, though, a deficit Dick soon would remedy.

In later years Sheindi joked that Dick was as taken with her delightful toddler, Andy, as he was with her. There may have been some truth to this: like Nancy, Sheindi offered the prospect of a ready-made family, and her Jewish heritage possibly added to her appeal. The historical persecution of the Jews may have resonated with Dick, who had been ridiculed for being different as a boy. His closest friends as an adult were Jews, albeit cultural and not religious ones. So too were several New York intellectuals, including Clement Greenberg, the art critic he revered.[44] Dick may have felt particular respect for "Jewish moral seriousness," one of the "two pioneering forces of modern sensibility" that Susan Sontag famously would single out in the coming decade.[45] Toward the end of his life Dick would tell his Jewish companion, the painter Pat Lipsky, that he held the Jews and the Chinese in highest regard as descendants of the world's oldest cultures.[46]

That summer, Sally Gross, a friend of both Sheindi and Jackie, came to visit them with her husband, Teddy, and their two-year-old daughter, Rachel. The women all knew each other from the Henry Street Settlement House, a social service agency where Jackie studied pottery; Sheindi, acting; and Sally, dance. Like Sheindi, Sally grew up on the Lower East Side in an Orthodox Jewish household. Sally was the youngest of her Yiddish-speaking parents' eight children, and as a child, she navigated for them as a translator.[47] She was twenty-four in 1957, a dark-haired, incandescent beauty whose deep-set eyes "held a steady, stubborn focus, as if somewhere she were on fire."[48]

Like all the people Dick met through Sheindi that summer,

Sally and Teddy Gross lived culturally rich, materially poor lives. A broodingly handsome man with an abrasive, brilliant delivery, Teddy was "probably the smartest"[49] of all his acquaintances in the fifties, remembered Robert Frank. To his friend Jill Johnston, Teddy was "a great hustler, jive artist, master of the put-down, wise child, city slicker, people watcher, [and] hipster at large."[50] He was also a jazz aficionado and a junkie.[51] Teddy enjoyed the company of musicians, likely his gateway to drugs, as it was for Miles Forst, who used heroin for recreation.[52] Miles would kick his habit at the nation's first federal "narcotics farm," in Lexington, Kentucky,[53] a place where famous musicians went to get clean, and where one might hear "the best jazz ever played anywhere."[54] Teddy would never break free.

Addiction is cunning, baffling, and powerful,[55] attendees at AA meetings learn. When Sheindi met Dick in Provincetown, she had no understanding of alcohol's dominion in his life. She'd grown up with people who drank schnapps and kosher wine, and that, sparingly. All she understood was that Dick got drunk. He also smoked marijuana, like many of her friends. Among her houseguests that summer was an attractive young man named Fred, who dealt pot on the side. Norman Mailer, one of his clients in town,[56] once jolted Sheindi awake one night when he blundered into her bedroom by mistake as he searched for Fred.

After Labor Day, Dick's social world reassembled in the city. He and Ivan returned as the Hansa's codirectors. Sheindi and Sally resumed babysitting for each other's children. Within a year, Dick would move in with Sheindi, Laurie, and Andy, a living arrangement that lasted halfway through the sixties. By 1963 it was apparent to many of their friends,[57] if not to the pregnant Sheindi, that Dick and Sally were lovers. The Grosses, who by then had two children, would separate sometime in the early sixties, when the vortex of heroin swept Teddy under. Sheindi and Teddy[58] had an intense emotional bond—she'd known him before meeting Dick—and she unsuccessfully tried to get him into treatment. At a distance of more than sixty years, the tangled interlace of their four lives is as hard to decipher as the border designs in the Book of Kells.

HIPSTERS, BEATNIKS, BOHEMIANS, AND SQUARES

If mainstream Americans could identify any living artists in 1955, the year Dick started at the Hansa Gallery, they likely named *The Saturday Evening Post*'s Norman Rockwell, or the self-taught nonagenarian Grandma Moses, whose memory pictures of bygone days adorned millions of Christmas cards. Jackson Pollock, or "Jack the Dripper" as *Time* magazine would dub him the following year,[1] was not yet widely known. The United States was in the middle of the biggest economic boom in its history, and cultural markers were wildly diverse: Disneyland premiered in Anaheim, California; Elvis Presley signed with RCA; Rosa Parks refused to give up her bus seat in Montgomery; Pete Seeger refused to testify before Senator Joe McCarthy's House Un-American Activities Committee; Emmett Till was lynched in Mississippi; and in San Francisco, Allen Ginsberg read *Howl* publicly for the first time. Mass media would home in on Beat writers two years later, after the publication of Jack Kerouac's *On the Road*, a novel that would spend the next twenty-four months on the *New York Times* bestseller list. With a nod to Russia's recent launch of the Sputnik satellite, a San Francisco newspaperman soon coined the condescending noun "beatnik,"[2] a word that rocketed into popular usage. Soon, Yves Saint Laurent would scandalize the world of haute couture with his "beatnik chic" ensemble of black leather jacket, knit turtleneck, and thigh-high boots; and in

suburban communities, couples would host beatnik costume par-
ties on Saturday nights.[3]

On the handwritten résumé Dick hastily diagrammed in 1961,[4]
the word "poet" reigns, relevant to everything yet more a declara-
tion of identity than a factual description. Dick gave his poems to
friends in high school, but as an adult he never showed anyone what
he wrote in a notebook he usually carried around.[5] Dick under-
stood poetry "as a basic redaction of feeling,"[6] remembered Victor
di Suvero, Mark's brother. "Bellamy was a poet, and I knew him as
a poet," he declared. But when Victor once asked to read his po-
etry, Dick put him off, saying, "You don't want to see it." None
survives. He was as harsh a self-critic of his writing as he would be
of his attempts at painting.

Dick's résumé grouped several early jobs within a bracket la-
beled "Hipster," making clear his early-twenties mind-set. "Beat-
nik" clumps the next group, scrawled "Bea" over "tnik" like a concrete
poem. Dick's beatnik philosophy was "a code he pursued vigorously,"
said the artist Michael Heizer, entailing "a strong sense of fairness,
selflessness in sacrificing for what he believed in, and an indifference
to possessions."[7] The critic Barbara Rose, who met Dick and his
friends as a college student, regarded them as coolness personified,
a group operating under the assumption that "there was a square
world, and we're not part of it, and we don't *want* to be part of it."[8]

Life magazine spoke up for the squares in "The Only Rebellion
Around,"[9] a snarky feature published as the fifties tailed off. Its re-
port on the "cult of the Pariah," as it called the Beats, took a page
from Allen Ginsberg and self-righteously howled against "talkers,
loafers, passive little con men, lonely eccentrics, mom-haters, cop-
haters, exhibitionists with abused smiles and second mortgages on
bongo-drums—writers who cannot write, painters who cannot
paint, dancers with unfortunate malfunction of the fetlocks."[10]
These misfits, they opined, "the hairiest, scrawniest and most dis-
contented specimens of all time," had one main purpose in life—to
"bug the squares."

The accompanying photo of a provocatively staged "pad"[11]
underscored the point: bare lightbulb, raffia-wrapped Chianti
bottle-cum-candlestick, avocado pit plant. A bearded poet in a

stereotypical turtleneck loafs on a mattress, Charlie Parker LP in hand. His impassive "chick" stands close behind, her wispy hair pulled back to reveal large dangly earrings. Their baby, in tee and diaper, lies conked out on the floor, watched over by a black cat. Beer cans are her toys, *Life*'s caption misinformed readers, goading their distaste. The unidentified model was Sally Gross, who must have found it an unpleasant, if well-paid, gig.

It was a different story when the Beats turned the camera on themselves. Alfred Leslie and Robert Frank's *Pull My Daisy* (1959), a pioneering independent film, was based on the third act of an unpublished play by Jack Kerouac, tantamount to a manifesto of the Beat avant-garde. Dick played a solemn, baby-faced cleric, and Sally his taciturn sister.[12] Frank remembered Dick "as being so elegant. I made a close-up of his hand with this ring on it; I remember how he let the cigarette just burn, so relaxed."[13] Unlike *Life*'s ersatz household, *Daisy*'s mise-en-scène was a credible picture of bohemian family life. Leslie adapted his own living space, creating a homey set with circular table, mismatched porch chairs, and Tiffanyish lampshade. As the film begins, Frank's camera slowly pans the loft, with its rack-stored canvases and soldierly row of toothbrushes assembled above the sink.

Years later, the filmmaker Emile de Antonio talked about why *Pull My Daisy* captured its moment so perfectly.

> I think that in the fifties, a lot of people were living in an underground world, without being aware of what the word "underground" meant; what everybody was hiding, was in that film—drugs, homosexuality, a different view of the world; and that was part of the Beat Generation, that total indifference to everything that would make a Westchester matron's jaw drop, hard; that in itself is a political statement. The film *Pull My Daisy* was a revelation of the world of what was to come in the sixties.[14]

"It was a formal film," Leslie reflected, "quiet in tone and movement . . . with a strong subtext of subversiveness, a Samuel Beckett, Chekhovian kind of quality in which nothing happens . . . like a Seinfeld

Alice Neel (left) and Sally Gross during filming of *Pull My Daisy*, 1959 (Photograph by John Cohen, courtesy of L. Parker Stephenson)

(From left) Alfred Leslie, Dick, and Jack Kerouac during filming of *Pull My Daisy*, 1959 (Photograph by John Cohen, courtesy of L. Parker Stephenson)

incident of nothing. But I thought in that you could see the natural-
ness of all of the lives of people."[15]

Jack Kerouac, who wrote and read *Pull My Daisy*'s voice-over,
may have had his friend Dick in mind when one of his characters in
his 1958 novella *The Subterraneans* explains the title's reference:
"[Subterraneans] are hip without being slick, they are intelligent
without being corny, they are as intellectual as hell and know all
about Pound without being pretentious or talking too much about
it, they are very quiet, they are very Christlike."[16] Dick was "the only
person I had ever known who was so spiritual," Michael Heizer said.
"I believe he was confused and saddened by people's ambitions and
actions."[17]

On any of several days during January 1958 a peripatetic art lover
could have seen the work of Jan Müller at the Hansa as well as
Jasper Johns's debut at Castelli's. Both artists painted recognizable
imagery and favored textured surfaces and occasional paint trails.
Müller's palette ran toward acidic greens and visceral reds, seem-
ing outward manifestations of his turbulent emotional life. Johns
preferred poker-faced grays, whites, and blacks in some paintings,
bolder primary colors in others. Müller reclaimed the narrative tra-
dition modernism had left behind, but Johns staked uncharted terri-
tory, impersonal things that were themselves flat, like numbers,
letters, flags, and targets, with no pretense of illusionistic space.

One fan of contemporary art who saw both shows on the same
evening was the collector Richard Brown Baker.[18] After his painting
class at the Art Students League ended, he ambled over to the Hansa
to take a closer look at Müller's *Temptation of Saint Anthony*, then under
purchase consideration by the Whitney Museum and today in its col-
lection. It was the night of Johns's opening at Castelli, and Dick and
the painter Myron Stout invited Baker to join them there. In de-
scribing the evening in his journal, Baker mentioned the throng of
"avant-garde enthusiasts" who greeted them at Castelli's, including
Betty Parsons, the artist/gallerist who had been Jackson Pollock's
first dealer; Paul Brach, a painter then represented by Castelli; and
the young art historian Robert Rosenblum, who in future years

would humorously designate Johns as the artist who "put a stake through the heart of Abstract Expressionism."[19]

Leo Castelli "gave the impression of having internalized Orwell's insight that history is written by the winners," his biographer Annie Cohen-Solal observed, "and so he determined to write his own part in it, and that of his artists."[20] Baker keenly observed that this process was already under way at Johns's opening. Castelli made sure to tell him "that in his [dealer's] opinion, Jasper Johns's work is the greatest new development in American art since Pollock and de Kooning." Setting this down in his journal, Baker put "dealer's" in brackets, as if to signal his distrust of art market soothsayers with a financial stake in their prophecies.

Another who saw Müller's and Johns's shows that January was MoMA's director of collections, Alfred Barr. It was Barr who bought for MoMA Müller's huge *Walpurgisnacht—Faust I* (1956), a demonic gathering of temptresses and witches. The purchase price of $1,500 was the largest financial transaction the Hansa had yet made.[21] When the check arrived, Dick and Ivan cashed it and rushed the money down to the Bowery, to Müller's bedside, where he lay dying.[22] Like giddy flower girls, the two men strewed the bills across Müller's bed and around the studio. *Jacob's Ladder*, a huge unfinished canvas, rested against his studio wall. A central figure on all fours, the color of red clay, wrests attention; as he starts to ascend the ladder, a chalky, mask-faced angel moves toward him on her belly. Müller died four days after his show closed. He had just turned thirty-five. After his funeral at Grace Church, his devastated friends buried his ashes in North Truro, on Cape Cod.[23] This loss felt like "a punch in the belly,"[24] Dick remembered. "I had been moved by Jan's paintings and by Jan as a person, as an artist, as much as I have by anyone."

Even if Johns's *Green Target* had interested Dick when he first saw it at the Jewish Museum, he wasn't in a position to offer him a show. As the Hansa's directors, Dick and Ivan didn't have the power to choose who showed there. Except for a few invitational groups and for backstage lobbying, directors had no say in the matter. Allan Kaprow, Johns's ardent proponent, tried to get the membership to accept him, but there was no consensus; besides, Johns didn't want to be part of a cooperative.[25] Less than a year after Castelli first

puzzled over his name at the Jewish Museum, the dealer launched Johns's career, a move that established his gallery as a locus for innovative art. This status was further enhanced two months later when he showed Rauschenberg's "combines"—sensual, hybrid constructions that merged elements of painting and sculpture. "Painting relates to both art and life,"[26] Rauschenberg would famously write. "Neither can be made. (I try to act in that gap between the two.) A pair of socks is no less suitable to make a painting with than wood, nails, turpentine, oil, and fabric."

Rauschenberg wasn't the only artist working in the shape-shifting gap between art and life. "Objects of every sort are materials for the new art: paint, chairs, food, electric and neon lights, smoke, water, old socks, a dog, movies, and a thousand other things,"[27] Kaprow wrote in assessing Pollock's legacy in 1958. While Rauschenberg's today iconic bird's-eye view of a real pillow and quilt partially slathered with paint was on view at Castelli's in March of that year, concurrently the Hansa presented Kaprow's first walk-in "environment." Parallel layers of cloth and plastic sheets hung suspended from the ceiling, strips freely painted with black, blue, and red heraldic bands.[28] "You didn't enter a space to find art installed on the edges," recalled Mica Weisselberg Nava, one of the scores of young people who saw Kaprow's show.[29] "You entered into the midst of a mazelike hanging, physically touching it with your hands." Richard Brown Baker, older and more pragmatic, thought Kaprow's environment "absurd" and regarded his Hansa friends as "a bit batty to have such a show," where nothing was for sale.[30]

If visitors were the animate component of Kaprow's unsalable environment on Central Park South, the artist soon posited, then what would it be like to work with people outside? He decided to find out at a now-historic spring picnic held at the rural New Jersey hardscrabble poultry farm owned by his hospitable friend and fellow Hansa member, George Segal. For the Hansa crowd, a picnic at his farm was the equivalent of a pastoral retreat. Kaprow, Segal, and Roy Lichtenstein were part of an unusual group of avant-garde artists who studied or taught at New Jersey's Rutgers University in New Brunswick,[31] a locus for artistic innovation in the fifties. Kaprow's first outdoor "Happening" took advantage of Segal's

"chicken coops, the fields, the tractors, whatever we wanted, in a casual atmosphere of friends that allowed people to do it, or not to do it, as they wished."[32] Dick invited everyone he knew to come, including a forgotten friend who brought along Claes Oldenburg.[33]

Months after Kaprow's first indoor environment he created a second, more sensory one at the Hansa, with the smell of disinfectant and a rotating drum that triggered a random sequence of audio effects. Unfortunately, Dick was unable to distinguish one of the sounds—a ringing telephone—from that of the Hansa's actual phone. He often stood chatting in the hallway during the run of the show, dashing back to his desk to pick up the receiver, only to hear a dial tone. As Wolf Kahn told it, Dick was the first gallery director in history to declare that a work of art was driving him crazy.[34] "All hell was breaking loose" in the New York arts community in 1958, the author and visual artist Fielding Dawson would write with hindsight twelve years later.[35] Aesthetic truths Dawson took for granted were "coming down around my head."

AN ERA'S END

The Hansa cooperative weathered transplantation and rotating management, but they could not survive the selective process of success. With the exception of Stankiewicz, Dick remembered, the artists were not being asked to join commercial galleries.[1] Side by irascible side, with no barrel of money, they stayed together for one more year beyond the season when Johns, Müller, Rauschenberg, and Kaprow, among others, signaled the approaching end of abstract expressionism. The majority of the Hansa's artists could barely afford the dues, and they squeaked by with odd jobs. Miles and Barbara Forst had wealthy parents but chose to live from hand to mouth. The most solvent members were women. The landscapist Jane Wilson was in demand as a fashion model, and several had mates who weren't artists: Fay Lansner's husband was Kermit Lansner, a visionary editor at *Newsweek*, and Lilly Brody was married to a stockbroker.[2]

When they were downtown, the gallery had paid a reasonable monthly rent of thirty-five dollars for their walk-up space. On Central Park South rent zoomed to $150,[3] and dues doubled.[4] They tried to recruit more members, hoping thereby to lower everyone's dues, but swelling their ranks proved nearly impossible. There was "a lot of disgruntlement, disagreement, turbulence, and fanfare about our taking on new artists,"[5] said Ivan, a man who rarely used one descriptor when four would do. "We were *constantly* in search

of them." To represent "different directions in art,"[6] Jane Wilson remembered, had been one of their goals in founding the co-op. But Miles Forst recounted their history more bluntly. "When we all got together, we hated each other's work, yet we decided to make this gallery. If we had had to vote on each other, we would have voted each other out. Can you imagine our bringing good people in? You had to have a majority or even a consensus, and that almost never happened."[7]

When the Hansa opened in 1952, the forty-year-old Pollock and the forty-eight-year-old de Kooning were not wealthy, although they'd been showing since their twenties. Not long after Pollock's death four years later, the self-effacing de Kooning became the most widely acclaimed painter of his generation. As abstract expressionism's hegemonic hold on young artists slackened, its appeal to collectors strengthened. By the end of the fifties, the best-known abstract expressionists were highly valued, just as *Fortune* magazine predicted. To own a de Kooning or a Pollock newly signified wealth and sophisticated taste.[8] When the Glass House architect Philip Johnson designed the new Four Seasons restaurant, he complemented its radical furnishings by commissioning a series of expressionist abstractions by Mark Rothko. The artist hesitated to accept, questioning the wisdom of installing serious artwork in a restaurant. In the end, he created a suite of brooding terra-cotta and black paintings, envisioned as a meditative environment for diners. "I hope to ruin the appetite of every son-of-a-bitch who ever eats in that room!" he was heard to say as he struggled to complete them.[9] But after he'd eaten there himself, Rothko had a change of heart about delivering his work. Astonishingly, he canceled the contract and returned his substantial fee.

Late in the summer of 1958 Robert Frank and Miles Forst drove to the Cape together to join their wives and children. Frank had just returned from Europe and the final preparations for the French publication of his first book of photographs, *Les Américains*,[10] the book that would bring him fame when republished in the United States the following year. A master photographer, Frank was a

relative novice with the moving image. He wanted to expand his practice, and he decided to make a 16-mm film with Ivan Karp,[11] a whimsical, antic home movie with parts for many of their friends, including Dick.[12] Ivan, who once had a job bowdlerizing steamy westerns for TV broadcast, appointed himself director. It would be a short-lived partnership. "After two days already it was not possible, and I continued by myself," Frank commented decades later without elaborating.[13] *Provincetown* (1958),[14] Frank's first—and virtually unknown—film, "was quite wonderful," he remembered.

A friend who charted its progress remembered that *Provincetown* was full "of German shots, Russian shots, Italian shots, French shots, Japanese shots."[15] The film captured the town's informal, sensuous character. Frank recalled that in one scene various men and his young son, Pablo, were "running on the dunes and finding bottles; we all had to find these bottles, and there's a woman [Mary] waiting for you," reclining on a couch at the water's edge. Mary wore a see-through negligee and dramatic stage makeup. "I was writing notes," she remembered, "placing them in bottles and casting them into the sea. Dick Bellamy was one of the men who turned up with the bottles they supposedly found. Dick came running towards me with the bottle and spontaneously prostrated himself on top of me."[16] Then Allan Kaprow, as Neptune, scared her suitors away by shooting up out of the water. "It was beautiful," said an eyewitness who watched as Kaprow, weighed down by seaweed, ropes, and bulky metal chains, "toppled backwards and the heavy chains bore him under."[17] He nearly drowned.

Dick appeared in "another wonderful scene,"[18] Frank said.

Near the cemetery in Provincetown we found a donkey. I said to Bellamy: "Now you try to get on this donkey." But the donkey didn't like it. And then at one point Dick got down on his knees, and he prayed to the donkey, and it was absolutely wonderful. And then he got on it. That idea of praying to the donkey was just beautiful; that's the kind of person Bellamy was, who would find something unexpected, something good.

Today the film exists more in memory than in fact. "I did a real stupid thing," the filmmaker confessed. "I used to teach film in a college. Sometimes I would tell them about editing; I said, 'Here.' I had this film from Provincetown, and it was in pieces really, and I said to the good students, 'Why don't you look at this and put it together.' That's how it got lost, half of it." Luckily, the section in which Dick romances Mary on the beach survived—Frank included the footage in his later film *Conversations in Vermont* (1969).

Abstract expressionism no longer seemed a teleological inevitability to the young Turks in Provincetown, who rejected the tacit assumption that only abstract art could be avant-garde.[19] Still, it shocked some die-hard abstractionists in 1958 when Val and Yvonne put on a show at the Sun of Alex Katz's portraits of his wife and collages of a lighthouse. When he learned that a few people were seen through the window brandishing their fists at his paintings,[20] the artist was unprepared for the level of outrage his work provoked. At the end of August the Sun showed the figurative expressionist Lester Johnson,[21] a revered painter nearly a generation older than Katz. In one photo Yvonne took at the opening, she stood outside on Commercial Street, looking in at the convivial crowd through the gallery's front window. It's easy to miss Dick, who sits apart, staring pensively out at the road, a cigarette in hand, disengaged from the tumult around him. If Hans Hofmann stopped in that evening, he eluded Yvonne's camera. Within days, the great teacher would shutter his famous summer school permanently, saddening many of his present and former students. It was a propitious moment for an abstract expressionist teacher to retire.

Art commerce surged in Provincetown that summer thanks to two new attractions: a fine small museum housed in a deconsecrated church, and an encampment of seven "platoon-size" tents with four hundred contemporary paintings, set up out near the Pilgrim Monument.[22] The collector Walter P. Chrysler Jr., heir to the automotive fortune, was behind both projects. When asked why he chose to open a museum in Provincetown, Chrysler later explained that it was "the largest and most active summer art col-

ony in America."[23] His museum had room for only a portion of his large collection of old and modern masters, a collection he started in 1923 as a precocious fourteen-year-old, when he used a birthday gift to buy a small Renoir watercolor.[24] The Renoir nude had not pleased his dorm master at the elite Hotchkiss School, who high-handedly confiscated and destroyed it as smut.

Dick and Sheindi went to see Chrysler's museum, as did a smart, fervent, and social young man who was then on a fast track to earn his Ph.D. in art history at Harvard. Henry Geldzahler was in Provincetown studying for his doctoral orals: "If you are obsessed," he believed, "vacationing and working are the same thing."[25] Like Chrysler himself, Geldzahler discovered art as a teenager: at age fifteen he saw the Whitney's 1951 exhibition of Arshile Gorky, a transformative experience that won him over to modern art.[26] Geldzahler remembered wandering into the Sun Gallery one evening to find himself in the middle of a Happening by Red Grooms.[27] The artist stood alone, painting on a canvas, his back to the crowd watching him. With bold, expressive gestures he marked out a fireman engulfed in flames.[28] Here was "action painting" playfully subverted to mean a live theatrical event. It was Geldzahler's first experience of a Happening, an art form Allan Kaprow had conceptualized only months earlier. In no other place on the East Coast that summer could Geldzahler have gotten a more up-to-the-minute sense of what interested young avant-garde artists.

Perhaps he returned for the Sun's next show, *The City*, a collaborative environment that included Robert Frank's photographs, Val's poems, and Yvonne's gritty sculptures surfaced with black roofing cement. Her visceral cutouts of cars, street scenes, and people embodied the expressive mood of action painting, but not its abstract form, a direction Claes Oldenburg would soon explore in his *Street* and *Store* series. Within two years Geldzahler would drop out of grad school and move to Manhattan. As the Metropolitan Museum's first curator of twentieth-century American art, he plunged into the breaking waves of the sixties, Dick Bellamy his principal mentor.

•

The Hansa's fractious artists fired both of their codirectors in 1958. "There were certain dissatisfactions about or with me," Dick recounted matter-of-factly.[29] Over time, his drinking—pints of Napoleon brandy were one of his favorites[30]—and shambolic stewardship had pushed his friends to the end of their patience. "I made a couple of mistakes and it severely injured my respect among several of the artists," Dick reported without giving details. Ivan too was "purged,"[31] as he put it, although the reasons are murky. Shortly after Jan Müller's death, Miles Forst overheard Ivan trying to sell the painter's work at prices Miles deemed too low, and he exploded in anger.[32] Although they'd been impressed by Ivan at the onset, "the members believed he knew nothing about art," Lois Karp recalled, "and they didn't like his personality. They thought he wasn't aesthetic enough."[33] For Ivan, the decision to fire him precipitated "a tremendous amount of personal anguish."[34] He felt betrayed, and he didn't understand why Dick hadn't intervened.[35]

Outspoken members like Miles Forst didn't stop at chucking management. In a final, futile attempt to reinvigorate their collective, they culled ranks, cowardly effected with secret ballots. Dick remembered the process as "horrendous," an "internal slaughter."[36] There were conspiratorial "pre-meetings"[37] to which no women members were invited. Jane Wilson and Jacques Beckwith, a confidant of Jack Kerouac's, were among those who resigned or received votes of "no confidence."[38] Dick's two closest friends were Jacques Beckwith and Miles Forst, respectively a sweetheart and a mischief maker, a seeming contradiction that mirrored Dick's dual identity. Beckwith painted small, gemlike paintings and had problems with his eyes. "There was a tenderness about him that was extremely appealing; he was an anomaly in that bunch,"[39] said Jane Wilson. By contrast, she identified a "core of self-indulgence" in Miles, a "self-protective" man who "emanated a negative charge." To Jane, Miles and Dick were indecipherable. "Dick looked at me and I looked at him. There was no communication."

In the beginning of September it belatedly occurred to the remaining artists that they had cleaned the Hansa's house too thoroughly.[40] They had no shows scheduled, no director, and half their former members. They interviewed several people as potential man-

agers, but no one would work for the wages and conditions they offered. A delegation went to see Dick, who was living with Sheindi in a fifth-floor walk-up at 343 Cherry Street. "One by one each member got up, made a speech, apologized to Dick, begged his forgiveness, and asked him to come back. "It felt like the Moscow trials," Fay Lansner recalled with grim wit. Dick agreed to return, she said, but "confidence in the cooperative had been lost."

"I couldn't leave them alone like that,"[41] Dick remembered. "I wanted to keep the gallery going for the sake of a couple of the artists." Nonetheless, it was clear to Dick, if not to the members, that the whole idea of cooperatives "had become obsolete." The Hansa "was losing qualities of freshness. There was a kind of dead rigor about it . . . Each of the artists had his own ego; his own presumption; his own belief, [yet] wanted the gallery to continue." They sought sponsors and considered incorporating as a nonprofit.[42] George Segal, elected "captain of the sinking ship,"[43] borrowed $500 from the art historian Meyer Schapiro for operating expenses. They soldiered on through their seventh and final season, disbanding with reluctance, and not a small amount of relief, in May 1959.[44] At the nearby Sidney Janis Gallery, a show of de Kooning's recent paintings was on view. On the day it opened, collectors queued outside as early as 8:15 a.m., *Time* reported.[45] "By noon, nineteen of the show's twenty-two oils were sold at prices ranging from $2,200 for the smallest oil sketch to $14,000 apiece for five big canvases. At week's end, a new de Kooning was not to be had for love or money."

The years that Dick and Ivan spent at the Hansa constituted their apprenticeship as art dealers. Practical-minded Ivan would make a smooth transition to the world of art commerce as a salesman at Martha Jackson's, and then as Leo Castelli's right-hand man. Castelli's judgment in hiring him in 1959 was nearly as shrewd as his decision the previous year to take on Jasper Johns. Earthy and expansive, Ivan was an ideal complement to the aristocratic Castelli, who took the pulse of the art world without laying his fingers on too many wrists. In the decade to come, Andy Warhol, John Chamberlain, Roy Lichtenstein, and Richard Artschwager would all enter Castelli's stable thanks to Ivan's initiative. Castelli "has had a lot of resistance to some of the better artists that he has shown,"[46] Dick told

a later interviewer. "He accepted the inevitable." Dick remembered at one point thinking that "Leo was as deferential to Ivan as Ivan was to Leo."

"There was nobody who was not enchanted with Bellamy,"[47] Castelli reminisced late in life. The two gentle, soft-spoken men mutually respected each other and were each held in great affectionate regard by their clients and by the artists they represented. Predictably for Dick and surprisingly for Castelli, they came to their calling repelled by the trade it required. "I was rather ashamed of doing business," the older man reflected.[48] "It didn't seem to me a gentlemanly occupation." Castelli overcame his initial aversion to commerce, propelled by his need to have himself and his artists written into history. "Dealers," Castelli once declared, are "as important as the artists themselves. *He* cannot exist without us, and we cannot exist without *him*."[49]

Dick was still a man "semi-submerged" in the fifties, said Paul Brach,[50] who remembered him as "a strange-looking, wispy, quiet-spoken, semi-invisible Eurasian man with a kind of quirky sense of humor and a real dedication to art." He seemed "like a kind of charming hanger-on, not a professional. Dick Bellamy was *around*, but by being around the art world long enough, and being *there* constantly enough, as the fifties moved into the sixties, he became one of the centers of the art world." By the time the Hansa closed, Dick understood that what he most wanted in life was his own gallery. In the *Wanderjahre* that followed, spent in Manhattan, Dick would visit artists' studios and keep track of the many galleries popping up downtown. With backing that seemed to come out of nowhere, he would enter an arena with spotlights trained on such dealers as Jackson and Castelli. No one, Dick least of all, could have foreseen that he would supplant them, for a few extraordinary years, as New York's most influential impresario of the new.

THE REPUBLIC OF DOWNTOWN

In 1959, when Dick first visited the studio of Marco Polo di Suvero, his initial reception was anything but cordial. The sculptor lived in a crumbling warehouse near the Fulton Fish Market, a few blocks north of Wall Street. "You can't come in. I'm working,"[1] Mark growled at his caller. Relenting, he threw open his door. Dick had no appointment, Mark neither telephone nor bell. He was one of the many young artists drawn to New York in the late fifties, hoping to gain notice in the capital of the postwar art world. Mark and fellow sculptor Charles Ginnever arrived together from the Bay Area in 1957. During their cross-country drive in Ginnever's Volkswagen bug, they talked about the state of contemporary sculpture, in agreement that most current work "looked a little bit like blown-up jewelry."[2] They resolved to create a more heroic sculpture, with the visual heft of Alexander Calder and David Smith, sculptors of the preceding generation they most admired.

In New York, Mark supported himself however he could, sweeping up fish stalls[3] and working in a prosthetics factory. The abstract expressionist painters Milton Resnick and his wife, Pat Passlof, were early fans of the first work he exhibited in New York—small-scale plaster hands that clenched, pointed, or flared open in anguish. After moving to a studio with more space, he began to help himself to wooden beams from demolition sites and disused pilings and barrels from the nearby waterfront, free art materials all. Ginnever

meanwhile, in grad school upstate, worked with massive ties from a defunct railway. Choosing related routes, they each went on to create what the sculptor and critic Donald Judd described as "wide-open, constructed, more or less composed sculpture,"[4] forms that no one had seen before.

In the late fifties, many artists in the United States and in Europe took advantage of the discarded and the unwanted, bits and pieces of everyday life encoded with the history of their use. Decades before, Marcel Duchamp had transformed urinals, shovels, and bottle racks into ready-made sculpture by changing their context. Cubists, Dada-ists, and surrealists pilfered the real world and made off with ticket stubs, wallpaper, and teacups they pressed into service as art ma-terials. The ordinary refuse of Manhattan—flattened boxes, bro-ken chairs, rusty gears—excited the imagination of the impoverished artists living downtown. Affluent society's frenzied consumer cul-ture repulsed them, with its emphasis on the new and the shiny. Ma-terialists of a different order, they assembled sculpture from castoffs, and they mixed and matched art and life in Happenings. "Every time you turned a corner," said the downtown resident and Happenings pioneer Jim Dine, "you'd see in the next trash can some wonderful piece of sculpture."[5]

When Mark began using scrap wood and metal combined in ways related to the gestural language of abstract expressionism, it was Pat Passlof who sent her friend Dick to see his work in prog-ress. Dick "looked like such a kid,"[6] Mark said, thinking back to that first, unexpected visit. His future dealer clambered onto a high table like a wily feline and spent a long time looking at the monumental sculpture muscled into the cavernous, low-ceilinged space. Then, for a different vantage, he jumped down and sat on the floor. Dick re-sponded viscerally, as he had to de Kooning and to Motherwell. He knew immediately that Mark would be the opening show of the gal-lery he dreamed about. He'd just have to find a place large enough to do it justice.[7] "Well," said the circumspect artist when Dick finally broke his silence and told him what he had in mind, "let's see if you get a gallery."[8]

The two formed an enduring friendship. Each had connections to China,[9] a passion for music and poetry,[10] and a fascination with

dreams. The importance of the great modernist sculptor David Smith was something else they agreed on—Smith was one of Dick's greatest heroes.[11] He never forgot the first time he saw Smith's sculpture in a midtown gallery in the early fifties. "It was not only the intrinsic quality of the work but the intensity I felt about it that made it a standard of excellence for me through the years."[12]

Dick was in and out of studios like Mark's all through the fall of 1959 and the following spring. He had no steady job and found sporadic work as a housepainter.[13] His contribution to household expenses was minimal, and the burden of support fell to Sheindi, who learned speed writing and temped as a secretary.[14] That September, when Ivan left Martha Jackson for Castelli, he suggested that she hire Dick to replace him, and she agreed. Compared with the Hansa, the work at Jackson's "was *really* being an art dealer," Ivan recalled.[15] "You went on the floor and very nicely dressed people came in; it was very decorous, and you made flowery speeches."

Dick proved temperamentally unsuited to sweet-talk Martha Jackson's chic clientele. With the exception of an Alfred Leslie painting he sold to Bob Scull,[16] Dick made no sales during the few weeks he lasted at Jackson. He made his mark there, if at all, with *Matisse to Manessier*,[17] an unremarkable and long-forgotten show. Its sly title has Dick's fingerprints all over it. By pairing the alliterative names of a famous artist and his less well known and considerably younger countryman, Dick mimicked the chance poetry of labels on multivolume reference books and card catalogue drawers, a format he would return to years later.

After Jackson let Dick go, Ivan again came to his aid,[18] urging his friend to contact the Cleveland art dealer Howard Wise, a European-educated former businessman who was about to open a gallery on Fifty-Seventh Street. Wise was keenly interested in what he called "present-day" art,[19] and to Ivan, the two seemed a promising match. But Dick failed to impress the older man, who must have regarded him as too close to the raggle-taggle do-it-yourselfers downtown. Wise was "the antithesis of Tenth Street,"[20] in the description of one of his artists. A visionary dealer, Wise went on to mount pioneering shows of kinetic and light sculpture as well as

video art, but without the help of the former director of the Hansa Gallery.

One evening that winter, Dick visited an artist friend living illegally in a commercial building on the Lower East Side. When the landlord shut off the heat at five p.m. and on weekends, the tenants kept their doors open to gain the rising warmth from the steam laundry on the ground floor. Walking down the stairs on his way out, Dick glanced through an open doorway into a stranger's workspace. Evocative, volcano-like reliefs hung on the wall, objects with projecting forms that hinted at eyes, breasts, and voracious mouths. Neither paintings nor sculpture, they were pieced together from remnants of canvas conveyor belts. Lee Bontecou invited him in. Dick loved her work, yet he was reluctant to ask her to wait to show in a gallery that wasn't more than a hope.[21] Dick let Ivan know about his find, and Ivan immediately arranged for the twenty-eight-year-old's debut at the Castelli Gallery.[22] It was typical of Dick to do what he thought best for an artist, often to his own detriment.[23]

Another artist Dick might have claimed, but didn't, was Frank Stella, then twenty-three. A Princeton grad, Stella was then working on an extraordinary group of symmetrically patterned abstract paintings. He used black house paint on unprimed canvas, creating white "pinstripes" in the areas left unpainted. During the Hansa's last year, when Dick and Stella were part of the informal social circle that the painter referred to as the "Central Park Crowd,"[24] Stella wasn't represented by a gallery. Although he invited Dick to make a studio visit, Dick never took him up on it.[25] Dick's failure to pursue Stella, "a formidable presence in all of his casualness,"[26] as he later described him, may reflect a clash of personalities. Or, ineptly, Dick may have let the moment slip away. Ivan *did* go to see Stella and brought along his new boss, who responded with excitement and chose a painting for the gallery's fall leadoff. Dick, likely drunk, charged up to Stella at the opening to berate him, saying, "Oh! You sold out for uptown!"[27]—an unmistakable dig.

There were times in the late fifties when Dick and Ivan worked together like volleyball teammates. They were still codirecting the Hansa when the two chanced upon John Chamberlain's sculpture

in a Tenth Street group show[28] and arranged for him to show as a guest artist at the Hansa.[29] Chamberlain was a character's character, a tattooed navy veteran with old-fashioned mustachios, mutton-chop whiskers, and an infectious, alcohol-fueled grin. He was "a fun maniac,"[30] said the painter Jim Rosenquist. Dick and Chamberlain, whom he would nickname "Chamberpot,"[31] became the best of friends. One reticent and bespectacled, the other brawny and brash, they may have seemed unlikely allies. But they both held the buttoned-down world in contempt.

When Chamberlain arrived in New York in 1956, fresh from a year at the experimental Black Mountain College, he was an assemblagist working with iron rods in the modernist mode of David Smith. When his stockpile of iron dwindled, Chamberlain turned his attention to the city's giveaway harvest: discarded lunch boxes, sand pails, benches, any scrap metal that had color on it. The crushed trim and chassis of automobiles were one step away. Chamberlain and his family were staying on Long Island with Larry Rivers when he devilishly pinched a fender from his friend's 1929 Ford and drove over it a few times to improve its shape.[32] Here then was the material that would engage, repel, and reengage him for the next fifty years.

Dick was to play a crucial, undocumented role in launching his friend's career. At his invitation, Chamberlain installed some of his sculpture in a loft Dick had sublet, and Dick prevailed on Martha Jackson to come and see it.[33] It was an important introduction. Months later, when Ivan went to work with Jackson, she allowed him to bring along one artist he admired.[34] He chose Chamberlain. As Ivan remembered it, Jackson regarded Chamberlain's work as "strange and pretty difficult"[35] and asked him to keep it in the basement.

One spring day in 1959 the novice collector Robert C. Scull walked into Jackson's, on the prowl "for really aggressive new art."[36] Ivan was a master of persuasion when he believed in an artist. He took Scull down to see Chamberlain's *Zaar* (1959), a sculpture that called to mind a Kabuki dancer with tilted, wind-filled sleeves. Like all of his early work, *Zaar* was a self-portrait, Chamberlain later said,[37] constructed with the force of his anger at that time in his life. Scull paid $275 for *Zaar*, one of the sculptor's first works made from crushed automobiles, today in the Nasher Sculpture Center collection

in Dallas. On the basis of that sale, Jackson gave Chamberlain a two-man show in January 1960; she paired him with Alfred Leslie, then a considerably more prominent artist. On the night of Chamberlain's opening, Ivan would reintroduce Bob Scull and Dick Bellamy, two men unlikely to have found each other without him.

Dick regarded himself as an "acolyte"[38] of Alfred Leslie's, whose abstract expressionist paintings were internationally known by the late fifties. Leslie had a unique interdisciplinary practice as a painter, writer, and filmmaker, an "octopussarian,"[39] in his parlance. As one hand directed *Pull My Daisy*, the other assembled[40] *The Hasty Papers*, a "one-shot Roman candle"[41] of a literary review. Dick lent a hand drafting letters to solicit content, but he worked at a maddeningly slow pace as he searched for the perfect words to express each thought, more annoyance than help to Leslie.[42] The final table of contents of *The Hasty Papers* included a history of stilts, the Cuban president Fidel Castro's address to the United Nations General Assembly, and the museum director Pontus Hultén's essay "Three Great Painters: Hitler, Churchill & Eisenhower."

Dick and Leslie exulted in the new jazz of the late fifties, particularly Ornette Coleman's anarchic, atonal style of improvisation. Weeks after Dick first heard Ornette play his alto saxophone at the Five Spot jazz club in November 1959, he described its impact in a letter to his friend Robert Beauchamp, a former Hansa artist: "new jazz musics at *funf* spot hit our circle like stunning everybody, pretty great I think, very beautiful cat, a real dream."[43] Ornette Coleman was "a little step ahead" of the sixties, the jazz musician most implicitly in tune with interdisciplinary avant-garde trends, in the opinion of the music historian Francis Davis.[44] For him, Coleman's album *The Shape of Jazz to Come* was one of the twentieth century's seminal events.

For Dick and his friends, "downtown" was more than a geographic designation; it was an artistic identity.[45] The Hansa Gallery, with its spirit of "anti-elegance, anti-polish, anti-regularity, and anti-

position,"[46] brought the downtown uptown when they moved above Fourteenth Street, widely regarded as the demarcation line. In the late fifties, most downtown galleries were modeled on the Tenth Street artist cooperatives. Provincetown's artist-curated Sun Gallery was an alternative model. During his summers on the Cape, Red Grooms became close friends with the Sun Gallery's cash-poor founders, whose can-do approach inspired him to open his own gallery when he returned to New York in September 1958. Red knew artists who had tried unsuccessfully to gain a foothold on Tenth Street. When the cooperative Phoenix Gallery turned down Claes Oldenburg's application for membership,[47] Grooms and Jay Milder resigned their membership in protest.[48] The two went on to found City Gallery with Michaela Weisselberg,[49] a young British artist who also spent the summer in Provincetown. They set up City in a listing wooden building with narrow, lopsided stairs at Twenty-Fourth Street and Sixth Avenue,[50] downtown in character if not in fact. Red's well-lighted third-floor studio, with dark floors and white walls, doubled as the exhibition space; one night a week, his smaller bedroom became a drawing classroom for his mentor, Lester Johnson. A portion of the students' tuition paid half the rent. It was Weisselberg who printed up flyers to announce City's debut, which the three pressed into the hands of visitors at the Whitney Museum.

City opened with a large cross-generational drawing survey. Oldenburg's expressive black-and-white nudes—the first work he ever showed in New York—hung near abstractions by Franz Kline and Alfred Leslie. The sonorous roster of participants printed on the announcement reads like Beat poetry: "Grillo, Grooms, Gross, Gross, Grosz . . ." The most surprising surname on the list was "Bellamy." Dick's contribution was a self-effacing lozenge-shaped piece of wood about as big as a tongue depressor, delicately painted with vertical bands of color.[51] When the show came down, Dick gave it to Red. Oldenburg received a similar gift, "a stick, about eight inches long and one inch wide, painted in thin gray stripes, austere and elegant."[52] Dick's paintings evoked the format, not the scale, of the unusual striped oval canvases that Alfred Leslie painted in the early fifties.

"I know how hard it is to make art because I've tried to do it myself,"[53] Dick told a later interviewer.

In the early fifties when waiting in an artist's studio, I would pick up a brush and paint on cardboard or whatever material was handy. Once I drew on the endpaper of a beautiful book entitled *The Bitter Box* by Eleanor Clark, Robert Penn Warren's wife. My drawing was black and very "Reinhardt-ish." As a matter of fact, I could claim that I originated techniques generally credited to such artists as Jackson Pollock and Ad Reinhardt. In my Provincetown days, I did some all-black things that later turned out to be exactly what Kline was doing. But I had no talent, and I realized just how very difficult art is to create.

Dick's participation in City's opening show was a one-off, heartfelt act of support. There's no record that he ever again exhibited his own work.

City Gallery operated for about a year. Then Red moved farther downtown to a former boxing gym near the entrance to the Williamsburg Bridge. He called his new quarters the "Delancey Street Museum," a tongue-in-cheek choice for an experimental art venue located in a neighborhood of curbside pickle barrels and discount dry goods. Dick invariably said yes when friends invited him to participate in their films and performances. Early in February 1960 Red's museum presented *Ballet of the Garden*, an antic Happening by Marcia Marcus. Red depicted "the excitement of daytime,"[54] and Dick, as some unremembered personification, wore a long costume that accidentally caught fire during the performance. Someone in the audience jumped up to douse it, not knowing whether it was part of the script; it wasn't.[55]

Quirky, open-ended galleries kept cropping up. On the south flank of Washington Square Park stood Judson Memorial Church, a Greenwich Village institution with a history of support for progressive social and political causes. In the fall of 1959 Judson's clergy reached out to the growing community of writers and artists in its neighborhood and opened the Judson Gallery in the base-

ment of their annex.[56] Dick was a faithful attendee, to judge from the number of artists who showed there whom he would subsequently represent. Dan Flavin, whose configurations of fluorescent light fixtures would bring him world acclaim by the end of the sixties, was still an abstract expressionist when, in 1961, Judson mounted his first solo exhibition. Like so many of his peers, Flavin scavenged the city for detritus that appealed to his eye. In his unheated apartment in the meatpacking district he arranged his street finds with the care previous centuries lavished on their curiosity cabinets. On Dick's first visit he "paced from room to room delightedly for some time, and then announced that he wished he could transport the entire apartment" to his art gallery.[57]

Two of Flavin's early works explicitly acknowledge Dick's importance to him. *Gus Schultze's screwdriver (to Dick Bellamy)* (1960) is a small relief fashioned from found objects that paid tribute to a veteran maintenance man at MoMA, where Flavin then worked as a guard. HOLY MOTHER LOADED WITH GRACE PLEASE HELP DICK is the inscription on another early sculpture, one of a series made with empty cans of Pope brand tomatoes and a glowing figural lightbulb with an image of the Virgin inside.[58]

Claes Oldenburg was another of the artists Dick would one day represent who showed at the Judson. There's a photo of Dick backed into a corner with Sheindi and Ivan at one Judson opening in 1959. Oldenburg's nearly abstract *Street Head I* hangs from the low ceiling nearby. To Dick's eye, European *art brut* and the raw, vital figures of Jean Dubuffet had "a profound influence"[59] on Oldenburg early in his career, and he loved the artist's gritty, graffiti-inspired drawings. Oldenburg gravitated toward transgressive imagery as a corrective for the "constipation" of the fifties,[60] and literalized the idea with a macabre string of sausage-turds, a "grimy, pinkish stocking stuffed in sections, which bulged from a cord wrapped up and down its length."[61] It was one of the rare works of art Dick ever bought for himself.

When the sixties began, there were only a handful of collectors of contemporary art. American art museums rarely acquired the work of living artists or honored them with exhibitions. MoMA was one of the exceptions. MoMA's two recent hires bolstered its

long-standing commitment to contemporary art: Peter Selz, a European-born specialist in German expressionism; and William Seitz, whose 1955 Princeton Ph.D. thesis on abstract expressionism had been the first written on the topic. At the time, the art history curricula at nearly all American universities defined modern art as "European." Few academics kept an eye on living artists showing in New York's galleries, uptown or downtown. One exception was the Barnard College professor Barbara Novak, who was married to Brian O'Doherty, an art critic at *The New York Times*. By 1960 she was teaching an innovative survey on American art from the eighteenth century to the present moment.

Henry Geldzahler's 1960 appointment at the Metropolitan Museum of Art fitted bifocals on the farsighted dowager, long content to look across the Atlantic for all the modern art that mattered. In hiring Geldzahler, the museum belatedly acknowledged that in the postwar period New York had wrested the capital of the art world away from Paris. The Metropolitan's director, James Rorimer, reportedly remarked to Geldzahler on his first day, "Well, I guess I won't be seeing much of you." When his new employee asked why, Rorimer answered, "What you're here to do isn't inside the museum."[62]

In the world outside, the artists' world, it was the era of "junk art," a descendant of the found art objects of the teens and twenties. It may have been this European pedigree that excited Peter Selz, the new curator at MoMA, who convinced the director, René d'Harnoncourt, to allow the Swiss artist Jean Tinguely to create a huge electrified assemblage, *Homage to New York*, in the museum's outdoor sculpture garden. For technical support, Tinguely relied on Billy Klüver, an American-based Swedish electrical engineer. A brilliant problem solver who worked at Bell Telephone Laboratories, Klüver would shortly earn his title as the "Father of Electronic Art" for his collaborations with Robert Rauschenberg, John Cage, and other avant-garde artists.

During several wintry weeks in February and March 1960, Tinguely and his team worked in MoMA's garden under the shelter of a large plastic dome created by Buckminster Fuller.[63] Tinguely's raw materials included "eighty bicycle wheels and a bassinet, washing machine parts and a weather balloon, pots and a piano, cable

drums and a radio, oil cans, an American flag, [and] a child's toi-
let."[64] With Klüver's expertise, he rigged *Homage to New York* to emit
odors, write poetry, and make music. For its sole performance on
March 17, they engineered a theatrical suicidal conclusion with
gunpowder, deadening noise, and pyrotechnics. By the time of the
event, *Homage to New York* grew to be a white-painted, twenty-three-
foot-long, twenty-seven-foot-high armature of discards.

Dick's name was not among those on the "white glove" list that
MoMA drew up for the much-anticipated performance, but he found
his own way to get in. Alfred Leslie, one of Tinguely's new friends,
spirited Dick inside the dome that night before it opened to the official
invitees.[65] No one there would forget how the evening ended. Just as
Homage to New York headed into its finale, the piano component of
what the press called a "gadget to end all gadgets"[66] burst into
flame. Two years earlier, MoMA had suffered a devastating fire, and
now, twice shy, the museum staff ignored chants from the crowd to
"let it burn."[67] They called in the fire department, who unwittingly
transformed the machine's orchestrated suicide into a mercy kill-
ing. Some considered darkly that *Homage* was a doomsday machine;
others took it as delightful entertainment. *Breaking It Up at the
Museum*, an eight-minute film by D. A. Pennebaker, documented the
piece as it "burned, whistled and clanked . . . before beating itself
into a fiery frenzy and leaving its wreckage strewn about the mu-
seum courtyard."[68] According to Alfred Leslie, if you look carefully
at the Pennebaker film, you can catch the glint of Dick's eyeglasses
as he watched the conflagration from the sidelines.

Six months before Tinguely's staged *Homage*, Billy Klüver was
guiding Pontus Hultén around Greenwich Village when they noticed
a wall poster heralding the grand opening of the Reuben Gallery.[69]
Neither of these two indefatigable champions of the avant-garde
had heard anything about it, nor were they enticed by the descrip-
tion of its debut event, Allan Kaprow's *Eighteen Happenings in Six Parts*.
As the men took up their walk again, they decided that whatever
that was, it wasn't worth attending. Even among the cognoscenti,
not everyone was a fortune-teller. Dick wouldn't have missed the
soon-to-become-historic Happening—he knew nearly everyone
involved. Like the pop-up City and Judson galleries, the Reuben

would have a short but influential life. Anita Reuben, a friend of Allan Kaprow's, paid the rent for an unheated third-floor loft in a triangular corner building close to the Tenth Street galleries, and the artists covered their own expenses.[70] Kaprow helped Reuben choose the roster of shows and performances, and Dick himself may have had a hand in shaping at least one exhibition.[71]

Eighteen Happenings in Six Parts was figurative expressionism brought to life, part theater, part living sculpture, radical even for the art world mavens in the audience. Kaprow's ephemeral Happenings—today a genre called live arts—went beyond his Hansa environments, where gallerygoers passed through at their own pace. Now people showed up at an appointed time and sat or moved around as he directed. Most of his cast of conscripted friends—Johns and Rauschenberg included—did as they were told, carrying out tasks like painting different sides of one piece of fabric. Alfred Leslie balked at the solemn choreography and infuriated Kaprow by improvising.[72]

Figuration eclipsed abstraction at the Reuben, where Happenings and junk art engaged the city and its inhabitants as both subject and substance.[73] To the artist Al Hansen, the Reuben "gently placed Abstract Expressionism in its coffin, put the lid on, lowered it into the grave and shoveled dirt on it."[74] There were many undertakers working downtown, and *Time* magazine's savvy Rosalind Constable made it her business to seek them out.[75] As Claes Oldenburg recalled, acute observers such as Constable "knew that a change was coming, and it was being hatched, but nobody quite knew exactly how it was going to appear."[76]

LIVING IN CHANGE

THE SECRET SHARER

"Important new work was being discovered every week, or so it seemed,"[1] wrote *The New Yorker*'s Calvin Tomkins, describing the feverish intensity of the New York art world in the early sixties. "The real trick was to 'get there before the dealer.'" It was just the stunt that Bob Scull tried to pull off as the fifties ended, when he trekked downtown to the few studios he had a lead on.[2] But he had a taxi business to run and didn't have much time to handicap his chances of being the first to find the hot artists.

Scull wanted to expand his collection of up-to-the-minute art. He wasn't going to come late to the ball again, as he had with Pollock, whose prices skyrocketed after his death. He needed a scout, someone to keep an eye out for him. With a gallery of his own, he could cut out expensive middlemen such as Castelli and Janis, especially if his director identified coming trends before others did. When he approached Ivan Karp, the man couldn't say no fast enough; he had learned from his experience selling him art at Martha Jackson's and Castelli's just how tightfisted Scull was with money. He wanted no part of his business proposal.[3] Ivan suggested that he meet his friend Dick, who was hoping to open his own gallery. Perhaps Scull remembered Dick as the guy who, months before, had sold him an Alfred Leslie.

In the context of the history of postwar American art, the coming together of Bob Scull and Dick Bellamy seems in retrospect

almost preordained. Ivan played matchmaker on January 5, 1960,[4] at the opening of John Chamberlain's show in the ancillary area upstairs at Jackson's. Ethel Scull would have been by her husband's side. Unlike her husband, she would never warm up to Dick. As far as Ethel was concerned, he was an uncouth beatnik, an alien species. But Scull recognized a vedette when he saw one. At first Dick horrified him, the collector later told *The New Yorker*, a reaction that softened to bafflement and then admiration.[5] He'd never encountered anyone as indifferent to his own financial straits as Dick, a man "whose only apparent ambition was to see the artists he approved of recognized and fed."[6] The men arranged a series of meantime talks that seesawed between their worlds—a dim sum breakfast in Chinatown[7] and a luncheon at MoMA's penthouse restaurant.[8] Dick won him over, and Scull swallowed his reservations about Dick's ability to converse with potential clients.

Scull agreed to support a gallery if Dick in turn would keep his financial role a secret. "Barring immitigable adverse circumstances, it seems likely I have backing to open a gallery in October,"[9] Dick wrote to his friend Beauchamp that April. "Plans have advanced rapidly, though nothing is on paper, and in the mind it is intensive but hazy yet towards the edges, there are open & tentative areas: so far I have had no important disagreement with the backer (secret; you don't know him), but as we further & further advance towards the brass tax, there will have to be some close calling; some of it perhaps uncomfortable." The letter is full of Bellamyian wordplay: "close call" becomes a verb as he advances toward the "brass tax," a double pun on "brass ring" and "brass tacks." Yet Dick seemed clear-eyed about the discomfort inherent in the alliance. By supporting Dick's dream, Bob Scull put his money on an eccentric and untested director. It was a gamble that returned his investment beyond his imagining.

Bob Scull was forty-three years old in 1960, the year he linked his future with Dick's. A handsome, solidly built man, he carried his head slightly forward, as if to give his intense eyes a head start. Born Ruby Sokolnikof on the Lower East Side,[10] his father, Meyer Sokolnikof, a Seventh Avenue *garmento*, clipped their surname to Skulnik,[11] and later the collector snipped it shorter still. Meyer had no time—or taste—for culture. It was Meyer's father, an amiable

schnorrer (freeloader, in Yiddish), who took his young grandson to the Metropolitan Museum and introduced him to the world of art. The industrious boy returned to earn pennies on its doorstep, chalking pictures on the pavement, images copied from pages he'd ripped from books in the public library.[12] In his teen years, Scull and his grandfather went to the opera, their tickets paid for by the proceeds of the enterprising young sharpie's earnings as a pool hustler. He'd quit this lucrative practice when two men he had taken for a considerable sum retaliated by breaking both of his arms.[13] He variously supported himself by selling shoes, repairing stoves, and modeling mail-order uniforms.[14]

Like Dick, Scull was largely self-educated. He attended City College for a time, studied applied art with the renowned Raymond Loewy at Pratt Institute,[15] and took drawing and anatomy courses at the Art Students League. By 1943, when he met the twenty-year-old Ethel Redner—an elegantly dressed Parsons School of Design advertising student and the daughter of a taxi fleet owner—Scull was designing clocks and laying out department store ads[16] as part of a faltering two-man industrial design company. He would later hint to his children that war industry contracts excused him from military service.[17] Ethel reported that Bob's color-blindness kept him out of the war.[18] Older and more mature than the college boys she'd been dating, the twenty-eight-year-old designer was passionate about Mozart[19] and dreamed of one day leading a cultivated life as a patron of the arts. He was "the handsomest boy you ever saw," Ethel said. "Just like a movie star!"[20] Nonetheless, her mother was appalled that Ethel, a self-described "Jewish American princess,"[21] had chosen a man with no apparent prospects. But Ethel must have sensed his driving ambition and been charmed by his vision of an art-filled future. They married in January 1944. The newlyweds lived a few blocks from MoMA, in a tiny apartment at the Parc Vendome.[22] For the price of a twelve-dollar membership to the museum, they saw every show and used its restaurant to entertain friends.[23]

When Scull's design firm went out of business, he went to work for his father-in-law, Benny Redner, "gassing the cars and working for the dispatcher."[24] Over time, Benny gave his daughter and his son-in-law a portion of his fleet.[25] It was a leg up that Scull never

Robert and Ethel Scull at an auction, 1965 (Photograph by Fred W. McDarrah / Premium Archive / Getty Images)

talked about—he later explained to a writer from *Vogue* that his work as an industrial designer of garages "led" into the taxi business.[26] He parlayed his and Ethel's shares of Benny's company into a lucrative business with 130 cabs and 400 drivers,[27] and he asked his wife never to mention how he'd gotten his start. "I felt it would make Robert feel more secure if I let him have his illusion about owning everything and having power," Ethel reflected years later.[28] Scull was a man with "an almost infallible instinct for making money and keeping it,"[29] his contemporaries observed with admiration in his heyday. His high-voltage chutzpah was no handicap. He once bragged to an artist that he used a nonexistent piece of property on Long Island as collateral for a bank loan.[30]

It wasn't until 1955 that the Sculls had the means to own anything beyond reproduction Picasso prints. After Bob's early stumble with a fake Utrillo,[31] they acquired several Renaissance bronzes and then moved on to the art of their own time. Scull's

growing collection was heavy on abstract expressionists and the younger Johns and Rauschenberg, then at the start of their careers. Scull had a sharp eye for newcomers, but sometimes he could be his own worst enemy. At the painter Ralph Humphrey's February 1959 debut show at Tibor de Nagy, he zeroed in on a small monochrome abstraction listed at $125.[32] He told the director, Johnny Myers, that it was more than he could pay and asked if the artist would reconsider the price. Scull returned a few days later and summarily offered twenty-five dollars for the painting. Perhaps he imagined the lowball figure would jump-start a bargaining process, but it outraged Myers, who asked him to leave and not return.

Scull believed that every man has his price[33]—"it never hurts to ask" was a personal adage. "Scull's negotiations were painful,"[34] Ivan Karp said. "He would work us over on price." Castelli put up with Scull as a client who "didn't have much money"[35] in comparison with some other collectors: "He was paying slowly, and he wanted to have them at very low prices." It was no secret that Castelli rebuffed his attempt to own everything in Jasper Johns's first show. Less well known is the time Scull tried to buy all the Black Paintings in Frank Stella's landmark debut.[36] But the artist nixed the idea, and in the end, Scull bought none of them.

Scull never divulged that he was color-blind. It's a testament to his intuitive understanding, and to his feeling for the art he was drawn to, that he assembled a magnificent collection and relied on Ethel's help as needed. When Jonathan Scull was a young teenager, he once accompanied his father to the Department of Motor Vehicles, where Bob needed to have his eyes tested for his driver's license. Jonathan recalled seeing him "walk up to the station where they ask you to tell them what number you see in the scope. Bob pulled out a fifty-dollar bill and said to the clerk, 'What color do YOU see?'"[37]

Scull's crudity turned off people like Johnny Bernard Myers, but others enjoyed his boisterous energy,[38] Alfred Leslie among them. When the artist became embroiled in a custody battle, it was Scull who paid for a streetwise attorney who carried an unlit cigar and spat on the floor. In a thick New York accent he advised Leslie not to dress up for the hearing and to carry big art books into the courtroom.

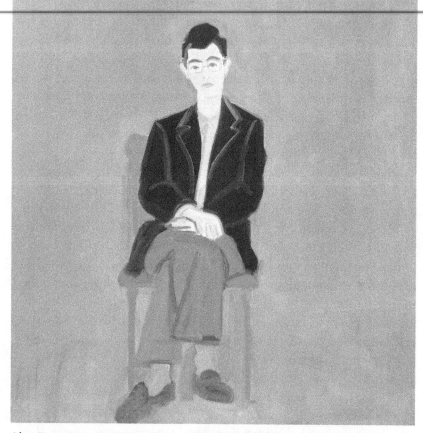

Alex Katz, *Richard Bellamy* (1960), oil on linen, 40 × 35⅞ in. (101.6 × 91.1 cm).
Collection of the Whitney Museum of American Art, New York; gift of Seymour
Levine 61.36 (Digital image © Whitney Museum of American Art, N.Y. © Alex Katz / Licensed by
VAGA, New York, N.Y.)

"Look," the lawyer counseled, "judges are people. She's Italian. She likes art." Leslie did as suggested and won his case.[39]

In the spring of 1960, when Dick and Scull were still negotiating, Alex Katz asked Dick to sit for his portrait. (Katz was not a candidate for their venture; he was already showing at the Stable Gallery.) "Dick was a very interesting guy to talk to," Katz recalled, "so I asked him to pose."[40] His near-monochromatic portrait, today in the Whitney Museum, is a picture of a man both open and closed. Dick sits on a chair set slightly off center in a field of flat, brushy beige. It could have been anywhere. He must have walked into the studio with the book he holds on his lap. He faces us head-on, yet protectively crosses his hands and legs. There's a melancholic downturn to his mouth, a shape echoed by his eyelids and the dark lintel of his brows.

The roster Dick compiled for his gallery's first year slowly fell into place. That Mark di Suvero would be his opener was a given. He cherry-picked several artists from the Reuben, former Hansa members all: George Segal, Jean Follett, Lucas Samaras, and Robert Whitman. Dick approached the figurative expressionist Lester Johnson, but Virginia Zabriskie had already claimed him.[41] Many of his top choices, such as Chamberlain and Leslie, "one of the best artists around,"[42] were committed to other dealers.[43] He wanted Stephen Pace and John Grillo, two former Hofmann students who were abstract expressionists, as was Milton Resnick, Pat Passlof's husband, but they likewise were unavailable.[44]

Dick invited Beauchamp by mail. A figurative expressionist who painted hybrid creatures performing provocative rites, Beauchamp was in Italy on a Fulbright. "The nearest thing we're thinking about now is the exhibitions for the first season," Dick wrote him six months before his gallery opened.[45] "I'm also thinking into the second. Of course you are deeply considered; so the only thing I can say now, that I want to say is, keep this in mind; this is so, that if there are any creepy dealers after you over there this summer, put them off if you can & wait, until we get together this September."

The bond between Bob Scull and Dick puzzled nearly everyone

who knew them. They were bound together in "a close but bizarre relationship,"[46] remembered Alanna Heiss, the founding director of the alternative art space PS 1, who met them both in the seventies. It was "based on how much Scull could torture Bellamy by criticizing him, and how much Bellamy could torture Scull by being inefficient or failing him in certain conventional ways"—almost a textbook description of passive-aggressive behavior. Their interactions were "like a dance," Samaras said.[47] The two were both genuinely interested in helping artists but came about it from opposite directions. Each filled an emptiness in the other. Dick "pushed all the right buttons"[48] on Scull, his son Jonathan reflected. "He represented all that my mother Ethel hated and that Bob loved. In many ways, Dick made my father gleeful; it was as if Dick were his

Milet Andrejevic, *Time Reveals the Truth—Portrait of Robert C. Scull* (1971–72), egg tempera, 40 × 50 in. (101.6 × 127 cm) (Collection of Stephanie Scull)

sybaritic twin." They were both "rogues with a mischievous sense of humor,"[49] said Jim Rosenquist. When they were younger, each aspired to be an artist. As grown men, in large part they lived through the lives of the artists they represented or collected, loving their art and their company with equal measure. Artists were at the center of Dick's life. Scull narrowed the distance between him and the artists he admired by buying their work. "Anybody that owns four or five paintings of an artist," Scull believed, "is already part of that artist's life. You keep thinking about the progress of the artist. What is he doing now? . . . Ownership is involvement."[50]

Dick was completely indifferent to social mores, Scull outwardly more conventional. Yet the two shared an attraction toward the unacceptable.[51] The collector presented himself to the world as an "exuberant gambler/hustler who flaunted a kind of vulgar faux-gangster persona,"[52] said the artist Robert Morris; Dick was timorous and quiet. Their unlikely friendship would survive their tortured alliance in the gallery business. Dick would deliver the eulogy at Scull's funeral.[53] "This is for the ages, so I can be honest,"[54] Henry Geldzahler told an interviewer who asked about Scull during the collector's lifetime. "A lot of nonsense is spoken about [Scull] and he's not perhaps the finest and least vulgar man in the world, but . . . he's got terrifically good taste within the artists that he likes. He always buys their best pictures. He's ready the way Dick is to change his mind as something new comes up . . . He understood abstract expressionism and he understood pop art; he was the first collector to understand the earthworks . . . It's really stunning." Dick, who savored the nuances of language, may have enjoyed the irony that Bob Scull was the invisible support behind his eyes.

"OUR GREENEST DAYS"

During the summer of 1960, Dick and his backer scouted commercial real estate in midtown Manhattan. He was looking to spend about $800[1] a month rent for a space big enough to show Mark di Suvero's sculpture. But Scull, a shrewd businessman, understood the prestige of an address on Fifty-Seventh Street, and he steered Dick to a $1,500 top-floor suite at Fifteen West Fifty-Seventh, a brownstone built a decade after the Civil War in what was then a bucolic neighborhood. By the turn of the century the residence had been repurposed for commerce and light manufacturing, its classically inspired ornamentation and stately cornice a vestige of an earlier age.[2] As the twenties roared in, the neighborhood became a fashionable shopping district interspersed with art galleries. Seventy garment workers and milliners toiled in the fourth-floor space Dick's gallery would occupy.[3] There, furriers employed by the firm of Stein & Blaine spent three years constructing an imperial sable coat with a price tag of $60,000, "the most expensive garment ever stitched together for a private purchaser," *The New York Times* reported.[4]

By the mid-forties, Fifty-Seventh Street represented "the heart, brain, and nervous system of the art business of America."[5] Dick's building was just west of Fifth Avenue, the vital artery that separates the east and west sides of Manhattan. Unlike today, when buses and cars travel only south on Fifth, traffic then streamed in both direc-

tions. The tony department store Bergdorf Goodman commanded the northwest corner of Fifty-Seventh and Fifth, where the Cornelius Vanderbilt mansion once stood. Tiffany's was a few steps farther downtown. After breakfasting there in 1961, had Audrey Hepburn not ambled east but crossed Fifth and headed west, she would have walked right past number 15.

"Come up with a name," Bob Scull charged Dick[6] before he signed the lease. By all accounts, the Richard Bellamy Gallery was never in the running—Scull likely would not have sanctioned it, nor would Dick have been comfortable branding his operation with his own name. Dick turned to Ivan, and the two inveterate wordsmiths brainstormed together for "a very blunt, campy name."[7] One promising idea was the Finger Lakes Gallery, but it was discarded as too suggestive,[8] Ivan remembered, perhaps because it might be shortened to "the Finger." Acme Gallery[9] was another, as was Five Star Gallery,[10] an allusion to top-tier hotels that in retrospect presaged pop art imagery.

Their list of potential names swelled to fifty. Seeking a sounding board, they dropped in on Barbara Rose and her roommate, Terry Brook, who still lived in the brownstone that once housed the Hansa Gallery. The former art history major and the poet listened as Dick, the former radio announcer, read their ideas aloud. "What about Jolly Roger Gallery?" Dick asked,[11] alluding to the pirate flag with skull and crossbones. The young women were unconvinced. O.K. Harris Gallery was the one Dick and Ivan liked best; it was the latter's handiwork. They imagined a Mr. O.K. Harris, a swinging businessman, perhaps involved with "wise-guy activity."[12] As an appellation for a gallery, the two men found O.K. Harris emblematic and American-sounding, "easy to remember and dead center of the vernacular."[13] At a social gathering at Scull's Long Island home, they presented the collector with their top choices.[14]

To their disappointment, Scull rejected O.K. Harris and also turned down their second favorite, the Oil & Steel Gallery, a name Dick coined.[15] (Ivan never stopped pining for O.K. Harris. After a decade in Leo Castelli's employ, he would leave in 1969 to found his

own gallery of that name in SoHo.[16] And decades after he first con-
trived Oil & Steel, Dick would use it for his pioneering gallery in
Tribeca, the "triangle below Canal Street" in lower Manhattan that
was not yet a gallery district when he opened there in 1980.)

"Call it the Green Gallery,"[17] Dick finally suggested. "Green" is
such a quiet word, a single sound sheltering multiple connotations.
He responded variously over the years when asked "Why green?"
Claes Oldenburg was given to understand that green stood for "the
color of money"[18] and would somehow induce people to buy art.
Likely that explanation was a facetious retrofit on Dick's part, one
that appealed to Oldenburg's sense of humor. It also surreptitiously
poked fun at Sidney Janis, who wanted his gallery decor to evoke
domestic refinement—he painted his walls gray because he thought
it would encourage sales. Dick explained to others that green, the
most difficult color in the spectrum to use in a painting,[19] was a
covert signal of a challenge.

It would've been just like Dick to choose a word with private
poetic connotations. He once titled a Jan Müller painting with a
favored line from T. S. Eliot, "Where the grey light meets the green
air."[20] Perhaps he thought about Federico García Lorca's "Green,
how I love you green" or Dylan Thomas's celebration of "The force
that through the green fuse drives the flower / Drives my green age."
This seems closest to the implication of newness and growth, likely
Dick's primary motivation for choosing the color, with or without
a specific poetic line in mind. In May 1961 Allan Kaprow referenced
green in an article about Happenings for *Art News*. He described a
new, "explosive atmosphere"[21] in the vanguard arts that had all but
disappeared in the preceding decade, when "one by one our major
figures have dropped by the wayside, laden with glory." The present
moment, he wrote, constituted "our greenest days. Some of us will
become famous, and we will have proven once again that the only
success occurred when there was a lack of it."

Not long after Dick and Alfred Leslie stood in the March chill
watching the histrionic finale of Jean Tinguely's *Homage to New
York*, Dick received a call from a distraught Pat Passlof—Mark di

Suvero had been in an accident.[22] Mark worked for a Tenth Street furniture maker and earlier in the day had made a delivery to a building uptown.[23] When the cabinet proved too big to fit inside the elevator, it was hoisted on top, and Mark scrambled up to hold it steady. But instead of making the expected slow ascent, the maladroit operator shot the cab up through the shaft, smashing the load against Mark's body and propelling him through two doorways. He came to rest beneath one ton of weight. The sculptor was pinned down, fully conscious, for forty-five minutes before his rescue.[24] His multiple fractures included three cracked vertebrae. When news of the calamity reached Victor di Suvero on the West Coast, he exclaimed, "I'll jump right on a plane." "Don't bother," the doctor told him. "Your brother won't last the night."[25]

A man of indomitable resolve, Mark foiled the dire predictions. Although he eventually regained the ability to walk with the aid of braces and canes, locomotion would never again be an unconscious action. He couldn't wait to resume making art. "Mark knew if he could get the work going, the body would follow," Victor recalled. Mark took up stone carving while confined to his bed, but the flying chips burrowed in his bedding.[26] He lived for a year at the Rusk Institute of Rehabilitation Medicine, where the staff allowed him to operate a hand welder from his wheelchair and even supplied an asbestos apron for his lap. He submitted an entry to a sculpture competition of the upcoming Seattle World's Fair[27] when Dick alerted him about it. His proposal for the centerpiece fountain did not win, but the process of designing it eased Mark back into his life as an artist.[28] Art was therapeutic, "an expression of life-energy,"[29] he said later. After leaving Rusk, he founded an art program at the Bird S. Coler Hospital[30] on what was then called Welfare Island. Art restored his spirit, and he wanted to share the experience with people at Coler like Lenny Contino, who learned to paint with a brush in his mouth and found his life's work as an artist.

On the evening of October 18, 1960, about seven months after his close brush with death, Mark's friends picked him up at the Rusk Institute and drove him to midtown to attend his opening at the Green. It's not hard to picture Dick greeting friends that night, not quite believing that his dream had been realized. With Ethel at

his side, Bob Scull likely stood at a remove, buoyed with expectations of commercial success yet trying not to act the proud papa. Ethel would have had no trouble stifling excitement.

The Green's rickety elevator was just about big enough to convey three people from the lobby to the gallery on the top floor. If it happened to stop at the beauty parlor on the third floor on its way up, the acrid smell of permanent wave treatments wafted in.[31] The elevator opened directly into the gallery, with its venerable oak floor that creaked when trod on.[32] Unlike Madison Avenue, where gallery windows faced east or west, the Green's faced south, flooding the front room with light. The interior of the north-facing Castelli Gallery, on Seventy-Seventh Street, was darker than the Green and lit by a spotlight track. Mark's was the first and last show at the Green illuminated with light from three windows. After that, Dick walled over the middle one to gain more hanging space for art.

It seemed a miracle that Mark had any show at all. During the previous week Pat Passlof and her gang had transported the sculptures from his studio on Front Street to the Green, where they set them up according to Mark's diagrams. For Dick, the work was even more impressive uptown than it had been when he first saw it in the sculptor's low-ceilinged studio.[33] There was room for three monumental sculptures in the larger of the Green's two rooms.[34] In the weeks leading up to the opening, Mark worked with his brother Henry to complete *Hankchampion*, an eight-foot sculpture left unfinished at the time of his accident. He had a stockpile of timber from nearby demolition sites, hauled up the stairs on his shoulders in earlier days piece by splintery piece.[35] *Hankchampion*'s title inventively saluted his brother and the manufacturer of the heavy chain that anchored its two cantilevered wooden slabs. The smaller-scale *Che Farò Senza Euridice* (1959–60), named for Gluck's famous aria of loss "What will I do without Euridice?," fit into the smaller gallery, just off the elevator. There were drawings there as well, and wax models of hands that were meant to be in bronze.[36]

Mark's sculpture had a major impact on the artists who came to see it. It inspired Richard Artschwager, a sculptor who, after ten years of "trying to get my shit together,"[37] was inspired by what he

Green Gallery, di Suvero debut, October 18–November 6, 1960. *Hankchampion* (1959–60) and *Barrel* (1959). Allan Kaprow (with pipe) in distance (Photograph by Rudy Burckhardt, © 2015 The Estate of Rudy Burckhardt / Artists Rights Society [ARS], New York)

saw at the Green. "There are sets of possibilities undreamed of . . . I realized—you can do anything." For Artschwager, the implicit message of Mark's sculpture was "Work with what's around." This meant the Formica laminate from his cabinetmaking business— "the great ugly material, the horror of the age," in his irreverent description.[38] An aural trope for Mark's tradition-shattering sculpture was Ornette Coleman's music, with its exhilarating radical departures from the traditions of jazz. Just as Mark's show opened possibilities for artists, musicians took permission from Coleman to explore the territory he pioneered. "Not only was Ornette's music beautiful and meaningful," said his contemporary Marion Brown, another altoist, "it made me realize what could be done,"[39] a phrase that echoes Artschwager's epiphany.[40]

The young Carl Andre was another artist provoked by the Green's inaugural exhibition. The previous year, he'd experimented with stacked pyramids of dressed lumber. "Frank [Stella] insisted on

taking me up to the Green Gallery to see the Mark di Suvero show,"[41] Andre recalled. "And that really did it. That was a fantastic show . . . because for me it broke open the scale problem . . . I was still pretty much locked into the monolith . . . and the Mark di Suvero pieces were sprawling." Most of Mark's angular abstractions did not sit on pedestals, but rested directly on the floor,[42] as did Andre's earliest stacked wood pieces. By the end of the decade he would achieve international fame as a sculptor whose flat, modular grids lay directly underfoot.

Mark's show impressed critics as well. In the December *Arts Magazine*, the sculptor and writer Sidney Geist seemed barely able to contain his enthusiasm after seeing the Green's opening show: "It was bound to happen, sooner or later, the appearance of some sculpture that was not merely tremendous or interesting or even terrific, but that deserved another adjective, like great: that stepped beyond our immediate experience into history."[43] Geist had not been so moved, he confessed, "since the Brancusi exhibition of 1933." To be linked with Brancusi, one of the founding fathers of modern sculpture, was a staggering tribute for a twenty-seven-year-old artist. But Geist hadn't finished. "From now on *nothing will be the same*," the normally un-hyperbolic reviewer declared, using italics for emphasis. "Here was a body of work, so ambitious and intelligent, so raw and clean, so noble and accessible, that it must permanently alter our standards of artistic effort." Reading this in his hospital bed at the Rusk Institute, Mark found Geist's pronouncement "very hard to live with."[44] It was painful to receive "that amount of compliments for works in a medium that I could not go into again."

During the early months when Mark was in traction, Pat Passlof organized a team of his friends to be at his bedside.[45] Mark expressed his appreciation by inviting her to share the limelight at the Green, directing Dick to hang a large black-and-yellow expressionist painting of hers on the east wall.[46] In a photograph taken on the night of his opening, Mark pitches slightly forward in his wheelchair, steadying himself on the armrests. A support corset girds his waist; metal frets and leather straps brace his legs. A watchful Pat stands nearby as well-wishers cluster around Mark, his face taut with pain. On the same evening, Dick's colleague Howard Wise

opened a show by the painter George McNeil across the street. Mark admired McNeil, an underrecognized fifty-two-year-old abstract expressionist, and was determined to see his show. His buddies helped get him and his wheelchair across Fifty-Seventh Street to the Wise Gallery, but when they brought Mark back to the Green's building, they discovered that the brownstone's antiquated elevator had stopped working, and he couldn't get back to his own opening.[47] So they drove him back to the hospital.

A succès d'estime, Mark's show was a financial flop. In the end, the only sales were to Scull, who bought three of the hands, two for $125 each and one at $200,[48] in addition to the drawings.[49] The architect Philip Johnson was taken with Mark's work and brought fellow collector Emily Tremaine to the Green.[50] *Hankchampion* interested her, but she felt that the eight-foot sculpture was too big for her Park Avenue apartment. Dick trucked it to her home in Connecticut, where she installed it in the middle of a field. Yet it didn't look right there either—the great outdoors provided no sense of scale. She decided against buying it, and *Hankchampion* returned to Dick.

At the end of his show, Mark had to decide what to do with the unsold sculpture. It was not practical to move it all back to Front Street, so he had his friends destroy *Barrel*, lauded weeks before as a "complex and explosive cat's cradle."[51] It wasn't the only early piece by the sculptor to be destroyed. The same fate awaited *For Sabatere* (1960), which honored the Spaniard Francisco Sabater, an anti-Franco guerrilla assassinated in January 1960.[52] The largest of Mark's early pieces, *For Sabatere* was more intricate and sophisticated than *Hankchampion*.[53] Dick showed it toward the end of the Green's first year, pairing the sculpture with Ronald Bladen's folded-paper collages and rough-textured plywood reliefs.[54] Thinking back decades later, Dick described *For Sabatere* as a lost masterpiece.[55]

"Destroying those pieces seemed to me just as natural as keeping them," Mark later reflected. "They were huge efforts to move from one place to another."[56] He needed to advance to the next phase of his art. "For wood work you really need a full body," Mark said pragmatically. "When you work in steel, the tools, cranes, and welders don't require as much brute physical work."[57] As soon as

Mark was able to return to his three-story warehouse——a space with "no hot water, no toilet on the same floor, and no heat except for one unvented gas radiator,"[58] his friends did the necessary but illegal wiring to support his welding tools.

Ladderpiece (1961–62), a transitional sculpture that was half wood, half steel, took almost a year to build. Fifty years later, di Suvero couldn't bear to look at it: "I just feel the pain. The wheelchair. The desperation."[59] Dick presented it at the Green as the centerpiece for a February 1963 benefit exhibition that introduced the paintings of Mark's protégé Lenny Contino and fourteen other students of his at the Coler Hospital.[60] Today in MoMA's collection, *Ladderpiece* was not sold until June 1965, when Philip Johnson stepped in and bought it in a well-intended but futile effort to save the gallery from closing.[61]

Scavenged wood was free for the taking, but metal was not. When Mark, unemployed, switched to steel, he struggled to pay for it. Dick pressed Scull to aid the sculptor, who was in great need. About a year after Mark's debut Scull acquired five more of his artworks for the bargain price of $1,000.[62] The deal included *Hankchampion* and *Che Farò Senza Eurydice*, as well as a commission for a piece in stainless steel. Scull couldn't rationalize paying outright for art that didn't yet exist, and instead he agreed to cover Mark's hardware store bills.[63]

Prison Dream (1961), the piece he made for Scull, is Mark's earliest sculpture in steel. Metal was more malleable than wood and offered new expressive possibilities. During the months that Mark was immobilized in the hospital, a friend brought him a copy of *Imaginary Prisons*,[64] the print series of fantastical subterranean structures by Piranesi, an eighteenth-century Venetian. Mark, whose family came from Venice, loved Piranesi's gigantic murky spaces. The resonantly titled *Prison Dream*, an analog of the artist's mental and physical state in 1961, departs from the macho postures of the earlier wood constructions. Its disrupted, attenuated lines convey the body language of a colt, tentative and full of moxie. Dick would include *Prison Dream* in the group show that opened the Green's second year, placing it across the room from Charles Ginnever's

dramatic *Calligraphic Sculpture* (1958), composed of massive railroad ties that rested on the oak floor.

Ginnever supported himself trucking artwork. When the show closed, Dick had him take *Prison Dream* out to East Hampton, where the Sculls had a vacation home on Georgica Road. But Bob Scull hated the sculpture when he saw it, and he refused delivery.[65] Ginnever brought it back to Front Street and unloaded it in Mark's lower hallway. The painter Neil Williams, who worked in the building, discovered that *Prison Dream* was missing a few hours later. Williams was one of "a delicious group of people,"[66] as the poet Robert Creeley remembered, a gang of close friends that included Mark, Dick, and Chamberlain. Williams and Chamberlain matched each other's handlebars and capacity for drink. A Green Gallery artist little known today, Williams was an innovative but insecure painter of elegant geometric abstractions that moved beyond the rectangular shape of the standard canvas. Like Dick, he was biracial, raised in a part–Native American, part-Anglo family on a Utah trading post. The day of *Prison Dream*'s disappearance, Williams learned that the fish vendor next door had done the sculptor "a favor" by getting rid of what he took to be a heap of scrap metal and had sold it to a junk dealer for ten dollars. Williams and Ginnever rushed to the junkyard to reclaim it. "I didn't mess it up like that," said the junk man nervously when they found the sculpture; "it was that way when I got it."[67]

As part of Scull's original bargain with Mark, he promised to donate one of his works to a museum of the sculptor's choice.[68] Scull had MoMA in mind, and he lent *Hankchampion* to their internationally traveling sculpture show in 1965–66.[69] Mark never forgot that Scull had rejected *Prison Dream*, and as partial payback, he didn't name MoMA when, in 1973, Scull was ready to part with *Hankchampion*. Instead Mark designated the Whitney Museum of American Art, a venue the collector regarded as less prestigious.[70] Today the sculpture is one of the gems in the Whitney's collection; the collector Patrick Lannan Sr. would buy *Prison Dream* in time, donating it to the Museum of Contemporary Art in Los Angeles.

•

Dick must have been elated by di Suvero's rave reviews, which confirmed his belief in the sculptor's importance. It's significant that the Green opened with a show of sculpture—art that occupies real space. "Sculpture is something you bump into when you back up to look at a painting," the painter Ad Reinhardt famously jested at about the time of di Suvero's show. Reinhardt believed in the preeminence of painting relative to sculpture, but Dick did not. Dick was particularly sensitive to three-dimensional works of art, and it is not by chance that the man who first saw the work of Brancusi, Calder, Lipchitz, and Moore while still a teenager, and in his early twenties fell in love with David Smith, would go on to launch the careers of so many major sculptors.

After the Hansa closed, George Segal gravitated to the Reuben Gallery, where he'd been on track for a solo show of his painting and sculpture. "One day out of the blue," he remembered, Dick "sidled up to me and said, 'Hold up showing; I'm going to open a gallery and I want you to show.' And I said okay."[71] Segal's Green Gallery exhibition immediately followed di Suvero's. In addition to his expressive figure paintings, the artist included some of his earliest sculpture—clunky life-size bodies fashioned from two-by-fours, chicken wire, and plaster-dipped burlap scraps. It was not well received. " 'Method acting' has come to painting in the work of George Segal," the *Arts Magazine* critic Sidney Tillim wrote sarcastically of the expressionist canvases, put off by the "slovenliness" of Segal's faceless women.[72] Segal's work didn't appeal to Bob Scull either. He asked Dick "to fire me," Segal recollected. "It was Dick who spoke up and said 'Give him another year.' "[73] So here was the "close calling; some of it perhaps uncomfortable" that Dick foresaw during the gallery's chrysalis stage. Decades later, the sculptor's wife, Helen Segal, described Scull's intervention with wry humor: "Scull was the silent partner; unfortunately, he wasn't silent enough."[74]

Segal was an artist in transition in the fall of 1960 when he first showed at the Green. Soon, two aha moments would help him find a signature style and international acclaim. The first lightbulb went on during the filming of *Sin of Jesus*, a lesser-known work by

Dick and George Segal during filming of Robert Frank's *Sin of Jesus*, 1961 (Photograph by John Cohen, courtesy of L. Parker Stephenson)

Robert Frank. Just as Allan Kaprow had turned to Segal for a place to stage his first outdoor Happening, Frank asked Segal early in 1961 to use his farm for his film's rural location.[75] By then widely respected as a photographer, Frank was in the process of making his mark in independent film, building on his early experience with the antic *Provincetown* and his fraught collaboration with Alfred Leslie on *Pull My Daisy*. The former friends originally envisioned *Daisy* as the first of a trio of short films they would do together.[76] For *Sin of Jesus*, Leslie wrote a screenplay based on the Isaac Babel short story "The Sin of Jesus" he'd read in 1949 in the *Partisan Review*.[77] But when their partnership dissolved,[78] Frank went ahead with *Sin of Jesus* on his own, transposing Babel's Russian setting to wintry New Jersey, with a frozen landscape.

The "sin" in the title of Babel's fable referred to Jesus's lapse of compassion for an unmarried, pregnant chambermaid, more sinned against than sinning. Initially he answered her prayers and wed her to a guardian angel. But when she accidentally killed her protector, Jesus returned her to a life of abuse. Roberts Blossom

played Jesus;[79] Julie Bovasso was Babel's hotel maid, transformed by Frank into a babushka-wearing egg farmer; and the young Telly Savalas played the violent brute who fathered her child. Dick and Red Grooms, assigned to the angelic choir along with other of their friends, were costumed in white robes and large, fluffy wings. Dick was a literal standout—his prominent eyeglasses made him easily recognizable, a distinction that may have amused people who knew him.

But there was nothing funny about *Sin of Jesus*, a film about the unrelenting "pessimism . . . desolation, doom, or despair [which is] the inner landscape of modern man, a place that is cold, cruel, heartless, stupid, lonely, desolate,"[80] in the filmmaker Jonas Mekas's description. Morton Feldman's haunting, dissonant score for flute, horn, trumpet, and cello set its emotional tone. "That's the worst movie I've ever seen," the French New Wave filmmaker and critic François Truffaut blurted out when the *Village Voice* interviewed him in Paris after a screening of the film in 1961.[81] The relative merits of *Sin of Jesus* notwithstanding, the production played a catalytic role in the evolution of George Segal's art.

At Frank's request, Segal cobbled together a domestic tableau for one of the sets. Rummaging for materials in his father's barn, he came across a trove of forlorn Depression-era furniture.[82] Their "sturdy forthrightness and lack of decoration"[83] impressed him, and he found himself appraising these evocative furnishings with fresh eyes. They were the country equivalent of the detritus his friends were harvesting from city streets. Richard Stankiewicz, for one, held that materials become interesting only when they have been used and then discarded.[84] Segal stood near Frank during the filming, watching his friend compose scenes with a viewfinder to assess the spatial relationships between actors and props. "Ah ha!" he said to himself. "I can use this old furniture with my figures! And then everything clicked together."[85] Rather than set his sculpted figures *in front of* paintings, as he had done earlier, he suddenly understood that he could place them *within* a specific three-dimensional context and compose the air around them.[86]

In the summer of 1961 Segal had the second flash of insight that made all the difference to his future practice. He was teaching an

adult education class in New Brunswick, not far from the New Jersey headquarters of Johnson and Johnson, the health-care company. One of his students, the wife of a J&J chemist who had developed a quick-setting plaster bandage for casting broken bones, brought him a generous sample of this new product and arranged for Segal to write a booklet on its use as an art material.[87] "I got the idea I could cover a living body with this material, let it set for a few minutes, pop it off, and I'd have a perfect record of a human being," he remembered.

Segal had no experience in making plaster casts. It was with a certain naïveté that he launched into the task, using himself as the model. One sweltering day, the shirtless artist positioned himself in a chair with breathing straws in his nose. He instructed his wife, Helen, to soften the bandage strips in water and then swaddle him, mummy-style, from head to foot. He was unaware that bare skin needs a protective coating before being covered by a cast. As the once malleable strips hardened into a carapace, they adhered to his hairy chest and arms. The unintended wax job aside, the fragments entranced Segal when they were finally ripped off. When he crudely pasted them together, he saw that they mimicked the shape of a middle-aged man with an uncanny, Egyptian-like presence and "flashes and glimmers of fingers and a mouth coming out."[88] Segal believed he had finally stumbled on a way to convey "the gift of a mental life."[89] *Man Seated at a Table*,[90] today in Germany's Städtisches Museum Abteiberg Mönchengladbach, is the vignette Segal created when he combined his cast with real furnishings. Its chair, table, and window frame were not props but sculptural presences, powerful in their own right. "I looked at the chair legs, and the table legs and the [man's] plaster legs and I said, 'my god, it's Cézanne,'"[91] Segal remembered, thinking of the masterful composition of *The Card Players*, with its multiple shafts, diagonals, and horizontals.

Dick earned seventy-five dollars a week during the Green's first two years; thereafter his salary rose to ninety dollars.[92] He later recalled that he'd had to "borrow money from the gallery to clothe myself and sometimes to take a vacation."[93] When Sheindi complained that his take-home pay didn't cover their expenses, he

would sneer, only partly in jest, "They couldn't pay me what I'm worth."[94] Scull kept tight control of operations through Marie Dickson, his long-standing office manager, who came to the gallery once a month.[95] Dick was the Green's only staff in its first half year, doing everything from sweeping to typing his own letters. It's not known who designed the gallery letterhead, but likely Dick had a major say in it. An all-bold, lowercase **green gallery** is centered at its top, the *g*'s punched up in size in lieu of capital letters. Perhaps it was Dick who suggested the Cheltenham typeface, a dignified serif font with small features at the end of strokes that hinted at art nouveau sensuality. It was the font *The New York Times* used for headlines, and the one L.L. Bean, Inc., adopted for its logo in 1912.

During the Green's five-year life span, Marie Dickson was in charge of its finances—Dick never had a gallery checking account of his own. "I was not engaged to do [the financial end of it] and I didn't choose to have anything to do with it," he described years later.[96] Viewed charitably, this outsourcing spared Dick the bother, the better to let him spend time finding new artists. But in all likelihood Scull didn't trust him to oversee money matters. Besides, Marie Dickson was already on Scull's payroll, and her services required no additional outlay. But with an off-site gatekeeper for the gallery's day-to-day expenses, Dick found himself in a subservient position. He met the maddening situation with characteristic humor. In an undated letter to Dickson[97] during the gallery's first month of operation, he attempted to account for a fifty-dollar dispersal, itemizing potato chips, light switches, furniture polish, and a key. Regarding an unexplained outlay of $36.35, he blithely noted, "it seems I have embezzled most of it."

Scull committed himself to the annual purchase of $18,000 worth of art from the Green,[98] an oral contract sealed with a handshake. "If I got stuck at the end of the month," Dick remembered, "Scull would buy paintings or pay in advance for things he would eventually buy. He wanted to make it possible for the gallery to survive, but he's not an altruist. He would have wound up with fewer paintings and sculptures if other people had been buying. As it was, Scull did acquire a lot of good work, and I think many of the artists benefited."[99] All told, Scull bought from the Green twenty paintings,

twenty-eight sculptures, and twenty-four drawings.[100] The collector promised not to interfere with the gallery roster, and in turn, Dick agreed to bring him along on studio visits, "to confirm his own impressions."[101] A limit to expenditures was part of the deal, Ivan Karp remembered; Scull expected art sales to generate the rest of the revenue.[102] In reality, "Scull was starving the Green Gallery."[103] Dick was in a constant tug-of-war with Dickson to pay his artists. As part of their agreement, Dick promised not to divulge Scull's financial support or his connection with the gallery's management, a promise he kept—even the Green's artists didn't know where the operating funds came from.[104] "I wasn't a backer," Bob Scull later fabulated when questioned. "I was an official buyer, one of the two or three people that promised to buy a certain amount of work."[105] Perhaps Scull feared that if word got out that he had enough money to support a gallery, it might undermine his ability to bargain with such dealers as Castelli. Scull took pride in being the first to buy art that others soon wanted. If people knew he had a financial interest in the Green, his independence as a pacesetter might be questioned and diminish his reputation as a collector sui juris.[106] When *The New Yorker* profiled him in 1966, Scull told the writer Jane Kramer that Dick originally had three backers, two of whom did not pan out, a statement impossible to corroborate. All he had done, Scull said, was to make "long-term loans against future purchases."[107] Within Kramer's earshot, the loose-lipped Marie Dickson complained to her boss, "I like Dick, but, hell—all that money you put into the Green, I *knew* you'd never get it back."[108]

Sheindi's snug quarters on Cherry Street worked when she lived there with the children, but after Dick joined the household, she began to scout for a bigger place. It was Jackie Ferrara who told her about the apartment with twelve-foot-high ceilings, which Jackie and her then husband, Don Ferrara, rented in the mid-fifties. The Ferraras had created a spacious front room by removing doors and walls,[109] and Jackie rebuilt its long-retired fireplace, putting in a brick mantel and a platform with an inviting seating area. The prior tenant had jerry-rigged an extension that sloped down toward the

backyard, with numerous windows, none of which shut properly.[110] By the time the Green opened in the autumn of 1960, Dick and Sheindi were settled in at 237 East Broadway.

Rent was sixty-five dollars a month,[111] the kind of deal friend handed to friend. When Jackie left, she first passed it to the film-maker Hollis Frampton and Frank Stella, who let Carl Andre use it as a studio. It remained a de facto storage area for them even after Dick and Sheindi took over the lease. Several of Stella's Black Paintings remained on the walls, and Andre left behind a table saw and his earliest sculptures, tall, pyramidal stacks of wood. The first time Sheindi tried to clean around them, she discovered that the sculptures harbored a small army of cockroaches when she inadvertently deployed them. To mollify a distraught Sheindi, Dick deconstructed one of Andre's sculptures and sheltered the components in the backyard. Andre lived nearby in a small, dark apartment just big enough to house his collection of men's and women's shoes, with no room for his sculpture.[112] "Carl was a pain,"[113] Stella remembered. "He didn't take care of his work."

That their new place was poorly insulated was not an initial cause for concern. With its roomy layout and ample backyard, it became a gathering center for their downtown community of artists, poets, and musicians. Friends described it as a "salon,"[114] and "a safe house and a place of comfort."[115] Sheindi's open personality accounted for much of the bonhomie. When Dick would call from the Green in the late afternoon to announce he was bringing people home to dinner, she managed to feed everyone on their tiny budget.[116] But their close friends didn't wait for an invitation. "The door was never locked at East Broadway—there were always people sitting at the dining room table."[117]

It was "a wonderfully exotic moment,"[118] with Dick as the maestro of fun, remembered the artist Dorothea Rockburne. There were celebrations for special occasions, such as the party for Stella when he turned twenty-four,[119] or for no particular reason, when Ornette Coleman might stop in.[120] Jazz was the sound track of those years, Sheindi's son Andy said. Miles Davis, Coltrane, or Mingus records seemed to be playing all the time. In warm weather there were cookouts in the yard, when Rockburne's daughter and the other

artists' kids designed their own costumes and staged "very imaginative and original"[121] plays. Rockburne recalled that Sheindi "was very loose, in a way, in her discipline, but also very present,"[122] and she made sure that everything ran correctly. John Chamberlain might drop by to bestow impromptu haircuts, and at various times Carl Andre or Robert Smithson babysat for all the children.

A "ladies' man,"[123] was the way one East Broadway neighbor described Dick; "insatiably seductive,"[124] said a woman friend who met him twenty years later. He was "extremely pretty to look at,"[125] said their friend Jill Johnston, a fledgling dance critic. "One liked being around him." He had a velvety baritone and a memorable physical presence and style of moving, a "graceful, slouching, dancerlike way of holding his body, cocking his head at a certain angle."[126] A male friend remembered Dick as "black hair, black glasses, a kind of thin phantom, moving-thinking-moving-thinking."[127] The dancer Yvonne Rainer even wove one of Dick's signature gestures into a duet she choreographed in 1962.[128] Casual hookups were not uncommon in their circle. "Everybody was sleeping with everybody. The boundaries were ill formed."[129] Rainer ran into Dick at parties several times before she and Robert Morris were a couple. "I'd be ready to leave, and there would be Dick, right in front of me, and we'd just go off together."[130] "Lust," Dick wrote in a roundup "report" to Bob Beauchamp and Jackie Ferrara, "is a pretty tricky subject. Besides disassociating it from allied emotions, for consideration in a separate section, there are other factors that impede direct and full discourse."[131] Those factors likely included the need not to tip his hand to Sheindi via Jackie. He never lost his eye for women. Not long before he died, weakened by emphysema, Dick joked about his attraction for a waitress with a "frank, fresh spirit, open bespectacled face, not small but well-proportioned frame, one of those mid-to-late 20s girls in whom magnificence of being requires some gesture of recognition, be it inchoate or thwarted or sometimes even realized."[132]

Poverty was a condition of their lives. Nonetheless, "you could live being poor; you could do something," Robert Frank recalled.[133] Jill Johnston, a close friend of both Sheindi's and Sally's, described the contradictions all in her circle lived with: "They juggled their

finances and their time by taking taxis, ripping off chickens from the supermarket, and wearing thrift shop clothes."[134] Whenever Andre stopped by, Sheindi reminded him to retrieve his sculpture, but as the fall pressed into winter their first year there, the wood blocks stayed in the yard.

In the neighborhood around East Broadway, opportunistic crime and violence were commonplace events. Once, Thalia Poons came to visit and locked her bicycle around a nearby pole. When she returned, she was dumbfounded to find that someone had yanked the post right out of the sidewalk and taken off with her bike, lock and all.[135] One night a not entirely blameless Dick found himself on the receiving end of inner-city road rage when he boxed in the car parked in front of his. His own decrepit vehicle, its make unremembered, was one in a string of similar wrecks he would drive in the course of his lifetime. On this particular evening he drove Sheindi and Stella to a party hosted by George Preston, a young painter and poet who showed at the Phoenix Gallery, a Tenth Street co-op. Preston lived in a storefront apartment at 48 East Third Street, where he hosted readings attended by people like Norman Mailer, Paddy Chayefsky, Elizabeth Taylor, and Eddie Fisher.[136] A photo of Preston's salon is the cover image of Fred and Gloria McDarrah's book on the Beat Generation's "glory days,"[137] attesting to its importance for the "Scene," a movable party that formed itself wherever the action was that evening.

Dick, Sheindi, and Stella had just settled back into his jalopy after leaving Preston's party when the driver of the trapped car and his friends sprang at them and began to smash Dick's windows with baseball bats and paving bricks.[138] Stella pushed Sheindi's head below the dashboard to shield her as the glass shattered. By the time Dick thought to scare them off by leaning on the horn, his car was totaled. Preston long remembered Dick trooping back inside to report his loss "very un-materialistically."[139] Preston understood that "people like us were mysterious, enviable, and disquieting to the local people on the Lower East Side."

"People like us" meant Beat and multiracial. Preston was one of several African American writers and artists in Dick and Sheindi's

circle. They knew LeRoi Jones, the future Amiri Baraka, then married to the writer Hettie Jones, who was Jewish; and the figurative expressionist Emilio Cruz, who lived with Sheindi's close friend, the dancer June Ekman, just across East Broadway. The innovative abstract expressionist Ed Clark, one of the first painters to experiment with asymmetrically shaped canvases, had a day job at the Sidney Janis Gallery. When Dick needed names for the Green's first mailing list, Clark helpfully passed along a copy of his boss's list.[140]

George Preston wasn't the only artist whose digs regularly transformed into the Scene. Alfred Leslie's studio at 940 Broadway, in the Flatiron district, was tantamount to a "cultural center."[141] Sometimes the painter served food—Leslie roasted a whole lamb for the party he threw for Jean Tinguely on the night *Homage* self-destructed. He'd been helping Tinguely construct it and had kept the meat fresh for a week by surreptitiously stowing it in a late-winter snowbank in MoMA's sculpture garden.[142] Music was a given at Leslie's celebrations. He was a superb dancer, and Sheindi's favorite partner.[143] When Dick danced, she said, it was often by himself, "and funny."

Uptown, the Scene could be found in the Green's back room, "a kind of beatnik Kaffee Klatsch for the younger avant-garde,"[144] where Robert Morris usually found one or two of his fellow Green Gallery artists sitting around.[145] Getting high was part of the fun. Dick was "almost like a poster child for pot,"[146] Lucas Samaras recalled with affection. "He brought out the poetic version of pot . . . It plunged into some area of his brain and brought out an interesting verbalization of what he was seeing." By and large, Dick seldom spoke. His stoned backroom visitors would horse around and joke with one another, "though not a lot of conversation went on between Bellamy and anybody in that room," remembered Morris. "We—the artists and Bellamy himself, who we regarded as more of an artist than a 'director'—were sitting in a space on Fifty-Seventh Street when we all belonged downtown in our ratty lofts. There was something slightly ridiculous about occupying that zone where the serious, moneyed New York galleries were located."

•

In December 1960, during the month when galleries often have group shows of smaller works to encourage holiday sales, Dick put up an exhibition overflowing with Hansa old guard and friends from Tenth Street. Claes Oldenburg designed its homey poster/invitation[147] with a scribble-scrabble background that threatened to engulf Dick's whimsical hand-lettered copy. "Hip flasks permitted," it touted. There was art for every taste, including Lilly Brody's exquisite watercolor nudes on eighteenth-century paper and Oldenburg's C-E-L-I-N-E, Backwards (1959), a crude papier-mâché sculpture addressing what Barbara Rose called "the brutality of city life."[148]

As winter set in, Dick and Sheindi were having their own struggles with city life. The downside of their spacious apartment, a joy in the fall, revealed itself when temperatures dipped below freezing. Their pipes froze if they forgot to let the tap run in the tub, and wind rattled past loose-fitting windowpanes. Four-and-a-half-year-old Andy, and Laurie, seven, shivered in their beds.[149] A fire in the hearth bolstered the effete radiators. When Dick ran through his supply of old furniture and scavenged crates he used for fuel, he reluctantly eyed Andre's deconstructed sculptures huddling in the yard. The artist had not reclaimed them and seemed irked at the mention of the subject,[150] tacitly acknowledging their abandonment.[151] Block by block, they disappeared, a loss the art world still mourns. "With a good bit of hesitation, and with a certainty that there was some violation being done, . . . I would slip one or two of the blocks into the fire, very tentatively at first . . . This took place over a period of time when the cold had increased, and soon it was with *pure relish* that I overcame my scruples and built a blazing fire during the most frigid nights . . . Finally it all went into the fireplace, and we survived the winter."[152]

SEEING AND UNSEEING

The Green Gallery had been open little more than a year when the auction of Rembrandt's *Aristotle Contemplating the Bust of Homer* put a jaw-dropping price on the priceless. Thousands turned out for "one of the greatest sales of the century," as *The New York Times* pronounced.[1] Although there were several old master paintings on offer at Parke-Bernet on the evening of November 15, 1961, Rembrandt was the star attraction. Lucky ticket holders sat or stood in the main gallery, others shunted off to rooms with closed-circuit TVs. A "work of unsurpassable romantic grandeur,"[2] *Aristotle Contemplating the Bust of Homer* lured twenty thousand viewers during the three-day exhibition prior to the sale. On auction night, the audience broke into applause as gloved handlers placed the celebrity painting in center stage. Bidding began at one million dollars.[3] In little more time than it takes for a boxing round, the Rembrandt was hammered down for $2.3 million, "the highest amount ever paid for any picture at public or private sale."[4] The Metropolitan Museum of Art had just purchased the world's costliest painting.

Some auction commentators decried the association of art and money. "The spiritual benefits bestowed by art are intangible, without price if not beyond price,"[5] a *New York Times* editorial advised readers. The writer felt a "persistent feeling of discomfort, even distaste" with the price paid by the museum. John Canaday, the newspaper's outspoken senior art critic, found the Rembrandt

"disfigured by its 2.3 million-dollar price tag."[6] During the run-away art market of the 1980s the gimlet-eyed auctioneer John Marion would look back and point to the auction of Rembrandt's *Aristotle* as the moment when the boom really began.[7]

The admixture of art and money made good copy. The very combination was slightly shocking in the early sixties, when talking in public about what things cost was considered to be in poor taste. *Time* kept watch as art commerce began to gain speed in 1958. "A new force is loose in the art markets,"[8] it observed. "It is the bucca-neer investor, who does not know what he likes but knows a good investment when he sees one. The result: a boom in art sales that is unparalleled in living memory." Weeks after the Met bought its pricey Rembrandt, *Time* published "The Solid-Gold Muse," bally-hooing the "mad and marvelous market"[9] for artists both living and dead. Leo Castelli and Martha Jackson were quoted, but not Dick, in 1961 still a peripheral figure who had made few sales apart from

Green Gallery, *Jean Follett, Charles Ginnever, Claes Oldenburg, Lucas Samaras, Myron Stout, Mark di Suvero,* September 19–October 14, 1961. (Clockwise, from left) di Suvero, *Prison Dream* (1961); Oldenburg, *The Big Man* (1960); Oldenburg, *Sewing Machine* (1961); uniden-tified artwork; Ginnever, *Calligraphic Sculpture* (1958); and Samaras, *Untitled* (1961) (Pho-tograph by Rudy Burckhardt, © 2015 The Estate of Rudy Burckhardt / Artists Rights Society [ARS], New York)

Scull's contractual purchases. Six months later, when Dick found himself shoulder to shoulder with Castelli as the market mushroomed around them, no one was more surprised than he.

"New art when I can find it," read an ad Dick ran in the Green's early years.[10] And find it he did—from artists who defined the sixties for future generations. How was he able to do this? Henry Geldzahler accounted for Dick's prescience by pointing to his uncommon openness. Dick seemed "never to define his position; he [is] always ready to readjust it with what he sees."[11] Asked to explain his own success as the man whom the critic Irving Sandler called "truly the 'eye' of the sixties,"[12] Dick credited his ability to feel at one with things that were external to him. "Being unpracticed, I was registering things very clearly, with an innocent eye. I had an intensity of perception where things just got interiorized immediately."[13] His friends had their own theories. Frank Stella credited Dick's ESP about the artist and downplayed the issue of taste, once suggesting to his former wife, Barbara Rose, that "Bellamy knows absolutely nothing about art, but he knows everything about people."[14] David Whitney, who would work closely with Dick, thought that his skill in picking "the best practitioners" derived from his "uncanny knack for [detecting] high ambition in many areas."[15] When asked to comment on his dealer's reputation as a bellwether, the Green Gallery painter Larry Poons pointed out, "Nobody is really born a full-blown genius."[16] Dick reminded Poons of "Gertrude Stein's definition of genius: somebody who knows who to be influenced by."

Often it was artists who tipped off Dick about promising talents, an information source most dealers today still rely on. Dick had the good fortune to be part of a unique posse of curators, collectors, and other dealers who went to studios together to follow up on leads. Ivan Karp—better organized than Dick—was usually the one[17] who arranged their outings on Sundays or Mondays, when galleries were closed. In the months before the Green opened, and continuing into its first year,[18] Dick and his friends tramped around to numerous studios, occasionally rewarding themselves with a late meal in Chinatown.[19]

"We called ourselves the Private Eyes,"[20] said the dealer and collector Allan Stone, who was still practicing law when he came along to scout for the gallery he opened on East Eighty-Second Street in December 1960. From time to time Dick would bring along Bob Scull. "Everyone sort of picked up the vibes from other people as you went along,"[21] Scull recollected. The MoMA curators Peter Selz and William Seitz were also part of this "little rat pack,"[22] as Henry Geldzahler dubbed their group. "There was a real reason for [Dick and Ivan] to go," Henry said, "and there was a real reason for me to go, too, because they'd both been in New York for a good ten years longer than I had, and I had a lot to learn from them." At first Henry "gave both Dick and Ivan equal points as mentors, but it became apparent that Dick had a wider range of sensibility than Ivan . . . It was from Dick that I had more to learn." To be on time for their Sunday sallies, Henry sometimes spent the weekend at East Broadway, arriving the night before and eating breakfast with the household the next morning.[23] "It's horrible looking for taxis and going to five studios on the fifth floor in one afternoon. But it's also the most exciting thing you can possibly do when it hits."[24]

Dick felt such a hit one Sunday in the fall of 1961 when he, Henry, and Ivan visited Jim Rosenquist's studio on Coenties Slip, the former maritime hub of the city where artists found spacious and cheap but illegal lofts.[25] Months before, Rosenquist had quit his day job as a master billboard painter[26] and given himself an "it's now or never" talk about finding himself as an artist. Besides, two union brothers had recently plunged to their deaths from a billboard scaffolding. But the scale, color, and imagery of billboards lingered in his imagination. At first he painted expressionist abstractions, nicknaming his colors for their associations with commercial art: dirty-bacon tan, yellow-T-shirt yellow, and Man Tan orange,[27] the latter an artificial tanning lotion that could leave skin the color of daylilies. "My chromatic alphabet came from Franco-American spaghetti and Kentucky bourbon,"[28] the artist recalled.

But his drippy, subjective abstractions felt like a dead end, and Rosenquist challenged himself to find a different way to paint. He began to tidy his edges, letting go of expressionist brushwork. He riffled through vintage magazines full of photos and illustrations

of people and objects, images slightly distanced in time. Rosenquist cut and reassembled his sources into composite "sketches" that he used as the basis for paintings of an emotionally cool, fractured world. The day the posse visited him, they rendezvoused on the street below and shouted up to the artist to come down and let them in—there were no doorbells.[29] Recently, other dealers had visited him, but no one made a concrete offer. His neighbors Jay Milder and Stephen Durkee, painters enthusiastic about his work, had urged Dick to see for himself.[30]

Rosenquist remembered Dick exclaiming, "Ah, I finally found something I can show!" when he saw the work that day.[31] Overhearing this, Ivan pulled the painter aside and counseled, "Don't sign any papers," but Dick never took on an artist with anything more than a handshake. It's likely that Ivan hoped he still might sway Castelli in Rosenquist's favor. But Castelli, a man well versed in art history, decided that Rosenquist's paintings were "very, very close" to Magritte and the surrealists, whom he considered passé.[32] Dick, largely unschooled in the history of painting, responded intuitively to the ambiguously juxtaposed and fragmented images. He remembered picking up "a very special kind of 'sound' "[33] when he saw Rosenquist's paintings for the first time. Dick was "in the moment,"[34] all senses in play. Initially what he saw hadn't made sense. He'd been drinking, he later revealed, and lay "languorously on the floor"[35] to puzzle them out.

Grounding himself—literally—was standard procedure for Dick. He had no back trouble yet often behaved like a skinny, latter-day Antaeus, the Greek god who derived strength from the earth. As Sheindi saw it, his preference for low poses did not bespeak humility, as some believed; it was a manifestation of a lifelong performance.[36] "Is that a way not to be noticed?" said Sheindi, posing a rhetorical question with wry Yiddish humor. As soon as Rosenquist said yes to the Green, Dick began to bring adventurous collectors to Coenties Slip. One spring evening he took Sheindi. When Dick asked what she thought—a huge painting of glistening cadmium-colored spaghetti stands out in her memory—she confessed that she didn't know. "Good, good," Dick responded. "That's the way it's supposed to be."

Dick and his friends didn't always agree on what constituted quality, "visible or invisible, / Invisible or visible or both: / A seeing and unseeing in the eye."[37] On the portentous Sunday the group visited Rosenquist,[38] they first went to see Roy Lichtenstein, who had been brought to their attention by his Rutgers buddies, Allan Kaprow and George Segal. Ivan came away electrified by what he saw, but Dick failed to connect with Lichtenstein's paintings inspired by ads for consumer products. Regardless of his sources, it was the idea of reproduction itself that most fascinated Lichtenstein. Like Rosenquist, he took as his starting point the world filtered through an earlier set of eyes.

Certain of his judgment, Ivan gradually convinced his boss, and Lichtenstein joined Castelli's stable. Ivan was the one who introduced Lichtenstein to Andy Warhol and to Rosenquist, who were similarly drawn to consumer culture as points of departure but were unaware of each other's art. Lichtenstein worked in relative isolation and until then had been unaware that any other artist was attracted to the kind of visual images that interested him.[39] A few months after Dick and Ivan first visited Lichtenstein's studio, the artist painted two slyly humorous "portraits" of Ivan and Allan Kaprow. For these twin paintings he adapted the identical cartoon drawing of a dapperly dressed man. Except for their titles, the two are impossible to tell apart. Each head sports a nimbus of radiating lines, comic strip shorthand for a sudden burst or bristling newness, an apt analogy for the art world in 1961.

Lichtenstein's salute to his notoriously elusive friend Dick was an "excellent In joke."[40] *Mr. Bellamy* (1961), today in the collection of the Modern Art Museum of Fort Worth, mimicked a single frame from a comic book narrative. The "Mr. Bellamy" of the title is nowhere in sight. A reference to him is embedded in the text of a thought balloon: "I am supposed to report to a Mr. Bellamy," muses a resolute military officer. "I wonder what he's like." There's a partially hidden figure and a yellow taxicab parked at the curb in the background. Perhaps the secret of Bob Scull's support was not so well kept after all.

Dick reeled in two more artists during group fishing expeditions. It was Ivan who first scouted the young Japanese painter Tadaaki

Roy Lichtenstein, *Mr. Bellamy* (1961), oil on canvas (framed), 56¾ × 42¹³⁄₁₆ × 1⅝ in. (144.15 × 108.75 × 4.13 cm). Collection of the Modern Art Museum of Fort Worth, Benjamin J. Tillar Memorial Trust; acquired from the collection of Vernon Nikkel, Clovis, New Mexico, 1982 (Digital image courtesy of the Modern Art Museum of Fort Worth, © Estate of Roy Lichtenstein)

Kuwayama and brought the posse to see him just as the Green opened for business in October 1960.[41] Kuwayama had studied Nihonga, the venerable Japanese style of painting known for its pure, luminous color, and he continued to grind his own pigments in New York. The impressive results of this laborious practice were evident in a series of large abstract compositions with radiant, impassive surfaces and passages of trickling paint. Kuwayama's art, on the cusp of a new, cooler aesthetic, arrested Dick's attention, and he returned, bringing Scull with him. Kuwayama spoke little English—and Dick never said much in any case. As a consequence, the artist didn't understand why Dick invited him to visit at the Green. Kuwayama politely complied, inadvertently out-Bellamying Bellamy by walking around the gallery in silence. "Goodbye" was the only word he uttered as he stepped into the elevator. Dick was sure that Kuwayama's behavior meant he had no interest in showing at the Green. But Ivan straightened out their faulty communication, and three months later Dick presented Kuwayama's New York debut.

The third artist was the British-born painter Richard Smith, who had arrived in the United States on a fellowship in 1959.[42] Smith's stunning, idiosyncratic paintings reverberated with the scale and shapes of New York—the huge, flashing neon of the Canadian Club sign in Times Square, the Chase Manhattan Bank's geometric logo. Dick loved Smith's painterly canvases and what he described as their "breathiness,"[43] or sensual energy. They were suffused with a joyous light, different from anything Dick had seen before. He found Smith's and Rosenquist's sensibilities closely connected, particularly their high-key color. At the time, Dick was unaware of the work of the British pop painter Richard Hamilton, or high-fashion magazine color photography, both of which made an impact on Smith before he came to New York.[44]

"We were stunned, delighted, and overjoyed,"[45] Dick reminisced, with the response to Smith's April 1961 exhibition. Dick remembered that Clement Greenberg made a point of coming to see Smith's show, as did the abstract expressionist Barnett Newman. As a token of affection, Smith gave his dealer *Bellamy*, an abstracted portrait.[46] Black disks resembling eyeglass lenses fill nearly half of the painting, today in North Carolina's Weatherspoon Art

Museum. If the shapes were to rotate—as gearlike flanges suggest they might—they would trace the symbol for infinity, an allusion to vision without limits.

Sometimes it took Dick a while to decide how he felt about the work he encountered in artists' studios. It was that way with Tom Wesselmann, brought to his attention by Henry Geldzahler, a man whose antennae must have been permanently extended in those days. Early in 1961 Oldenburg was working on a Happening for the Reuben Gallery and was desperate for volunteers.[47] Henry and Wesselmann were two of his friends who agreed to take part. Wesselmann remembered being asked, "What do you do?" as soon as Henry was introduced.[48] "I'm a painter," he said, and Henry immediately asked to visit his studio.

De Kooning was both idol and anti-model for Wesselmann, a former cartoonist. "I wanted to paint like de Kooning,"[49] he reflected. "But I could not do it because he was already doing it, so I moved in the exact opposite direction in every respect. Instead of abstract, I did representational; instead of big, I did small; instead of loose, my work was tight." He consciously rejected all but one of his idol's practices, mixing media: in his groundbreaking *Women* series of 1953, de Kooning collaged a cutout mouth from a Camel cigarette advertisement onto a painted face. The work Henry and Dick saw in Wesselmann's tiny workspace was droll—a diminutive series of meltingly posed nudes surrounded by homey and patriotic imagery. Blunt and aggressively sexual, Wesselmann's women proffered shaved or hairy pubes, neither of which the men's magazines of the time had dared to display.[50] His wryly grandiloquent title for the series, *The Great American Nude*, ironically referenced its scale and played on the trope of the great American novel and the American dream.[51]

Exhilarated by Wesselmann's collages, Henry sent out an all-points bulletin to his friends, spreading word of his find. Dick's response was equivocal.[52] Then (and now), when dealers are interested in an artist but not yet ready to make a commitment, they often stash a few examples of the work in the gallery's "back room." During the Green's second year, Dick kept several Wesselmanns on hand to show to select clients. Meanwhile, Henry arranged visits

to Wesselmann's studio for Ivan, and for Alex Katz, who was help-
ing the Tanager Gallery, a Tenth Street cooperative, to recruit new
members. Ivan loved what he saw and brought over Emily and Bur-
ton Tremaine, who bought something on the spot. Without a firm
promise from Dick, Wesselmann accepted Katz's invitation to join
the Tanager, where on December 8, 1961, his well-received[53] *Great
American Nude* series debuted.

Not far away, on Second Street, Claes Oldenburg's *Store* had
recently opened, just in time for holiday shoppers. Sharp-eyed art
lovers may have recognized that some of the artist's untidily painted
reliefs of dry goods and edibles had been on offer six months earlier
uptown, as part of Martha Jackson's pioneering show *Environments,
Situations, Spaces*.[54] "I'm for art that does something other than sit
on its ass in a museum," Oldenburg famously wrote for Jackson's
brochure. Jackson only had room to display Oldenburg's wall-
mounted "inventory." At the downtown *Store* he added merchandise
in the round, fashioned from chicken wire, plaster, muslin, and shiny
enamel paint. The goods for sale ranged from galumphy sneakers
and hosiery to gaudily painted hamburgers and pies. A toy ray gun
cost $34.99, a Pepsi-Cola sign $399.98.[55] It's "the best thing since
L.L. Bean," quipped the poet and critic Frank O'Hara.[56] "I'm so
depressed," an envious Andy Warhol told a friend after a trip to *The
Store*.[57] He didn't yet have a gallery, and here was an artist who
shared his interest in common objects.

Oldenburg's *Store* was the first "off-site" exhibition ever associ-
ated with a commercial gallery in New York. The phrase "in cooper-
ation with Green Gallery" appeared on the poster and on Oldenburg's
tongue-in-cheek stationery and business card, where he styled him-
self as "Claes Oldenburg, Prop." Dick paid half of the expenses and
took a commission of one-third on sales over $200.[58] All told, the
Green took in $285, Oldenburg nothing at all. There were few pay-
ing customers among the passersby who peered through *The Store*'s
glass front. One savvy collector, the Wall Street regular Charles
Carpenter, would drop by at lunchtime with a crisp hundred-dollar
bill and ask Oldenburg expectantly, "What have you got?"[59]

At the end of his workday on many Thursdays during *The Store*'s
run, Scull drove down to schmooze with Oldenburg before re-

turning to Ethel and his sons on Long Island. It was the cook's night off, he told the artist, and he often took Oldenburg to dinner in neighborhood places he remembered from his childhood. The Lower East Side was famous for places like Ratner's dairy restaurant and purveyors of overstuffed pastrami sandwiches such as Katz's Delicatessen, with its fading exhortation to "send a salami to your boy in the army." In those days, Scull was an attractive figure, Oldenburg recalled; "it was difficult not to respond to him."

Art makes the familiar unfamiliar, the Soviet critic Viktor Shklovsky proposed decades earlier.[60] After visiting *The Store*, the Ohio-based curator Ellen Johnson felt compelled to stroll through the nearby streets on the Lower East Side, "suddenly aware of the curious, tawdry beauty of store-windows full of stale hors d'oeuvres, hamburgers or Rheingold ads, stockinged legs."[61] For Johnson, Oldenburg's art altered her perception of his sources. It was an experience, she said, akin to the sensation she felt while driving around Aix-en-Provence and l'Estaque in southern France after seeing Cézanne's paintings. His *Mont Sainte-Victoire* made the actual mountain more visible. Oscar Wilde expressed the phenomenon similarly: "There was no fog in London until Whistler painted it."

Beginning in late January 1962, the Green subsidized a series of Happenings by Oldenburg[62] in *The Store*'s narrow back rooms, an enterprise the artist undertook because "theater is the dominant art in New York," he facetiously explained.[63] Collectively known as the Ray Gun Theater, Oldenburg's un-Broadway-like, absurdist offerings were sometimes volatile and frightening, miming sacrificial rites,[64] or made a farce of the mundane maneuvers of everyday life. Oldenburg played such stereotypes as the Bum, the Beggar, or the Voyeur,[65] acting alongside Sheindi and many others in Dick's circle.[66] "One can only cherish [a Happening] as one cherishes a firecracker going off dangerously close to one's face,"[67] Susan Sontag wrote during the genre's heyday in the early sixties. Dick never discussed his responses with Oldenburg,[68] but the artist took comfort in his simply being there: "If Dick stepped into the room, the room immediately changed," he recalled. "Dick had a certain enigmatic presence, but you felt that this was someone who wished to express his sympathy with what you were doing." Happenings

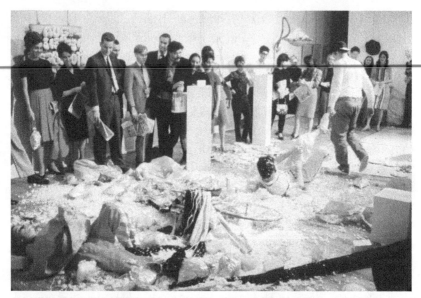

Green Gallery, *Sports*, October 5, 1962, a Happening by Claes Oldenburg, per-
formed by Pat Oldenburg, Lucas Samaras, and Claes Oldenburg. Andy Warhol,
Sam Wagstaff, and John Chamberlain are behind the first pedestal; Dick is behind
the second. (Photograph by Robert McElroy)

were impermanent and amorphous, everything that museum art
was not. As a radical art form, they had a short half-life: "The per-
formances that we were doing . . . quickly became over-discovered,"
Oldenburg later reflected. "Instead of a few friends showing up . . .
you'd have a lot of limousines with seekers of thrills."[69]

Dick embraced the anarchic genre of Happenings, attending
many, performing in several, and presenting a few. The sixties
were barely a week old when Allan Kaprow enlisted Dick and sev-
eral friends to be in *The Big Laugh*,[70] a festive theater piece with less
pomp and more hilarity than his breakthrough *Eighteen Happenings
in Six Parts*. Oldenburg and Jim Dine ran around with painted clown
faces, and the ingeniously versatile Lucas Samaras, who studied
acting with Stella Adler, made carnival-style sales pitches. Kaprow
entrusted Dick to hand out balloons on a stick. It was all over in
seven minutes. *The Big Laugh* played on a bill at the Reuben with a
Happening by the young artist Robert Whitman, a former Kaprow
student and Hansa member, who joined the Green in its first year.

Photos document Dick and Sheindi in the darkened audience, beaming at their friends cavorting in Whitman's frenzied opera *E.G.*, part of *An Evening of Sound Theater—Happenings* at the Reuben in June 1960.[71]

The following year, Sheindi was part of the cast[72] when Whitman premiered *Ball* at the Green, the first Happening ever staged uptown. For this plotless series of vignettes, the artist covered the gallery walls with kitschy posters, brushy drawings, and a large papier-mâché relief of a ball. In one scene, Sheindi and Pat Oldenburg stood flanking a pedestal topped with an electric skillet. "I intend my works to be stories of physical experience," Whitman wrote of his Happenings,[73] and he did not usually signal an ending. There would be a last image that would stay, and gradually the audience would realize nothing more was going to happen and they would start to clap.[74] In her review for *The Village Voice*, Jill Johnston described *Ball*'s "tension not rising but contained in the image, therefore seeming, when it explodes, to explode from no place or out of nothing special because life is like that."[75]

Nine months later, art world cognoscenti[76] would gather at the Green to see Claes Oldenburg's *Sports*. Happenings were typically dark, disorderly affairs, enacted downtown, where messiness didn't matter. But when the Italian makers of the smash hit *Mondo Cane*—the world's first "shockumentary" in newsreel format—asked Oldenburg to present a Happening that they could film,[77] he designed one for the Green. The first *Mondo Cane* film had surveyed bizarre customs, rituals, and lifestyles around the world. For a sequel, the filmmakers thought that a wacky Happening was just the thing. The New York Yankees were up against the San Francisco Giants in the second game of the World Series on October 5, 1962, the day Oldenburg presented *Sports* during the run of his show at the Green. Lucas Samaras acted out a baseball player with a bat that morphed from hard to soft. "The basic bat changed from solid wood to something stuffed, limp and loopy that stretched for an additional 20 feet," remembered Pat,[78] the other key performer in addition to her husband. On his instructions, she whacked at Lucas with huge, droopy boxing mitts. At the Happening's untidy conclusion, foam rubber blocks and Styrofoam peanuts littered the floor. "We were able to

put everything back in a matter of an hour, as if there had been no performance,"[79] Oldenburg boasted with a wink. "Whatever the artist wanted to do, Dick Bellamy did it, and that was great."

The Green earned a reputation as a hot spot for work with an edgy, anti-art personality. That few collectors bought the art Dick put on view seemed beside the point to him, if not to Scull. The issue of unprofitability aside, during its second year the gallery began to attract curatorial attention. The MoMA curator William Seitz included Jean Follett and Lucas Samaras in his huge international survey, *The Art of Assemblage*, a show that closed in the fall of 1961, just days before the Met bought its multimillion-dollar Rembrandt. To demonstrate the historical lineage of assemblage, Seitz included Picasso's *Still Life with Calling Card* (1914) and a replica of Duchamp's *Bicycle Wheel* (1913). Follett used scavenged cooling coils, casters, springs, and a light switch in her relief on view; Samaras's found materials included buttons, bullets, feathers, and foil. Truly, it was a show of "art out of anything,"[80] as a headline in the *Times* read.

The Art of Assemblage marked the apex of Follett's career; Samaras's was just getting started. In December 1961 Dick presented his unforgettable debut. Donald Judd likened the majority of Samaras's "messy, improbable [and] exceptional" objects to "mental, and sometimes actual, cacti."[81] Their vulnerable scale, intimacy, and imagery only served "to sharpen the thorns." Some of the artist's assemblages contained treacherous razor blades, or a long needle, imperceptible until "just before you are impaled upon it," Judd deadpanned. Some critics predicted that *The Art of Assemblage* would prove the kiss of death for "junk aesthetics."[82] But the establishment's embrace wasn't to blame when it died soon after. The zeitgeist shifted. Less expressive, cooler, and ironic art gained favor, and the Green Gallery became *the* place to see it. Happenings, assemblage's unruly offspring, carried on the spirit of *épater le bourgeois* for a while longer after the MoMA show, until pop art stepped up to air-kiss the bourgeoisie on both cheeks.

In the fall of 1961 Castelli took on Roy Lichtenstein,[83] and Rosenquist joined the Green. Despite Ivan's lively interest in Warhol, Castelli passed on his work, steering the disappointed artist to Eleanor Ward's Stable Gallery,[84] the better to broaden the circle of

enthusiasm for the radically new art trend that suddenly seemed to be everywhere. As attentive students of the art market, Castelli and his advisers understood that synchronic events would bolster Lichtenstein's appeal to collectors, museums, and the press. To that end, Castelli asked Dick to schedule Rosenquist's debut to overlap his Lichtenstein show,[85] set to open on February 10, 1962. Martha Jackson's fortuitously timed debut exhibition of Jim Dine, another exemplar of what was then called neo-Dada, would close just before Lichtenstein's opened. Dine showed canvases that combined painted surfaces with such three-dimensional objects as household tools, clothing, and, yes, a kitchen sink.

A self-described marketing innocent, Dick agreed to his friend's request, recalling that Castelli "saw what was building and had the imagination to grasp the historical moment."[86] Two weeks after Rosenquist's opening at the Green, Lichtenstein debuted a mile farther uptown. The neo-Dada artists didn't seem "a new breed" to Dick.[87] "I saw them in a studio context, and my art experience of their work was continuous and not different to any other. The aesthetic sensation was not the 'brand new' product people were talking about. It's the sensibility of any new work you have to touch on." Although Dick was an acutely sensitive "barometer,"[88] in Castelli's description, he wasn't always aware of the implications of his own readings. "I was really only focused on the sensibilities of Oldenburg and Rosenquist,"[89] Dick recollected. "I guess I'm showing these artists because I like their work."

To Dick's amazement, Rosenquist's show was a sellout.[90] His success surprised the artist as well, who wondered in advance if anyone would even come to his opening.[91] One of those who did show up was Richard Brown Baker, Dick's collector friend from his Hansa days. When a reporter later solicited Baker's advice for would-be collectors, he shared his strategy: "I get there early and I make fast decisions."[92] Baker picked Rosenquist's haunting *Flower Garden* (1961), today in the Yale University Art Gallery, a pale landscape of sprouting arms that model rings or rubber gloves. Joseph Hirshhorn, another incisive collector, snapped up Rosenquist's *The Light That Won't Fail I* (1961), today in the Hirshhorn Museum, Washington, D.C.

Dick began to bring collectors down to Rosenquist's studio well before his show opened. Bob Scull had first crack and became the first to buy a Rosenquist. Emily and Burton Tremaine were next. Unlike Scull, a relative beginner as an arts patron, the Tremaines were seasoned collectors of modern art. Emily Tremaine and Bob Scull were each the more public "eye" of their respective marriages— their lives a study in contrasts, "old money versus new money."[93] The couples became rivals when their daring taste coincided, as it did with Rosenquist. Dick must have felt like King Solomon as he tried to satisfy their competing desires.

On Emily Tremaine's first visit to Rosenquist's studio, she arrived wearing a pair of heart-shaped spectacles with tinted lenses.[94] It was a sophisticated touch of levity, in the spirit of Peggy Guggenheim's outré eyewear. Emily's kitschy glasses were "a delightful, delicious tint of blue," Dick recalled, but he "really couldn't see how she saw anything" through the colored glass.[95] She would have known that the young protagonist in Vladimir Nabokov's *Lolita* had a similar pair. Part of Dick's charm was the guileless way he talked about the literature he loved, and perhaps they talked about *Lolita*, one of his all-time favorites.

By referencing Nabokov, a writer with a love-hate relationship to American consumer culture, the canny collector may have signaled her support for the new art she was among the first to collect. In February 1962 Sidney Tillim wrote one of the earliest commentaries on what was about to be christened "pop," a meditation on Oldenburg's *Store*. He began with an evocative passage from *Lolita*, an inventory of the gifts Humbert Humbert purchased for his illicit love: "four books of comics, a box of candy, a box of sanitary pads, two cokes, a manicure set, a travel clock with a luminous dial, a ring with a real topaz, a tennis racket, roller skates with white high shoes, field glasses, a portable radio set, chewing gum, a transparent raincoat, sunglasses, some more garments— swooners, shorts, all kinds of summer frocks."[96] Tillim proposed that young artists such as Oldenburg, who found their content "in mass man and his artifacts," shared Nabokov's "nearly morbid fascination" with consumerism. The items enumerated by the great writer would have qualified as "radiant commercial articles"[97] to

Oldenburg, a Yale-educated artist who considered bad taste "the most creative thing there is."[98]

Tillim was having a busy start to 1962. In January, *Playboy* published his feature on "The Fine Art of Acquiring Fine Art." There was no neo-Dada art in sight. Expressionist, primarily abstract art hung on the walls of *Playboy*'s glamorous, staged tableaux of an art gallery and a bachelor pad. "Dealers are the obstetricians of art," Tillim proposed,[99] skirting the issue of how docs decide just which babies to deliver. In January 1962 the New York gallery scene resembled the man described by the humorist Stephen Leacock as having "flung himself upon his horse and rode madly off in all directions."[100] At Tibor de Nagy, the writer and painter Fairfield Porter offered gestural landscapes and portraits long admired by his abstract expressionist contemporaries. Leo Castelli showed John Chamberlain's crushed metal sculpture, and the Allan Frumkin Gallery introduced Peter Saul's cheeky, complex paintings of everyday objects interlaced with graffiti and comic book images.

At the Green, Dick featured Joan Jacobs, a twenty-eight-year-old painter from Los Angeles, today an invisible artist. She'd been brought to Dick's attention[101] by her husband, Everett Ellin, the director of the new contemporary art section at the blue-chip gallery French and Company.[102] Jacobs painted centrally placed trees, crosses, or stars set against an aluminum circle or square. Here and there, unpainted metallic surfaces shimmered with reflected light. In the months preceding her New York debut, Jacobs's career had gathered momentum. Along with Johns, Rauschenberg, and the Green's Tadaaki Kuwayama, she was among the hundreds of artists in the 1961 Pittsburgh International Exhibition of Contemporary Painting and Sculpture. William Rubin, the editor of *Art International* and a future MoMA curator, singled her out for special praise: Jacobs was "totally unknown to me before and very impressive."[103] The sculptor David Smith, who knew the artist through her husband, encouraged her, and the two exchanged work.[104] Smith was aware that the art deck was stacked against women. "Keep doing this," he advised Jacobs's contemporary Rosalyn Drexler when he saw

her sculpture in 1960. "Because women start and then they stop, and you don't hear about them again. Keep going."[105]

It seemed a promising start. But Jacobs was not the only artist attracted by the imagery of common signs and symbols. The Los Angeles artist Billy Al Bengston and New York's Robert Indiana staked claims on similar terrain, and in 1964 Indiana's iconic love logo—"LO" over "VE"—brought him world fame. Survival is never easy in the Darwinian environment of the art world, and sexism— an applicable term that wasn't yet in general use in 1962—influences natural selection. "There was no real equity for women,"[106] recalled Carolee Schneemann, today internationally known as a pioneering performance artist. "Women were somewhat anomalous; they were the special guests. Theirs wasn't the 'real' work that was being done. Women were regarded as oddities that sometimes had to be given a forum." To the painter Mimi Gross, a woman's success as an artist depended on her level of aggression—too much would turn people off, as would too little. A career "seemed to depend more on personality than talent."[107]

A timid person, Joan Jacobs felt at home in the less competitive Los Angeles art world of the late fifties. When her husband accepted a job in New York in 1960, she decided not to move east. To sustain a career, artists need more than mere talent: the strength to weather rejection, a high tolerance for and skill in schmoozing, and the confidence that what they are doing counts for something. When Jacobs's debut at the Green elicited no enthusiasm[108] and her next show, at Jill Kornblee's gallery, was damned by Donald Judd's faint praise,[109] she withdrew from the art world. A champion horsewoman since girlhood, Jacobs, by then divorced, moved to Kentucky to breed horses; she died there in 1985, eulogized for the excellence of her Saddlebreds.[110]

The Green Gallery was an extraordinary forum for any young artist. Not many were women. Dick's record in this regard is only slightly better than his contemporaries' abysmal showing: Janis showed Marisol; Castelli, Lee Bontecou. During the Green's five-year run, a scant handful of women pop up in Dick's group shows. In addition to Joan Jacobs, he awarded solos to Pat Passlof and to Sally Hazelet Drummond, who painted delicate, meditative

abstractions with confetti-like flecks of paint. Tellingly, both women got their start in Tenth Street cooperatives, a less cutthroat culture than that of Fifty-Seventh Street. If, like Paul Brach, they had held off showing in co-ops until they could snag an uptown gallery, there's no telling how long they would have waited.

Non-verbality was Dick's modus operandi, saying nothing his preferred way to communicate. Most of his studio visits exemplified "the intensest rendezvous,"[111] in Wallace Stevens's phrase, "in which being there together is enough." He tried to avoid expressing enthusiasm, and said "the nicest things in the lowest voice,"[112] recalled Barbara Rose. He later described his thinking process:

> When you go to an artist's studio I think it is best to keep your mouth shut. One always wants to look good in the artist's eyes and to say something brief and astute, if one can. Generally I would say nothing, because I felt that I knew what I was looking at, and the artist ought to know that I knew what I was looking at; and if it was very, very good, I didn't have to tell them, because he knew that I knew. Of course, I was wrong about that, all along the line.[113]

"To be a giant and keep quiet about it"—the opening line of "Trees," Dick's favorite poem by Howard Nemerov[114]—expressed his unvoiced credo. Described in his *Times* obituary as a man of "towering modesty,"[115] Dick was "so blatantly self-effacing that you just had to pay attention."[116] When Dick was a boy, his gentle mother, Lydia, advised him to "never speak with a loud voice, for people will try to get away from you. So speak with a soft voice and they will strain their ears to hear what you have to say."[117]

"A fabulous and fastidious listener,"[118] in Alfred Leslie's description, Dick excelled at using an emotionally symbolic body language as he leaned forward to pay close attention. On those occasions when Dick did comment, his speech was often full of stuttering starts and sentence fragments, phrases begun and aborted as he unself-consciously removed and replaced his eyeglasses.[119] Glances

and reassuring smiles punctuated the long, wordless periods he spent with friends.[120] His silences were singular, never slack. "There was always the sense that he was really there."[121] Kunié Sugiura "took many things away from his silence. He taught me how stupid my question was, or how difficult it was to make a judgment or decision."[122] His friends came to expect get-togethers where they'd "nod, say a few things . . . sort of like a Quaker Meeting."[123]

Just before the Green opened, Dick wrote to a friend, "[I] have periods of good behavior and at present am on the most extended and profound."[124] But in the gallery's second year, as the gap widened between Scull's expectations of a quick return and Dick's ability to pull salable rabbits out of his hat, his stretch of clean living trailed off. Dick tried his best to make their venture a success, spending seven days a week at the gallery and seeing as many artists' work as possible. "At night I would hang out with the artists, going to bars and visiting their studios,"[125] Dick later told an interviewer. Bars must have presented a particular challenge. It took Sheindi a while to understand that Dick's inability to fulfill his oft-expressed intention to stop drinking was one of alcoholism's very characteristics.[126] Sheindi took him to AA meetings, but he never went on his own. For a brief period he tried psychotherapy, but after each session he would fall into the nearest tavern.

"Alcohol was almost an attribute of our lives," the art critic Calvin Tomkins recalled, "as necessary as turpentine for some artists."[127] The message was "If you didn't drink, you weren't one of us."[128] Dick "had this way of ducking around the corner to get a drink in the middle of the day," recalled Julie Finch,[129] who would marry Donald Judd after Dick introduced them. The Green wasn't always open for business at the advertised times,[130] or the gallery might be open but unmanned.[131] A visitor who arrived at lunchtime might find the phones off the hook and Dick nowhere in sight. He liked to repair to a bar on Sixth Avenue he dubbed "the Green Gallery Annex."[132] Such behavior evoked the spirit of Charles Egan, a Fifty-Seventh Street dealer a generation older than Dick who likewise had a canny eye and a drinking problem.[133] The first to exhibit

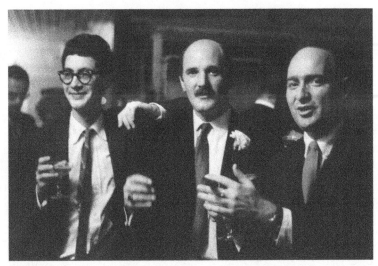

Dick and Ivan Karp flank Malcolm Morley, at the painter's wedding reception, 1962. (Photographer unknown, courtesy of Marilyn Karp)

de Kooning, Kline, and Jack Tworkov, Egan was known to open his gallery in the morning and head directly for a bar.[134]

Dick could function as an alcoholic, but only up to a certain point. "You never knew when he was going to spend the afternoon drunk, in the back [of the Green]," Oldenburg recalled, "and you'd have to somehow keep people from going back there."[135] Dick repeatedly attempted to break his dependence on alcohol. "I landed up in the whiskey hospital more than once," he confessed,[136] referring to the storied Charles B. Towns Hospital on Central Park West and Ninetieth Street, where he would go to dry out until it closed in 1965.[137] The facility he nicknamed "the Farm" and "the Generals" had two floors reserved for alcoholics—one for patients determined to quit,[138] another for those who weren't. Its top floors housed morphine addicts, "mostly well-known physicians who checked in, on average, at six month intervals."[139] The hospital's stiff fees, as much as $350 a week, were beyond Dick's means. Patrick Lannan Sr. covered the cost of at least one stay,[140] but his other benefactors are unknown.

The night before Dick's first stay at Towns, in 1961, he took Sheindi by the arm and navigated her into every joint he could think

of to experience each "for the last time."[141] On another occasion it was Larry Poons who helped Dick check in; the two, likely stoned or drunk, arrived at the hospital in a horse-driven carriage that had clip-clopped its way uptown through Central Park.[142] During one of Dick's weeklong "cures," a visitor brought him a stuffed iguana. The painter Alice Trumbull Mason, a friend of his from the Hansa days, was in treatment there at the same time and was greatly amused to imagine her fellow patients laying eyes on Dick's lizard, uncertain whether it was real or just the mischief of delirium tremens.[143]

Dick was in his mid-thirties, but he behaved "like a twenty-year-old,"[144] he said with hindsight in his mid-fifties. "The gallery was very loosely organized, and I would just take what came . . . There was no real thinking about the business aspect, or what a stable of artists means, or what a dealer does to promote them apart from sitting there and trying to sell a painting every time someone asks the price of it." It took Dick a while to understand that he even *was* an art dealer, he told another interviewer, "rather than being an observer who just happens to be in a position to give exhibitions to people."[145]

During drinking bouts, Dick was unkempt and his office disheveled. This repulsed Ethel Scull,[146] who wouldn't use the toilet at the Green.[147] One afternoon early in 1962, when her husband was out of the country,[148] Ethel summoned Dick to their home in Great Neck.[149] Once there, they traded pleasantries, and it perplexed Dick that she didn't seem to have anything important to say. But on their ride back to town Ethel swiveled around from her seat next to the chauffeur to address Dick in the back. She confided that his sorry state grieved Bob, who was thinking of cutting him loose. "Brush your teeth," she admonished, regarding his offensive smoker's breath. She urged Dick to pull himself together and to polish his desktop with Pledge. "It shook me up a little," he remembered with characteristic understatement. Not long after that, he did get a handle on his drinking, professing uncertainty as to whether it had been Pledge or the popularity of Rosenquist's paintings that triggered the turnaround.

POP GOES THE WEASEL

When British artists coined the phrase in the mid-fifties, "pop art" signified mass visual culture, ephemera that didn't take itself seriously as art. A catchy name, it resurfaced in the sixties with a fresh meaning: art that *referenced* pop culture.[1] Just as Leo Castelli had hoped, art's radical new look exploded into awareness with the confluence of Rosenquist's and Lichtenstein's debuts, shows that followed on the heels of Wesselmann at the Tanager and coincided with Dine's and Saul's uptown exhibitions. At the time, Castelli likely was not yet aware that the force propelling pop was a global phenomenon. By the spring of 1963 Philip Johnson would confidently declare pop to be "the most important art movement in the world today."[2]

In the United States, pop spawned collectors previously indifferent to contemporary art. The New York insurance broker Leon Kraushar may have spoken for these neophytes when he admitted, "It was when I discovered pop art that I became really involved. Here was a timely and aggressive image that spoke directly to me about things I understood. The paintings from this school are today. The expression is completely American, with no apologies to the European past. This is my art, the only work being done today that has meaning for me."[3] Said the Delphic Andy Warhol, pop is about "liking things."[4] Some dealers fished for clients in unconventional venues, setting up displays in banks and swank liquor stores.[5] An expensive apartment building lobby became auxiliary gallery space

for Allan Stone, *The Wall Street Journal* reported. By enticing buyers who'd never stepped inside his home base on the Upper East Side, Stone saw his sales climb 20 percent. "I doubt that I'd ever have seen the painting if it hadn't been hanging in the apartment house," said one of Stone's new customers.

With ill-concealed disdain, Emily Tremaine dismissed arrivistes who bought art for what she considered the wrong reasons.

> I think there was some opportunism associated with some of the collectors of Pop Art. The very boldness of the Pop artists' work attracted early publicity. I think that some people who did not really think too deeply were attracted to it because it was new. They knew a soup can when they saw it and they felt more comfortable with things than with ideas; so they were willing to accept Pop Art as being all about things, even though the ideas, I think, were often missed by them.[6]

Perhaps she had in mind Lichtenstein's sophisticated reply when he was asked to explain his rationale: "I am calling attention to the abstract quality of banal images."[7]

Pop had a youthful, contagious appeal and quickly attracted a national audience. In Philadelphia in March 1962 a team of energetic nonprofessional women decided to organize their own exhibition of the new style.[8] Joan Kron, Audrey Sabol, A. C. Wolgin, Janet Kardon, and others were smart, wealthy, and Jewish, members of the fine arts committee of the Young Men's and Young Women's Hebrew Association Arts Council,[9] which was established to bring culturally experimental art to the city. Once a year, the committee had the use of two rooms as a gallery. If the Philadelphia Museum of Art had been interested in contemporary art—they were not—these women wouldn't have been involved; the museum board was then inhospitable to any but old-moneyed families. But with unusual foresight, during weekly trips to New York in 1961–62, the women educated themselves by visiting studios and galleries, taking advantage of the Pennsylvania Railroad's "Ladies' Day Special" on Wednesdays, a round-trip ticket for the bargain rate of five dollars.[10]

Together, these women regarded themselves more as producers

than curators, relying on the guidance of Audrey Sabol's mentor, Billy Klüver, the scientist who collaborated with Tinguely on his *Homage to New York*. Klüver steered them to Johns and Rauschenberg, as well as to the Green's Rosenquist, Oldenburg, and Segal. Misleadingly titled *Art 1963—A New Vocabulary*, this first East Coast exhibition of pop art opened at Philadelphia's YM&YWHA on October 25, 1962. Even its catalogue, published as a printer's proof on long sheets of newsprint, has a pop-ish air.[11] At the end of its run, Allan Kaprow staged a Happening called *Chicken* in the Y's gym—about the life and death of a chicken vendor.[12] The centerpiece was a huge tar-paper fowl, and live, dead, and cooked chickens abounded, most of them courtesy of George Segal's farm.

Visitors to Segal's second show at the Green, in May 1962, stepped around chalky life-size people absorbed in ordinary tasks. A nude woman with her back to the room sat painting her fingernails red as she considered her reflection in a mirror. Another woman, dressed in a tee and shorts, sat hunched over a coffee cup on a cobalt-blue tabletop, as acutely alone as the single figures Edward Hopper painted. They all seemed "in arrested development," wrote Donald Judd, "ambiguously dead or alive, like the plaster casts taken from the molds in volcanic ash of struggling Pompeians."[13] The show contained a few figurative expressionist canvases. "Dispense with Segal's paintings," was Judd's tough-love directive. Segal's plaster people were the only instance Judd knew of when "someone less than Giacometti's age" had used the figure convincingly. It was high praise from Judd to evoke the European master, and although Segal's humanistic content had nothing in common with pop irony, the artist was swept to fame as part of the movement.

Dick designed a clever, attention-getting ad for Segal's second show.[14] As if in fulfillment of his mother's counsel to "speak with a quiet voice and people will listen to you," Dick's seemingly empty rectangle and minuscule type size stood apart from the other, bolder gallery ads in the *New York Post* on May 13, 1962. The text, "GEORGE SEGAL PAINTING / AND STATUES," was Dick at his most fey. "Statue" is a quaint, stilted noun in this context, more appropriate

to the colossal figures adorning the façade of the former Parke-Bernet auction house, which were meant to symbolize "Venus awakening Manhattan to the importance of art from overseas,"[15] than to the work of an avant-garde artist. "Statues" is also the name of a children's game in which kids move around and then freeze in position when the one who is "it" makes eye contact, an apt analogy for the experience of looking at a Segal sculpture. The lifelike quality of the figures jolted the collector Bagley Wright on his first visit to the Green, when he walked in on a pensive man "who was real and not real," perched on a beat-up bike.[16]

Andy Warhol wanted both fame and fortune. Whichever came first, he felt sure the other would follow. One route he mapped out in the early sixties took him through the Green Gallery.[17] "You needed a good gallery," he reasoned, "so the 'ruling class' will notice you."[18] But Dick was unmoved by the paintings he first saw in Warhol's studio.[19] Those images of Superman, Coke bottles, and dance diagrams were "not the fabric of my experience," Dick later explained, and he walked away "highly suspicious of the work."[20] Warhol came geographically close to the Green in April 1961, when his contacts at Bonwit Teller department store, around the corner on Fifth Avenue, used his paintings as the backdrop for a window display of spring frocks. It's impossible to know if Dick passed by the installation at Bonwit's, so close to the Green. But Scull likely made a point to see the artist's work in this unexpected context. In the coming years, Scull would boast that "early in 1961"[21] he became the first collector ever to buy a work of pop art by Warhol.

Thanks to Scull, the Green became the first gallery in the country[22] to show Warhol's pop paintings. He pulled his weight and lobbied Dick to include the artist in the group exhibition that topped off the Green's second season in June 1962.[23] "I certainly liked Andy well enough, and I wanted to do some rethinking,"[24] Dick later said. "I was rather astonished that Claes dug him and they were exchanging works." Dick put a few of Warhol's smaller works[25] in the entry room and installed *200 One Dollar Bills*, a large-scale compositional grid, on the main gallery's prestigious south wall, in

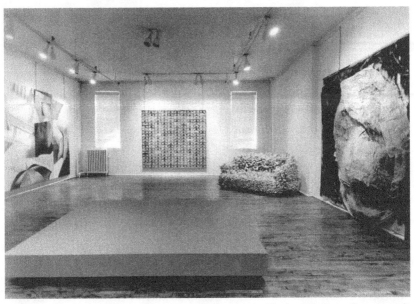

Green Gallery, *Group Show*, June 12–July 21, 1962. (Clockwise, from foreground) Morris, *Slab* (1962); Rosenquist, *A Lot to Like* (1962); Warhol, *200 One Dollar Bills* (1962); Kusama, *Accumulation No. 2* (1962); and Whitman, *Untitled* (1961) (Photograph by Rudy Burckhardt, © 2015 The Estate of Rudy Burckhardt / Artists Rights Society [ARS], New York)

the sympathetic company of a vertically sectioned radiator and the delicate horizontals of the rattan shades. Scull bought it for $1,200.

Generically titled *Group Show*, the exhibition included other painting and sculpture that advanced the conversation about what constituted a work of art. It was an astonishing sleeper of a show, the first of a string of Dick's inspired provocations. Dick hoped to include Alfred Leslie's *The Jolly* (1960),[26] a motion-based installation whose wit and wizardry appealed to his iconoclastic taste. Shipped abroad for Pontus Hultén's traveling exhibition of kinetic art,[27] the trunk that housed *The Jolly* couldn't be found. Had *The Jolly* been available, visitors would have seen a helium-filled balloon tethered to a brick that appeared to float on water. The accompanying instruction manual, today in the collection of Stockholm's Moderna Museet, impishly called for Jolly Guards with Jolly Batons to prod into motion any onlookers who stood still as they tried to understand what they were looking at.[28]

Instead of *The Jolly*, it was Robert Morris's painted plywood *Slab* (1962) that owned the floor- and airspace at the center of the room, literally stopping people in their tracks. The eight-foot-square platform was "as negative a sculpture as it was possible to make,"[29] in the artist's later description. When asked why he'd made it, Morris said it wasn't possible to reconstruct the moment: "How should I remember to/for you a sense of how the world felt, how nailing together a slab of gray plywood resonated to impulses compounded of desperation, humor, speculation, anger, indifference, malice, doubt?" When Morris first approached uptown galleries, photographs of his radical constructions in hand, Dick was the only dealer intrigued enough to make a studio visit.[30]

Robert Morris's studio was an easy walk from Dick and Sheindi's home on East Broadway. The artist worked in a small unheated room near the Fulton Fish Market, in the same crumbling brick building occupied by Mark di Suvero. Although the two men had tangent studios, aesthetically they were worlds apart. Once, Mark pushed open Morris's door and poked his head in. "Don't stop working," Mark said with a big grin. "I just came to hate a little."[31] On the day Dick first visited Morris's workspace, he wordlessly scrutinized the artist's inexpressive gray-painted blocks, walls, and beams, bare-bones sculpture-cum-performance props. Settling himself across *Slab*, Dick drifted into sleep. As if his catnap sealed the deal, he awoke and told Morris he wanted to show him at the Green.[32]

Like Judd, Segal, and Flavin, Morris began his artistic career as an abstract expressionist painter. Unusually, he was also a dancer. A few years earlier in San Francisco, Morris and his then wife, Simone Forti, had been part of Anna Halprin's improvisation and dance workshop, a germinal group that at various points included Trisha Brown, Yvonne Rainer, June Ekman, and Sally Gross. They were all in New York by 1960, members of the powerhouse generation of young dancers that would shape the emergent postmodern sensibility. Dance became "any movement to look at,"[33] a premise rooted in John Cage's equation of art and life. Morris, Forti, and Rainer performed at the Reuben Gallery, the home of Happenings, often on the same program with Oldenburg and Dine. Within a

year of Morris's arrival, vanguard dance and the visual arts were on an equal footing below Fourteenth Street.

Morris's *Passageway* (1961), a temporary installation, was one of a series of events at the Chambers Street studio of Yoko Ono, who was active in the downtown avant-garde. *Passageway* transformed Morris's viewers into performers when they opened the loft's front door and stepped into a plywood corridor that curved as it narrowed to impassibility. Like the later *Slab*, Morris's passage to nowhere conformed to his self-imposed regulations of the early sixties: "work alone with simple tools," creating "only what the unaided body can achieve with inexpensive materials."[34] These pieces largely began as props for Forti's performances.[35] For Forti's contribution to Yoko Ono's series, she staged five "dance constructions" in different parts of the loft, requiring viewers to move from piece to piece as if they were in an art gallery.[36] Forti never showed at the Green,[37] but her "investigations into ordinary movement" were an important influence on Morris's practice.

Yayoi Kusama's *Accumulation No. 2* (1962), a sofa studded with fabric penises that poked up from every inch of its back, arms, and seat, was the maximalist omega to *Slab*'s minimalist alpha in the Green's June show. The phalluses encrusting her furniture had a magical significance for the artist and attempted to contain fear by representing it. "I was scared of penises,"[38] Kusama explained when later asked why she created the *Accumulation* series. Not long after she arrived in the States in the late fifties, she wrote to a magazine back in Japan: "I am planning to create a revolutionary work that will stun the international art world."[39] Kusama kept her promise with the five Pollock-scale paintings she showed at the Tenth Street cooperative Brata Gallery in 1959. Their exquisitely obsessive, eyelet-patterned images derived from hallucinations she began suffering as a teenager. In this *Infinity Net* series, the emotionally volatile artist spun gold from the dross of mental illness, an alchemical skill she would never lose.

Dick admired Kusama's white-on-white paintings, remembering them a decade later as "textural, and aggressively passionate."[40] He courted her before the Green opened,[41] but the two didn't really connect[42] until two years later, when he again visited her studio.[43]

She had just finished the chair she called *Accumulation No. 1*, and he invited her to be part of his upcoming group show. Encouraged by Dick's enthusiasm, she hastily started *Accumulation No. 2*, the large sofa. Kusama remembered that Dick offered her the opening slot of the Green's next season, but she declined, "due to lack of money."[44] If she couldn't afford to hire assistants for her labor-intensive sculpture, she did get help from her neighbor and former lover,[45] Donald Judd, who had the loft above hers.[46] It's hard to imagine the ur-minimalist helping her with the monotonous production of hundreds of fabric phalluses, but he did. "All day unending stuffing," he remembered.[47]

Even if Kusama couldn't produce enough work fast enough for a solo show in the fall, exposure in *Group Show* advanced her career. "I got quite a reputation by presenting only two of my sculptures last June," she wrote Dick six months later, "because you are the top avant-garde gallery in New York City."[48] *Group Show* gave visitors a foretaste of Oldenburg's upcoming solo, with two of his juicily painted plaster sculptures hanging from the ceiling—*Men's Jacket with Shirt and Tie* (1961) and *Roast Beef* (1961). While *Group Show* was still on view, *Life* magazine cheerily alerted readers that "Something New Is Cooking" in the art world.[49] But it wasn't Oldenburg, Kusama, Morris, or even Warhol that *Life* had in mind. They were interested in the Green's Rosenquist and Segal, as well as Castelli's Lichtenstein, and Allan Stone's Wayne Thiebaud, whose lusciously painted desserts prompted the pun in the title. A news feature, not a critique, "Something New" nonetheless pointed out the double-edged nature of pop. Lichtenstein simultaneously mocked and admired household gadgets, they reported, and Thiebaud both criticized and celebrated the commonplace, mass-produced aspects of every-day life. This ability to mean two things at once was the essence of irony, a natural instinct for the singular, contradictory Dick Bellamy, a man who was and was not an art dealer. He was "us" and "them," king and court jester.

The art world was on hiatus in August 1962 when Dick handed over the keys to his empty gallery to Claes and Pat Oldenburg and

took off with his family for Provincetown. It had been a stressful year. Determined and sure of himself, Scull kept the pressure on Dick to turn a profit, an impatience likely fueled by Rosenquist's dramatic success. In the four years Dick had been with Sheindi, she'd watched his need for drink wax and wane, but increasingly she despaired that he'd ever be able to quit. For a while at least, the sun and salt air of the Cape smoothed their fraying partnership.

Oldenburg's downtown studio was big enough for Happenings and small sculpture, but to fabricate the several monumentally scaled pieces he had in mind for his uptown debut, he needed a bigger place. It was a boon to work in the Green's large, well-lit gallery overlooking Fifty-Seventh Street, the extra-broad thoroughfare that slices Manhattan across its middle, the Hudson at one end, the East River at the other. Oldenburg remembered the street from his childhood, when on visits to the city from Chicago he and his family stayed nearby at the elegant Barbizon Plaza Hotel on Central Park South.[50] New York was a stopover en route to Sweden, where his father was a diplomat. "Fifty-Seventh Street was important because it led to the pier where the [ocean] liner was waiting."

Street sights were idea factories for Oldenburg. It was pleasantly unsettling to his sense of interior space to stand on the sidewalk, peering in through the front windows of Fifty-Seventh Street showrooms that sold grand pianos or Porsches and Jaguars. The supersize sculpture he would make at the Green triggered a similar disequilibrium,[51] juxtaposing "inner" and "outer" with manipulations of scale. One of his sketches for the show details an outsize human body in pieces, designed to dangle over the street, hanging from the Green's window like a vertical shop sign, visible from outside and inside the gallery.[52] In another, a huge layer cake rests in a room near a tent-size fedora, as if the wind knocked it off the head of a dapper giant. He'd stocked *The Store* with plaster sculpture, and that summer in the Green he worked with canvas. Pat Oldenburg's skill in stitching together canvas components on her portable Singer sewing machine was crucial.[53] Both of their names appear on the show's poster and invitations, hers inverted. The central image is a biplane, an acknowledgment of Pat's role in "getting us aloft."[54]

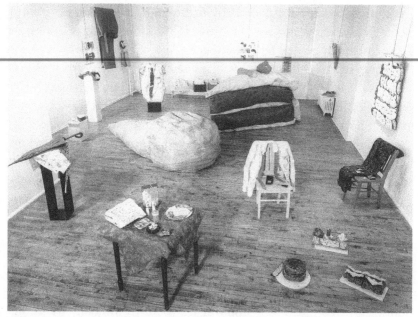

Green Gallery, *Claes Oldenburg*, September 18–October 20, 1962 (Photograph by Rudy Burckhardt, © 2015 The Estate of Rudy Burckhardt / Artists Rights Society [ARS], New York)

One of the smaller canvas sculptures, *Soft Calendar for the Month of August*, today in the collection of the Metropolitan Museum, is a tangible testament to the thirty-five days they labored in the stifling confines of the Green that summer. The larger pieces kicked up the size of three much-beloved foods: a hamburger plus pickle, a slice of chocolate layer cake, and a pistachio ice-cream cone. Cutting, stitching, and painting them was one thing, filling them another. The Oldenburgs' friend Robert Breer, an avant-garde filmmaker, laughed at the memory of sitting with his friends on the Green Gallery floor prior to the opening, stuffing chunks of foam rubber and cardboard ice-cream containers—each of which had to be folded into shape—into the voluminous innards of the burger.[55] Alone in the gallery one evening, Pat and Claes made love on the beef patty and covered themselves with the bun—"We almost choked from the heat of it!"[56] she later recalled. Yayoi Kusama was taken aback at Oldenburg's opening when she saw *Soft Calendar*[57] and recognized its kinship with her own innovative stuffed-canvas

work. She felt proprietary about it and regarded herself as the artist who "invented 'soft sculpture.' "[58]

Richard Artschwager had never heard of Claes Oldenburg when he dropped in at the Green during the run of his show.[59] A grouping of painted plaster bow ties caught his eye. Dick sent him downtown to meet the artist, who agreed to barter art for Artschwager's wood-working expertise. His was the hand that crafted the carpet-size wood bacon strips and mastlike toothpick for Oldenburg's BLT sandwich, a mammoth soft sculpture today in the collection of the Whitney Museum. When Oldenburg commissioned a base for a lingerie counter he envisioned, Artschwager proposed that he use Formica, a non-art material whose potential both artists would exploit in the coming years.

Days after Oldenburg's exhibit closed, the world at large found itself at the brink of nuclear war, seventeen years after the bombing of Hiroshima. To deter future assaults on Cuba following the failed Bay of Pigs invasion, the Soviet Union was determined to install intermediate-range nuclear missiles. The United States was equally determined to keep them out.[60] For a string of days that October, many Americans were gripped by apocalyptic fears.[61] Even Dick, avowedly apolitical,[62] would have been enveloped by the dread of those around him. The October 23 face-off between the superpowers was an ill-omened date for the opening of Dick's next show, the debut of the Bennington College art instructor Philip Wofford, who painted expressive abstractions. Wofford never forgot the palpable angst he and everyone else in New York felt at the time. On the cab ride to his opening, he looked out at the city passing by and wondered if it was the last time he'd see it as it was then.[63] Wofford's place on the Green's schedule, sandwiched between Oldenburg and Wesselmann, was a piece of bad luck. Dick couldn't sell Wofford's work, and his show went unreviewed. "Those collectors who can't swallow pop art have adopted a wait-and-see attitude," Dick reflected eight months later.[64]

Pop made its theatrical entry into the big-time business of art in Sidney Janis's *The New Realists*, which opened on Halloween night,

1962. Janis brought together pacesetters from both sides of the Atlantic,[65] a strategy he'd first used in 1950, when he showed emerging American talents such as de Kooning and Pollock alongside better-known French modernists. Oldenburg's *Lingerie Counter* (1962), bespangled with faux girdles and brassieres with torpedo-cone cups, had a prized place in the window of the ground-floor showroom Janis rented as an auxiliary space. Enlightened window-shoppers savored the irony, as did *The New Yorker*'s Harold Rosenberg,[66] of seeing art inspired by the schlockmeisters of the Lower East Side offered for sale on swanky Fifty-Seventh Street. "Art history was being made,"[67] declared Rosenberg, a critic respected for his historical acumen. After seeing *The New Realists*, Rosenberg concluded that the rhetoric of abstraction "has been reused until it is all but exhausted."

Punning on the autumnal season and the gallery's opportunism, Sidney Tillim commented, "Sidney Janis has moved in on the 'pop' craze at harvest time."[68] For Brian O'Doherty, writing in *The New York Times* only days after nuclear war had been averted, the find of the show was the Green Gallery's George Segal, whose tableaux of life-size figures were "as memorable and upsetting as stumbling into a ghost town dusted with fallout."[69] With the appearance of *The New Realists*, O'Doherty wrote, " 'pop' art is officially here." The West Coast curator Walter Hopps long remembered "how really insane the [*New Realists*] opening was."[70] Jean Tinguely "set the tone of hysteria," Hopps said, by doctoring a refrigerator given to him by Marcel Duchamp. The Swiss artist wired its insides with red lights and a loud siren that went off whenever anyone opened the door. Hopps thought that Tinguely's piece "set the noise and tone that was to continue all the way through the sixties."

Rosenberg's enthusiasm for *The New Realists* appalled many abstract expressionists and their supporters. Tom Hess, the editor of *Art News*, mocked the show as an "implicit proclamation that the New had arrived and that it was time for the old fogies to pack."[71] Some of the fogies in question—the veteran abstract expressionists de Kooning, Rothko, and Motherwell, as well as Philip Guston and Adolph Gottlieb—showed with Janis. Following a meeting to coordinate a joint response,[72] all except de Kooning resigned from

the gallery to protest its support of pop art. Such were their feel-
ings of betrayal, Oldenburg remembered, that the next summer
one of them kicked sand on a recumbent Sidney Janis as he sunned
himself on the beach in East Hampton.[73]

De Kooning was the only member of the old guard to attend
the opening. People remembered that he paced back and forth for a
while in front of the art and left the gallery without talking to any-
one.[74] "Overnight, it seemed, the art world changed," Guston's
daughter Musa Mayer would recall. "My father was in despair over
the selling of art, over the slick, depersonalized gloss . . . that was
taking center stage in New York. Art was no longer struggle; art had
become marketing."[75] There was no struggle in sight that November
when the Stable Gallery introduced New York to Andy Warhol's
silk-screened paintings of movie stars and soda bottles. Nor was it
evident at the Green a week later, when Dick gave uptown audi-
ences their first chance to see Wesselmann's latest still-life col-
lages and *Great American Nudes*, images that made explicit the implied
eroticism of commercial advertisements. Some of Wesselmann's
three-dimensional ensembles boasted working radios, fluorescent
lights, and household fixtures that extended into the gallery space.
The artist could not believe his good fortune that his show over-
lapped *The New Realists*, which "produced an outpouring of money.
It just came roaring in, and in my own show, when we sold the
show out—everything I did we could sell—a couple of things we
let go from the show and I painted new pieces to take their place.
It was like a machine."[76]

Some up-to-the-minute curators at MoMA wanted to orga-
nize a full-scale exhibition of pop, but others on staff were
unhappy about art with a stage-managed entrance. The idea for a
pop show was torpedoed by those who did not wish to see the
museum programmed by "a combine of galleries, collectors, and
promoters."[77] Perhaps in consolation, MoMA hosted a public
forum on pop late in the run of *The New Realists*, in which the art
historian Leo Steinberg found it apt to quote Victor Hugo, who
summed up Baudelaire's system of aesthetics in five words: "You
create a new shudder."[78]

Pop and its rapid pace of acceptance gave many the shudders.

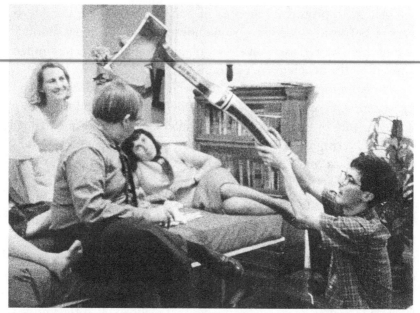

Dick jokes with Henry Geldzahler and a plastic hatchet as Claire Wesselmann and
Lois Karp (reclining) look on. Claire and Tom Wesselmann's apartment, Bleecker
Street, circa 1963 (Photograph by Jerry Goodman, collection of Claire Wesselmann)

"Everything gets known too quickly for there to be any space be-
tween the scouting party and the main body of troops,"[79] the painter
and World War II veteran Paul Brach commented, referencing the
original military context of "avant-garde." The artists in Dick's stable
were of various minds about pop. Robert Whitman *hated* it at first.[80]
"Then I realized that the reason I couldn't stand it was because it was
so terrific. Not standing it and liking it is the same thing, almost. I
was impressed." Beauchamp, a figurative expressionist, might not
have agreed with Whitman's koanlike equation, but he remembered
feeling "kind of glad"[81] when pop came along. "Abstract expres-
sionism had become dull and in such a stalemate. [Pop] was like a
fresh wind. At least you could see something you could react to.
Those people—Claes Oldenburg, others—were just brilliant."

For artists like Mark di Suvero, who saw the world through
the polarizing lens of leftist politics, art that cozied up to bour-
geois consumerism was contemptible, not to mention lowbrow.

Mark quit the Green "for reasons of conscience,"[82] as Dick politely phrased it in a later interview. Dick's embrace of pop must have seemed a betrayal to Mark, whose art, after all, had been his dealer's first love. "Pop art was a way of giving validity to commercial art,"[83] Mark remembered, "and I didn't want to be confused with commercial art. We thought that was what the struggle was. Now I think it was something different—the struggle was between figurative art and abstract art. At that time it was like war."

Mark decamped to join a group of sculptors and painters who wanted to opt out of the gallery system.[84] More hippie commune than Tenth Street co-op at the onset, the soon-to-be-named Park Place Group set up headquarters in a gallery-less downtown area around City Hall. "We started by sharing everything, our ideas, the money, the women,"[85] Mark said years later, acknowledging that their macho mind-set didn't survive for long. Although Dick's friends don't recall discussing politics with him, it's possible that he had unvoiced sympathy for the group's professed anticapitalism. Mark is not so sure. Dick "voted for Barry Goldwater for president in 1964,"[86] Mark recalled with exasperation, though Dick had just said so to goad his friend—in actuality Dick never voted.[87] Nonetheless, their friendship survived, and Dick occasionally attended Park Place's informal "noise-making" jams, where pot and free jazz ruled the day.[88]

At the tail end of 1962, Dick followed Wesselmann's splashy uptown entrance with Ronald Bladen's somber-toned, crusty-surfaced abstractions.[89] An older artist whom Dick revered, Bladen was then in transition from expressive wall-mounted reliefs to a cool signature style of freestanding geometric sculpture. It was terrible timing—three days after Bladen's show opened, a printers' strike and ensuing lockout shut down New York's seven major newspapers for a punishing 114 days. Wesselmann's show was widely reviewed, but Bladen caught the eye only of Donald Judd, who admired his rival's "boldness, size, simplicity and novelty" but dismissed his practice as "ultimately not enough."[90]

When Sidney Janis joined the expanding league of galleries

showing pop art, Dick's friends cautioned him that the more commerce-minded dealer would blindside him[91] with the not uncommon practice of "artist-napping."[92] They had reason for concern—in the fifties, the Janis Gallery used stipends to entice Pollock, Rothko, and Clyfford Still away from Betty Parsons, the undercapitalized, visionary dealer who had shepherded them to fame. ("Pussyfoot" was the nickname Dick and Ivan assigned to Janis during their Hansa days.)[93] The prophecies Dick heard proved accurate when, six months after Oldenburg's fall debut at the Green, he switched to Janis.[94] Perhaps Janis hadn't needed piratical tactics. Dick's shortcomings nettled Oldenburg. When Dick sold his work to Count Giuseppe Panza, he didn't consult with the artist before assuring the collector that Oldenburg himself would come to Italy—at his own expense—to restore any of his fragile pieces that might be damaged in transit.[95] Sometimes Dick wouldn't show up for an appointment they'd set, or would arrive late.[96] And Oldenburg wasn't happy when Dick put his own spin on a given artwork regardless of its title. "I had a sponge," he remembered, "that Dick insisted was a brain. It did look like a brain; it was a metamorphic piece. I think he sold it as a brain, not as a sponge."[97] The final straw, Oldenburg once confided to Artschwager, was an unsigned check he received in the mail.[98]

Dick's devotion to his artists was unfaltering; he was "a close friend to every artist he exhibited,"[99] but as time went on, Green Gallery artists found themselves torn between loyalty and the advancement of their careers. The Green was like a "brother gallery," Janis a "father gallery,"[100] Wesselmann once heard Oldenburg say. To Wesselmann, Dick "seemed like one of us," but he came to realize that as good a soul as Dick was, and as perceptive as he was, it was better to be represented by someone more adept at the business of art. Dick was a dealer who "held art in [his] hands like a hot coal, rather than as something that can be sited in history and talked over and over until someone else got the point,"[101] the New York Times art critic John Russell would write in admiration a decade after the Green closed. As pop art's fortunes rose,

Dick resolutely refused to exploit the opportunity. Worldly failure for him was a badge, Barbara Rose saw, proof of the principled disinterestedness "he pursued as relentlessly as had Alfred Stieglitz."[102] Yes, pop brought attention to the Green, but Dick had other, differently challenging art he wanted to show.

TOMORROW IS YESTERDAY

Of the several unprecedented group exhibitions Dick assembled on Fifty-Seventh Street, *New Work: Part I* may be the one that most influenced the taste of the sixties. In the first few days of January 1963, as people were adjusting to pop art, the Green gave them new cause to shudder by introducing the future exemplars of minimalism, op art, and conceptual art. Dick's fondness for art with explicit or covert erotic content was also in evidence, a trait in sync with the sexual revolution in progress in the wider culture. So dizzying was the speed of change embodied by *New Work* that it put the New York school abstractionist Jack Tworkov in mind of time travel. "Went to Green Gallery," the sixty-two-year-old artist wrote in his journal the day after the opening, "where tomorrow is yesterday, where yesterday was the beginning of ancient history."[1]

Donald Judd was a frequent visitor to the Green from the day it opened, but during the first two years Dick hadn't known that the critic he so admired was also an artist.[2] After hearing this, he asked Judd if he could be the first to see his work—"when you're ready." It's not known if Judd ever told Dick he was "ready." The first time Dick saw Judd's work was in spring 1962, the day he went to see Kusama and she brought him upstairs to Judd's studio.[3] Dick was so enthusiastic about what he saw that he urged Judd to approach Castelli, "since [Castelli's] gallery was the best to be with in every way."[4] But Judd didn't want to start out "on top," preferring the

Green Gallery, *New Work: Part I*, January 8–February 2, 1963. (On floor) Judd, *Untitled* (1962). (Clockwise, from left) Judd, two untitled reliefs (1962); unidentified artwork; Kusama, *Accumulation* (1962–63); unidentified painting; Poons, *Slice and Reel* (1962) and *Cripple Creek* (1962); and Andrejevic, *United Desires* (1962) (Photograph by Rudy Burckhardt, © 2015 The Estate of Rudy Burckhardt / Artists Rights Society [ARS], New York)

provisional spirit of the Green. He felt that neither he nor the Green had yet made a "complete statement." Dick conjectured that Judd's decision "might have been as simple as the fact that the Green Gallery space was larger than the beautifully proportioned room at Leo's . . . but in the end I think he was sincere about entering the art world in some less-established way."

Judd had started out as a painter. He debuted as a sculptor in *New Work*, with two large wall reliefs and a stunning floor piece of perpendicular wooden boards linked by an angled black pipe. He painted its panels and the reliefs a color resembling industrial underpaint, a blazing red-orange that, in his thinking, heightened awareness of edges, lines, and textures. One of these was enormous, with flanges at top and bottom aggressively projecting a foot into the spectator's space; the other, a rectangle, had a long, narrow slit with protruding metal triangles. Judd never titled his works, an inventory headache that Dick cured by casually assigning his own names—the slotted relief became the *Letter Box*, or the *Kleenex Box*.[5] But Judd had no sense of humor about his work.[6] He may have tolerated

some initial jocularity from friends,[7] but in time, the quips enraged him. Given Dick's instinct for mischief, it is possible that the more Judd expressed his displeasure with nicknames, the more his dealer continued to assign them. When asked about the nicknames in a 1976 interview, Judd erupted, "That's that bastard Bellamy who did all that."[8] He dismissed the names Dick put on the backs of photographs as "not titles at all. That's Bellamy slang. That's just gallery slang."

For Judd's friend Dan Flavin, titles were handles to meaning. *New Work* included two of Flavin's electric light sculptures, never previously shown. Knowingly ironic, Flavin called this series of abstract constructions "icons" and dedicated each to a person who had inspired him. Traditional icons venerate the holy, and many have gold backgrounds that shimmer in guttering light. In Flavin's iteration, electric bulbs provide a steady radiance. The series was inspired by the narrator in Ralph Ellison's 1952 novel, *Invisible Man*, who gains visibility, if only to himself, by installing more than a thousand lightbulbs in his basement room, powering them with stolen electricity.[9] Flavin's electrified series began as sketches he drew in moments snatched during his workday as a guard at New York's American Museum of Natural History. When his supervisor warned him, "Flavin, we don't pay you to be an artist," he agreed, and he quit.[10]

He drew dozens of icon proposals but translated only eight into three-dimensional objects. Dick chose two for *New Work*, one evoking the spirit, one the flesh, and hung them side by side between the windows. *Icon IV (the pure land) (to David John Flavin 1933–1962)*, a white Formica square, commemorated the artist's twin brother, David, who died of polio while he was making it. The radiant, fluorescent glow from its one electric light hinted at the soul's immateriality. By comparison, *Icon V (Coran's Broadway Flesh)* seemed resolutely corporeal. Flavin arranged twenty-eight incandescent "candle" bulbs in porcelain sockets belly to belly around the perimeter of a pink square, a visual nod to brightly lit dressing room mirrors and the razzmatazz of a Broadway marquee. He thought of *Icon V* as an "emblem"[11] of what today would be called gay identity, telling a prospective buyer that he named it after a friend, "a young English homosexual who loved New York City." Virginia Dwan, a Los Angeles collector and gallery owner who would in time back many

of the artists championed by Dick and Bob Scull, never forgot seeing *Coran's Broadway Flesh* in *New Work*, a show that introduced her not only to Flavin but also to Morris and Judd. "[The exhibition] was so offbeat at that moment in art history," Dwan recalled in the eighties, "and it really stood out very strongly in my mind."[12]

Larry Poons's never-before-seen dot paintings in *New Work* had the wattage of a Pachinko parlor, powered not by electricity, but by the energy generated by vibrating green spots of spray-on fabric dye in a field of red. Brian O'Doherty, a critic and physician, explained to his readers that when our eyes fix on a few of the painted dots, those in the peripheral field of vision "begin to hop and snap and jerk,"[13] leaving afterimages of the opposite color. "Thus these paintings become a screen of images and afterimages, dancing around in an electric and upsetting Morse code." *Slice and Reel* was an experimental shaped canvas with a perilous section that jutted out at shin level. Next to it Dick hung the luminous *Cripple Creek*, Poons's breakthrough painting, the first of his series of optically assertive, anti-compositional paintings, later treasured as "among the most vivid visual manifestations of New York in the '60s."[14]

Dick found the paintings "ravishing."[15] He loved to pronounce "L. Poons," as the artist then signed his work, jokingly telling people that he chose the artist for the sound of his name.[16] Poons was twenty-five years old at the time of *New Work*, a member of the generation whose identity was shaped by the movies, particularly Marlon Brando in *The Wild One* (1953) and James Dean in *East of Eden* (1955).[17] Tellingly, one contemporary critic found Poons's paintings "lyrical without a melody."[18] He had studied music before he began to paint, and he earned his bona fides as a Beat in 1959–60, when he and friends ran the Epitome Café, a Greenwich Village coffeehouse where poets read and Jack Kerouac once banged on Poons's guitar as if it were a bongo drum.[19] Poons and several other Cage-influenced music enthusiasts played gigs together as the New York Audio-Visual Group.[20] He heard Ornette Coleman's music for the first time just as he was finding his way as a painter. The experience was catalytic. "Yes, it's possible . . . to make new, exciting stuff,"[21] Poons remembered saying to himself in response.

It was Geldzahler[22] or Rosenquist—perhaps both—who alerted

Dick to Poons, triggering the artist's transformation from someone supporting himself as a short-order cook to a painter with a Fifty-Seventh Street waiting list. Bob Scull did not have to wait in line—he became the first collector to own a Poons. Speaking to the camera in *Painters Painting*, Emile de Antonio's 1972 documentary film about the American postwar art world, Scull says that he'd been so impressed by Poons's work that he'd given him eight weeks' worth of his cook's salary in exchange for a painting and never mentioned Dick.[23]

Conceptual art was a category awaiting its name in January 1963. Dick had already shown Morris's performance props. In *New Work* he introduced the artist's *Card File* (1962), a work about its own creation. Seemingly a piece of functional office equipment, it hung on the wall with its metal lid propped up,[24] an implicit invitation to flip through the alphabetized, cross-referenced texts sheathed in slanting plastic sleeves. These straight-faced informational entries added up to a creation saga, a task-based, improvised process in the spirit of choreographer Anna Halprin. On the card labeled "Mistakes," Morris recorded the "total number [of] typing errors" he made during *Card File*'s execution—twelve by December 31, 1962—and revealed that it was none other than Dick who discovered that he'd incorrectly spelled the word "stationery" as "stationary." Morris's hollow *Column* (1961), a favorite of Dick's,[25] was also in *New Work*. For the artist's first performance at the Living Theater, Morris hid himself inside the 8 × 2 foot prop, intending to surprise the audience by tipping it over as if it moved on its own volition.[26] But it was impossible to control as it hit the ground, and his resulting head injury required stitches. As a work of sculpture, *Column* was not much admired by Judd or Samaras, who "kept shoving it around the room so as to get it out of the way of everything else."[27] (It ended up in a corner near the windows.)

As he did with Morris, Dick used *New Work* to show two facets of Samaras's practice, pastel drawings of nudes with interlocking knees, and the artist's astonishing new pin boxes, "shimmering with hostile straight pins and stuffed with suppurant relics,"[28] in Sidney Tillim's graphic description. By his own telling, Samaras was an artist attracted by the "high erotic content in things iridescent, sparkling, fragile, sharp, oily, hairy . . . but all of these things with control."[29]

Eros infused Yayoi Kusama's tall cabinet, a "jam-packed assemblage of stuffed white erections."[30] Few would have missed the erotic undertones in *New Work* as they moved on to Milet Andrejevic's[31] *United Desires*, a spare geometric painting of carnal safe-deposit-box cylinders,[32] and George Segal's *Lovers on a Bed*, where a postcoital couple lay facing each other, entwined like the duos atop Etruscan coffins.[33]

Interest in Rosenquist grew exponentially in the fifteen months following his Green debut in 1962. Dick had been saving 1963's end-of-season spot for him, but he scrambled to find a substitute when the curator Dorothy Miller commandeered several of Rosenquist's new paintings for MoMA's *Americans 1963*[34] and Lawrence Alloway siphoned others for the Guggenheim Museum's *Six Painters and the Object*.[35] Dick filled the void with *Contemporary American Group Show*, a selection of geometric abstraction and crisp-edged minimalist art that included work borrowed from other dealers. Ellsworth Kelly's

Green Gallery, *Contemporary American Group Show* [*New Work: Part III*], May–June 15, 1963. (On floor) Morris, *Wheels* (1963), and Judd, *Untitled* (1963). (Clockwise, from left) Poons, *The Enforcer* (1962); Stella, title unknown; Kuwayama, *Untitled* (1961); and Kelly, *Gaza* (1952–56) (Photograph by Rudy Burckhardt, © 2015 The Estate of Rudy Burckhardt / Artists Rights Society [ARS], New York)

majestic *Gaza* (1952–56), a red-and-yellow painting on loan from Betty Parsons, had the prime wall between the windows. Judd's red, bleacherlike progression of parallel treads and Morris's huge Vitruvian *Wheels* (1963) sat on the floor in front of it. Castelli lent Frank Stella's painting of concentric squares of high color, which Dick hung on the east wall next to Larry Poons's *The Enforcer* (1962). In one eyeful, visitors entering the main gallery saw the prominent "*X*" in Stella's composition echoed in the crossed spokes of Morris's wheels.

If you stood with your back to the west wall, you could see what Dick saw, the linear rhythms of Stella's strong horizontals resonating in the treads on Judd's floor piece. A painting of elemental geometric forms by the young Walter Darby Bannard, making his debut, added to the mix, as did Kenneth Noland's painting of concentric circles in bold contrasting colors, an abstraction both gestural and minimal. Dick and the artist were good friends,[36] and for a short time in the early sixties, perhaps when Noland was between studios, his orgone box lived in the Green's back office.[37]

The historic group shows Dick organized at the Green reflect the creative chaos of the early sixties, "a jumble of concurrent events, attitudes and discoveries," as Richard Artschwager later described it.[38] Dick's purview was broad, his eclectic taste a brand in itself. By 1963 his ads in national art magazines read "the green gallery/contemporary art,"[39] without naming names. Dick's "names" did not necessarily like one another's company. Di Suvero had no time for pop art or for Morris's plywood boxes; and Morris "wasn't all that taken with the aestheticized preciousness" of James Lee Byars, a performance artist Dick showed at the Green.[40] "The history of art and art's condition at any time are pretty messy," Judd wrote a year after *Contemporary American Group Show*.[41] "They should stay that way." Dick thrived on aesthetic disarray and gravitated toward art he didn't understand. "Don't look at things that you immediately like," Dick advised Hanford Yang, a young, solvent MIT-trained architect who happened into the Green and became a client.[42] "Look at things that bother and agitate you. The things you don't like are probably the things that challenge your brain." In the brief lull before critics and art historians

grouped artists into separate categories, "we were all in there together," said Larry Poons.[43] "There weren't any distinctions made between the abstractness of, say, Stella, Lichtenstein or Warhol. Nobody was drawing any lines . . . everything existed together on the same wall, and it was fine."

DARK GREEN

Dick began to unravel during the Green's fourth year. The third season had been his most successful—pop accounted for 80 percent of his sales[1]—and he'd done three times as much business as the previous year, but he managed only to break even. To stay competitive with the better-capitalized Janis, Castelli, and Marlborough-Gerson galleries,[2] Dick had begun to match their practice of advance payments to artists against future sales.[3] These monthly drawing accounts held the promise of a living wage for artists but drained the Green's profits.[4] Nonetheless, Dick resisted raising prices—to do otherwise was greedy according to his worldview. His arrangement with Scull may have seemed a Faustian bargain. He had the gallery he'd dreamed about, but at what price to his soul?

Pressured to turn a profit at the Green, Dick was suffering even more stress at home. Sheindi gave birth to their son, Miles Curtis Bellamy, on December 4, 1963, two days after Dick turned thirty-six. The baby's name honored Dick's dad, Curtis, and Miles Forst, his best friend, with a nod to the great Miles Davis. "We all waited in great anticipation for the new baby to arrive," remembered Emilio Cruz,[5] who was out at a party with Dick and Miles Forst the evening Sheindi's water broke. On hearing the news, Dick and his equally plastered pals headed for the hospital. "Give the baby a modern name," Emilio teasingly suggested along the way, "like Aluminum, Chrome, or some chemical lifted from the peri-

odic table." But Dick wasn't convinced. His own names included "Agony, Ruth, Minnie, Shirley, Shitty, or Helen, if it is female, or Richard, Curtis, George, or Roscoe if 'male.' "[6] During their ride, Emilio, Miles, and Dick kidded about circumcision, should the baby be a boy. As a follower of Reich, Sheindi strongly opposed the practice, and the men traded tales of the pros and cons. When the trio of drunks arrived at the hospital, Dick must have been a mess—he wasn't allowed past the front desk.[7]

Dick's private life grew increasingly public. Castelli remembered that his friend became "jittery, pushy when he had too many worries."[8] His artists were aware that Dick had "personal problems," Wesselmann said discreetly in a later interview, problems he "didn't know much about."[9] "Love problems," Rosenquist baldly stated in his autobiography, without elaboration.[10] Dick was trying to control his drinking, and he turned for help to Harry Smith,[11] the avant-garde filmmaker, musicologist, and painter. Smith introduced him to various mood-altering drugs as potential replacements for alcohol. "Dick was curing himself from one thing by doing the other, whatever was easier to get and would take away the pain," his neighbor Sherman Drexler recalled.[12] But Sheindi laid down the law about smoking pot in front of Andy and Laurie, and Dick was spending more and more time at the Grosses' apartment,[13] just across East Broadway. By late 1963, many of their mutual acquaintances were aware that Dick and Sally had become lovers,[14] but it wasn't until the morning Sheindi walked out of her building and saw Dick at Sally's side, negotiating her baby carriage down her front steps, that she recognized she'd lost him.

In the early sixties Sheindi and Sally constituted bright stars in the interlocking constellations of Lower East Side friendships. The two were in and out of their friends' creative lives. Jill Johnston tapped them both, as well as Emilio Cruz and LeRoi Jones (the future Amiri Baraka), for her uproarious *Dance Lecture Event # 2*[15] at the Judson Memorial Church. Dick would have been there, as he must have been for *Check* (1964), the dance Morris choreographed at the Judson, when he corralled Sally and her young daughters Rachel and Sidonia, as well as Sheindi's Andy and Laurie, to "wander" in and among the audience as part of a cast of forty.[16] At an early performance of

Yoko Ono's *Bicycle Piece for Orchestra*,[17] a photographer shot Dick and Sally sitting on the sidelines as pigtailed Rachel performed the score on her two-wheeler, a score consisting of two instructions: "Ride bicycles anywhere you can in the concert hall. Do not make any noise."[18]

Sally was part of the developing community of postmodern dancers at Judson, dancers in the process of defining the remarkable era's new "joyous defiance of rules."[19] For one 1962 piece, the choreographer Elaine Summers told Sally she could wear anything she wanted, and she chose a red sleeveless leotard, no tights, no bra, and she did not shave her legs—"I knew I was the first person who ever came out on a dance stage looking like that."[20] Judson dancers were conscious of their role in effecting change. "I was aware, and I think many of us were, that there was ground to be broken, and we were standing on it," reflected Yvonne Rainer.[21] Dick was in the background at Judson, the critic Dore Ashton remembered, helping to organize events and advising them on attracting the public— "because he was good at that."[22]

The Green's fourth year began with one of Dick's classic mélanges:[23] a show with a Segal nude sitting on a bed, folk art–ish sculpture by H. C. Westermann,[24] and a modestly scaled painting of a type-writer by Sidney Tillim, who was a painter as well as a writer. At the show's end, Dick purchased the Tillim,[25] one of his rare acquisitions. The peripatetic performance and installation artist James Lee Byars was next up. By his own description the "World's Most Famous Unknown Artist,"[26] Byars was, like Dick, a connoisseur of irony. Both men scripted themselves as eccentrics, roles that could be improvised but never relinquished. In the course of the next three decades the two would work together on a number of performance-based projects, with no tangible product to sell.[27]

Dick respected artists as society's elite,[28] and he tried never to say no to those he supported. He found space at the Green for at least one of Byars's eastern-inspired minimalist performances in 1963; just when is uncertain—the documentation is tantalizingly

vague and contradictory.[29] All accounts mention the artist unfurling long scrolls of paper or silk across a platform of one hundred handmade white boxes that ran the length of the Green's main room.[30] For one performance Byars donned an egg-shaped headpiece and dressed an accomplice in a white couturier gown.[31] Yvonne Rainer wore a black dress and heels and danced improvisationally[32] around the "sea of white boxes"[33] as Andy Warhol's movie camera whirled.[34] Perhaps it was another event that included a little girl who periodically entered the spare, minimally designed set to read poetry by Dame Edith Sitwell.[35]

Morris's fall debut provoked a mini avalanche of critical attention.[36] Devoted visitors to the Green would have been familiar with the artist's *Slab*, *Column*, and *Card File*. These were back for a bow in October, this time in the company of two sets of relatives, one minimal, the other conceptual. Morris's show was "a major event of the current season," declared Brian O'Doherty, who assigned the artist to the pop art camp.[37] "In Pop you are as good as your ideas, and Mr. Morris's are good," O'Doherty enthused, pointing to the "enjoyable frustration" of the artist's "grunting box that won't open." Dick sold this *Box with the Sound of Its Own Making* (1961) to the Seattle collectors Virginia and Bagley Wright, who later donated the iconic work to the Seattle Art Museum. Like *Card File*, it documented its own creation, this time aurally. A small loudspeaker hidden inside a well-crafted wood cube broadcast the sounds of its construction, three and a half hours' worth of sound. It was a performance, really, or at least it was considered so by John Cage, who listened to it in its entirety when he visited the artist's studio before the show.[38] In a letter to Jinny Wright soon after the sculpture arrived at their home, Dick inquired, tongue in cheek, if the noisy sculpture "is keeping you up at night."[39] Morris, he reminded her, had been reluctant to part with it. "I was sublime about your having it and the artist, like a slow fuse, is accumulating happiness, the poor, grey glum soul."

Morris played with the idea of artistic ego in *I-box*, a small box in the shape of the letter *I*. A frontal photo of the naked artist waited inside, invisible until you opened the door. A shameless

Green Gallery, *Robert Morris*, October 15–November 2, 1963 (Photograph by Rudy Burck-hardt, © 2015 The Estate of Rudy Burckhardt / Artists Rights Society [ARS], New York)

punster, Dick enjoyed telling people that the artist/artwork was "well hung."[40] There were other clever self-portraits as well as such pieces as *Litanies*, today owned by MoMA, a small lead-covered box with a keyhole and twenty-seven keys, each engraved with a word from the writings of Marcel Duchamp. The seventy-six-year-old grand-Dada himself not only went to see Morris's show but also paid a visit to his studio—and was "extremely excited" by what he saw.[41] "Dada, poor dada, Morris had hung you on the wall and I'm feeling so glad," chortled the *Herald Tribune*'s review,[42] punning on the title of a recent Broadway farce, *Oh Dad, Poor Dad, Mamma's Hung You in the Closet and I'm Feelin' So Sad.*

The MoMA curator and collector Philip Johnson bought several pieces, including *Litanies*,[43] "half because he wanted them, but half to help Dick,"[44] his partner, David Whitney, recalled. Scull took home the artist's padlocked bronze cupboard with its tantalizing directive embossed across the front: LEAVE KEY ON HOOK INSIDE CABINET. He already owned Jasper Johns's *Painted Bronze* (1960), a kindred sculpture of two bronze cans of ale with painted trompe

l'oeil labels. The conundrum of Morris's impenetrable cabinet intrigued the Scull children, who discovered a way to bypass its chunky lock by tunneling in from underneath, to leave one of their own keys inside.[45]

Following Morris's splashy entry, Larry Poons made his debut; and not unexpectedly, his eye-dazzling canvases also attracted favorable press and the interest of collectors. There was even a humorous review in a little-known Beat newsletter,[46] which connected the painter's effervescent dots with the perky singers of the swing era: "Larry Poons's dotty paintings have more bounce than the Andrews Sisters." For Poons's poster-size invitation,[47] Dick showed the artist in helmet and grimy overalls, astride his beloved BSA Gold Star motorcycle. His wife, Thalia, perches behind him, unseen but for her hands mischievously covering his eyes with two spoons, creating a Bellamyesque pun on his name. *Life*'s 1948 photo of a smoldering Jackson Pollock exemplified the cult of artistic personality, but it was still a novel practice in the early sixties to call attention to the artist himself on invites and ads.[48]

"Not this time, Green Gallery, not this time,"[49] admonished the *Times*'s umpirelike chief critic, John Canaday, regarding Donald Judd, the gallery's third introduction in a row. Canaday spoke for those nonplussed by Judd's red-painted constructions when he dismissed them as "merely an excellent example of 'avant-garde' nonart that tries to achieve meaning by a pretentious lack of meaning." The *New York Post* critic Irving Sandler, who cut his eye teeth on abstract expressionism, had no trouble finding meaning, but the muteness of the art depressed him: "There is little room for man's spirit in this world of dumb things."[50]

In the nearly two years between Rosenquist's debut and his second show in January 1964, the average price for his paintings zoomed from $600 to $4,000.[51] A cynical TV reporter tried to bait Dick at the opening[52] by proposing that sales were the sole reason he was showing Rosenquist. "That is not the first reason; no," Dick responded with deliberate slowness. "For people to see the paintings. It's a world, after all, that an artist has made out of nothing. When

he has an exhibition, he wants to be judged with the highest kind of scrutiny possible, with the highest kind of standards."

The explosion of interest in American artists that Dick helped to ignite left him shell-shocked. Some of his bestselling artists had to face the fact, as had Oldenburg, that their futures were elsewhere. Dick's insouciance about money disgusted Rosenquist, who as early as 1963 explored the possibility of joining Castelli's stable.[53] "Stay there and perhaps things will improve," Castelli counseled, feeling it would betray Dick if he took him on. Months later, the artist again brought up the subject, threatening to approach Janis if Castelli didn't act. This time Castelli said yes. Years later Castelli learned that Dick had already advised Rosenquist to leave "because he felt that he couldn't do well enough for him." Nonetheless, it must have been wrenching for Dick. "I'm very sorry to lose you," he told Rosenquist when they parted ways. George Segal too was in a quandary, torn between loyalty to Dick and advancing his career. In the summer of 1963 Segal had had a taste of how other dealers handled business when he debuted in Europe at the Paris gallery of Ileana Sonnabend,[54] Leo Castelli's former wife and longtime adviser. When Segal talked to Dick about his dilemma, his old friend encouraged him to go with Janis, knowing he could never match Janis's offer of a guaranteed $20,000.[55]

Dick's son, Miles, was only three days old when Dick described himself as "the purest walking zombie"[56] in the weeks leading up to the birth. "Had I been somehow able to get to St. Louis," Dick wrote to his friend Adam Aronson, a Missouri financier and collector, "all the television programs would have turned to spook shows." The highly publicized occasion he missed was the entwined openings of Aronson's bank in a suburban St. Louis shopping center[57] and a pop art show that Dick and the Castelli Gallery organized. In the sixties, banks usually attracted new accounts with such giveaways as toasters or redeemable S&H green stamps. But Aronson imaginatively inaugurated his bank with a six-week exhibition of pop art. Castelli flew out for the event. Sheindi, nearing her due date, must have been glad to have Dick remain close to home. As Castelli waited at LaGuardia Airport for his outbound flight, a *Wall Street Journal* reporter interviewed him about the recent spate of art

exhibitions in nontraditional venues.[58] "Banks have dignity and character," Castelli explained; "the art dealer should have mobility in showing his paintings to the public." "We are not in the art business,"[59] Aronson clarified in his interview with the St. Louis financial reporter assigned to cover the show. "But instead of having reindeers running around our bank at Christmas . . . or giving out lollypops or popcorn, we are bringing the people culture." In return, the new culture of pop brought Aronson's enterprise unmatched publicity.[60]

When baby Miles was two months old, Judd and his future wife, Julie, paid a visit to East Broadway.[61] Dick was playing with his son when they walked in, Julie remembered, "bouncing him on his knee. Don made a point of noticing that the baby had no diapers on, and he was quite startled . . . He thought this was bohemian. I saw this sink full of dishes . . . Sheindi Tokayer was an actress, so I took that all in . . . and I washed the dishes for her." Sheindi's acting career was then on hold. She'd studied at the Herbert Berghof Studio[62] in Greenwich Village and passed the tough audition for Uta Hagen's class. The celebrated actress was starring on Broadway as Martha in Edward Albee's *Who's Afraid of Virginia Woolf?*, the bitter character Elizabeth Taylor would portray in the screen version. When the part of young Honey opened up, Hagen recommended that Sheindi try out for it. But a long-running play is no place for a pregnant actress, and the opportunity passed.

Sheindi had a good singing voice, and in the spring of 1964 she landed a part as the nun in *Home Movies*, their friend and neighbor Rosalyn Drexler's "socially outraged, and sexually outrageous"[63] one-act musical.[64] Reverend Al Carmines, the Judson Memorial Church's ebullient assistant minister, composed the score and played opposite Sheindi as Father Shenanigan. Andy Warhol's talented but troubled friend Fred Herko also had a role in this bawdy spoof.[65] During the months when Dick's not-so-covert affair with Sally put a strain on his relationship with Sheindi, he was there for every performance of *Home Movies*.[66]

One tequila-laced afternoon in early June, John Chamberlain

arranged to meet Dick and Larry Poons at the Provincetown Play-house in Greenwich Village when the play let out.[67] Chamberlain was often ornery when he drank. In the early evening he got himself kicked out of the Kettle of Fish, a neighborhood tavern, and whiled away the remaining time in a basement champagne bar next to the theater on Macdougal Street. As Chamberlain recollected, he was "smashed" when he left to find Dick, and he noticed a patrolman in the doorway of a bar that had a COME ON IN sign. "Come on out," he bellowed at the cop. A crowd of onlookers gathered as he kept up his belligerent banter. Sheindi's friend June Ekman watched as Chamberlain "took on the horse"[68] of a mounted policeman. By this time, Dick was with him, and the animal cornered both of them against a wall. Dick managed to slip away, but his friend did not. A nightstick came cracking down on Chamberlain's head. He was then arrested and charged with disorderly conduct and third-degree assault,[69] and he spent that night at "the Tombs," the street name for the police detention center in Lower Manhattan. After Ivan Karp posted bail for him the next morning, Chamberlain—his head wounds stitched and bandaged—went home to pack. He and Dick were flying to Venice, the first trip abroad for each.

The Venice Biennale was the art world's grand stage, where only a few artists had speaking parts; most were walk-ons. Founded in an era of nationalistic fervor at the end of the nineteenth century, it grew in prestige over time, and by the sixties, nations tussled for top billing determined by jurors who met in secret every two years to award prizes for artistic excellence. In 1964 Chamberlain was among the artists chosen by Commissioner Alan Solomon to represent the United States—the reason why he was going to Europe. Dick, unconnected by business with his good friend Chamberlain, probably had multiple reasons for making the trip. The day of their departure, the two arrived at JFK only to discover that foggy-headed Dick forgot to bring his passport.[70] Sheindi drove it out to the airport, accompanied by June holding baby Miles on her lap. But it was too late—they missed their flight. The next one out routed them through London, with a long layover. Once aloft, the duo worked their way through a bottle of Scotch, and in London

they hired a cab to drive them around, memorably, to see the Turners at the Tate. By the time they touched down in Venice, they were nursing twin hangovers and were disappointed to learn they'd missed the first round of parties.

Despite the ascendancy of New York school artists in the postwar period, non-Europeans rarely received the top awards at the Venice Biennale. In 1952 the sculptor Alexander Calder was the first American to win the highest honor. Castelli and Sonnabend hoped that Robert Rauschenberg would be next—in the preceding months, the two had trumpeted his formidable talents.[71] Rauschenberg, Chamberlain, Johns, and Stella—all represented by Castelli—were four of the eight post–abstract expressionists Solomon selected for the American pavilion, a fact that raised eyebrows.[72] Rauschenberg was already well regarded abroad, having shown in London and Paris, while few in Europe had heard of Chamberlain or had seen his sculpture made from scraps of crushed automobiles. Sonnabend, who represented Chamberlain abroad, cleverly scheduled his European debut at her gallery directly following the Biennale's opening week.

Dick and Chamberlain—one in a crumpled suit,[73] the other with a bandaged head and plump handlebar mustache—were swept into the cosmopolitan crowd gathering force for the Biennale's opening festivities, fueled by free-flowing Bellinis, the Venetian mixture of Prosecco and peach puree. At one reception Dick met Nancy Fish, a twenty-six-year-old American actress. In the autobiographical novel she wrote years later, Fish included a thinly veiled account of their love affair. Dick is the "sleepy, slippery eel" who squiggled into her world by "pressing a joint to my mouth, a champagne glass in my hand, a kiss on the cheek."[74] Their magical time together began with a late-night gondola ride to the Lido, where they walked along the shore and made love beside the moonlit Adriatic. Fish and her "Ezra-Pound-quoting, Camel-smoking art dealer" would breakfast on brandy-laced, hair-of-the-dog *caffè lattes* and brace for the raucous onslaught of "American painters, Time-Life people, critics, correspondents, collectors, curators, dealers." Castelli, the man of the hour at the 1964 Biennale, would have been the American gallerist most sought after by European dealers; but with

word spreading about Morris, Judd, and Poons, and the demand for Rosenquist, Wesselmann, and Segal exceeding the supply, Dick would have been a close second. Perhaps it was in Venice that summer that Dick first met the dealer Robert "Groovy Bob" Fraser,[75] who in 1962 had opened a gallery in London, one of the first in Britain dedicated to cutting-edge art.[76]

He and his beautiful companion likely crossed paths with the Sculls every day. As early collectors of Rauschenberg, the couple were rooting for him to win. Despite the officials' last-minute bureaucratic wrangling over technicalities,[77] Castelli and Sonnabend's strategic politicking succeeded, and the jurors awarded Rauschenberg the Biennale's grand international prize in painting. Ethel's exaltation at his success could only be matched by *Vogue's* lavish spread on their home and art collection a few weeks later, confirming her status as a superstar of art and fashion.[78] But for Dick and the Green Gallery, Rauschenberg's success proved to Scull that he no longer needed privileged access to Dick's artists. He was a profit taker, and it was time to step away.

In all likelihood, Scull had broken the news *before* they all left for Venice.[79] The end of an art season provides a natural closure in the life of a gallery. Business slowed in the summer months; galleries went quiet and phoenixed in the fall. Perhaps Scull rationalized that Dick didn't need him anymore—so many of the Green's artists were selling well. Yet these very triumphs were dilemmas to Dick. He was morally compelled to soft-pedal accelerating prices even as his cash advances ate up his profits. His artists needed more of everything in 1964. When Judd began to work in metal rather than wood, Dick struggled to find the money for this more expensive material. "I wasn't able to support the artists in the style to which they were beginning to become accustomed," Dick recollected with characteristic humor.[80]

As their time in Venice drew to a close, Nancy Fish had the measure of alcohol's importance in her new lover's life. On the eve of Dick's departure for Paris—he and the collector James Michener planned to travel together to attend Chamberlain's opening[81]—he kept her waiting for hours at the Caffè Florian on Piazza San Marco. Just when she was about to give up and leave, she spotted him at a

café across the square. He was so far gone, Fish described in her novel, that when he stood up, "he toppled the chairs over backwards and collapsed on top of her."[82] Dick's mood was grim when he returned home that summer, remembered Lewis Winter, one of the young collectors who patronized the Green. "All those European dealers wanted stuff from him," Lewis said. "He came back mumbling 'the world's changed; I don't know quite how to handle it.' "[83] Chamberlain was on the threshold of an international career, but Dick let the opportunity slip away like a fistful of sand. Dick was "the wrong man at the right time," Larry Poons reflected decades later.[84]

The domestic storms Dick set in motion before he left for Europe did not abate. He'd pressed Sheindi's tolerance to its limit. Life with a straying alcoholic partner was hard enough, but sharing him with Sally topped it all. Dick's weeks in Europe gave her space to think. She found someone to replace her in *Home Movies* and fled to Provincetown.[85] But when Dick returned, he tracked her down there and promised he'd stop drinking if she came back to New York. But as the Green began its fifth year in September, this time without the prop of Scull's support, Dick would not, or could not, stop drinking. Nor did he stop seeing Sally. That fall and winter, during the untidy dissolution of the life he'd built with Sheindi, there were mornings when she discovered Dick asleep on her front stoop, his abject, lifelong response to domestic discord. Still, Sheindi did not want her life with him to end. "I was arrogant," she confessed fifty years later. "I never thought he'd leave me." But eventually he told her, "Sheindi, you have to let me go,"[86] and she did. By then, heroin had demolished Sally's marriage to Teddy Gross, and Dick switched households and moved in with Sally.

The women's friendship snapped, and their mutual friends aligned themselves behind one or the other, depending on their view of Sally as sanctuary or siren. Except for the time in 1966 when Sally phoned to let Sheindi know that Teddy was dead,[87] thirty-five years would pass before the two spoke again.

WRONG MAN AT
THE RIGHT TIME

It's a wonder that the Green had a fifth year at all. "I don't know, Jim. I just don't know . . . I don't think I'm going to open the gallery this fall . . . and I think I'm going to close it forever in the spring."[1] Rosenquist vividly recalled Dick's muttered soliloquy, precipitated most likely by Scull's retreat. Dick was angry and sullen when the Green reopened in September 1964. He had "great animosity" toward Scull for abandoning him, one of his collectors remembered, but "expressed it just in passing."[2] In truth, he'd lost more than his backing. "Dick was best when he had something that rubbed against him," recalled Samaras.[3] With neither flint stone nor support, Dick drank more, which in turn fueled his depression. In one harrowing incident he'd climbed up on a gallery window ledge and had to be talked down.[4] He was in a "terrible state," said Sheindi, who remembered an evening when Miles Forst found him walking down Canal Street toward the Manhattan Bridge.[5]

Not only was Dick without a backer, but he'd lost his assistants. Jeanie Blake had sat at the front desk or in the back room typing the communiqués he crafted between sips of bourbon. Her sangfroid had been immediately apparent to Dick during her job interview when he lay on the floor and she carried on unperturbed.[6] He'd hired her on the spot. Perhaps in reaction to Scull's pullout, Dick left for Venice without letting her know that the job picked up again in September.[7] When he tried to hire her back, she was no

longer available. The personable Samuel Magee Green Jr. worked alongside Jeanie doing general office maintenance.[8] Dick enjoyed the confusions generated by his surname, and Sam, for whom truth was a malleable commodity, did not correct people when they assumed the gallery was a family business. Like his friend Andy Warhol, Sam was a born social climber, and he gave his name as "Samuel Adams Green" to convey the impression that he was a scion of the Adamses of Massachusetts. He wasn't. The enterprising young man quit the Green in 1963 to become the first full-time director of Philadelphia's new Institute of Contemporary Art, a dizzying career move for a twenty-three-year-old.[9]

So it must have seemed providential when David Whitney answered Dick's call for help.[10] A RISD grad and a former assistant in MoMA's exhibition department, Whitney was the much-younger life partner of Dick's client Philip Johnson. With Whitney as his urbane, unflappable first mate, Dick captained the Green for one more year. "What would the art world be like without Dick?" the sculptor Walter De Maria later mused.[11] "Dick gave artists a showcase that nobody else would have at that time." Arne Glimcher, a young dealer from Boston who opened the Pace Gallery at 9 West Fifty-Seventh Street in late fall 1963, regarded the Green as the great "proving ground" of the sixties. It was at the Green where he first saw "things that we had never even considered possible in the vocabulary of art."[12] For Glimcher, the Green's landmark show, "the most shocking of the decade," was the Samaras exhibition in September 1964, the first show on the docket when Whitney arrived.

The previous spring, Samaras had learned that his parents were planning to move and he would have to vacate the cramped bedroom where he'd slept, worked, and stored his art and materials since high school. An artist with a restive, inventive practice, Samaras proposed to Dick that he re-create the tiny room at the Green as part of his fall show. Today the idea of exhibiting an artist's personal space and possessions is commonplace. In 1964 it was unprecedented. Granted, van Gogh painted his spare little bedroom in Arles, and "life as art" was common currency in the avant-garde, but no one had sliced off a room-size piece of reality and re-presented it as art.

Filled to the brim with Samaras's earlier, unsold artwork, *Room No. 1* was tantamount to a gallery within a gallery. "It was like a large version of my boxes," the artist later reflected. "A controlled place."[13] Cleverly positioned in the Green's west corner, the 6 × 12 foot *Room* co-opted an existing wall and window, its faux ceiling a few inches shorter than the one in the gallery. Visitors were able to enter through an open door and edge around the *horror vacui* decor. Towers of books and bags of art materials vied for floor space with Samaras's narrow bed, its blanket coyly hitched up to expose a glimpse of bare mattress. Priced at $17,000,[14] it had no takers. Eight years later, the Whitney Museum re-created *Room* for the artist's retrospective. By then it had acquired "the dignity of a historical style," wrote Robert Hughes, "like a period room at the Metropolitan."[15]

Dick disappeared for more than a week during Samaras's show, with no clue to his whereabouts. "All of a sudden, I just was running the place," Whitney said of his baptism by fire at the Green.[16] Whitney would learn that Dick had checked himself into the Towns Hospital to dry out and had no show planned to follow Samaras. Recalling the moment decades later, the self-effacing Whitney said, "I wasn't as good as Dick, but it was a nice show." He chose work by Judd and Flavin, among others, and, surprisingly, di Suvero, back for the first time since huffing off two years earlier. Neil Williams was also in the mix. Whitney selected an elegant, sensitively colored geometric abstraction by this painter, who was one of the first to move beyond the rectangular shape of the standard canvas. Williams was highly respected by his peers, but few people are familiar with him today.

A different posthumous fate awaited another of Dick's favorites included by Whitney. *New Work* introduced New York to the defiant young artist Lee Lozano,[17] whose bad-girl imagery kicked wink-and-nod eroticism in the teeth. Her graphic visual puns such as *Let Them Eat Cock* picked up where Claes Oldenburg's whimsically phallic ray guns left off. At the same point in the sixties when she scrawled "tits," "cock," and "ass" on her drawings, the contemporary comedian Lenny Bruce was repeatedly arrested for voicing these crudities in public.[18] If Lozano's anger at patriarchal control had a

Lee Lozano, *Ream* (1964), oil on canvas, 78 × 96 in. (198.1 × 243.8 cm). Collection of the Blanton Museum of Art, University of Texas at Austin; gift of Mari and James A. Michener, 1968 (Photograph by Rick Hall, © The Estate of Lee Lozano)

match in popular culture, it was Lesley Gore's "You Don't Own Me," a proto-feminist hit in 1964, that proclaimed, "Don't tell me what to do / Don't tell me what to say."

Lozano painted hydra-headed hammers, ravenous wrenches, and aggressive drill bits with provocative one-word titles such as *Ram, Cram,* and *Ream*.[19] In the years ahead, she would keep upping the ante of transgression. Her desire to "impose form on one's life the way one makes art"[20] led to a series of performative "Life-Art" experiments that gradually edged out her paintings. *General Strike Piece* (1969),[21] one of the first, began when she withdrew from a three-person show that Dick organized. Lozano left New York for Dallas in 1971, the year she began *Boycott Women*, an ongoing performance in which she avoided interacting with women in everyday

life. She sustained this nearly impossible ban for twenty-eight years, "cruelly caught in the space between art and madness."[22] She died in 1999, just as her work found an attentive worldwide audience.

"All coherence goes" when a conceptual revolution is under way, the philosopher Arthur Danto concluded in 1964.[23] He'd just seen Andy Warhol's Brillo-box sculptures at Eleanor Ward's Stable Gallery, on display for the first time. "Brillo boxes may reveal us to ourselves as well as anything might," he proposed.[24] But game changers don't immediately set the art market on fire. Today highly prized, Warhol's boxes were "very difficult to sell," remembered Ward.[25] The next crop of unfamiliar art Dick introduced at the Green were also hard sells. Oldenburg, Rosenquist, and Segal found ready buyers, but Judd, Morris, and Flavin would not. Like the pop artists, the minimalists were worlds away from abstract expressionism, but on a different trajectory. Although "simplicity of shape does not necessarily equate with simplicity of experience,"[26] as Morris famously said, it took a while for collectors to warm to minimalism. Metaphorically speaking, the public had almost no place to hang their hats.

"But is it art?" was a question often posed in the sixties when people encountered these pieces of sculpture, which looked like nothing they'd seen before. The critic Harold Rosenberg believed that much of the best art of the twentieth century belonged to a "visual debate" about what art is.[27] The Green challenged viewers to revise their ideas about what was and wasn't art, and the decision was often long in the making. Whether or not the Green's audience gave Judd, Morris, and Flavin the benefit of the doubt depended on their tolerance for uncertainty. The collector Lewis Winter remembered standing in the Green during Flavin's debut show in November 1964, pondering whether he should buy "a primary picture," a wall-mounted rectangle of red, yellow, and blue lights that mimed the outline of a landscape painting. "I looked at it and looked at it, and realized it was made with commercial bulbs, and I didn't understand enough of what it was, and I thought I couldn't put my money into it."[28]

Dan Flavin, *Untitled (Green Gallery)* (1964), pencil on paper mounted on cardboard, 5 × 8 in. (12.7 × 20.3 cm) (David Zwirner / The Estate of Dan Flavin, © Stephen Flavin / Artists Rights Society [ARS], New York)

Dan Flavin was six years old when fluorescent lightbulbs debuted at the 1939 New York World's Fair. By the mid-sixties, mass-produced fluorescent fixtures were ubiquitous. For Flavin, these functional objects became sticks of color that he configured as sculpture and installed on the Green's walls and floor. Visitors stepped into an immersive environment, "a quiet cavern of muted glow," in his description.[29] *Gold, pink and red, red's* graduated progression of fixtures sat on the floor in a "luscious knifing position" in front of the focal windows, now heavily shaded.[30] The luminous stalk of his *pink out of a corner (to Jasper Johns)* fit upright at the intersection of two walls. By siting art in a corner, Flavin followed the innovative lead of early twentieth-century Russian artists. The corner he chose—the room's only right angle uninterrupted by doors or windows—would twice serve as a site for art. In the show directly following Flavin's, Robert Morris nestled a gray pyramidal polyhedron into the same sweet spot.

The *Village Voice* art critic David Bourdon brought a friend along when he came to review Flavin's show. As the two men walked to

lunch afterward, they were "startled"[31] by the sight of a hardware store display of fluorescent light fixtures, and they stood there on the sidewalk trading views on what was and wasn't art. Flavin's radical sculpture affected their perception of life. The cartoonist James Stevenson would illustrate a related phenomenon when MoMA presented *The Responsive Eye*, an exhibition of op art. The art lover in his *New Yorker* cartoon has just stepped out of an op art show and is back on the street. Suddenly he can see things he'd never before noticed—the grid patterns of windows and the crisscrossings on mesh trash baskets.[32]

Flavin depended on his then wife, Sonya, to do the wiring. He was "proud not to know about electrical wiring. He didn't ever try to master it," remembered his friend the painter John Wesley with a chuckle.[33] Today Flavin's works command million-dollar prices at auction and are collected by museums worldwide, including the Guggenheim and the Stedelijk Museum in Amsterdam. But the Green couldn't sell any of his sculpture in the fall of 1964. Wesley helped the Flavins deinstall the show. A mischievous someone— he assumed it was Whitney—put a little "sold" sticker next to every work, a pallid joke for an artist as impoverished as Flavin.[34]

During the years that Bob and Ethel Scull were Dick's covert support, their social and monetary fortunes steadily rose. Ethel was not happy living out on Long Island, her son Jonathan remembered. "She felt like a queen confined to her castle."[35] She entertained there, sometimes royally, sometimes not. Sheindi remembered a formal dinner with place cards at the table—bulls for the gents, bumblebees for the ladies—where guests dined on Thanksgiving leftovers.[36] One lavish dinner Ethel organized to show off their collection became the talk of the insular art world[37] for the wrong reasons. Ace gossip Andy Warhol reported that when the hostess saw Mary Lou Rosenquist, the painter's wife, pluck a blossom from one of the beautiful flower arrangements, she screamed, "You put that right back! Those are *my* flowers."[38]

The Sculls moved closer to the art world's accelerating heartbeat in April 1962. Their eleven-room apartment[39] at 1010 Fifth

Avenue faced the Metropolitan Museum of Art, a seeming "extension" of their home, Scull later reminisced.[40] Looking through his front window at the facade, he could see portrait medallions of two of the greatest artists in history—Bramante and Velázquez—and perhaps the ghost of the boy from the Lower East Side who'd walked up the steps with his grandfather. Their apartment occupied one half of the fifth floor, across the hall from Arthur Ochs Sulzberger Sr., the publisher of *The New York Times*.[41] It was a place that Dick and Sheindi barely knew—Ethel invited them there only once.[42] Dick, she felt, was "too smelly, too wacky."[43]

Although Bob was the one who decided what to buy, Ethel took charge of the art when it entered their home.[44] Their living room was decorated in white, punctuated with four "impossibly uncomfortable" leather and steel chairs by Mies van der Rohe.[45] A fussy housekeeper, Ethel used plastic seat covers in the dining room[46] and followed her three teenage sons around to wipe off their fingerprints.[47] Evening meals at the Scull household were formal,[48] and after the cook announced dinner, the children would stand behind their chairs at the long Louis XVI table to await their mother and father. Hearing them approach one evening, Adam, the youngest, lobbed a butter ball at his eldest brother, Jonathan, and ducked when he returned fire. The missile globbed onto Barnett Newman's *White Fire II*, today in the Kunstmuseum Basel. Quick-thinking Jonathan grabbed his butter knife and scraped it off, and the stain grew fainter over time.

The boys treated other works whimsically, as did their parents. A life-size effigy of Henry Geldzahler lived in their foyer. It wasn't a portrait per se. Geldzahler was the volunteer model for Segal's vignette *The Farm Worker (Henry's Piece)* (1962–63),[49] which Scull bought from the Green. "How pale you look," Scull might murmur to the seated figure as he pretended to take Henry's pulse. His sons carried on conversations with the silent farmworker and touched him for luck before exams. When, in 1963, Scull formally commissioned Segal to do his own portrait—the sculptor's first commission—the collector was not happy with the resulting artwork. Segal chose a standing pose for Scull, dressed in shirtsleeves and slacks, who rests his arms on an open car door. The cast

immortalized his paunch and embodied a discomforting ennui. Before long, Scull returned the sculpture[50] to Dick and recommissioned his portrait, this time in tandem with Ethel's.

She was leery about being cast in plaster, but Scull talked her into it, invoking posterity. "Somehow or other I could see a book sixty years from now saying, 'who the hell posed for this thing?'" he accurately predicted, "and having a little line at the bottom in six-point type" that cited the name "Scull."[51] A portly man, Scull dieted in advance of the casting session.[52] Ethel, model-thin, phoned *Vogue's* editorial director Alexander Liberman for advice on what to wear. "Courrèges," he counseled.[53] Knowing that whatever she chose would be destroyed by Segal's casting, she decided not to sacrifice her designer original and instead wore an inexpensive knockoff. But she offered up her couturier boots for art's sake.

Segal tried to make the experience as easy as possible, with separate casts for head and body and soothing Vivaldi streaming from the record player. First he capped Ethel's Kenneth-styled coiffure with plastic wrap and slathered her every surface with petroleum jelly.[54] He started with the body portion, swaddling Ethel's legs and torso with ice-cold strips of plaster-saturated gauze. She grew numb, itchy, and hot during the forty-five minutes it took to dry. Ethel was claustrophobic, and her tolerance for confinement ended when he went on to encase her head. She demanded that Segal abort the process before the mold hardened, and he ruined the cast when he wrenched it off.[55] He completed the sculpture later, consulting enlarged photographs of her head as he modeled it in clay. "I knew this was an important piece," Ethel confessed, "but all along I kept thinking, 'To hell with posterity! Let me out!'"[56]

By contrast, her experience with Andy Warhol was a lark. As the first step in painting the portrait that her husband commissioned from Warhol, he whisked her off to a sleazy pinball arcade. "Start smiling and talking,"[57] he instructed, sitting her down on the swivel seat of a Fotomat booth. Ethel knew that Warhol based his paintings of Marilyn, Elvis, and Liz on preexisting photographs, and initially she had "great visions"[58] that as a starting point he would have her photographed by Richard Avedon. But Warhol had other plans. So Ethel vamped, grinned, primped, and pouted for

the countless photos that popped out of the photo machine, four to a strip. Back in his studio, Andy silk-screened a select few onto colored panels. Today jointly owned by the Met and MoMA, *Ethel Scull 36 Times* is one of the twentieth century's best-known portraits. "What I liked about it mostly was that it was a portrait of being alive," said Ethel.[59]

Like Warhol himself, Ethel was a media darling in the sixties, with the celebrity status of socialites and starlets and with her own public relations specialist.[60] The press loved Ethel's far-out art in situ on Fifth Avenue. To the dealer Arne Glimcher, the Sculls were "the sizzle collectors that made the world see the work through the images of their apartment. I think a lot of people thought Bob was a vulgarian—but who cares? The Medicis were vulgarians."[61] Theirs was "one of *the* great social success stories of New York since World War II,"[62] observed the cultural reporter Tom Wolfe in one of his kinder comments. Their art collection eased their rise, and they, in turn, enhanced the cachet of contemporary art.

The Sculls' social calendar had new priorities in the fall of 1964. It wasn't Dan Flavin's opening they celebrated that November, but the debut, three days later, of Warhol's flower paintings at Castelli's. They even cohosted a huge after-party at the artist's studio.[63] As photographers flocked around the fashion model Jean Shrimpton, Ethel is reported to have screeched, "I'm paying for this *fucking* party, why aren't they taking MY picture?"[64] It's a good, possibly mythical story. But crudeness, actual or alleged, helped make the flamboyant Sculls as newsworthy as their art. At one point during the party Warhol and the filmmaker Emile de Antonio stepped back from the crowd to gossip about the Sculls. It was de Antonio's view that Scull was "the oddest figure out of this whole scene, because at one level he's coarse beyond description . . . and yet at another, he really saw what was going on and put his money out."[65]

"The Green Gallery is to Pop Art what Woolworth's is to mass culture," Brian O'Doherty quipped in October 1963.[66] But the analogy didn't stay apt for long. By 1964, after the departures of

Oldenburg, Rosenquist, and Segal, the Green was like a school for minimalism, with Dick teaching reading to all levels. Not long before Leo Castelli's death, in 1999, the dealer talked about the debt he owed to his friend: "Dick actually was the person who first understood what the minimalists were doing. He discovered them. I got to know them through him . . . He had a very fine sense of discovery. There was nobody like him. I certainly consider myself his pupil, although he is younger than I am. But he was there before myself."[67]

The label "minimalism" was still in the offing when Dick showed Morris and Judd. Like most art historical labels, it was inexact at best. Yet people understood the profound aesthetic shift it implied, a shift, in the opinion of the twenty-first-century dealer David Zwirner, that represented perhaps "the last really great newness."[68]

Morris and Judd broke "the cultural barrier" for minimalism at the Green, Carl Andre later acknowledged.[69] It was only after their shows that people began to approach Andre about exhibiting his own work. The group of Morris's severe gray-painted constructions that Dick exhibited in *Sculpture (part one)* in December 1964 "nearly appears not to be art," Judd wrote in convoluted praise.[70] Although Morris's forms were "minimal visually," he explained, "they're powerful spatially." Morris had two nearly back-to-back exhibitions in the Green's final year, an occurrence as unusual then as it would be today. But with a diminished stable, Dick must have had spots to fill. Besides, Morris had an abundance of new work. The mailer announcement for *Sculpture (part two)* was an envelope, and like the majority of Morris's boxes, it was never intended to be opened. Pertinent information was printed diagonally across the envelope's outside back. The show's standout was an untitled grid of large mirrored cubes arranged on the floor, six feet apart, today in the collection of the Tate Modern. As viewers circled around and stepped through it, they saw not only the art itself but also what it reflected, the "complex and expanded field" of avant-garde art.[71]

"The [gallery] that I'm doing now has certain limitations," Dick told his good friend Richard Brown Baker in the autumn of 1963 during an interview for the Archives of American Art's fledgling

oral history project.[72] Dick mused about what it might be like to run two galleries, one commercial and the other a kind of project space where he would have "a certain kind of utter freedom that sometimes can be very beautiful, and sometimes can be very foolish, but there is not enough of it." Oldenburg's *Store* on the Lower East Side was the first time Dick ventured outside the Green's box. Less well known is the exhibit he sponsored in March 1965 at the seedy and celebrated Hotel Chelsea, a mile and a half downtown. Daniel Spoerri, a Swiss artist on his first visit to the United States,[73] was living and working at the Chelsea in room 631.[74] Over a period of weeks, Spoerri dined in his quarters with Duchamp, Warhol, and other denizens of the art world. Then he glued down the dinner remains, happenstantial arrangements of grease-stained napkins, desiccated food leavings, and snuffed-out cigarette butts, which he called the "typography of chance." Learning of the installation through word of mouth, Dick went to see the artifacts of several dozen meals Spoerri had on display.[75] Perhaps Dick had the ready-made gallery of Samaras's bedroom in mind when he annexed room 631 in the Green's name. He asked Kaprow to write a text for the invite and paid an attendant to sit on-site for nearly two weeks. While the gallerist Paula Cooper found the vignettes "creepy and weird,"[76] to the artist Richard Tuttle they were "totally wonderful, very aesthetically freeing."[77] Oldenburg's faux food found buyers, but Dick couldn't sell Spoerri's remembrances of meals past.[78]

"Dick not well [in the Green's] last year," Whitney wrote in his notes for a book[79] he began in the seventies and never completed. Dick's treatment-induced sobriety did not hold. He quickly relapsed and continued drinking at an even more destructive rate. "Dick has been really dreary,"[80] Flavin complained in his journal at the time of his debut show in November 1964. "His work shows it. The announcements arrived a day late. No ad in the *Times* last week or this week. No posters returned for my mailing until Tuesday. Hanford [Yang] called. He wants to buy the red and red structure. I tried to direct him to Dick but the way things are I may have

George Segal, *Richard Bellamy Seated* (1964), plaster and metal, 49¾ × 39½ ×
20 in. (126.4 × 100.33 × 51 cm). Collection of the Saint Louis Art Museum; gift of
Judith Aronson in memory of Adam Aronson (Photograph by Herb Weitman, St. Louis, ©
The George and Helen Segal Foundation / Licensed by VAGA, New York, N.Y.)

to conduct the business."[81] Within seven months Dick's drinking would precipitate the Green's finale and his disappearance beneath a cloak of near invisibility—one Dick helped to weave.

David Whitney's was one of two projects in the seventies to document Dick and the Green's importance to art history. "Legendary" was the adjective routinely linked with his name, but as time went on, fewer and fewer people knew why. Anecdotes of his risible, inexplicable, and at times self-destructive behavior were traded around like baseball cards.[82] *The Green Gallery Revisited*, a 1972 exhibition at Hofstra University's Emily Lowe Gallery, brought together many of the artists Dick had discovered.[83] It even included a reconstruction of Daniel Spoerri's *Room 631*.[84] For a show in a college gallery on Long Island, *The Green Gallery Revisited* was remarkably well covered.[85] But it had no catalogue, and the audiotaped artist interviews have been lost.[86]

Dick's intimates were aware that within him, "sleazy beings roamed in equanimity with the righteous,"[87] as the sculptor Daisy Youngblood observed. She fashioned dark, impenetrable slits for his eyes in her masterful 1982 clay portrait of him.[88] He could be an aggressive drunk, and once, he hostilely tried to throw Jeanie Blake onto one of Samaras's chair sculptures.[89] He continued to torment her that evening at an opening they both attended, and his friends advised her to leave if she wanted to be safe. Likely Whitney was present at one out-of-town party when Dick had to be restrained as he lurched at his friend Jill Johnston with a carving knife.[90] Johnston was then living with the dancer Lucinda Childs, with whom Larry Poons was also in love.[91] Dick, a self-proclaimed "creep's creep,"[92] had no stake in the matter, but he once invited Johnston, Childs, and Poons to dinner on the same night[93] just to see what would happen. His act was part of a mean-spirited and ultimately successful campaign to break the women apart and clear the way for Poons. Those who loved Dick usually made allowances for what Alanna Heiss obliquely called his "rascally behavior."[94] But to the few immune to his charms, Dick was a "voracious voyeur,"[95] an outlier who looked in at life.

Dick's passive silences may have comforted his friends, but partners who expected reciprocity in their daily lives had their hands

full. "He was predictable in his unpredictability," said Sally.[96] "People were forever picking up around him." His bumbling ways and lack of ambition exasperated her. He was abusive with Sally in ways he never was with Sheindi, a friend said.[97] Once, with no notice, Dick gave Sally thirty minutes to get ready for a fancy black-tie event. Friends rushed over to help, and she was made up and dressed on time, but it was hours before he came to pick her up. He might take no account of Sally's feelings at openings where she was present, making a beeline for Sheindi, as if she were still paramount in his life.[98] Sally and Dick "were at each other's throats half the time," Sidney Tillim remembered.[99] An endless round of "call and response" was ingrained in their interactions—in his later years, he'd answer the phone with "Yes," and she'd respond "No."[100] As Mark saw it, Sally treated Dick as if he were slightly deficient mentally, and "he loved that game,"[101] as if playing the fool. To Alfred Leslie, Dick and Sally's complex dynamic was like the verbal jousting in *Who's Afraid of Virginia Woolf?*[102]

Over the years of his off-and-on life with Sally, Dick remained close to Andy Tatarsky, Sheindi's son, yet maintained a hurtful emotional distance from Sally's daughters.[103] His fathering skills were spotty at best. In Sheindi's opinion, Dick wasn't nice to their son, Miles, in all the important ways.[104] He had no sense of what not to say to a child, and he and Miles Forst used to tease little Miles "quite cruelly."[105] His outwardly benign demeanor notwithstanding, Dick was a very critical man. As Miles grew to manhood, Dick's thoughtlessness grated on their relationship.[106] Miles was an undergraduate at Bennington College when Dick, oblivious to his judgment's chilling impact on his son,[107] dismissed out of hand a poem Miles wrote that particularly impressed Sidney Tillim. Dick was a severe censor of his own creative work and had fierce, unstated expectations for the boy who looked so much like him and shared so many of his interests.

FADE TO BLACK

Without the slender buttress of Scull's support, the Green slowly buckled and collapsed. Dick was almost never around in the final year, and often incapacitated when he *was* there.[1] It was Whitney, mostly, who ran the gallery. The names "richard bellamy/david whitney" top the gallery's new letterhead at an artful angle.[2] If this graphic alliance entailed a monetary arrangement, no documentation survives. "The passage of time . . . [has] not dimmed my unblinking perception of you as my knight in shiny armor,"[3] Dick wrote to his former assistant in the late seventies, his gratitude only partially deflected by humor. The two men had similar tastes in art and likely made studio visits together. With Oldenburg, Rosenquist, Segal, and di Suvero out of the stable, there was room to bring in Ralph Humphrey, who was new to the Green but not to New York. He'd had several solo shows since his debut at Tibor de Nagy's in 1959, when Scull outsmarted himself and came away with nothing after offering Johnny Bernard Myers an insultingly low price for a work he admired. Dick would have seen Humphrey's softly brushed one-color abstractions on visits to Bennington in the early sixties, where the painter was then teaching.

Humphrey's "frame paintings," on view at the Green that May, resonated with Dick's emotional state and with art he'd shown over the years. Like the delicate aura cast by Sally Hazelet Drummond's surfaces, there was a tenderness about the way Humphrey

treated the large blank fields at the heart of each painting, mono-
chromatic voids "framed" by a band of a different color. As had
Flavin in his fluorescent *a primary picture*, these rectangles within
rectangles alluded to the shape of paintings and their frames down
through history. Minimalist in form, with an air of the forlorn,
they called to mind Edward Hopper's paintings, one reviewer
wrote;[4] to another, they were like stilled TV screens or unfilled
billboards, "close to much and near to nothing."[5] Their sheer emp-
tiness bedeviled Klaus Kertess, a recent Yale art history grad, who
keep returning to puzzle them through.[6] He learned that their
nondescript titles, such as *Sinclair*, *Wentworth*, or *Victoria*, were the
names of single-resident-occupancy hotels, grim warehouses of lost
souls that then dotted the artist's Upper West Side neighborhood.
Initially, Kertess couldn't believe the luminous, understated work
had content. "In the end," he said, "I realized Ralph's paintings were
like a mirror for me: they were desolate and yet they had an amaz-
ing giving component at the same time."[7] Like so many shows at
the Green, Humphrey's was important to artists, "a big influence,"[8]
for example, on the young Brice Marden, who had just begun to
pare down his palette to one color per painting.

In late May 1965, not long before Humphrey's show was due to
close, word reached Dick of the death of his hero, David Smith. The
fifty-nine-year-old sculptor's truck had spun off a mountain road
and hit a pole as he followed behind Ken Noland's Lotus sports car
on their way to an art opening in Bennington, Vermont.[9] "Only
Jackson Pollock's fatal crash nine years earlier," Robert Hughes would
write from the vantage of the eighties, "subtracted so much, so soon,
from American art."[10] Dick took down Humphrey's paintings and
installed *Flavin, Judd, Morris, Williams*, a show of Green Gallery artists
a generation younger than Smith, who felt a kinship with him as the
pathfinder who led the way to an authentic American style of
sculpture.

Although the exhibit may have been in the works before Smith's
death, it became an homage to the great artist and the Green
Gallery's capstone. Flavin's monumental tribute to the Russian con-
structivist artist Vladimir Tatlin—a ten-foot-tall stepped arrange-
ment of cool white fluorescent tubes—had the plum spot between

the windows. This was not the first of the thirty-nine pieces Flavin would dedicate to Tatlin over the course of his career, but it was the first one ever shown.[11] Another Flavin, a single eight-foot strip of white light, leaned against the west wall at an angle of 45 degrees. The piece honored Smith by name,[12] its tilt as vivid an emblem of loss as a flag at half-mast. One of Judd's sculptures also expressed bereavement, his grief at the loss of Susan Buckwalter, an intrepid Kansas City collector, a friend who'd died at much too young an age. *To Susan Buckwalter* (1964) is a stately procession of wall-mounted, galvanized iron cubes whose mottled surfaces entrap ambient light, a tacit homage to the signature light-snaring burnishes on David Smith's stainless steel. Planned as such or not, *Flavin, Judd, Morris, Williams* was the Green's valedictory.

To stay in business, Dick would have needed $50,000, he told the critic Amy Goldin, whose "requiem" for the gallery appeared six months later.[13] "And why," he asked rhetorically, "should anyone indulge my whims?" But there *were* people in the wings. The wealthy older artist Lilly Brody covered the Green's rent during its final year.[14] In late spring, Philip Johnson provided a small infusion when he stepped forward to purchase di Suvero's early *Ladderpiece*.[15] Geldzahler knew people willing to put up money to keep the gallery going, but he sensed that Dick "was so relieved at the idea of closing it" that it would have been cruel to force him to keep it open.[16] Even if a deep-pocketed angel materialized, Walter De Maria understood, the pressure of another year of "high-caliber shows, month after month" was more than Dick could handle.[17] As Poons saw it, literature moved Dick's heart more deeply than art. "If a page of Proust would mean more to Dick than a whole bushel full of great paintings," he later conjectured, "it might explain some part of how he got out of the Green Gallery, not on purpose, not by point of view, not with a purpose."[18]

Precipitately, Dick decided to close "one morning and did close that afternoon."[19] It must have anguished him to disappoint the art-ists who'd stayed loyal. Although he later told an interviewer that by 1965 he considered the Green "superfluous," a gallery that "had

run its course,"[20] he had plans in place for a sixth year. Lee Lozano was all set to open the season in September[21]—Jill Johnston had even written a preview of what would have been her debut.[22] Yayoi Kusama was in the midst of making work for her upcoming solo with Dick.[23] And De Maria, on the threshold of his career as an earth art pioneer, expected to make his uptown debut at the Green with a group of nearly imperceptible penciled images of landscapes and objects he called "invisible drawings."[24] De Maria remembered that Dick was hoping to show Robert Whitman's movie sculptures, had the Green stayed open.[25] But the art world in 1965 was unlike the one Dick entered when he opened the Green, and he had no interest in navigating the surging market.

Dick was "pacing off against his usual bone weary paralysis and shaking his head from side to side from time to time," Flavin wrote to Judd in mid-August after visiting the Green on a trip from his home in upstate New York.[26] "Otherwise, he was after piles of bills and receipts while alternately at a typewriter or on the telephone. There was a dull, being busy fever in his entire activity." Dick told Flavin that "four lawyers played with his books but they could not come up with any scheme which would keep the gallery open even for the time being. His only hope is to meet each creditor as he comes and convince him that he should not apply a terminal pressure. His position is exasperatingly fragile." Flavin was still irritated by his experience the previous fall, when Dick had been unable to accept "a room with fluorescent light as gallery merchandise." One way or another, Flavin confided to his friend, "it's a relief to be free of my bind with Dick."

At the time, it was widely believed that Janis and Castelli were "the places you went to make money after Bellamy discovered you,"[27] *The New Yorker* mentioned in its 1966 profile of Bob Scull. When the Green closed, Dick committed himself to finding galleries for his artists. Castelli, given first choice,[28] immediately claimed Poons but deliberated about taking on Morris and Judd. He still hadn't made up his mind about minimalism. When both Johns and Barbara Rose urged him to accept Morris, Castelli decided in his favor. Stella lobbied him on behalf of Judd, and Castelli acquiesced. Richard Feigen remembered being offered Richard Smith, Flavin, and Judd,

but he wanted only Smith.[29] Arne Glimcher gladly chose Samaras for the Pace Gallery;[30] Neil Williams went to André Emmerich, Flavin to Jill Kornblee. After Dick moved out, the fourth floor at 15 West Fifty-Seventh remained vacant for more than a year. Klaus Kertess, the young man who gradually came to appreciate Ralph Humphrey's persuasive, demanding paintings, rented the space and opened the Bykert Gallery. It was "the cheapest space on Fifty-Seventh Street," Kertess remembered, funky and full of karma. His young assistant was Lynda Benglis, an artist who would go on to an international career when the art world began to warm to women in the seventies. The Bykert's inaugural exhibit was Humphrey, whose Green Gallery show "really changed" Kertess's life.[31] The paintings sold well.[32]

THE PLEASURES OF
MERELY CIRCULATING

GOLDOWSKY DAYS

Dick has dark circles under his eyes and a distracted look in a photo *Esquire* published during the Green's final season, one of a dozen images that accompanied the magazine's feature on the bull market in contemporary art, alerting any readers who'd been in seclusion. "It is hard to adjust to the rapidity of change," wrote *Esquire* of the American artists who'd so quickly become "blue chip."[1] By the time the accelerating "rush for art" turned into a "stampede,"[2] Dick had pulled himself to safety, keeping out of harm's way for the remainder of his life. To the critic John Russell, writing in the early eighties, Dick had the general persona "of a small furry forest animal that is likely to climb the nearest tree at the sight of an intruder."[3] After the Green, Dick became a private dealer who focused on the "secondary market," discreetly reselling art owned by collectors or other dealers. Although Castelli offered him the use of his gallery as a base, Dick declined. He needed "anonymity as well as autonomy,"[4] he told a later interviewer, and in the fall of 1965[5] he aligned himself with the lower-profile Noah Goldowsky, whose gallery dealt primarily in resales.

Noah had a modest space on the second floor of a small brick building at East Eighty-First Street and Madison Avenue, upstairs from a funeral home and across the street from a school. "People kind of ignored it," di Suvero recalled.[6] If you wanted to see new art, "it just wasn't one of the places you went to on Madison Avenue."

Dick called his new operation the Hyena Escrow & Garnashee Development Company (HEGDCO),[7] purposely misspelling "garnishee" as "garnashee," a portmanteau word with a soupçon of Nash Motors, Ogden Nash, and gnashing teeth. Hyenas, he would have reminded anyone confused by his choice, were creatures said to laugh. Noah's office was to the right of the 15 × 20 foot gallery, Dick's to the left, a "storage closet"[8] of a space barely 6 × 8 feet, just big enough for a filing cabinet, a desk and chair, and a seat for a visitor. Shortly after settling in, Dick wrote a lighthearted letter to his friend Richard Brown Baker. "I have a fine office. I am proud of it and who knows how much longer I will be here in it, the great, corporate world of commerce poses such lures. I am fine and dandy. And you are always welcome in my office; I have never before had a proper office."[9] Tucked behind his desk at Noah's, Dick chatted with anyone who came to see him, "treating unfamous artists like they're famous."[10] An egalitarian in a hierarchical world, he was unusually approachable, someone who freely shared information without first determining where someone fit in the pecking order.[11] The future German museum director Kasper König felt as if he were stepping into a Raymond Chandler novel when he came to see Dick in that tiny room. "Here was this 'gumshoe,' with his feet up on the desk. There always seemed to be time for things."[12]

Dick knew Noah from the Five Spot[13]—jazz was one of many interests they held in common. Noah was a generation older than Dick, a quiet, sweet man with a generous nature who wore handmade shirts and beautiful suits, a cigarette invariably dangling from his mouth, its ash untapped.[14] He had catholic taste in art and literature and an adventurous spirit—as a teenager in the twenties, he'd walked from Paris to Moscow.[15] A native New Yorker, Noah was the son of Morris Goldowsky, a well-known union organizer in the garment trades who published his memoirs in Yiddish.[16] Dick's guardian angel, Noah counted de Kooning, Kline, and the photographer Aaron Siskind as personal friends. During the early days of abstract expressionism, Noah and his first wife, Lola Caine, an heiress to the Caine Steel fortune, backed the Charles Egan Gallery.[17] He and a partner had a gallery in Chicago in the fifties,[18] and in 1961 he moved back to New York with his second wife and opened his

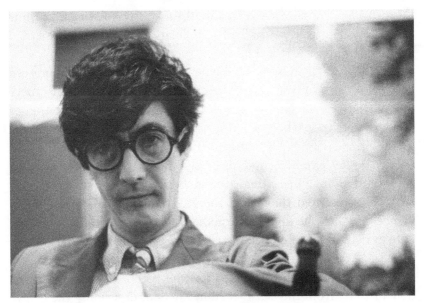

Dick at Goldowsky Gallery, 1967 (Photograph by Stephanie Chrisman Duran)

gallery. Noah proved a savior to Dick, teaching him good business practices and supplying a sense of order to his life.[19] He'd even remind him to pay his phone bill.[20] Initially, Dick paid no rent, but gave Noah a cut of his sales,[21] and occasionally Dick's clients bought art from Noah's inventory.[22]

Bob Scull lived around the corner. Any lingering resentment Dick had toward his erstwhile backer was gone, and their friendship resumed, fueled by mutual interests in Green Gallery artists and the excitement of discovering new ones.[23] The two were "almost inseparable,"[24] and if they weren't together, they were on the phone with each other. "You could be with Dick for a couple of hours, wherever he was, and there would be two calls from Scull—it was just like somebody talking to their stockbroker, somebody they relied on completely,"[25] a friend said. Nonetheless, Dick harbored a supercilious notion of Scull's achievement level and was amazed that the collector liked his art as much as he did. Each in his own way, Dick and his former patron made artists feel that their work was important. "Between the two of them they helped a lot of people out using a little bit of money . . . Scull facilitated a lot of things for

Dick. And of course vice versa. Scull took very good care of him, and Dick did right by Scull. Scull could have done more, to be sure," recalled the artist Michael Heizer.

Yoko Ono was in her early thirties when Dick began to represent her at Noah's. Yoko was one of the most innovative artist-performers to emerge from the Fluxus movement, an informal confederation of downtown friends whose playful, subversive, and visionary sensibility she helped define.[26] By the mid-sixties she'd already given a solo concert of her experimental music at Carnegie Hall,[27] created and advertised an imaginary one-woman exhibition in a New York gallery, and presented the stoical *Cut Piece* (1964), a historic performance in which she invited the audience to scissor off her clothing. Late in 1966 Yoko sent Dick instructions for a conceptual art piece. "H.e.l.p.," the directions began. "Give this message to someone on a balcony."[28] On December 18, 1966, he received a more conventional letter[29] from the artist, then in London, describing the growing interest in her art and her urgent need for representation and financial support.

As a purveyor of ideas, Yoko had few tangible artworks to sell, and she was chronically short of money. Her letter mentioned that John Cage generously offered to help her find a gallery. "Dick Bellamy was arranging things for me in NY," she told Cage, "and I would like to go through Dick." Parenthetically, she let Dick know that "John was very happy to hear that you were still active," intimating that Cage and his friends were not yet aware that Dick was still dealing art after the Green closed. Yoko had been looking for a New York gallery for a while—in January 1965 she approached the Castelli Gallery, proposing an unusual exhibition of collaborative paintings, one of which instructed viewers to hammer nails into the *Mona Lisa* "until it becomes only smile."[30] But Castelli's wasn't a good fit, Ivan Karp told her.[31] (That year, Castelli's muscular lineup included one-man shows for Lichtenstein, Warhol, Chamberlain, and Artschwager, all with concrete objects to sell.) Yoko also went to see Dick at the Green.

Richard was standing straight with a casual authority of the "High Priest" of the then New York art world, as he was

Alfred Leslie, *Robert Scull* (1967), 40 × 32 in. (101.6 × 81.3 cm), graphite on paper (Courtesy of Alfred Leslie)

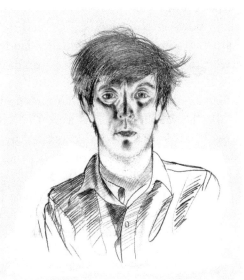

Alfred Leslie, *Richard Bellamy* (1973), 40 × 32 in. (101.6 × 81.3 cm), graphite on paper (Courtesy of Miles Bellamy)

hailed at the time in one of the big magazines. He spoke in
a very soft voice, and told me how it was difficult to sell my
work. "If you'd put a scratch or something, then I could sell
it as a unique work of art . . ." I like the way he put it. It was
funny. Suddenly, he started to look like a poet trying to do
his best in a jungle of art-selling. I told him that that was
exactly the point. I cannot put a scratch on my work because
then it will be unique. I gave a quick explanation of what my
work was about . . . that I was selling ideas, that I should
patent my ideas like people patent household machines and
have them mass produced . . . Dick made a quick nod a few
times in a harried manner.[32]

Regardless, their sensibilities aligned. In Yoko's letter from
London she mentioned only in passing her just-closed show at the
Indica Gallery, an art space run by Marianne Faithfull's husband,
John Dunbar. She said nothing about the evening of its preview,
when she met the winsome Liverpudlian who would soon change
her life, and she, his.[33] Yoko's enigmatic *Yes Painting*, an apparently
blank portion of the ceiling framed by a pane of glass, captivated
John Lennon when he climbed a ladder to inspect it through an
attached magnifying glass. "It doesn't say 'no' or 'fuck you,' it says,
'yes,' " he was relieved to discover.[34]

At Noah's, Dick brokered Yoko's first sale. The buyer? Robert C.
Scull. "I thought of her as a particularly severe case of 'suffering
artist,' " Dick later told a reporter, "and was sympathetic."[35] Yoko
was working on a series of conceptual vending machines. When
a viewer deposited a coin in the *Sky Machine* (1966) that Scull bought,
out popped the word "sky" on a handwritten card. "I would like to
see the sky machine on every corner of the street instead of the coke
machine. We need more skies than coke,"[36] Yoko proclaimed in a
statement she drafted for her solo exhibition at Wesleyan University
in January 1966, a show Dick likely facilitated.[37]

Dick's friendship with Yoko continued after she married Lennon,
who'd studied at the Liverpool College of Art in the late fifties. He
made delicate line drawings as well as music and later illustrated
two bestselling books. Among Dick's personal papers is a delight-

fully altered picture postcard, dated June 7, 1971, of Arnold Böcklin's *Spring Evening (Two Nymphs Listen as Pan Plays on His Pipes)* (1879) in a Budapest museum. Böcklin's spellbound fangirls eavesdrop as the randy Greek goat-god amuses himself with his music. Lennon drew eyeglasses on Pan, an attribute he shared with Dick,

Collage by Yoko Ono and John Lennon (1971) (Courtesy of Miles Bellamy)

and penned a few unreadable notes floating on the breeze. One nymph's noggin has been replaced by a headshot of Yoko. Lennon and Dick were great punsters, and on the reverse side Lennon drew a tiny bell and clapper above "Bellamy."

Dick's reputation as an "eye" accompanied him to Madison Avenue. He may have thought he was in hiding there, but some in the press saw behind his blind and singled him out for special attention. Grace Glueck of *The New York Times*, the nation's first reporter to exclusively cover the visual arts as news,[38] described Dick in 1968 as "possibly the most talented talent-spotter from here to the Coast" and pronounced one of his "unpretentious" shows—a three-person group of di Suvero, De Maria, and the newcomer Richard Serra—"among the freshest of the season."[39] Dick's position under the umbrella Noah provided confused posterity, and it is Noah, not Dick, who's credited with introducing Serra, even today.[40] Dick met the young sculptor by chance on a Venetian vaporetto in 1966[41] and invited him to look him up back in New York. He "became my first audience," said Serra, describing the man who came to his studio, lay down on the floor, and read poetry aloud. "He wasn't like anyone I had met before . . . Rather than being critical of a work, he would take a very circuitous route to tell you that he might be interested in something else . . . He might say, 'The left side of the room seems more interesting than the right side, and maybe that's more worth pursuing, even though it seems to me that you've invested more energy over here than you have over there.' " Commenting years later on Dick's tendency to avoid outright judgments, the poet Robert Creeley would recollect, "I never heard him say anything was better than anything else, which was a wonderful quality."[42]

In the seven years Dick spent at Noah's, he did nothing to monetize his growing influence as an éminence grise.[43] Perhaps his greatest achievement in the post-Green years was to enable the careers of the artists he believed in, whether or not there was money to be made. De Maria and Heizer were two of the beneficiaries, major proponents of earth art, or land art,[44] a new kind of art that

wasn't intended to be sold or exhibited indoors. From its concep-
tion prior to 1965,[45] Dick's undocumented, intangible support facili-
tated De Maria's *Lightning Field* (1977), a world-renowned installation
today maintained by the Dia Art Foundation. On a desolate plateau
in western New Mexico, De Maria arranged a magisterial grid of
four hundred stainless steel spikes. Sunlight mutates their appear-
ance throughout the day, and in the very rare moments when nature
obliges, a lightning strike briefly anoints one. Heizer, too, rejected
the idea of art as an item of "barter exchange." Beginning in the late
sixties, the American landscape became his canvas, and he drew
with dyes on the dry lakes of the Mojave Desert and blasted trenches
into the sandstone of Nevada's Mormon Mesa. "The museums and
collections are stuffed, the floors are sagging," he wrote in 1969, "but
the real space still exists."[46]

"Anything that ever happened for me came through Dick,"[47]
Heizer later said. "He liked to work behind the scenes." Dick was in
at the beginning when the sculptor envisioned *North, East, South,
West*, today permanently installed at Dia:Beacon. Its four Euclidian
depressions together measure 125 feet in length and sink into the
gallery floor to a depth of twenty feet, dimensions that "had no pre-
cedent in the art of recent times" when the work was first developed.[48]
Perhaps Heizer's most geographically accessible work, *North, East,
South, West* exemplifies his sculpture "that attempts to create an
atmosphere of awe."[49]

Dick roped in Bob Scull to help to support these new works. It
didn't take much doing. In the second half of the sixties Scull became
enthralled with the idea of engendering earth art and became an
important patron for Heizer and De Maria. When Scull described
this new passion in a 1970 interview, he sounded as if a little bit of
Dick Bellamy had rubbed off on him. "My present involvement with
non-saleable or non-ownable art may be a manifestation of my need
to get into art with profit-less possibilities. I think I need it to restore
my essential gratitude for an artist allowing me to become part of
his creative process. Now it is pure and has the least to do with the
money value of a work of art."[50]

●

Not long after Dick settled in at Noah's, the Whitney Museum moved a few blocks away, setting up shop on Madison Avenue in a fortress of stacked concrete boxes with a huge, cycloptic eye on the world. It was Dick who brought the young Robert Zakanitch to the attention of the Whitney curator Robert Doty, setting in motion a chain of events that began with a Whitney painting annual and led to the artist's debut at the Stable Gallery.[51] After Dick saw photos of Rafael Ferrer's conceptual art pieces in 1969, he sent him over to meet Marcia Tucker, a daring associate curator at the Whitney who valued Dick's leads.[52] Ferrer's infamous installation in Tucker's *Anti-Illusion* show—fifteen large blocks of melting ice set down in the Whitney's entry ramp—garnered international attention. Dick practiced acts of gratuitous kindness even if he didn't personally respond to the art.[53] "He always picked up these young artists that he felt had some kind of talent and then tried, of course, to find a home for them,"[54] Leo Castelli reflected in the late sixties. Perhaps the best-known recipient of Dick's attention during the Goldowsky years was California-based Bruce Nauman, whose strange fiberglass and rubber sculptures resembled nothing Dick had seen before.

Dick's behavior on his first visit to Nauman's studio was nothing the artist had ever seen before either. When engaged in looking, Dick lost track of time. He looked at art as if he were listening to music.[55] "I never experienced that before, twenty minutes looking at drawings,"[56] said Nauman. "Was I supposed to say something? What was I supposed to be doing? I wasn't used to anybody spending that much time." Dick decided that Castelli's was the best New York gallery for Nauman, and he eased his older friend into seeing things his way. First, Dick put a few of Nauman's eccentric plaster casts and latex pieces in a 1966 group show,[57] and the following year he showed the artist's startlingly unconventional self-portrait, *Neon Templates of the Left Half of My Body Taken at Ten-Inch Intervals* (1966). Dick sold this to his former assistant, David Whitney, who was then working for Castelli. Enthusiastic about Nauman, Whitney asked the artist to ship other recent work to the gallery. Frank Stella remembered that Castelli mistakenly held him responsible when Nauman's peculiar sculpture arrived. "Get these pieces out of here!" he ordered Whitney. "And tell Frank not to send me any more artists

like this."[58] But Castelli gradually adjusted to Nauman's "new shudder," and early in 1968 he gave the artist his first solo show in New York. "Most people found it horrifyingly awful," Castelli later said[59] of the art that within a decade would influence artists around the world.

Dick prized group shows as the best way to introduce such bushwhackers as Nauman and Serra, who walked away from familiar ground. In the mid-sixties Dick began to notice a critical mass of young painters[60] who rejected minimalist aesthetics and practiced what would come to be called "lyrical abstraction."[61] Their sensuous, romantic abstractions in soft or vibrant colors were anything but austere. In one of his first projects at Noah's,[62] Dick introduced Dan Christensen, juxtaposing his monumentally scaled, poetic painting near a deceptively all-black grid by painter Ad Reinhardt and a night scene by Ralph Blakelock, the nineteenth-century American landscape painter who excelled at rendering moonlight.[63] Christensen was thrilled by the august company, although the canvas Dick chose was so huge "you couldn't even see the whole thing" unless you stepped into a hallway.[64]

Exhibition titles were Dick's forte. *Modest Masterpieces on Paper,*[65] likely one of the shows that Dick assembled from Noah's inventory,[66] is unmistakably his.[67] Clement Greenberg, who admired only some of the artists Dick showed over the years,[68] "had a soft spot for Dick," a friend remembered, and made a point of seeing *Modest Masterpieces.*[69] *From Arp to Artschwager,* an off-season roundup of art that mattered to Dick, had three iterations (1966–68).[70] Each included one of Noah's exquisite, biomorphic-shaped sculptures by the modern master Hans Arp.[71] As had Christensen, artists appreciated the historic company—Judd, for one, loved Arp's work.[72] *From Arp to Artschwager* jump-started several careers. Neil Jenney, today internationally celebrated for meticulously painted, foreboding landscapes, was making "anti-minimal" sculpture with wiggly aluminum rods when Dick included the twenty-two-year-old in the second in the series, in 1967.[73] By the following year, Jenney was on his way, with a show in Germany organized by a dealer who'd seen his work at Noah's.

Peter Young was another of the singular talents Dick launched

Dick in front of
Peter Young's
painting *#3—1967*
(Courtesy of Peter Young)

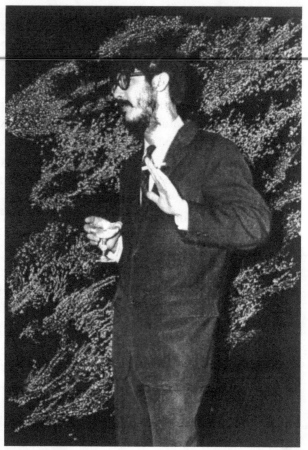

during his years at Noah's.[74] When Dick first visited his studio, Young was painting gridded, densely clustered dots of spectral color. Dick immediately brought the painter to the attention of James Michener and other collectors, and to such dealers as Joe LoGiudice, a promising young man who regarded him as a mentor.[75] Unfortunately, Dick was too trusting. LoGiudice had a faulty moral compass, and in 1973[76] he decamped to Mexico, owing money not just to Dick but to Young, di Suvero, Artschwager, and John Tweddle, debts they could ill afford to cancel.[77] To make matters worse, LoGiudice never let the artists know who'd bought their art, making it impossible for them to borrow it back for museum shows. Dick was powerless to right the wrong.

At Noah's, Dick also spotlighted the ongoing careers of such artists as Jo Baer, today in museum collections around the world. As with several of those he represented in the late sixties and seventies, he brought Baer to the attention of curators, but he put little energy into sales. "His style lacked much in results; he lost sales or never even tried,"[78] she reflected. Dick first saw her paintings in 1960, when together with the painter John Wesley she moved from Los Angeles to New York. Baer experimented with hard-edged pop imagery and a series based on graph-paper patterns before developing her signature series of radiant, radically spare canvases with white central squares rimmed by slender bands of color. It was Dick, in the early sixties, who'd named a group of these luminescent paintings *Koreans*,[79] explaining that most Westerners would find her subtle compositions just as unfamiliar as Korean art. Yet Dick stopped short of showing her at the Green, a hard-to-fathom decision a half century later. Baer's "pictures that picture their own shape,"[80] in her words, were as exemplary of the new minimalist aesthetic as the sculpture of Judd and Morris, who professed to make objects that referenced only themselves. But these men regarded painting as a medium inferior to sculpture, a view Baer vociferously argued against.[81] Dick had a special affinity for sculpture, and consciously or not, he may have reflected the bias of the sculptors he was showing at the time.

Perhaps the endemic sexism of the art world was also a factor in Baer's long wait for Dick's support. In California, Baer was a friend of several of the priapic artists who constituted L.A.'s "Cool School," a style launched at the now-fabled Ferus Gallery (1957–66). "The Ferus was one big buddy-fuck," she said, thinking back. "No girls allowed."[82] With nonchalant arrogance and tongue-in-cheek humor, they made this clear in a 1964 exhibition poster: "The Ferus Gallery presents, as a public service, The Studs." Before coming to New York, Baer created several undocumented and today unknown pieces of proto-feminist performance art, using her costumed, eye-catching body "to get rid of a bit of anger." An acquaintance who walked into a Ferus opening one night right behind her recalled that she wore "a man's undershirt and a pair of blue sateen boxer's trunks. She had laced up her shoes the way boxers do, and protruding from

the crotch of her trunks were two red satin balls. She sort of sa-shayed in and stood there and said, 'Okay, guys, do I have enough balls to be in a show here?' "[83] Most women didn't fight art world sexism openly in the late fifties and early sixties, a point that Judy Chicago would make graphic ten years later when she literally jumped into a ring wearing trunks and boxing gloves in an infamous photo of 1970.

Baer's experience of date rape triggered another unrecorded performance. Her friend Stanley Kubrick arranged a blind date with a Hollywood dialogue director who attacked her in her own home. The next day, she went to a party dressed as a succubus, with a "stocking over [my] face, hanks of hair pulled out of the top, with only a large gold hoop earring sewn over my mouth, through which I sucked fluids and kept saying to people 'Succubus?' I wore a bikini, but with the breasts flattened and a big black artificial rose covering my crotch. No one knew who I was. I scared the hell out of everyone, including myself."

In the second half of the sixties Dick's shoestring operation at Noah's became—along with Castelli's, four blocks away—the go-to places for European curators, enlightened young men such as the Dutchman Jean Leering, who came to the States for the first time in December 1965 to scout for a pioneering show of artists who worked with light.[84] Dick took Leering to visit Baer's and Flavin's studios and introduced him to young Keith Sonnier, whose flocked cheesecloth and satin constructions were, in the artist's words, "de-fined by its defiance of the traditional ideal of what could be consid-ered art."[85] By then a frequent out-of-town exhibition juror and visiting critic at art schools, Dick discovered Sonnier's odd-duck sculpture in a grad studio at Rutgers.[86] Not only did Dick promote the sculptor's career, he treated him like family. "For so many of us in that period when he was at Goldowsky's, Dick and Sally were like our parents in the art world; it was wonderful," he remembered.[87]

Sonnier was one of several American artists who had bigger careers in Europe because Dick singled them out, observed Gary Kuehn, another of the beneficiaries.[88] After Dick made the intro-

ductions, Leering included Baer, Flavin, and di Suvero in the 1968 *Documenta* exhibition, the prestigious postwar series held every five years in Kassel, Germany.[89] Dick's recommendations were also important to the Swiss curator Harald Szeemann as he put together *Live in Your Head: When Attitudes Become Form*, the seminal 1969 exhibition of post-minimalist and conceptual art held in Bern, Switzerland. Szeemann's handwritten lists of New York artists occasionally mention who suggested them. Next to Kuehn and Serra's names, Szeemann jotted "Dick Bellamy."[90]

As the sixties progressed, European dealers who wanted to sell pop art were obliged to go through Ileana Sonnabend's Paris gallery,[91] which meant split commissions and reduced profits. Business opportunities were more lucrative with the American minimalists and post-minimalists. The German gallerist Rolf Ricke first encountered Nauman's work when he came to see *From Arp to Artschwager* in 1967.[92] Ricke marveled at the unfamiliar art in the show and took note of the unexpected way Dick installed it, creating relationships of piece to piece. "I saw things on the floor and on the walls, [yet] it was not an overdesigned situation. Your dialogue with art became so simple." Dick's groupings were revelatory, and Ricke went back to Cologne to create a kindred series of installations in his own gallery.

Dick stayed afloat with occasional sales of the artists he represented.[93] He also earned commissions from other dealers, as when he sold John and Yoko two boxes by Joseph Cornell[94] and escorted John out to Queens to meet the reclusive artist.[95] Dick could be exasperatedly selective about who bought what, and under which conditions. Tadaaki Kuwayama had two paintings in a group show in Buffalo[96] that interested Maurice Tuchman, then the curator of twentieth-century art at the Los Angeles County Museum of Art. At the opening, Dick sold the paintings to Tuchman on the proviso that he visit the artist's studio to see his other work—"otherwise you won't get them."[97] When it became clear that the curator wasn't coming, Dick canceled the sale. The collector Larry Aldrich, who shared Dick's interest in lyrical abstraction, didn't get to first base in buying a Kuwayama. Aldrich saw two of his paintings in another gallery and tried to buy them from the artist. When Kuwayama asked Dick's advice, he urged him to spurn the sale, providing no explanation other

than "He's not good enough to have your artwork." Aware that he'd responded harshly, Dick added, "If you really need money, you can sell it, but not through me."

Max's Kansas City, the bar made famous by Andy Warhol and crew, opened up halfway through the sixties. Dick's friends Neil Williams and Forrest "Frosty" Myers, a Park Place sculptor, counseled the proprietor Mickey Ruskin during the bar's planning stage, urging him to accept art in payment for food and drink tabs. As a result, Ruskin would own Flavin's memorial to the victims of the Vietnam War, a haunting sculpture that cast an unearthly red glow in the back room at Max's that doubled as Andy's clubhouse.[98] A crushed-metal sculpture by Chamberlain hung near the jukebox, and Dorothea Rockburne's folded-paper collage could be seen in the bar. Max's attracted celebrities as well as such young artists as Barbara Zucker, who cofounded A.I.R., the country's first women's co-op gallery,[99] in the early seventies, when feminism fired women into action. Baer's performative practice briefly resurfaced in New York, and she addressed rampant sexism in her own way. In response to a now-forgotten insult: "I walked through [Max's] with an Alaskan wolf skin over my head, ears pricked, nose and muzzle playing widow's peak, with the front paws tied under my chin, bushy tail down back and grey-streaked fur blending with own white and dark wild hair. Bobby-pins thru the eyes held it on. Got a standing ovation from Warhol's back-room 'Coquettes.' "[100]

For many of Max's patrons, being high was part of the fun. "Everybody's eyelids were very heavy,"[101] said Bebe Buell, who remembered "the cannabis eye, the Quaalude eye, [and] the look people get when they're feeling no pain." In the sixties and seventies Dick worked his way through mescaline, cocaine, Thai stick, and opium,[102] as well as hash and the drug later known as Ecstasy. After Dick left Sheindi, he, Sally, and her daughters lived in the East Village, in a household that sometimes included the children of their neighbors LeRoi and Hettie Jones[103] during the rocky end of their marriage. Sally would eventually move to Sixty-Ninth Street and Columbus Avenue on the Upper West Side. When Miles Bellamy

Miles Bellamy in Provincetown, summer 1970 (Photograph by Elspeth Halvorsen Vevers, courtesy of Miles Bellamy)

was old enough, he spent time there with his father on weekends and during the summer. On Sunday mornings Dick liked to muster a troupe of friends—often divorced dads and their kids—and head to Nom Wah Tea Parlor,[104] a dim sum restaurant in Chinatown. Tasty, varied, and inexpensive, dim sum was a near constant in Dick's life in New York—one of the first times he met with Scull was over such a meal.

Central Park too was an abiding presence in his life. During his semester at Columbia, he'd lived near its northern edge; the Hansa's brownstone faced the park's southern flank; Noah's gallery was a block east and Sally's apartment a block away to the west. In the second half of the sixties Dick crossed it daily, walking to and from his job, undaunted by weather or the petty crime then rampant: "We beg delinquents for our life. / Behind each bush, perhaps a knife," wrote Robert Lowell, one of Dick's favorite poets, in "Central Park," a poem published in 1965.[105] When an unexpected blizzard crippled the city in 1969, Dick was seen trudging home like a Sherpa through the blinding storm.[106] Not long after the New York City Marathon was established, in 1970, a runner who knew Dick looked up as he approached the finish line and saw him perched in a tree, watching the race.[107]

By 1972 Dick's life at Noah's was starting to fall apart, as it had during the Green's final season. In response to an interviewer's question about his departure from Noah's, Dick later mentioned his growing discomfort after seven years under his friend's wing. "Apart from my physical deterioration, I would describe my overall psychic condition as cowering,"[108] Dick said, recounting his mental state. He valued Noah's tutelage, but he recognized that it was time to move out on his own: "For a full year I was in a totally paralyzed, completely miserable, nothing-can-happen state. I kept telling myself, *I've got to leave Noah's*, but avoided any mention of the subject in front of him. Somehow I thought I'd be letting him down, even though I knew I was a real pain in the ass for him a lot of the time. Noah had begun to charge me half the rent and insurance by then."

Dick owed Noah money he didn't have. He decided to raise it by selling an Oldenburg he'd bought early in the artist's career, the papier-mâché *Ray Gun Rifle* (1960), today in the collection of the

Museum of Modern Art, Ludwig Foundation, Vienna. By the early seventies it had significantly appreciated in value. When the Green shut down, he'd scrambled to find no-cost, temporary storage for what little art he owned. Judd had made space for several things, including *Ray Gun Rifle*, which was in poor condition, with a deteriorating lumpy snout. Judd, as custodian, took it on himself to have the piece conserved. Time passed. Judd regarded *Ray Gun Rifle* as his own property when finally Dick came to reclaim it.[109] The ensuing legal dispute was settled in Dick's favor, but it ended their friendship. Dick tried to restore good feelings, he remembered decades later, and wrote Judd "a note of amity" only to be "stunned, mortified, and enraged" when he received no reply.[110] Dick had "known a few artists in his time," he later commented, "but hated only one," and took to referring to him as "Jon Dudd" or "Donald Dudd."[111] During happier days, Judd had given Dick a "read good" drawing, with "For Bellamy, Never to Be Sold" written on the back.[112] Dick honored the letter of the command, but presented it as a gift to his curator friend Jean Leering.

When Dick finally announced that he was leaving Noah's, Robert Elkon, who ran a nearby gallery on Madison Avenue, tried to fire up a partnership, to no avail.[113] The upscale Marlborough-Gerson Gallery represented such twentieth-century masters as Francis Bacon and Jacques Lipchitz and asked Dick to come in as its director,[114] but the high-powered environment was not the right answer, and that too didn't happen. Reese Paley was also casting about for a gallery director. Dick's "self-effacing, 'backing off' personality" immediately beguiled him; it "left all the room in the world for gathering in subtleties."[115] Paley begged Dick to take over his gallery. "Name the price," he said uncharacteristically. Dick thought about it, but declined. By then, Mark di Suvero was living abroad to protest American involvement in the Vietnam War, and Dick realized that what he most wanted to do with his life was to represent Mark as a private dealer, "without the impertinences of an office or gallery."[116]

1973 AND ALL THAT

Dick spent the years between 1973 and 1980—his "hiding in caves" period, as De Maria called it[1]—at 333 Park Avenue South, near the corner of Twenty-Fifth Street,[2] a five-story building with perplexing half floors and an offtrack betting office at street level. Back when Park Avenue South was known as Fourth Avenue, 333 housed Louis Comfort Tiffany's glassblowing studio. In his small, dark loft, Dick created an environment of "elegant simplicity,"[3] with a few special pieces of art placed here and there for contemplation. Over the years, he mounted only two exhibitions[4] in the space, more showroom than showplace. At times he lived there—he had a tiny area for sleeping and a handwritten note taped to the door asking people to knock before entering.

The neighborhood had good, if dusty, art karma—just around the corner stood the imposing Sixty-Ninth Regiment Armory, where, in 1913, New Yorkers had their first shocked look at modern art in the historic Armory Show. By the 1970s it was an anonymous, unfashionable district, within easy walking distance of Max's, Warhol's Factory, and the tennis courts Dick regularly used. Dick's unnamed operation wasn't the first contemporary art space in the area. After David Whitney had left Castelli's, he opened a gallery on East Nineteenth Street.[5] During its short life (1969–71), Whitney's gallery showed several of the artists Dick had introduced at Noah's,[6] an indication of the two men's shared taste and the high regard

Whitney had for Dick as a mentor. The young man had moved downtown, he told *The New York Times* in 1969, "because it was the only space I could afford. And also I wanted to get away from the money scene. I'd like to encourage people to look at pictures again."[7]

As a private dealer, Dick nominally represented a few artists, including Leslie and Baer, but his principal focus was di Suvero. "You've been (springboard?) (wings?) (slingshot?) to my art," the sculptor wrote him in the late seventies.[8] Dick had an impressive visual memory—he could rattle off the size, shape, title, and year of every one of Mark's sculptures. To give prospective buyers the chance to see work too large for Park Avenue, Dick rented an auxiliary warehouse. He was Mark's tireless advocate, cajoling collectors and curators to see the sculpture in person and to consider a purchase. "I'd like Philip [Johnson] to see it & was going to write to him, but obviously I'm asking you first," he later wrote to Whitney.[9] "I'm thinking of Seagram Plaza. I feel the recoil. But I hope you'll call me about it anyway & come, even though you both say No Way Jose." It galled Dick that important museums with advantageous sites might be unwilling or unable to acquire a di Suvero. In 1979 he tried to persuade Leon Arkus, the director of Pittsburgh's Carnegie Museum, to buy a major sculpture made from scrap iron, audaciously proposing that he solicit funds from steel industrialists who lived in the city. With fey histrionics, he wrote, "Leon! *Scrap Iron Kings!* Waiting! Unleash yourself on those magnates of the prime product in your princedom . . . Your Golden Triangle's image glows in the very fibers of my vocational being: it is the best site in a major city I have seen."[10] For whatever reason, Arkus took no action.

Dick provided essential support when Mark moved to Europe in 1971. Through his near-magical connections he found large outdoor workspaces for him in the Netherlands and in France. In 1975, the year Mark returned to the United States, Dick worked to facilitate the Whitney Museum's di Suvero retrospective, a highly unusual show, with sculpture on view inside its home on Madison Avenue and at fourteen open-air sites throughout the five boroughs. Dick was a connoisseur of space, a key participant, over the years, in the collaborative process of siting his friend's sculpture. He would

Dick and Mark di Suvero, circa 1975 (Courtesy of Mark di Suvero)

walk around a given spot, learning it from every angle, the better to predict which placement might work best. Outfitted with a hard hat, he thought nothing of scuttling up a forty-foot I beam to gain a better view of the surroundings.

For a sculptor like Mark, represented in far-flung public and private collections, photographs of the art in situ were essential. Dick kept collectors and critics current with 8 × 10 inch prints, but, dissatisfied with the quality—and cost—of photos taken by professionals, he taught himself to use a camera.[11] As he saw it, documentation was part of his job. Although he never thought of himself as an artiste, his shots expertly communicate the perception of depth experienced in walking around an actual sculpture, no small accomplishment. Some of Dick's earliest photos record the historic exhibition in Le Jardin des Tuileries, when in 1975 the French honored di Suvero as the first living artist to show there. It was Dick's habit when photographing to rise early to stake out a particular piece

and then wait for the "defining moment" when the sun obliged his high specifications for lighting. In January 1977 Bellamy stood in the snow in the di Suvero fields at the Storm King Art Center, New York, to shoot *Ik Ook* (1971) in black-and-white, capturing a delighted young girl who fit herself into a crook along its lower reaches. For Mark, bodily interaction with his sculpture was the sincerest form of compliment; he reputedly did not consider his works with horizontal swings properly christened until he received reports that people had conjugaled on them.

Dick lived with Sally for an eleven-year stretch in the sixties and seventies.[12] Her salary as a teacher was likely the only predictable component of their household income. During that time Dick contributed to their expenses and also paid child support to Sheindi. The sole record of his personal finances dates from 1975, after he'd left Noah's.[13] The income page is missing, but among the disbursements are $3,500 to Sheindi, $3,200 to Sally, and $17,700 for travel and entertainment. Throughout their years together, Dick and Sally weathered financial and emotional crises, particularly in 1966, the annus horribilis when Teddy Gross took his own life; Bob Thompson died of an overdose; and a joy-ridden Jeep killed Frank O'Hara, who had been looking up at the moon. That year, Alfred Leslie and his young son narrowly escaped death when fire destroyed his studio and, with it, his film masters, manuscripts, and cache of new figurative paintings about to be shown at the Whitney.[14] Most tragic of all was the loss of twelve firemen who died fighting the blaze.[15]

Sally gave few dance concerts in the decade after the Judson group disbanded,[16] a period roughly coincident with her years with Dick and his time at Noah's. One rare performance was *Friends* (1973),[17] a duet she choreographed for Noah's long, narrow gallery. In the first section, she partnered with a floppy man-size cloth doll, arranged in a spiral around her.[18] The generic figure had neither face nor clothes, yet seemed almost alive, so tenderly did Sally guide him across the floor, rolling, crawling, or advancing slowly on her back with seamless transitions. On Sally's second pass through the space, Dick was her passive partner, resting on her as she inched along the ground. Such was its expressive power that *Friends* brought tears to the eyes of at least one person who saw it.[19] Throughout Sally's

career, critics would praise her skill in choreographing "coolly re-
fined and yet intense" dances,[20] some interwoven with covert "strands
of her family history."[21] An old acquaintance, who saw *Friends* when
Sally and Dick performed it again at Hunter College, remembered
thinking that the inanimate doll was a private reference to Teddy.[22]
Dick was in anguish when he and Sally separated, likely in 1974.
There were periods when he seemed to be "just half in control,"[23]
Sidney Tillim recalled. On some nights he slept in the hallway out-
side her door,[24] a familiar pattern. For a while, he may have lived in
his car.[25]

In the seventies, Dick's feelings toward money were little different
from those he'd expressed in the fifties and sixties. He remained
uninterested in acquiring wealth. For Dick, money muddled the
picture when one was looking at art. The work he'd shown at the
Green was too new to have an established price, and he'd fought
a losing battle against equating worth and value. His attempt to
control overpricing was the greatest source of tension between
him and his artists, he confided to the critic Amy Goldin in 1966.
"The pressure toward overpricing is very strong," she could see. "A
painter's fame depends to an unholy degree on the prices he can
get."[26] Not long after money geysered all over the art market in the
sixties, Dick stepped out of view. It would take Bob Scull longer.

As the let-it-all-hang-out sixties progressed, Bob developed a
taste for cocaine[27] and a reputation for treating the young women he
met in artists' studios as fair game.[28] "I couldn't see what our situa-
tion really was," Ethel said of her glitterati years from the vantage
point of the early eighties.[29] "I was blinded by all the activity." What
she wore continued to garner attention, whether it was Andy's
custom-designed party dress made out of yellow and black paper
bananas[30] or the skirt Adolfo "whipped up for her" to wear at a ribbon-
cutting event for the presidential candidate Eugene McCarthy.[31]
Dressed in the "Barbarella" black jersey jumpsuit she paired with a
bandolera cartridge belt for a black-tie party in 1970, Ethel posed with
attitude when the *Times* photographed her at home in front of the
couple's Jasper Johns flag painting. "When I told the salesgirl I wanted

to try it," said the Bronx-born Ethel of her Pancho Villa–style accessory, "she gave me such a look."[32]

Bob Scull began changing his life by changing his art. Through Dick he'd met Michael Heizer and Walter De Maria, artists, he would later assert, who "deserve to be supported like scientists in advanced-study institutes."[33] It was Scull who early on suggested to De Maria that he work in metal rather than in wood[34] and then helped to finance such grand projects as the *Lightning Field*. Scull had a new vision of himself as a patron: "What I really needed was to be *used*. Like the guy who sponsored Giotto's frescoes—used in the best possible way."[35] In 1965 he began to dismantle his and Ethel's art collection and auctioned off a dozen major paintings by abstract expressionists.[36] Few observers were inclined to take him at his word when he explained that he was no longer "emotionally attached to" the art.[37] "I bought because I cared for them as experience—not as an investment."[38] Some interpreted his timing as an augury of a coming market shift,[39] proof of his *sechel*, or smarts, for knowing the right time to unload art eclipsed by the new trends of the sixties. Scull dismissed the idea that he'd "axed" abstract expressionism, pointing to the Klines and Rothkos he still owned. What now excited his interest, he said, was the possibility of enabling the creation of new art. He revealed plans to funnel the auction proceeds—$165,000—into the Robert and Ethel Scull Foundation.[40] Still, it was highly unusual for a collector to publicly cash in art so recently acquired.

In 1970, Bob Scull again winnowed his collection and chose six prime artworks for auction, several by pop icons. The sale yielded $197,500.[41] Speaking as if it were a decision that he and Ethel jointly made, he told Grace Glueck of the *Times*, "After careful thought we've decided to let these few things go out into the world because they're history, darling—and I'm not involved with history."[42] But the very act of selling entangled him in history. Oldenburg's *Assorted Food on a Stove* (1962), today in the Museum Ludwig, Cologne, brought $45,000, a record for the artist, as was the $27,000 realized by Rosenquist's *Silver Skies* (1962).[43] When two of his artworks—Mark Rothko's *No. 16* (1960) and Jasper Johns's *Double Flag* (1962)—failed to achieve the minimum he set, Scull bought them back for $85,000

and $105,000, respectively.[44] It's clear today that the sales in 1965 and 1970 were a prelude to the historic auction at Sotheby Parke-Bernet in 1973, arguably the twentieth century's most consequential sale of contemporary art, when the art world as it was then known ended "not with a whimper, but with a bid," as Barbara Rose quipped at the time.[45]

After Scull consulted with Dick about what to sell,[46] the collector cherry-picked fifty works of art, a quarter of his and Ethel's collection. Eighteen of these he'd bought from Dick, and fifteen from Castelli, at a total cost of $150,000.[47] Scull took pride in his selection. "I put the sale together as if I were making an exhibition, tried to give it balance, see that the things worked with each other. The catalogue is all I'll have to show for the collection, so I wanted it to be a good reminder of another era of my art life."[48] It was only a few weeks before the sale that Ethel got to see the catalogue. "From the Collection of Robert C. Scull," its front cover read. When she asked Bob why her name was missing, he told her he'd done it "for tax purposes," and she chose to believe him.[49]

On October 18, 1973, the evening of the sale at Sotheby Parke-Bernet, Ethel was in acute physical pain. She'd spent the previous ten months in bed after severely injuring her back. Nonetheless, she was at her husband's side, dressed in a floor-length Halston, with the "Scull's Angels" logo emblazoned across the bodice. Scull's Angels, the name Bob Scull had chosen for his brand-new company, winked at the bad boys of the biker world. He himself had drawn its appealing emblem,[50] a bright-eyed cherub with arms extended, phone in one hand, radio transmitter in the other, an image befitting the first taxi fleet in New York to install two-way radios. The Sculls were masterful publicists—the auction brought attention to Scull's Angels, and vice versa. Only a month earlier, he'd hired the syndicated columnist and etiquette expert Amy Vanderbilt to lecture his diamonds-in-the-rough drivers on courtesy. Money couldn't buy the avalanche of national publicity the stunt generated for the impending sale, as reports of the manners lesson often mentioned his art collection.[51]

On auction night, most eyes were on the Sculls. But some in the crowd spotted Dick and singled him out as the important behind-the-scenes operative. "Look," the collector-lawyer Lee

Eastman pointed out to Barbara Rose. "There's Dick Bellamy, the man who made all this possible."[52] Dick was not interviewed for E. J. Vaughn's disquieting documentary *America's Pop Collector: Robert C. Scull—Contemporary Art at Auction* (1974). Dick was drinking heavily and was unavailable, Vaughn remembered.[53] Castelli, however, is in the film, and he talked unguardedly about his slow-paying client Bob Scull, who "collected the Green Gallery. It was his thing. He couldn't do anything, Dick Bellamy, without asking Scull. He collected him."[54] Scull hadn't yet signed Vaughn's release when he happened to see the rushes, with Castelli's remarks. The idea that he "collected" Dick infuriated Scull. Touchy about his legacy, he threatened to pull out if Castelli's comments made it into the final cut. A pragmatic young man, Vaughn acquiesced, but he included them verbatim in the academic thesis he later wrote about the film. In light of what was to follow, some of Scull's comments in the film seem oracular. The sale represented "getting on with your life,"[55] he told a woman who asked about his future. "My next venture is living, honey."[56]

Ethel was not reconciled to the sale. "I say it's a shame," she commented glumly on camera. "It should have gone to a museum."[57] Well before October 18, Sotheby's advanced the Sculls almost $2 million.[58] When the checks arrived, Ethel remembered her husband declaring, "Now we are safe for the rest of our lives." In the end, it wouldn't be "we." With so many empty spots on their walls after the sale, the Sculls repainted their apartment. Ethel worked with the decorator, and her color-blind husband, for whom, on occasion, she'd had to describe Rothko's colors, was in charge of sending their remaining art to a warehouse for safekeeping. A year later, when Bob Scull walked away from their marriage, Ethel would learn that the art in storage was in his name only. In the protracted proceedings of *Scull v. Scull*, Dick testified for Bob, and Castelli on behalf of Ethel. It would take eleven years of acrimonious litigation before a court awarded Ethel a 35 percent share of the collection.[59]

In 1961, Rembrandt's *Aristotle Contemplating the Bust of Homer* jolted the American art market awake when it went for $2.3 million. The 1973 Scull auction of fifty contemporary artists yielded a nearly identical amount and marked "the birth of today's art market,

as we know it," in the view of the former Christie's executive Amy Cappellazzo.[60] Had Dick lived into the twenty-first century, he would have been demoralized to hear a Sotheby's auctioneer declare that "the best art is the most expensive, because the market is so smart,"[61] or to read the confessions of an artless collector who told *The Wall Street Journal* that sometimes he and his wife "don't know if the stuff we're buying is historically significant, but because the prices are so high, we need to believe they're important."[62]

Throughout his life as an art dealer Dick Bellamy took particular care with his correspondence, spending days fashioning beguiling communications, rich in circumlocutions and playful spelling. He knew very well how to spell the name of the famous auction house Christie's when writing to an executive there, but he spelled it "Christy's,"[63] as if by transforming it into the diminutive possessive of a girl's name, he could cut big business down to size. He toyed with salutations. "Segal" was the brusque beginning of an early note to the sculptor;[64] "Georgeala"[65] began another, a Yiddish diminutive yet. To "Hen," Henry Geldzahler, he confessed in 1990, "How good the sight of you makes me feel!, no matter how glancing sometimes; but this last time for such a stretch and in professional operation was one of the very nicest and pithiest, resulting in one of the best ever warm-tummy sensations of the Geldzahler sightings."[66]

A 1963 letter to his close friend the collector Virginia Wright began:

> If I were truly to attempt a clear statement to you about your beautiful relations to the works of art which you confront, it would surely tax my capacities, so poor they are before this subject, and considering the strains forced upon me by recent circumstances——the gurglings issuing deeply from 36 years of reckless living, the birth of my first child, and the unconscionable pressures from the activities of being a crooked dealer——that I simply would not be able to do it, it would hang me up for days, I am having a bad enough time getting out of this sentence.[67]

Some letters he wrote during the years he worked on Park Avenue South were frank attempts to drum up business, as when he contacted the Whitney Museum director Thomas Armstrong in 1977:

> I embolden myself to write you offering for sale to the Whitney works by artists within my immediate purview, more or less. I have not ever before done this—those acquisitions by the Museum in which I had a part have been the outcome of exhibitions, etc., results of the natural haphazard course of things when I was working within public galleries. I trust it is customary for dealers to address offerings for acquisition to you and if it is, I shall perhaps from time to time do so, if that is OK with you, when fortune, hunch and discipline might direct me; and I will try to be brief.[68]

He was disarmingly honest. "I should like to take this opportunity to apologize for a past minor matter," he wrote the German collector Peter Ludwig in 1982, after describing certain paintings he had for sale. "In February of last year, I wrote offering a 1959 cardboard Oldenburg—the price quoted—quoted by mistake—was much too high."[69]

Some of his letters tried to lure influential writers to focus on his artists. To Calvin Tomkins at *The New Yorker* he wrote in 1982, "One does so dislike to grope in vain for the right phrasing that would ask you to pass by to see what's here without imposing. But I shouldn't fail to ask you, no matter how awkward."[70] A 1990 letter to *Newsweek*'s longtime art critic Jack Kroll mock assailed his sixty-four-year-old friend for earlier sins of omission.

> I don't know whether you're dead or alive; you were alive when, I am recalling, I frantically attempted contact . . . in 1972 trying to attract the attention of a big shot on the preemy national magazine to Mark [di Suvero's] show . . . but the Dutch equivalent of whisky downed me . . . What the hell do you do there at *Newsweek* . . . ? Do you still look at art? Did you ever? Do you have any feeling left at all for the

scruffy admirers of your noble dome & animal being from the old days?[71]

And Dick kept up a running banter with his clients. In a 1981 letter to the developer and philanthropist A. Alfred Taubman, nominally about storage bills, he spun off a dizzying, hilarious riff of visual associations triggered by the recent sight of him at an auction and, in passing, made the extraordinary revelation that he'd subverted the sale of a di Suvero.

> . . . a result of my subjective feelings for you of course combined with (and comprising but a part of) the glow of your physical presence—(I mean a literal glow, a blue nimbus that seems to emanate from the head and surrounds it, Wilhelm Reich having named it orgone energy and the Christians experiencing obviously the same phenomenon around its major people—I have myself seen the blue glow surround only, besides yourself, Hans Hofmann, Billy Graham and Claes Oldenburg—great females give off violet and are more numerous) and in being as physically stunned plus mentally aghast for having the moment before talked a potential bidder out of being an actual one for the di Suvero (which then went for a hideously low price), lacking presence of mind, was unable to rise to the occasion, hug you, fall to my knees, nip at your thighs or etc., as I wish you would imagine being done in that august greedy assembly for, I wish to affirm, the impulse was surely there . . . I long to see you. Your servant, Richard.[72]

Dick's frustration with press inattention to Mark's work erupted in a 1988 letter to Paul Richard,[73] the art critic for *The Washington Post*, written during a return flight from Germany.

> I am not a whiner, Mr. Richard. I ask for so little. I casts my eye over this *Trib* and I see listings under the *Kunstverein* which is to hold the di Suvero show. I use this ruse of humility in pleading with you to use your (probably pitiful) influence

Dick and Lucas Samaras in Seattle, 1976 (Photograph by Philip Tsiaras)

with the editor to get this in: Mark di Suvero, Wurttemberg-ischer Kunstverein, May 10—into July.

But of course I want more. Had your cheap newspaper sent you to Stuttgart to see the great Giacometti show? Will the cheap bastards send you to Venice to cover the Biennale? Which is on the way to Stuttgart. An art friend's response to the news about Mark's show said, Who the hell's gonna go to Stuttgart? The sonofabitches are draining me dry, I'll have to get to Venice this year to buttonhole and maybe even resort to the walking sandwich-board method I've thought to do so often . . . God bless you! Obediently, Richard Bellamy

Tilted Arc (1981), Richard Serra's monumental commissioned sculpture installed diagonally across the broad plaza of the Jacob K. Javits Federal Building in downtown Manhattan, was instantly unpopular. When the *Times* reported that thirteen hundred government employees signed petitions to have it removed,[74] Dick wrote an idealistic, unpublished letter to the editor in support of

the beleaguered art. Calling Serra "one of our best and most *diffi-cult* sculptors," he expressed his "fond belief that after the exhilara-tion of attack subsides . . . many of those who . . . object to the work will be persuaded—perhaps by the existential benignity of the possibility of closer, more abrupt and spontaneous personal contacts afforded by the 'disruption of foot patterns caused by the work' if not alone by the fineness of the purely visual aspect of it—to reverse their opinions, change their minds."[75]

Dick's hoped-for reversal did not happen. In the early-morning hours of March 15, 1989, workmen dismantled *Tilted Arc* and spirited it away.

BEL AMI

After Dick lost his lease on Park Avenue South in the late seventies,[1]
he searched for a ground-floor space to show di Suvero's large
works, still regarding himself as a private dealer. It was Scull, a
friend remembered, who encouraged him to get back into the busi-
ness of mounting shows.[2] In the pre–razzle-dazzle sixties, when the
two opened the Green, only a handful of people, and even fewer
museums, collected art of their times. A few years later, there
was a thriving market for contemporary art. If Dick had a gallery,
he may have reasoned, he could reintroduce such artists as Jan
Müller, Myron Stout, and Alfred Leslie and present newcomers who
deserved to be seen. In the end, he took Scull's advice and searched
for space in Tribeca, then an unprepossessing area with none of the
foot traffic of booming SoHo a mile uptown. He found a loft with a
spectacular view on the fourteenth floor of a commercial building
at the far western end of Chambers Street, near the Hudson River.
The panoramic cityscape visible from Dick's windows included the
nearby Twin Towers, the tallest buildings in the world when they
were built in the early seventies. Dick kept a pair of binoculars handy
to scan river traffic and, in warm weather, to indulge his voyeuristic
impulse, focusing on the shapely artist Daisy Youngblood, who sun-
bathed unclothed on a low roof opposite.[3]

Dick called his gallery Oil & Steel, an allusive pairing he'd kept
in the wings for two decades after Scull rejected it in favor of Green.

Dick in front of Alfred Leslie's *First Fall* (1956), Oil & Steel Gallery, Chambers
Street, 1985 (Photograph by Peter Sumner Walter Bellamy)

To his client A. Alfred Taubman, Dick mugged, " 'Oil & Steel' means big business, the insane pursuit of funds, elementary justice."[4] People read what they wanted into what the *Times* called his gallery's "impersonal, industrial-sounding name."[5] For De Maria, a drummer as well as a sculptor, Oil & Steel matched the beat of "rock and roll."[6] Jim Rosenquist theorized that the words were a sly pun—"Oil them up and steal their money,"[7] in the spirit of Mel Brooks's Engulf and Devour Corporation.[8] Dick's new stationery proclaimed Oil & Steel a "division" of HEGDCO, a Rumpelstiltskinean acronym for his onetime Hyena Escrow & Garnashee Development Company. The ambiguity of Oil & Steel occasionally worked to Dick's advantage, hilariously so. To grease free entry to restricted art events, Alanna Heiss, his partner in pranks, printed up business cards identifying the two of them as "foreign correspondents" for the "*Oil & Steel Quarterly*," a petroleum and steel industry publication.[9]

Reflections from the Hudson enhanced the "almost preternatural brilliance"[10] of the light in the gallery. For Dick, nothing was more important to the visual experience than light. "He would walk into a place and immediately turn off the fluorescents,"[11] di Suvero recalled. "He'd turn on the incandescent light or open the window or the shade to allow natural light to come in." At Oil & Steel, Dick had several kinds of shades to modulate the changing light streaming through its casement windows.[12] When he showed Heizer's little-known black paintings from the sixties, he let the artist design his own lighting.[13] Neil Jenney wanted only artificial light for his paintings, and Dick obliged by blackening the windows and installing light-blocking shades. In a note of thanks to the collector Christophe de Menil, whom he took off-site to see di Suvero's monumental *Mozart's Birthday* (1989), today in Storm King's collection, Dick bemoaned the less-than-ideal illumination, which he called an "insidious harshness of the light exacting its toll on the pleasure of looking."[14]

Although Dick elevated self-neglect to a high art form,[15] he was "fastidious beyond imagination" about his galleries, Alfred said, remembering his dealer's exasperating perfectionism about such small details as flowers for openings.[16] Dick had been on Chambers Street for a few years when he hired a highly unusual team to assist with installations. In 1983–84 Tehching Hsieh and Linda Montano

Dick with Linda Montano (at left) and Tehching Hsieh, installing Alfred Leslie's *100 Views Along the Road*, Oil & Steel Gallery, 1983. Montano and Hsieh were tethered together for their *Art/Life One Year Performance* (1983–84) (Life image; photograph by Tehching Hsieh and Linda Montano, courtesy of the artists and Sean Kelly Gallery, New York, © circa 1984 by Tehching Hsieh and Linda Montano)

tethered themselves together by an eight-foot rope for a demanding yearlong performance. The inseparable duo proved to be perfect art installers.[17] Linda Montano later reflected that Dick intuited "exactly the RIGHT JOB for us. We were both on either end of the paintings, holding them in great harmony and hanging them in great harmony and the spacing was correct."[18]

Dick rented Oil & Steel as what real estate agents call "raw space." He built a loft bed in an alcove near his desk and in lieu of shelves used a net to hold books.[19] He fitted out a daytime rest bed for himself by placing a Japanese mat on top of a large round steel sculpture by David Rabinowitch, an artist today known more widely in Europe than in the United States. It was a year before Dick's inexperienced crew finished the custom-built wooden floor he designed, during which time the gallery had the look of a construction site. It was this circumstance that confused Sophie Calle, the internationally celebrated French photographer, who was then just

starting out. One day she happened into Oil & Steel and saw a disheveled homeless man sleeping on the floor amid a jumble of materials.[20] "What a charming beggar," she thought, when he awoke and engaged her in conversation. On a lark—chance occurrences are integral to her practice—she accepted his invitation to dinner. Hours later, the guy arrived to pick her up in a wreck of an automobile—stale food wrappings littered the floor and seats, and most windows were cracked or missing. "Oh my God," she thought, "he broke into a car to take me out." Events turned stranger still when the tramp brought her to One University Place, Mickey Ruskin's fashionable art restaurant. As they entered, people inexplicably popped up to greet her escort. Seeing the artist Joseph Kosuth across the room, she dashed over to him. "Tell me *who* I'm with," she begged. "Dick Bellamy," he said. "A legend." It was the beginning of their friendship and Dick would later secure an American publisher for her first book, a compilation of photographs that she dedicated to "Dick Bel Ami."[21] All his friends were familiar with the string of decrepit VW vans Dick owned. If they weren't sufficiently dilapidated when he bought them, he would go in with a penknife and slash the interiors,[22] ostensibly to deter would-be car thieves, but also to express reverse snobbery. With broken floorboards, no heat or windshield, the vans exacerbated cold weather, and Dick thoughtfully provided passengers with lap robes liberated from various airlines.[23]

During the five years Dick spent on Chambers Street he did many fewer exhibits than he had at the Green and kept them on view for longer periods.[24] His inaugural show in 1980 opened before the walls were up or the custom-built floor set down. Richard Nonas was a cultural anthropologist turned sculptor, adroit at coaxing emotional expressivity from steel rods, wooden beams, and groupings of stones. A presence in the downtown avant-garde, Nonas had helped found Manhattan's Clocktower Gallery, a precursor of PS 1, with his fearless friend Alanna Heiss.[25] At Oil & Steel, Dick continued to represent Alfred Leslie and Peter Young, among others,[26] whose work he'd shown at Noah's. Alfred's 1983 show, *100 Views Along the Road*, was one of the most memorable. His spectacular black-and-white

landscape watercolors—intense, unpeopled evocations of hills, high-
ways, and stygian skies—"gain[ed] in impact by sheer, staggering
force of number," the *Times* reviewer wrote.[27] Alfred's watercolors
attracted buyers, but not so the work of Grégoire Müller (no relation
to Jan), a Swiss artist and writer who painted politically charged
scenes of violence in the Middle East and in the Philippines.[28] Dick
tried unsuccessfully to connect the young man with a better-situated
gallery, predicting that "not that many people are going to see [his
show] and I'm not going to sell anything."[29] When this proved to be
the case, the two men "shared a kind of mutual jubilation about it,"
Dick remembered.

As they had been at the Green and at Goldowsky's, Dick's group
shows at Oil & Steel were "quirky selection[s] that provoke surpris-
ing associations."[30] A group he presented at the height of the eighties
revival of figurative painting included an elegantly minimalist paint-
ing by Jo Baer as well as work by Jan Müller, a rarely exhibited artist
in the decades since his death. "Who would have imagined that the
flat naïve figures Jan Müller was painting shortly before he died in
1958, would seem like auguries of the New Image style?" a *Times*
reviewer asked rhetorically.[31] In January 1985 Dick honored Müller
with an ambitious exhibition of his late work, with paintings bor-
rowed from MoMA, the Whitney, and the Guggenheim. Most
unusually, he published a catalogue with color reproductions and
essays by revered writers.[32] Such publications were a common prac-
tice in the art world, but this was a first for Dick. There was a
new, art-savvy woman in his life who helped him understand the
importance of catalogues to curators, collectors, and reviewers.

Dick and Sally renewed their relationship at about the time he
opened Oil & Steel. Their bond would falter again in 1983, when
he fell in love with twenty-nine-year-old Barbara Flynn, the intrepid
founder of a tiny unheated gallery in Little Italy, a healthy walk from
SoHo and the burgeoning area of the East Village. She was twenty-
six years younger than he. As an art history grad student with no prior
experience or financial backing, Barbara founded Art Galaxy, a
not-for-profit art space that earned praise for "small but exquisite
exhibitions [that] tackle big subjects."[33] It was Michael Heizer who
took Dick there and introduced him to Barbara. Attracted to the

willowy young woman and her moxie, Dick returned to talk at length, tossing flowers on her cold floor and getting down beside them in his prototypical horizontal posture. This "almost elflike, sort of loving, and very agile"[34] man became her sensei and lover.

The first time Barbara visited Dick on Chambers Street, his reckless attempt at romantic lighting—he threw a cloth over a bare bulb—brought out the firemen just as she managed to smother the flames with a quilt. She took it in stride. Before long, Barbara was living with Dick in the fishbowl that was Oil & Steel, where gallery visitors might find them still in bed or having late-morning coffee *en déshabillé*. "It was delirium to see them," Mark remembered. "They were just so in love."[35] Dick's unresolved conflict between aesthetics and business could be detrimental to the artists he represented, but Barbara was adept at the balancing act art dealers must perfect to stay solvent. He "seemed to get a lot younger all of a sudden,"[36] his son Miles recalled.

Barbara's mother, Carolyn Flynn, was a Midwesterner about Dick's age. When the day came for the two to meet, Barbara brought her to the opening night of Oil & Steel's benefit show for PS 1. (Dick was a founding board member of PS 1.) On this stressful occasion he appareled himself in a flower-patterned lime-green and orange thrift shop housedress, worn over boxers and belted with string. He accessorized with sneakers and socks, one of which lolled around his ankle.[37] It was a knowingly comic ensemble, carried off with a straight face, guaranteed to stifle normal chitchat. The poised Mrs. Flynn didn't know what to make of Dick or his outlandish garb. "At least it could have been a *better* dress," she later commented to her daughter. The antic was directed as much at Barbara as it was at Mrs. Flynn. "It was sexually confusing, posited at a very early (exploratory) stage of our budding relationship,"[38] Barbara reflected.

If this was a test, Barbara passed. During the decade of the couple's personal and professional partnership, Dick regularly tested her eye and impressed on her the need to see all of an artist's work to understand it fully. They traveled together in the States and abroad to experience firsthand David Smith's sculpture as well as the work of Heizer, Serra, Leslie, and di Suvero. It seemed to Barbara that Dick wanted to share "all the knowledge he had of his first love: sculpture. It stands as the most generous act any human being has

Dick with a Mark di Suvero sculpture, Oil & Steel Gallery, Chambers Street, circa 1983 (Photograph by Dianne Blell)

made to me in my life."[39] She didn't judge his behavior when on occasion he cross-dressed or barked inexplicably,[40] eccentric impulses given freer rein as he aged. For Barbara, the gestalt of this fifties bohemian had an "organic perfection." Like many alcoholics, Dick developed hypoglycemia and easily unraveled if he didn't eat regularly. Alfred vividly recalled Barbara's empathetic response when Dick, highly anxious, trembling, and sweating, pushed away from a restaurant table and curled up in a corner. She joined him on the floor and held him in the spoon of her body, with her eyes closed, until the crisis eased.[41]

With Barbara in his life, Dick had fresh energy for his artists. She was particularly interested in Rabinowitch, Stout, and Leslie, and she collaborated with Dick to widen the audience for their work with a series of well-documented exhibitions. In 1988 she closed Art Galaxy and opened Flynn, a commercial gallery housed in a renovated machine shop on Crosby Street, not far from SoHo. For Flynn's inaugural show she and Dick were able to help Rabinowitch realize an earlier proposal of his to create five large sets of concentric circles carved directly into the wall.[42] Dick had a long-standing passion for

Stout's elegant masterworks, black-and-white compositions of eccentric, biomorphic shapes that courted the edge of the frame but stopped just short of it. Stout's process was one of accretion—it usually took him years before he regarded a painting finished, "tickled to death," in Geldzahler's affectionate description.[43] Unfortunately, Stout didn't live to see the retrospective that Barbara, Dick, and their colleague Douglas Walla organized in 1990.[44] In his preface to the catalogue[45] Dick described an exhibit of Stout's paintings and drawings he'd planned for the Green's second year, a show he'd reluctantly canceled because there wasn't enough completed work.[46] Most of Alfred's early sixties breakout series of black-and-white figure paintings were destroyed in his studio fire, but with scholarly zeal, Barbara tracked down what remained of these paintings and drawings for a series of exhibitions documented with a catalogue that included an interview with Alfred and photos of the lost work.[47]

Together and Apart, the title of one of Sally Gross's dances,[48] could stand as the leitmotif of her life with Dick, who once again picked up the threads of their relationship even before he and Barbara parted in the early nineties. Throughout the years, Dick remained supportive of Sally's dance career, and she choreographed several programs[49] at Oil & Steel. Sally succeeded—as Sheindi had not—in getting Dick to take better care of himself, strengthening him with massive doses of vitamins.[50] He was on Antabuse in 1972,[51] and by the eighties he qualified as a "dry drunk," who used recreational drugs and drank on occasion.[52]

A Tribeca pioneer, Dick watched the area gentrify around him. When the landlord tripled his rent in 1985,[53] he moved out of Manhattan to Queens—one of New York's "lesser boroughs,"[54] in his droll description. Mark di Suvero made room for Oil & Steel within his huge compound on Vernon Boulevard, bordering the East River. Several years earlier, when Mark needed an outdoor studio and living quarters, Dick and Henry Geldzahler helped him find the parcel of land and abandoned warehouses that the sculptor transformed into Spacetime C.C. (the C.C. for Constructs Corporation), a vital center for creative activity. Dick brought along his random-width

Dick with a Myron Stout painting, Oil & Steel Gallery, Chambers Street, circa 1983
(Photograph by Dianne Blell)

floor to Queens—he wasn't about to leave it for his landlord.[55] "I either [will] go to the dogs (there are seven of them there) or engage in dizzying commercial expansion," Dick jested shortly before he relocated.[56] Some nicknamed the area "the East East Village,"[57] as it was only one stop past Grand Central Station on the subway. But Mark's place attracted no foot traffic. It was eight blocks from the train and even farther from PS 1, which had been founded by Alanna Heiss in 1976. Dick and Barbara lived in a single-story renovated stable not far from Spacetime. Here he stored the papers and files he'd accumulated during his years as an art dealer, archives she would gradually put in order.

During his thirteen years in Queens, Dick presented a few exhibitions for artists he'd long championed. Primarily he worked as a private dealer and applied his sizable energy to several major retrospectives for Mark—at Storm King (1985) and in Stuttgart (1988) and Nice (1991). He remained committed to Alfred, whose career did not quickly recover in the fire's aftermath. Periodically Dick pushed Alfred's friendship to the limit by his maddening behavior of brushing off "unworthy" purchasers.[58] Mark once caught Dick

dismantling a group of his tabletop sculptures in advance of a visit from a collector Dick didn't respect.[59] In effect, he was more Mark's "cultural representative" than his dealer, Walter De Maria wryly observed.[60]

Dick had an office at Spacetime, where he would talk on the phone, dictate letters, and sift through the photographs he took of Mark's work, pinning the most pleasing shots up on the wall. Music was always on, usually classical but sometimes a jazz recording that he'd have on repeat for days.[61] His high-ceilinged gallery space fronted the river on the ground floor. When Dick slid back its majestic steel door, the fourth wall disappeared, replaced by the Manhattan shoreline. Water light advantaged whatever he had on view, particularly Alfred's immense *Quotidian Landscape* (1986). Dick liked to row out onto the river in a dinghy and sit looking at it from afar.

The California painter Mary Corse was among the new artists Dick began to represent during his Oil & Steel years. Her monochromatic minimalist canvases came alive in changing light or when the viewer's position shifted, thanks to the tiny reflective glass beads she mixed into her acrylic paint. As Dick had done over the years for the artists he treasured, he raised money for her when she was in need. In a letter to one collector awaiting a delivery, Dick wrote, "I have surely not forgotten her even if you have: Art is long. Her great beauty and spirit are unbroken by a long series of misfortunes; she has now (with my financial aid) a system of hoists and tracks from the studio to the kiln so that huge tiles can travel to and fro without breakage; my faith in her will be vindicated and your purchase delivered within our lifetimes. She has the violet glow."[62]

In the eighties and nineties Dick's heterodox taste included several emerging artists, including Chakaia Booker, an African American sculptor whose primary material was discarded rubber tires and who richly adorned herself with wearable cloth sculpture. "He liked being around strong women," a friend observed, "women whose being radiated, and who had a somewhat strange beauty."[63]

Mark's property included an illegal dumpsite on top of an abandoned landfill. In 1986, not long after Dick joined him in Queens, Mark and his crew cleared away the junk and rubble, transformed

Alfred Leslie, *The Quotidian Landscape* (1986), charcoal on paper, 27 × 42 ft. (8.2 × 12.8 m), Oil & Steel Gallery, Queens (Photograph courtesy of Alfred Leslie)

the area into outdoor studio and exhibition spaces, and created a neighborhood park he christened "Socrates." He'd chosen the name to entice the surrounding Greek community to use it, but it was a long time before locals took the bait.[64] When Mark stood at the water's edge, he could see the northern tip of Welfare Island (today Roosevelt Island), the site of the rehabilitation hospital where twenty-five years earlier he'd regained his life as a sculptor.

An infant when his mystifying father left Sheindi, Miles Bellamy spent most of his childhood distanced from Dick and afraid of him.[65] But the gap narrowed when as a young man Miles discovered bohemianism and used Dick as a role model. After Bennington, Miles worked in bookshops and galleries in New Mexico and the Bay Area. There in the late eighties, he opened the Upaya Gallery, mounting shows with such declarative, Bellamyish titles as *Contemporary Art:*

Part 1 or with self-explanatory phrases such as *Sculpture Built on the Premises* and *Disparate: Seven Workers*. Advised by a San Francisco museum director that there was no future for him in the city, Miles moved back east in 1993 and joined his father at Oil & Steel. He set up the gallery's first computer, a device Dick referred to as "the magic brain"[66] and never learned to use. Father and son looked alike, sounded alike, and shared a vulnerability to alcohol, an addiction Miles would conquer.

They became close companions and often played doubles tennis. For a man so timorous in the competitive art market, Dick was a "cutthroat" on the courts,[67] a "wild animal out on the prowl, ready and waiting to pounce."[68] Seemingly made of rubber, he might perform graceful yet frightening pratfalls during matches.[69] He was known to play barefooted on occasion.[70] Some of his partners were slightly embarrassed when Dick showed up in ludicrous, affected getups—holey T-shirt, ratty shorts, colored socks, and high-top sneakers.[71] He had a "crazy sense of wrong-style," Mark said,[72] and off the courts he favored antediluvian suits with torn pockets and split seams.[73] He never carried tissues or a handkerchief and might blow his nose on newspapers picked up on the street.[74] With rare exceptions, his friends made allowances for his idiosyncrasies, thoughtless though some were, and politely ignored them.

Clowning was a language Dick spoke fluently. He faced life with a sense of amusement, enacting a parody of what other people did. "Play is connected with no material interest, and no profit can be gained from it," the Swiss cultural theorist Johan Huizinga wrote in his classic *Homo Ludens*,[75] as if he were describing why Dick found it so appealing. For one Art Galaxy opening, Dick had shown up with a huge, silvery salted fish he'd bought in Chinatown and draped over his shoulders like a boa.[76] He liked to arm himself with a set of water pistols, ready to hand one off for a fake shoot-out anytime, anyplace. He dueled with his peers, and with young Alexandra and Lucas, the children of Sheindi's son Andy Tatarsky, whom he regarded as his grandchildren.[77]

Dick played at commerce, discouraging some would-be purchasers and coaxing others to buy what he thought they should have. One such advisee was Holly Solomon, a collector turned gallerist,

who, back in the sixties, had followed Bellamy from the Green to Goldowsky's. When it came to Dick's attention that Holly believed he hid art in the bathroom to keep it away from her, he started to make a game of it, purposely stashing art for her to find.[78] "Ha! What's this?" she'd say, emerging from the toilet with something she was about to buy.

The downsides to Dick and Barbara's May/September romance became clearer to them over time. He knew she was thinking about starting a family, and he felt she should be with a younger man. He himself was done with child rearing. Dick, by then a peripheral figure operating on the fringes of the art market, was also aware that to advance in her profession, she needed to be part of the larger art world. Although it was difficult for him, he persuaded Barbara to move on, and by 1992 they'd gone their separate ways. Within a few years, Barbara and Dick forged a new, professional relationship. She closed Flynn in 1994 and, with David Smith's estate in tow, joined the staff of Larry Gagosian, an art dealer unburdened by a reluctance to turn a profit.

When his former schoolmates organized the fiftieth reunion of the Wyoming High School class of 1945, they tracked down the elusive New York art dealer who'd left home to join the merchant marine a few years after they all graduated. Surprisingly, Dick attended and brought along Sally. The reunion gave Murray Reed the chance to catch up with Dick, the first time he'd seen him in half a century. Dick's warm, intimate style of reconnecting deeply impressed him. "There was no trace of the conventional dialogues of such situations, no effort to joke about age or appearance."[79] Dick's straightforward manner, while welcomed, unnerved Reed. He recalled Dick's face leaning in close, "the honest, direct look in his eyes, and [his] low voice," an affect that left him "a bit shaken. Seems odd to say, that last word, but true."

Dick had had a hacking cough for several years,[80] and in the mid-nineties doctors diagnosed emphysema and tachycardia. Not long after Barbara left, he had a pacemaker installed. He'd been aware of the dire consequences of smoking since the days of the Green Gallery, but it wasn't until three decades later, with his pacemaker in place, that Dick stopped smoking three packs of

unfiltered Camels a day.[81] As a teenager, he'd witnessed the treachery of Lydia's congenitally weakened heart and in the fifties had watched as Jan Müller's plastic valve gradually stopped working. Now his own ticker and lungs turned traitor. He talked about cutting back his workload, possibly moving his operation out of Mark's compound to the nearby house he'd lived in with Barbara and was then sharing with Miles.[82] He had his assistant organize the many thousands of photographs he'd taken of Mark's sculpture and then sold them to Mark to retire a debt.[83] It was emblematic of Dick to hide his pain and act normally as his health deteriorated. He continued to play tennis—"It was hard toward the end," said a friend.[84] "We had to wait for him to catch his breath between every point; sometimes I was very nervous." And he took unwise, taxing trips. Knowing how much simply showing up would mean to the young sculptor Paul Wallach, Dick and Miles undertook an exhausting two-and-a-half-hour train ride each way to make the briefest of appearances at his opening in Baltimore.[85]

Music was a constant in Dick's life. In high school he'd rushed home to sit with Lydia and listen to classical recordings as she rested downstairs. As an adult, he often invited friends to concerts at Lincoln Center or the Hollywood Bowl, excursions that easily became events in themselves, so often did his performative instincts take over.[86] In late 1997 and the early months of 1998 he bought many extra sets of tickets for concerts and would gather large groups of friends to come with him. Those closest to him sensed he was preparing to die.[87] At least twenty were there for a performance of Bach's Mass in B Minor at Carnegie Hall in December, the month Dick turned seventy. "It felt like a final gathering," a friend said.[88]

Dick was reading through Proust again, and he kept copies in each of the households where he might spend the night.[89] He explored the idea of moving back to Cincinnati, even though none of the relatives he'd known there were still alive. In a letter dated March 11, 1998, he inquired about a position as caretaker of an Ohio sculpture park, a facility with a live bait shop and pay-to-fish lake on its property. In this fantasy of retirement Dick must have envisioned himself out in a boat, a rustic Gone Fishin' sign hanging askew from the bait shop's doorknob.[90] He informed the park administrator

that he needed only "shelter, a cook, & a young housemaid—from Kentucky, if possible. I don't have any savings . . . It is fitting I end where I began . . . Having a world famous art dealer—practically a home-town boy . . . would not be bad publicity."[91]

On Saturday, March 28, Dick spent a quiet afternoon at home. He and Miles had played doubles tennis on Friday, and he was tired. When he phoned his friend Pat Lipsky to check in, he told her he wanted to catch up on some reading. The two had an outing planned for the next day, to see Lee Lozano's paintings at the Wadsworth Athenaeum, in Hartford, Connecticut.[92] They arranged to meet at 8:30 a.m. at the Port Authority Bus Terminal in midtown Manhattan. The next morning, Pat was there on time, but Dick was a no-show. In Queens, Miles discovered his dad stretched out peacefully in bed. He'd died sometime during the night, with his glasses on, one arm cradling a tattered copy of Proust's *In Search of Lost Time*.

POSTSCRIPT

Nancy Christopherson, the wife Dick never got around to divorc-
ing, was one of the first people I tried to reach when I began research
for this book in the mid-nineties. By then mentally fragile, Nancy
no longer answered her phone and did not respond to my letters. I
briefly fantasized a stakeout and moved on to interview other people.
In 2003 Sheindi Bellamy chanced to pass Nancy's building on
Amsterdam Avenue on the Upper West Side. Sheindi lived nearby
and occasionally visited Nancy over the years. When she looked up
at Nancy's windows, normally darkened by shades and fifty years of
grime, she was shocked to see painters at work in vacant, brightly
lit rooms. The superintendent brought her up to date. A few months
earlier Nancy had been out shopping when she slipped on ice and
broke her hip. Unable or unwilling to provide information about
family or friends, she became a ward of the state and was sent to an
elder-care facility in the Bronx. Her daughter, Poni, a Steiner School
teacher who settled in Germany in the early sixties, had died there
of breast cancer in 1986 at age forty-one.

Nancy never returned home. With no "next of kin" on file, her
landlord emptied her apartment and threw her possessions into
dumpsters, including several photographs by Diane Arbus, long-ago
gifts from her beloved friend. I heard the news from Sheindi, who
managed to learn the name of Nancy's nursing home. I had no idea

what to expect the first time I visited Nancy there. To my relief, she was welcoming, if in and out of lucidity. She remained sunny but easily distracted when I returned twice more. The administrators were unable to locate any of her relatives, but through online research I found Jeanne Christopherson, a niece in California, who had once lived with her aunt in New York. Nancy gained Jeanne as an advocate, and I an insightful informant.

Sheindi, for her part, patiently answered my questions with good cheer for more than a decade until she passed away at age eighty-five, in 2014. Although Sally and I were in touch not long after Dick died, she subsequently declined my interview requests. She died in 2015 at age eighty-one.

With remarkably few exceptions, people were happy to talk with me about Dick. Walter De Maria, notoriously inhospitable to writers, ignored my polite letters for more than a year. With nothing to lose, I changed tactics and mailed him an envelope of seven vintage picture postcards, each annotated with text keyed to the image. "I don't want to take a big bite of your time" was the message on the reverse of George Stubbs's *A Lion Attacking a Horse*. He phoned three days later and stayed actively interested in my project. Ivan Karp needed no cajoling and talked at length about his life after the peevish Hansa members fired him. When he joined the two-year-old Castelli Gallery in 1959 as its first director, his starting salary was $100 per week, much more than what he and Dick earned at the Hansa. Ivan left Castelli's in 1969, a resignation precipitated in part, as some accounts have it, by his boss's decision to bring Dan Flavin into his stable. "That's not art, that's lighting!" Ivan reportedly told Castelli, and suggested he sell it to the Tremaines,[1] whose fortune derived from the manufacture of fluorescent fixtures.

OK Harris, a name he'd come up with nine years earlier for what became the Green Gallery, opened in 1969, one of the first galleries in SoHo. With his sometime accomplices Allan Stone and Al Hansen, Ivan continued to salvage architectural sculpture he shamelessly called "rubble without applause."[2] Over the years, he donated most of his chunky collection to the Brooklyn Museum;[3] today some of these carvings are embedded in the walls of the nearby

subway station. Ivan captained OK Harris for forty-three years but never again "identified"—he disliked the verb "discovered"—talents as historically significant as Chamberlain, Warhol, and Lichtenstein. He died in 2012 at age eighty-six.

I was too late to interview the Sculls. Ethel never remarried and was seventy-nine when she died, two weeks before September 11, 2001. Bob stayed single for several years after their divorce. When in 1978 he married Stephanie, an Irish-born artist nearly forty years his junior, the couple left Manhattan for a quiet life in Connecticut. He passed away in December 1985, defeated by diabetes at the age of seventy. The Warhol he'd bought from Dick for $1,200 in 1962, *200 One Dollar Bills*, fetched $385,000 at an auction held the year after his death. In 2009 it was back on the block. Trading was brief and spirited, just as it had been for Rembrandt's *Aristotle*. The opening bid of six million immediately doubled to twelve. The number inflated with each new bid and came to rest at $43.7 million, sold to an anonymous bidder over the telephone.

In the early seventies, developers demolished the shabby-chic brownstone on West Fifty-Seventh that once housed the Green, erecting in its place a fifty-story skyscraper, its colossal sidewalk sentinel a bright red, Oldenburg-ish numeral "9." Storefront shuls with small congregations dotted East Broadway when Dick and Sheindi lived on the street. One could buy a glass of tea at the corner store and pick up a copy of *The Jewish Daily Forward*, a Yiddish-language newspaper. Today the *Forward* is an English weekly and a Yiddish biweekly, and most of the synagogues are closed. The neighborhood remains a haven for immigrants, but now most shop signs are in Chinese. Like so much commercial real estate in Tribeca, 157 Chambers now houses multimillion-dollar condos.

Barbara Flynn, today based in Australia, taps her expert knowledge of sculpture as the curatorial adviser for public art in Sydney's City Centre. Sheindi's son Andrew Tatarsky, who sustained the close relationship with Dick that began during the East Broadway years, is today an internationally recognized leader in the treatment of substance misuse. Miles Bellamy, a purposeful placer of ampersands

and commas like his father, cofounded Spoonbill & Sugartown, Booksellers, in Williamsburg, Brooklyn, in 1999. He and his business partner, Jonas Kyle, do a brisk trade in artists' monographs and art historical texts that every so often mention the name of the legendary Richard Bellamy.

APPENDIX:
GREEN GALLERY EXHIBITIONS

October 18–November 6, 1960: *Mark di Suvero: Sculpture* (artist's debut); included an abstract painting by Patricia Passlof

November 15–December 10, 1960: *George Segal*, paintings and sculpture

December 13, 1960–January 7, 1961: *Gallery Group Show: Paintings, Sculpture and Drawings* Robert Beauchamp, Lilly Brody, John Chamberlain, Mark di Suvero, Miles Forst, Jean Follett, Julius Hatofsky, Sally Hazelet [Drummond], Lester Johnson, Aristidemos Kaldis, Tadaaki Kuwayama, Claes Oldenburg, Felix Pasilis, Patricia Passlof, Lucas Samaras, Richard Stankiewicz, Myron Stout, Robert Whitman, Philip Wofford, "and others too numerous to mention"

January 10–February 4, 1961: *Tadaaki Kuwayama*, paintings (artist's debut)

February 7–March 4, 1961: *Felix Pasilis*, paintings (artist's uptown debut)

March 7–April 1, 1961: *Patricia Passlof*, paintings (artist's debut)

April 4–29, 1961: *Richard Smith*, paintings (artist's debut)

May 2–27, 1961: *Ronald Bladen––Mark di Suvero*, wall reliefs, floor pieces

May 30–June 25, 1961: *Gallery Group Show*
Lucas Samaras, Sally Hazelet [Drummond], Robert Whitman, Claes Oldenburg, Robert Beauchamp, George Segal, Mark di Suvero, Tadaaki Kuwayama, Richard Smith, Felix Pasilis, Jean Follett, Patricia Passlof, Miles Forst, Myron Stout

September 19–October 14, 1961: *Jean Follett, Charles Ginnever, Claes Oldenburg, Lucas Samaras, Myron Stout, Mark di Suvero*

October 17–November 11, 1961: *Robert Beauchamp*, figurative expressionist paintings (artist's uptown debut)

November 14–December 2, 1961: *Milet Andreyevich: Paintings** (artist's debut)

December 1, 1961–January 31, 1962: *Claes Oldenburg: The Store*, 107 East Second Street, presented by the artist "in cooperation with the Green Gallery"

December 5–23, 1961: *Lucas Samaras: dinners, liquid aluminum pieces, pastels, and plasters* (artist's debut)

December 29, 1961–January 6, 1962: *Ball*
Theater piece/performance by Robert Whitman. Performers included Pat Mushinski[†] [Oldenburg], Lucas Samaras, Claire Wesselmann, Tom Wesselmann, Charlotte [Sheindi] Tokayer, and Robert Whitman

January 9–27, 1962: *Joan Jacobs*, paintings (artist's East Coast debut)

January 30–February 17, 1962: *James Rosenquist*, paintings (artist's debut)

February to May, 1962: Claes Oldenburg's Ray Gun Theater, ten Happenings presented at 107 East Second Street, "in cooperation with the Green Gallery"

February 20–March 10, 1962: *Tadaaki Kuwayama*, paintings

March 13–April 7, 1962: *Sally Hazelet Drummond*, paintings (artist's uptown debut)

Scheduled, then canceled: April 10–May (?), 1962: *Myron Stout: Paintings and Drawings*

April 10–27, 1962: *Contemporary Painting and Sculpture*
Myron Stout, Burgoyne Diller, Peter Agostini, Philip Pavia, John Chamberlain, Franz Kline, James Rosenquist, Milet Andrejevic, Mark di Suvero, Ronald Bladen, Neil Williams, Julius Hatofsky, Anthony Magar . . .

May 8–June 2, 1962: *George Segal: Recent Paintings and Sculpture*[‡]

June 12–July 21, 1962: *Group Show*
Claes Oldenburg, Philip Wofford, Richard Smith, Yayoi Kusama, Andy Warhol, Robert Morris, James Rosenquist, Robert Whitman (includes Segal, *Woman Painting Her Fingernails*, from the previous show)

September 18–October 20, 1962: *Claes Oldenburg*, sculpture and drawings (artist's uptown debut)

* The artist changed the spelling of his surname from Andreyevich to Andrejevic in 1962.
† The artist's name also appears as Pat Oldenburg or Patty Mucha.
‡ Segal debuted his signature sculpture at this show.

October 5, 1962: *Sports*, a Happening by Claes Oldenburg. Performers included Oldenburg, Pat Oldenburg, and Lucas Samaras

October 23–November 10, 1962: *Philip Wofford*, painting (artist's debut)

November 13–December 1, 1962: *Wesselmann: Collages/Great American Nude & Still Life* (artist's uptown debut)

December 11, 1962–January 5, 1963: *Ronald Bladen*, plywood relief paintings (artist's uptown debut)

January 8–February 2, 1963: *New Work: Part I**
Milet Andrejevic, Dan Flavin, Donald Judd, Yayoi Kusama,[†] Robert Morris, Larry Poons, Lucas Samaras, George Segal

February 19–March 16, 1963: *Richard Smith: Paintings*

March 19–April 13, 1963: *Milet Andrejevic: Paintings*

Scheduled then canceled: April 15–May 25, 1963: *James Rosenquist*

Late April–May 4, 1963: *Benefit Exhibition*
Mark di Suvero, *Ladderpiece* (1961) and art by Lenny Contino and fourteen other of Mark's students at the Bird S. Coler Hospital

May–June 15, 1963: *Contemporary American Group Show [New Work Part III]*
note: same name as April 1964 show
Robert Morris, L. Poons, Kenneth Noland, Tadaaki Kuwayama, Donald Judd, Frank Stella, Darby Bannard, Ellsworth Kelly

September 24, 1963–mid-October, 1963: *Group Show*
Yayoi Kusama, Milet Andrejevic, George Brecht, Leslie Kerr, Robert Morris, Lucas Samaras, George Segal, Sidney Tillim, Tom Wesselmann, H. C. Westermann

October 15–November 2, 1963: *Robert Morris*, sculpture (artist's debut)

November 5–23, 1963: *Larry Poons*, paintings (artist's debut)

November 16, 1963: James Lee Byars, performance

November 26–December 14, 1963: *Robert Beauchamp*, paintings

December 17, 1963–January 11, 1964: *Don Judd*, sculpture (artist's debut as a sculptor)

* "*Part I*" suggests that Dick had more artists in mind than room in which to show them. Confusingly, there was no *Part II*, and two *Part III*s, in May 1963 and April 1964.
[†] Kusama debuted her signature sculpture at this show.

January 15–February 8, 1964: *James Rosenquist*, paintings and sculpture

February 11–March 7, 1964: *Tom Wesselmann*, paintings

March 11–April 4, 1964: *George Segal*, sculpture

April 8–May 2, 1964: *New Work Part III*
Dan Flavin, Donald Judd, Larry Poons, Richard Smith, Neil Williams, Kaymar, George Segal (*The Dry Cleaning Store*)

May 6–30, 1964: *Neil Williams*, paintings (artist's debut)

June 3–26, 1964: *Group Show*
Walter Darby Bannard, Burgoyne Diller, Tadaaki Kuwayama, Richard Smith, Neil Williams

September 16–October 10, 1964: *Lucas Samaras*, installation (*Room # 1*), sculpture, and drawings

October 24–November 14, 1964: *New Work (Contemporary American Group Show)*
Richard Smith, Don Judd, Mark di Suvero, Neil Williams, Dan Flavin, Miles Forst, Lee Lozano

November 18–December 12, 1964: *Dan Flavin: fluorescent light* (artist's uptown debut)

December 16, 1964–January 9, 1965: *Robert Morris: Sculpture (part one)*

January 13–February 6, 1965: *Tom Wesselmann*, paintings

February 10–March 6, 1965: *Larry Poons*, paintings

March 3–15, 1965: *Daniel Spoerri, Room 631*, Chelsea Hotel, open between 4 and 8 p.m.

March 10–April 3, 1965: *Robert Morris: Sculpture (part two)*

April 7–May 1, 1965: *Richard Smith*, experimental, three-dimensional paintings

May 5–29, 1965: *Ralph Humphrey*, paintings

May 26–June 12, 1965: *Flavin, Judd, Morris, Williams**

* This valedictory show was an informal tribute to David Smith, who died on May 23, 1965. Because its opening date precedes the date of Humphrey's closing, it's possible that the announcement was printed retroactively.

NOTES

PREFACE

1. Saul Steinberg, in Calvin Tomkins, "A Keeper of the Treasure," *New Yorker*, June 9, 1975, 46.
2. Vladimir Nabokov, *Speak, Memory* (New York: Everyman's Library, 1999), 301.

INTRODUCTION

1. Richard Bellamy, letter to Vera List, December 21, 1975. Richard Bellamy Papers, I.A.273. The Museum of Modern Art Archives, New York, NY.
2. This reconstructed sequence of events derives from descriptions of the Sculls' life and living quarters in Tom Wolfe, "Bob and Spike," *The Pump House Gang* (New York: Farrar, Straus and Giroux, 1969).
3. Ibid., 175–76.
4. Robert Scull Appointment Books, 1955–1973, Archives of American Art, Smithsonian Institution, passim.
5. Eventually, customs caught Ethel at her game. Jonathan Scull, in conversation with the author, New York, NY, January 22, 2009.
6. Leo Castelli, in Laura de Coppet and Alan Jones, *The Art Dealers* (New York: Clarkson N. Potter, 1984), 103.
7. *The Solomon R. Guggenheim Inaugural Selection* (New York: Solomon R. Guggenheim Museum, 1959), unpaged.
8. Adam Gopnik, "The Art World: The Death of an Audience," *New Yorker*, October 5, 1992, 140.
9. B. H. Friedman, unpublished diary entry, October 21, 1959, courtesy of B. H. Friedman.
10. Pati Hill, telephone conversation with the author, August 4, 2003.
11. Richard Brown Baker, diary entry, October 22, 1959. Richard Brown Baker Papers. Yale Collection of American Literature. Beinecke Rare Book and Manuscript Library.

12. Miles Forst, in conversation with the author, New York, NY, June 24, 2002.
13. Lois Karp, telephone conversation with the author, October 27, 2003.
14. Ivan Karp, in conversation with the author, New York, NY, January 16, 2002.
15. Douglas Martin, "Jerry Tallmer, Critic Who Created the Obies, Dies at 93," *New York Times*, November 11, 2014.
16. Ivan Karp, in conversation with the author, New York, NY, January 16, 2002.
17. *The Solomon R. Guggenheim Inaugural Selection*, unpaged.
18. Amy Gold, "The Power of Pop: Robert and Ethel Scull, and the Influence of Pop Art Collecting" (B.A. thesis, Princeton University, Department of History, 2002), unpaged appendix.
19. Robert Scull, in "At Home with Henry," *Time*, February 21, 1964, 68.
20. Oral History Interview with Ivan Karp, 1969 March 12, Archives of American Art, Smithsonian Institution.
21. Ivan Karp, in conversation with the author, New York, NY, March 20, 1996.
22. Sidney Geist, "A New Sculptor: Mark di Suvero," *Arts Magazine*, December 1960, 40.

1. HIS FATED ECCENTRICITY

1. "Greatest Film Milestones 1920s," *FilmSite*, www.filmsite.org/1929.html (accessed November 15, 2012).
2. Bobbi Yerkes, telephone conversation with the author, August 21, 2002.
3. Ilse Hoffman Maile, letter to the author, January 29, 2002.
4. Application for Marriage License, no. 360, Hamilton County, OH, October 9, 1926.
5. "Seniors' Book of Truth," *La Cuesta* (North Arizona Normal School Yearbook, 1918), 108.
6. Sheindi Bellamy, telephone conversation with the author, July 10, 2002. Sheindi Tokayer changed her surname to Bellamy in the mid-1960s.
7. This and the following information on C. P. Hu from *Who's Who of American Returned Students*, Tsing Hua College, Peking, 1917. Susan Soong, e-mail to the author, December 3, 2012.
8. The University of Heidelberg, according to his daughter Rebecca Hu Soong, as told to her daughter-in-law, Susan Soong, e-mail to the author, June 19, 2009.
9. Ibid.
10. Lydia, b. 1900; Theodore, 1901; Hannah, 1902; Emmanuel, c. 1903; Susanna, 1905; Alexander, 1912; Daniel, 1915; Rebecca, 1923.
11. C. P. Hu called Absalom "a fanatic." Susan Soong, e-mail to the author, December 6, 2012.
12. Jack Davies, telephone conversation with the author, May 27, 2013.
13. His B.A. and B.D. were granted by Charles City College, Sioux City, Iowa, a Methodist Episcopalian school that would be absorbed into Morningside College in 1910.
14. Jack Davies, telephone conversation with the author, May 27, 2013.
15. Albert Richardson, e-mail to the author, January 4, 2002.
16. Rebecca Hu Soong, in conversation with the author, Los Angeles, April 29, 2004.
17. Ibid.

18. Lydia told the 1930 census that she immigrated in 1914; she may have had her reasons for fudging the date.

19. Karen J. Underhill, archivist, Northern Arizona University, e-mail to the author, March 28, 2003.

20. "Seniors' Book of Truth," *La Cuesta* 1918, 108.

21. Transcript for Lydia Hu, 1916–1918, Northern Arizona Normal School, Flagstaff, AZ.

22. Rebecca Hu Soong, in conversation with the author, Los Angeles, April 29, 2004.

23. Jack Davies, telephone conversation with the author, January 10, 2006.

24. Kasper König, in conversation with the author, Venice, Italy, June 12, 1999.

25. Sally Gross, letter to the author, September 7, 2003.

26. In many conversations and e-mails, the extended Hu family kindly shared details of the history recounted in the following paragraphs.

27. See Tim Luard, *Escape from Hong Kong: Admiral Chan Chak's Christmas Day Dash, 1941* (Aberdeen, Hong Kong: Hong Kong University Press, 2012), as well as hong kongescape.org/Yee.htm (accessed February 18, 2016).

28. Richard Bellamy, letter to Virginia Wright, June 6, 1964. Richard Bellamy Papers, I.A.515. The Museum of Modern Art Archives, New York, NY.

29. Joe David Bellamy, *The Bellamys of Early Virginia* (iUniverse, 2005). See also his *Kindred Spirits: 400 Years of an American Family* (PublishingWorks, 2011) and *Island in the Sky: Bellamy and Allied Families* (Bellamy House, 2010).

30. Joe David Bellamy, e-mail to the author, December 14, 2011.

31. Joe David Bellamy, *Kindred Spirits*, 186.

32. Jack Davies, telephone conversation with the author, January 10, 2006.

33. Joe David Bellamy, e-mail to the author, January 17, 2001.

34. Archives, Medical College of Pennsylvania (formerly Women's Medical College Hospital).

35. Pat Lipsky, telephone conversation with the author, March 7, 2004.

36. Agnes Gund, Richard Bellamy Memorial Service, MoMA PS 1, Long Island City, NY, May 13, 1998.

37. Jack Davies, telephone conversation with the author, May 27, 2013.

38. Jack Davies, telephone conversation with the author, January 10, 2006.

39. Don Moore, telephone conversation with the author, January 1, 2002.

40. Bobbi Yerkes, telephone conversation with the author, August 21, 2002.

41. Phyllis Hall, telephone conversation with the author, October 23, 2001.

42. Ibid.

43. Bobbi Yerkes, telephone conversation with the author, August 21, 2002.

44. It was located at 1606 Freeman Avenue and closed in the fifties when the city acquired the building and leveled the block for urban renewal.

45. Jack Davies, telephone conversation with the author, January 10, 2006.

46. Ibid.

47. Miles Bellamy, in conversation with the author, New York, NY, June 30, 1999.

48. Phyllis Hall, telephone conversation with the author, October 23, 2001.

49. Kunié Sugiura, in conversation with the author, New York, NY, June 21, 2000.

50. Jack Davies, telephone conversation with the author, January 10, 2006.

51. Yunte Huang, *Charlie Chan: The Untold Story of the Honorable Detective and His Rendezvous with American History* (New York: W. W. Norton, 2010), 254.

52. Huang, "A List of Charlie Chan Films," in *Charlie Chan*, 302–303.

53. Emily Rauh Pulitzer, who attended Wyoming High School a few years after Dick, was one of the two Jewish students in her class. Emily Rauh Pulitzer, e-mail to the author, July 1, 2002.

54. Don Moore, telephone conversation with the author, January 1, 2002.

55. Sheindi Bellamy, telephone conversation with the author, October 24, 2001.

56. The mistaken belief that Jews had horns, perpetuated for centuries, derived from depictions of rays of light emanating from Moses's head.

57. Lydia miscarried twice; both were boys. One "had red curly hair" and "favored me lots," Curtis Bellamy revealed to Dick as an adult. Curtis Bellamy, letter to Richard Bellamy, June 3, 1965, in the collection of Miles Bellamy.

58. Bobbi Yerkes, telephone conversation with the author, August 21, 2002.

59. Mark di Suvero, in conversation with the author, Long Island City, NY, February 3, 2010.

60. Phyllis Hall, telephone conversation with the author, October 22, 2001.

61. Bobbi Yerkes, telephone conversation with the author, August 21, 2002.

62. Billy Marsall, in conversation with the author, Wyoming, OH, July 19, 2002.

63. Alan McAllister, e-mail to the author, January 2, 2002.

64. Ibid.

65. Althea Richardson Surface, letter to the author, March 5, 2002.

66. Murray Reed, e-mail to the author, January 2, 2002.

67. Jack Davies, telephone conversation with the author, January 10, 2006.

68. Ruth Churchill, telephone conversation with the author, October 16, 2002.

69. Dick's exploit shares several points in common with a celebrated hoax of Virginia Woolf's that was popularized in an American comic book, circa 1945. In 1910 she dressed up in blackface and exotic robes and convincingly presented herself to the British Royal Navy as the Prince of Abyssinia. "The Dreadnought Hoax, 1910," *The Museum of Hoaxes*, www.museumofhoaxes.com/hoax/archive/permalink/dreadnought_hoax/ (accessed June 1, 2011).

70. Don Moore, telephone conversation with the author, January 1, 2002.

71. Oral History Interview with George Segal, 1973 November 26, Archives of American Art, Smithsonian Institution.

72. Don Moore, telephone conversation with the author, January 1, 2002.

73. Phyllis Hall, telephone conversation with the author, October 22, 2001.

74. Don Moore, telephone conversation with the author, January 1, 2002.

75. Ruth Churchill, telephone conversation with the author, October 16, 2002.

76. Sheindi Bellamy, telephone conversation with the author, July 10, 2002.

77. Pat Lipsky, telephone conversation with the author, March 7, 2004.

78. Phyllis Hall, telephone conversation with the author, October 22, 2001.

79. Thomas Berger, letter to the author, January 19, 2002.

80. In a March 4, 1991, interview with Billy Klüver and Julie Martin, Richard Bellamy mentioned seeing Henry Moore's sculpture as a teenager. My gratitude to Sue Spaid, who kindly helped me to identify *Four Modern Sculptors*, assembled by the Cincinnati Modern Art Society and Curt Valentin, shown at the Cincinnati Art Museum from October 1 to November 15, 1946.

81. Richard Bellamy, interview with Billy Klüver and Julie Martin, March 4, 1991.
82. Virginia Wright, in conversation with the author, Seattle, WA, January 31, 2003.
83. Richard Bellamy, in de Coppet and Jones, *The Art Dealers*, 127.
84. Bobbi Yerkes, telephone conversation with the author, August 21, 2002.
85. Faye Sauder Bruce, in conversation with the author, Wyoming, OH, July 20, 2002.
86. Phyllis Hall, telephone conversation with the author, October 23, 2001.
87. Bobbi Yerkes, telephone conversation with the author, August 21, 2002.
88. On January 16, 1942, Lydia attended a bond rally in Indianapolis with the movie star Carole Lombard, who died in a plane crash that night on her way back to Los Angeles. During the war Lydia gave a luncheon for the exiled Dutch queen Wilhelmina. Jack Davies, telephone conversation with the author, January 10, 2006.
89. Lydia was not licensed to practice medicine and likely did paperwork. Emily Rauh Pulitzer, e-mail to the author, July 1, 2002.
90. An army private and bugler from October 1 to December 21, 1918, he was a lieutenant commander in the navy from February 15, 1944, to January 1, 1945, Military Personnel Records. As his nephew Jack Davies recalled, his mother, Dorothea, chided her brothers Doc and Orin that she had no relatives serving in World War II, and they then both enlisted. Jack Davies, telephone conversation with the author, May 27, 2013.
91. Lydia suffered from a "bad leakage heart." Curtis Bellamy, letter to Richard Bellamy, June 3, 1965, in the collection of Miles Bellamy.
92. Pat Lipsky, telephone conversation with the author, March 7, 2004.
93. Jack Davies, telephone conversation with the author, May 27, 2013.
94. Jack Davies, telephone conversation with the author, July 20, 2014.
95. Phyllis Hall, telephone conversation with the author, October 23, 2001.
96. Barbara Flynn, in conversation with the author, Venice, Italy, June 6, 2001.
97. Phyllis Hall, telephone conversation with the author, October 22, 2001.
98. Undergraduate transcript for Richard Townley Bellamy, University of Cincinnati, College of Liberal Arts, 1945–46.
99. Phyllis Hall, telephone conversation with the author, October 22, 2001.
100. Thomas Berger, personal letter, January 19, 2002.
101. Thomas Berger, quoted in "Thomas Berger, 'Little Big Man' Author, Is Dead at 89," *New York Times*, July 22, 2014.
102. Phyllis Hall, telephone conversation with the author, October 23, 2001.
103. Sheindi Bellamy, in conversation with the author, New York, NY, July 18, 2013.
104. Thomas Berger remembered her as hostess in the spring or summer of 1946.
105. Joe David Bellamy, e-mail to the author, July 8, 2002.
106. William Crozier, telephone conversation with the author, August 13, 2003.
107. Jack Davies, telephone conversation with the author, January 10, 2006.
108. Pat Lipsky, telephone conversation with the author, March 7, 2004.
109. Joe David Bellamy, e-mail to the author, January 17, 2001.
110. Albert Richardson, e-mail to the author, May 8, 2010.
111. After 1948, Hannah lost touch with her brothers who remained in China. Theodore, who had an American doctorate in agriculture, settled in Jiaozhou, where he headed a university agriculture department. Emmanuel had an M.B.A. from

Columbia University and chaired an economics department in a Jiaozhou university.

112. Hannah Yee, letter to Beulah Bellamy, January 29, 1981, courtesy of Joe David Bellamy.

113. Hannah once confided to Dick's cousin that she owned a Rolls-Royce too big to navigate the small streets of Hong Kong. Jack Davies, telephone conversation with the author, May 27, 2013.

114. Hannah Yee, letter to Beulah Bellamy, January 29, 1981, courtesy of Joe David Bellamy.

115. Richard Bellamy, letter to Vera List, December 21, 1975. Richard Bellamy Papers, I.A.273. The Museum of Modern Art Archives, New York, NY.

116. Robert Graves, "Mrs. Fisher, or the Future of Humour," in *Occupation: Writer* (New York: Grosset & Dunlap, 1950), 47–70.

117. Graves, "Mrs. Fisher," 61.

118. Robert Frank, in conversation with the author, New York, NY, May 24, 2002.

119. Kunié Sugiura, in conversation with the author, New York, NY, June 21, 2000.

120. Application for a Marriage License, State of Ohio, Hamilton County, January 13, 1948.

121. John Wesley, in conversation with the author, New York, NY, November 28, 2001.

122. Richard Bellamy, interview with Billy Klüver and Julie Martin, March 4, 1991. He slightly misremembered its title.

123. F.S.C. Northrop, *The Meeting of East and West: An Inquiry Concerning World Understanding* (New York: Collier Books, 1972), 15.

124. Richard Bellamy, interview with Billy Klüver and Julie Martin, March 4, 1991.

125. Ibid.

126. Albert Richardson, e-mail to the author, January 4, 2002.

127. Jack Davies, telephone conversation with the author, September 6, 2014.

128. Richard Bellamy, interview with Billy Klüver and Julie Martin, March 4, 1991.

2. PROVINCETOWN, 1948–49

1. Norman Mailer, *Why Are We in Vietnam?* (New York: Macmillan, 2000), 2.

2. James C. O'Connell, *Becoming Cape Cod* (Hanover, NH: University Press of New England, 2002), 81.

3. A. J. Philpott, "Biggest Art Colony in the World at Provincetown," *Boston Globe*, August 27, 1916.

4. The factual record of Peter Hunt's life is inexact. Unless otherwise stated, the information in this and the following paragraphs draws on Laurel Guadazno, "Peter Hunt, Folk Artist," *Provincetown Banner* (October 18, 2001), http://province townhistoryproject.com/PDF/mun_001_1055-peter-hunt-information.pdf (accessed June 17, 2009); and Lynn C. Van Dine's fictionalized biography, *The Search for Peter Hunt* (Pittsburgh: Local History Co., 2003).

5. MoMA owns Pa Hunt's painting, *Peter Hunt's Antique Shop* (1930–34).

6. Mary Heaton Vorse, *Time and the Town: A Provincetown Chronicle* (1942) (New Brunswick, NJ: Rutgers University Press, 1991), 211–12.

7. "Remade Furniture Offers Home Hints," *New York Times*, May 6, 1943, 16.

8. Richard Bellamy, interview with Billy Klüver and Julie Martin, March 4, 1991.

9. Betty Cavanna, *Paintbox Summer* (Philadelphia: Westminster Press, 1949), 63, 65, 95–96.

10. Ibid., 63.

11. William Baziotes, letter to Weldon Kees, June 20, 1949, from the collection of Gallery Gertrude Stein, in Jennifer Liese, "Toward No Laocoön: Forum 49 Allies the Arts" (M.A. thesis, School of the Art Institute of Chicago, 2002), 24–25.

12. Oral History Interview with George Segal, 1973 November 26, Archives of American Art, Smithsonian Institution.

13. Hans Hofmann, quoted in William Seitz, *Hans Hofmann* (New York: Museum of Modern Art, 1963), 37.

14. "Hans Hofmann: Quotes," *HansHofmann.net*, www.hanshofmann.net/quotes .html#.UnAS4XA3uSo (accessed October 26, 2015).

15. Irving Sandler, *A Sweeper-Up After Artists: A Memoir* (New York: Thames & Hudson, 2003), 16. See also "Interview with Red Grooms, January 6, 2000," in "Hofmann's Legacy: Hans Hofmann," *PBS Online*, www.pbs.org/hanshofmann /red_grooms_interview_001.html (accessed July 5, 2003).

16. Richard Bellamy, in de Coppet and Jones, *The Art Dealers*, 122.

17. Ibid., 123.

18. Hofmann and Hunt were among the sponsors listed on Forum 49's printed letterhead. Jennifer Liese, e-mail to the author, July 6, 2009. The sponsors were George Biddle, Mr. and Mrs. Adolf Gottlieb, Mr. and Mrs. Hans Hofmann, Peter Hunt, Karl Knaths, Dwight Macdonald, Dr. Carl A. Murchison, Paul Smith, John C. Snow, and Hudson D. Walker.

19. Liese, introduction to "Toward No Laocoön."

20. Sandler, *A Sweeper-Up After Artists*, 85.

21. The importance of the Forum 49 exhibition has been overlooked by art historians, even though it preceded the celebrated *Ninth Street Show* of 1951, often credited as the earliest group display of abstract expressionism.

22. William Baziotes, letter to Weldon Kees, June 20, 1949.

23. Fritz Bultman, in Tony Vevers, "Abstract Expressionism in Provincetown," *New York–Provincetown: A 50s Connection* (Provincetown, MA: Provincetown Art Association, 1994), 6. Pollock and Tennessee Williams became friends during the summer of 1944 on the Cape. The character of Stanley Kowalski in *A Streetcar Named Desire* may owe something to Pollock, a man similarly given to violent, drunken outbursts; see David Kaplan, *Tennessee Williams in Provincetown* (East Brunswick, NJ: Hansen Publishing Group, 2007), 72.

24. Jackson Pollock, in Michael Leja, *Reframing Abstract Expressionism* (New Haven, CT: Yale University Press, 1993), 182.

25. B. H. Friedman, *Jackson Pollock: Energy Made Visible* (Boston: Da Capo Press, 1995), 132–33.

26. Oral History Interview with Richard Bellamy, 1963 August 5, Archives of American Art, Smithsonian Institution.

27. "Jackson Pollock: Is He the Greatest Living Painter in the United States?," *Life*, August 8, 1949, 42.

28. Editor's note, Letters to the Editor, *Life*, August 29, 1949, 9. See also "Disapproval of Modernist's Art Voiced in Provincetown," *Cape Cod Standard Times*, August 8, 1949, in Liese, "Toward No Laocoön."

3. THIS CALLING OF ART

1. Nancy Christopherson, in conversation with the author, Bronx, NY, May 5, 2003. At the time of the interview Nancy had limited recall of her life.
2. Richard Bellamy, letter to Virginia Wright, 1977. Richard Bellamy Papers, I.A.515. The Museum of Modern Art Archives, New York, NY.
3. Doon Arbus, telephone conversation with the author, January 31, 2002.
4. Jeanne Christopherson, telephone conversation with the author, May 12, 2003.
5. Ralph Lee, telephone conversation with the author, November 6, 2007. This is the source for the following quotation as well.
6. Richard Bellamy, interview with Billy Klüver and Julie Martin, March 4, 1991.
7. Unless otherwise noted, Nancy's niece Jeanne Christopherson is the source of information about her aunt; Jeanne Christopherson, telephone conversations with the author, 2003–10.
8. Lakewood High School Alumni Association, e-mail to the author, February 9, 2002.
9. Anaïs Nin, *The Diaries of Anaïs Nin, 1944–1947* (New York: Harcourt Brace Jovanovich, 1971), 141. Nancy and Nin acted in Maya Deren's silent film-poem *Ritual in Transfigured Time* (1946). With Nancy's beatific good looks and innate grace, she, like Nin, was a natural for Deren's surrealistic film, which featured both professional and untrained dancers.
10. Anaïs Nin, *A Child Born Out of the Fog* (New York: Gemor Press, 1947).
11. Richard Bellamy, interview with Billy Klüver and Julie Martin, March 4, 1991.
12. Sheindi Bellamy, in conversation with the author, London, England, April 15, 2001.
13. Jean Bultman, telephone conversation with the author, February 4, 2002.
14. Janet Whelen, telephone conversation with the author, January 28, 2008.
15. Pati Hill, unpublished manuscript, 2009, courtesy of Pati Hill.
16. Pati Hill, in conversation with the author, Sens, France, June 15, 2003.
17. Pati Hill, unpublished manuscript, 2009, courtesy of Pati Hill.
18. Her fifties work is undocumented but was likely similar to what she did in the sixties. Remy Charlip, telephone conversation with the author, February 3, 2003. She would serve on the Judson's technical staff for *Pomegranada*, a Koutoukas-Carmines opera, and do costumes for *The Pelican*, undated cast notes courtesy of Erik La Prade.
19. Ralph Lee, telephone conversation with the author, November 6, 2007.
20. Nancy Christopherson, in Patricia Bosworth, *Diane Arbus* (New York: Alfred A. Knopf, 1984), 77. The reclusive Nancy was one of Bosworth's informants when she wrote her biography of Diane Arbus, and she required Bosworth to refer to her by the pseudonym "Cheech" whenever she was quoted.
21. Emile de Antonio, in Bosworth, *Diane Arbus*, 223.
22. Rebecca Soong, in conversation with the author, Los Angeles, April 28, 2004. Lydia's youngest sister met her nephew only once, on a trip to New York in 1952.
23. Albert Poland, e-mail to the author, February 23, 2011. Arthur Lubow kindly brought this portrait to the author's attention.
24. Catrina Neiman, e-mail to the author, June 1, 2003.
25. Jeffrey Rosenheim, telephone conversation with the author, April 28, 2003.
26. Richard Bellamy, letter to Robert Beauchamp and Jackie Ferrara, January 1960, in the collection of Jackie Ferrara.
27. Nancy Fish, in conversation with the author, Los Angeles, April 28, 2004.

28. Alfred Leslie, in conversation with the author, New York, NY, April 23, 2002.

29. Pati Hill, in conversation with the author, Sens, France, June 15, 2003.

30. Sheindi Bellamy, in conversation with the author, New York, NY, February 10, 2002.

31. Robert Frank, in conversation with the author, New York, NY, May 24, 2002.

32. Jeanne Christopherson, telephone conversation with the author, June 4, 2003.

33. Alfred Leslie, telephone conversation with the author, May 19, 2003.

34. Richard Bellamy, interview with Billy Klüver and Julie Martin, March 4, 1991.

35. Sheindi Tokayer, in conversation with the author, London, England, April 15, 2001.

36. Miles Forst, in conversation with the author, New York, NY, January 25, 2002.

37. Dick attached a copy of the poem to his February 3, 1986, letter to collector Sid Bass, I.A.26, Richard Bellamy papers, I.A.515. The Museum of Modern Art Archives, NY.

38. Richard Bellamy, interview with Billy Klüver and Julie Martin, March 4, 1991.

39. The talk would have been Willem de Kooning's "A Desperate View," delivered on February 18, 1949, at the Subjects of the Artist, Art School, New York, NY.

40. Richard Bellamy, interview with Billy Klüver and Julie Martin, March 4, 1991.

41. "De Kooning's Words: Overview," Willem de Kooning Foundation, www.dekooning.org/documentation/words/a-desperate-view (accessed September 12, 2014).

42. William Styron, likewise from Newport News, modeled a central character on Barbara in his 1951 novel *Lie Down in Darkness*. Alfred Leslie, in conversation with the author, New York, NY, 1991.

43. Paul Brach, in conversation with the author, Wainscott, NY, July 8, 2000.

44. Mary Frank, in conversation with the author, Woodstock, NY, August 12, 2009.

45. See Arnold Shaw, *52nd Street: The Street of Jazz* (Cambridge, MA: Da Capo Press, 1977).

46. Jesse Forst, telephone conversation with the author, February 25, 2010.

47. Dorothy Rouse-Bottom, telephone conversation with the author, June 15, 2006.

48. Sherman Drexler, in conversation with the author, New York, NY, September 21, 2003.

49. Alfred Leslie, in conversation with the author, New York, NY, June 28, 2000.

50. Unless otherwise noted, the source for this and the following paragraph is Miles Forst, in conversation with the author, New York, NY, June 24, 2002.

51. Nancy Christopherson, in conversation with the author, Bronx, NY, May 23, 2003.

52. Miles Forst, in conversation with the author, New York, NY, June 24, 2002.

53. Jill Johnston, *Mother Bound* (New York: Alfred A. Knopf, 1983), 121.

54. Sheindi Bellamy recalled that it was Madison Street; Poni's friend Wendy Clarke remembered Rivington Street.

55. Doon Arbus, telephone conversation with the author, February 2, 2010.

56. Nancy Christopherson, quoted by Sheindi Bellamy, in conversation with the author, New York, NY, March 31, 2002.

57. Alfred Leslie, telephone conversation with the author, April 1, 2014.

58. Alfred Leslie, interviewed by Judith E. Stein, *Art in America*, November 2009, 91.

59. Alfred Leslie, telephone conversation with the author, May 19, 2003.

60. Bosworth, *Diane Arbus*, 145.

61. J. Michael Lennon, e-mail to the author, April 5, 2010.

62. Alfred Leslie, in conversation with the author, New York, NY, July 6, 2000. Unless otherwise noted, this is the source for details of the party.

63. Robert Morris, "Studios," in *Robert Morris: Ten Works, Five Decades* (New York: Leo Castelli Gallery, 2012), 21.

64. Mimi Gross, in conversation with the author, New York, NY, July 30, 2000.

65. Tuli Kupferberg, in Peter Manso, *Mailer: His Life and Times* (New York: Simon & Schuster, 1987), 171.

66. Kupferberg cofounded the satirical sixties rock group the Fugs, which took its name from the word Mailer substituted for "fuck" in his novel *The Naked and the Dead*.

67. Allen Ginsberg, in Manso, *Mailer: His Life and Times*, 171.

68. Miles Forst, in conversation with the author, New York, NY, January 25, 2002.

69. Hilary Mills, *Mailer: A Biography* (New York: McGraw-Hill, 1984), 129.

70. Miles Forst, in conversation with the author, New York, NY, January 25, 2002.

71. Calder Willingham, in Mills, *Mailer: A Biography*, 133.

72. Alfred Leslie, in conversation with the author, New York, NY, July 6, 2000.

73. Richard Bellamy, résumé, compiled March 9, 1961. Richard Bellamy Papers, II.B.28. The Museum of Modern Art Archives, New York, NY.

74. Joe David Bellamy, e-mail to the author, January 18, 2001.

75. Ibid.

76. Richard Bellamy (1998), in Erik La Prade, *Breaking Through* (New York: Midmarch Arts Press, 2010), 201.

77. Pat Lipsky, telephone conversation with the author, March 7, 2004.

78. Miles Forst, interview with Billy Klüver and Julie Martin, March 4, 1991.

79. Bill Glynn, telephone conversation with the author, February 2002.

80. Jean Hill, telephone conversation with the author, September 15, 2003.

81. Ed Henry, telephone conversation with the author, December 21, 2001.

82. Jean Hill, telephone conversation with the author, September 15, 2003.

83. Althea Richardson Surface, letter to the author, March 5, 2002.

84. Ed Henry, telephone conversation with the author, December 21, 2001.

85. Bill Glynn, telephone conversation with the author, February 2002. Unless otherwise noted, this is the source for the following paragraph.

86. Jean Hill, telephone conversation with the author, September 15, 2003.

87. Barbara Flynn, in conversation with the author, Provincetown, MA, September 21, 2003.

88. Robert Brown, telephone conversation with the author, January 10, 2002.

89. Rhoda Lauten, alumni director, Rudolf Steiner School, e-mail to the author, February 8, 2002.

90. Wendy Clarke, telephone conversation with the author, February 24, 2002.

91. Ibid.

92. Jeanne Christopherson, telephone conversation with the author, September 15, 2003.

93. Sheindi Bellamy, in conversation with the author, London, England, April 15, 2001.

94. Ibid.

95. Jane Wilson and John Gruen, in conversation with the author, New York, NY, February 4, 2002.

96. Jill Johnston, in conversation with the author, London, England, October 7, 2000.

97. Wendy Clarke, telephone conversation with the author, February 24, 2002.

98. Ibid. Wendy's mother was the future film documentarian Shirley Clarke, who shot

home movies of Poni and her daughter. See "Shirley Clarke," Wisconsin Center for Film and Theater Research, www.wcftr.commarts.wisc.edu (accessed October 26, 2015).

99. Sheindi Bellamy, e-mail to the author, June 4, 2012.

100. Joe David Bellamy, *Suzi Sinzinnati* (New York: Penguin, 1989), 70.

101. Hamilton County transfer records for 5 Springfield Pike. Doc signed the house over to Gay on July 20, 1954.

102. On a visit to Wyoming nearly fifty years later, Dick's son, Miles, would meet a neighbor who presented him with a set of porcelain place-card holders purchased at the sale, in all likelihood one of Lydia's wedding presents. Pauline and Ben Saunders, in conversation with the author, Wyoming, OH, July 20, 2002.

103. Curtis Bellamy, letter to Richard Bellamy, March 17, 1965, in the collection of Miles Bellamy.

104. Jack Davies, telephone conversation with the author, January 10, 2006.

4. HANSA DAYS

1. Oral History Interview with Richard Bellamy, 1963 August 5, Archives of American Art, Smithsonian Institution; Oral History Interview with Richard Stankiewicz, 1963, Archives of American Art, Smithsonian Institution. Stankiewicz recalls that the group began to form in late 1951.

2. Pauline Pasilis, e-mail to the author, September 16, 2003.

3. Oral History Interview with Richard Bellamy, 1963 August 5, Archives of American Art, Smithsonian Institution.

4. L[awrence] C[ampbell], "813," *Art News*, December 1961, 12–13.

5. Felix Pasilis, e-mail to the author, September 18, 2003.

6. "Hansa Documents, 1952–1954," Richard Bellamy papers, II.A.6. The Museum of Modern Art Archives, New York, NY.

7. Felix Pasilis, e-mail to the author, September 18, 2003.

8. Ibid. The Hansa's opening show, held from November 24 to December 7, 1952, included paintings by Barbara Forst, Wolf Kahn, Jan Müller, and Jane Wilson, as well as sculpture by Richard Stankiewicz; advertised on November 30, 1952, in the Newport News *Daily Press*, a newspaper co-owned by Barbara Bottom Forst's family.

9. Paul Brach, in conversation with the author, Wainscott, NY, July 8, 2000. A few years after turning down the Hansa's invitation, Brach made his New York debut with Joan Mitchell, Mike Goldberg, and Robert Goodnough in *Four Younger Americans* at the Sidney Janis Gallery. When Leo Castelli opened his gallery in 1957, Brach was one of the first American artists he showed.

10. Oral History Interview with Richard Bellamy, 1963 August 5, Archives of American Art, Smithsonian Institution.

11. Oral History Interview with Richard Stankiewicz, 1963, Archives of American Art, Smithsonian Institution.

12. John Gruen and Jane Wilson, in conversation with the author, New York, NY, February 4, 2002. Although the gate proceeds from the two lectures and a concert were invariably less than the speaker's honorarium of twenty-five dollars, the series succeeded in attracting notables not yet familiar with the Hansa members' art.

13. Oral History Interview with Richard Bellamy, 1963 August 5, Archives of American Art, Smithsonian Institution.
14. Richard Bellamy, interview with Billy Klüver and Julie Martin, March 4, 1991.
15. *Drawings, Water Colors, Pastels,* Hansa Gallery, January 5–16, 1954.
16. Wolf Kahn, in La Prade, *Breaking Through,* 121.
17. Miles Forst, in conversation with the author, New York, NY, January 25, 2002.
18. Oral History Interview with Richard Bellamy, 1963 August 5, Archives of American Art, Smithsonian Institution.
19. Cynthia Navaretta, "Women Artists of the Fifties," *Women Artists Newsletter,* June 1977, 1, 6.
20. It would gain new vitality in 1955, when the city dismantled the light-blocking structure.
21. Alfred Leslie, e-mail to the author, April 22, 2010.
22. Miles Forst, interview with Billy Klüver and Julie Martin, 1993. See also Mark Stevens and Annalyn Swan, *de Kooning: An American Master* (New York: Alfred A. Knopf, 2004), 336, 367. Cathy Curtis kindly brought this reference to the author's attention.
23. Jan Müller's girlfriend Barbara Bluestein was among them. Barbara Bluestein, telephone conversation with the author, September 13, 2002.
24. John Gruen and Jane Wilson, in conversation with the author, New York, NY, February 4, 2002. See also Oral History Interview with Richard Stankiewicz, 1963, Archives of American Art, Smithsonian Institution.
25. The critics and writers Meyer Schapiro, Irving Sandler, Dore Ashton, and Fairfield Porter regularly visited and reviewed their exhibitions. Dore Ashton, in conversation with the author, New York, NY, February 22, 2001; Irving Sandler, in conversation with the author, New York, NY, October 1, 1999.
26. Oral History Interview with Richard Bellamy, 1963 August 5, Archives of American Art, Smithsonian Institution.
27. Ibid.
28. F[rank] O'H[ara], "Reviews and Previews, Hedi Fuchs," *Art News,* November 1954, 65.
29. Wolf Kahn, telephone conversation with the author, August 9, 2000.
30. Emile de Antonio, introduction to Emile de Antonio and Mitch Tuchman, *Painters Painting: A Candid History of the Modern Art Scene, 1940–1970* (New York: Abbeville Press, 1984), 24. This book is an edited transcript of the unedited footage de Antonio shot in 1970; *Painters Painting,* the film, was released in 1973.
31. Oral History Interview with Richard Bellamy, 1963 August 5, Archives of American Art, Smithsonian Institution.
32. Robert Delford Brown, interview with Mark Bloch, *Umbrella online* (March 2008), www.umbrellaeditions.com/issue.php?page=110&issue=10.
33. Oral History Interview with Leo Castelli, 1971, Archives of American Art, Smithsonian Institution.
34. "Hansa Documents, 1952–1954," Richard Bellamy Papers, II.A.6. The Museum of Modern Art Archives, New York, NY.
35. Robert Frank, in Anne Wilkes Tucker, ed., *Robert Frank: New York to Nova Scotia* (Boston: New York Graphic Society; Little, Brown, 1986), 52–53.
36. Felix Pasilis, e-mail to the author, September 16, 2003.

37. Dorothy Rouse-Bottom, telephone conversation with the author, June 15, 2006.

38. Paul Brach recalled that the six-month affair began at Feldman's family bunga-low in the Rockaways, where Morton, Joan Mitchell, Michael Goldberg, and Miles and Barbara had gone for a holiday in the mid-fifties. Paul Brach, in con-versation with the author, Wainscott, NY, July 8, 2000. See also Wolf Kahn, in La Prade, *Breaking Through*, 120.

39. June Ekman, in conversation with the author, New York, NY, March 21, 2015.

40. Barbara Forst, in Bosworth, *Diane Arbus*, 147.

41. Oral History Interview with Richard Stankiewicz, 1963, Archives of American Art, Smithsonian Institution. See also Oral History Interview with Richard Bel-lamy, 1963 August 5, Archives of American Art, Smithsonian Institution. Mrs. Duveen's first name is variously spelled in print as Anneta and Annetta.

42. Meryle Secrest, e-mail to the author, July 5, 2011.

43. Peter Duveen, letter to the author, August 4, 2011. See also Anneta Duveen, interview with Peter Duveen, Hebron, NY, July 20, 2006, and Peter Duveen's Hansa archive, courtesy of Peter Duveen.

44. Anita Coleman also canvassed for suggestions, and Robert Brown, the Arbuses' friend, gave her Bellamy's name. Robert Brown, telephone conversation with the author, January 10, 2002.

45. Oral History Interview with Richard Bellamy, 1963 August 5, Archives of American Art, Smithsonian Institution.

46. U.S. Census Bureau source, www.slideshare.net/RussellJWhite/then-and-now -1955-to-2010-10821744.

47. Miles Forst and Jan Müller worked on Dick to accept as he weighed the pros and cons of the job. Oral History Interview with Robert Beauchamp, 1975 January 16, Archives of American Art, Smithsonian Institution.

48. Richard Bellamy, in de Coppet and Jones, *The Art Dealers*, 122.

49. Ibid.

50. Eric Hodgins and Parker Lesley, "The Great International Art Market," *Fortune*, December 1955, 152.

51. Lucas Samaras, telephone conversation with the author, April 22, 2003. Brown, who sometimes joined John Cage on his mushroom hunts, was widely read in Bellamy's circle.

52. Alfred Leslie, e-mail to the author, May 1, 2012.

53. Allan Kaprow, in conversation with the author, New Brunswick, NJ, March 11, 1999.

54. Barbara Rose, telephone conversation with the author, April 22, 2003.

55. Richard Bellamy, in de Coppet and Jones, *The Art Dealers*, 133. Dick remem-bered the year as 1956, but the show ran from January 2 to 19, 1957.

56. Allan Kaprow, in conversation with the author, New Brunswick, NJ, March 11, 1999.

57. Ivan Karp, in conversation with the author, New York, NY, March 20, 1996. Others recall that the first freelancers earned five dollars per article; Douglas Martin, "Jerry Tallmer, Critic Who Created the Obies, Dies at 93," *New York Times*, November 11, 2014.

58. Karp covered shows by Miles Forst, Jan Müller, and Richard Stankiewicz. Ivan Karp, in conversation with the author, New York, NY, March 20, 1996.

59. Oral History Interview with Ivan Karp, 1969 March 12, Archives of American Art, Smithsonian Institution.

60. Ivan Karp, interview with the author, January 16, 2002.

61. Ivan Karp, in conversation with the author, New York, NY, March 20, 1996.

62. Ivan Karp, in conversation with Barbara Rose, 1968, Barbara Rose Papers, 1962–circa 1969, Archives of American Art, Smithsonian Institution.

63. Ivan Karp, in conversation with the author, New York, NY, March 20, 1996.

64. Adrian Dannatt, "Interview with Ivan Karp," *Art Newspaper*, January 6, 2002.

65. Ivan Karp, in conversation with the author, New York, NY, January 16, 2002.

66. Ivan Karp, in John Freeman Gill, "Ghosts of New York," *Atlantic*, June 2010, www.theatlantic.com/magazine/archive/2010/06/ghosts-of-new-york/308096/ (accessed July 7, 2010).

67. Richard Bellamy, in de Coppet and Jones, *The Art Dealers*, 122.

68. Richard Bellamy, interview with Billy Klüver and Julie Martin, March 4, 1991.

69. Ivan Karp, in conversation with the author, New York, NY, March 20, 1996.

70. Walasse Ting, letter to the author, February 20, 2002.

71. Ivan Karp, in conversation with the author, New York, NY, March 20, 1996. George Segal misspoke when he cited the Hansa's weekly salary as "five dollars." Oral History Interview with George Segal, 1973 November 26, Archives of American Art, Smithsonian Institution.

72. Ivan C. Karp, "The Ecstasy and Tragedy of Jackson Pollock, Artist," *Village Voice*, September 24, 1956, 8.

73. Ivan Karp, in conversation with the author, New York, NY, March 20, 1996.

74. Oral History Interview with Ivan Karp, 1963 October 18, Archives of American Art, Smithsonian Institution.

75. According to Sheindi Bellamy, who would meet Dick the following summer, Dick was disinterested in the political process. Sheindi Bellamy, in conversation with the author, New York, NY, November 7, 2011.

76. Sheindi Bellamy, in conversation with the author, London, England, April 14, 2001.

77. Richard Bellamy, interview with Amy Newman, February 7, 1996. Richard Bellamy Papers, II.B.31. The Museum of Modern Art Archives, New York, NY.

78. Ivan C. Karp, *Doobie Doo* (New York: Doubleday, 1966), 188.

79. Claire Burch, "How I Let the Andy Warhol Silver Helium Pillow Go Down in Value," www.dnai.com/~cburch/howistuff.html (accessed August 20, 2002).

80. Ivan Karp, in conversation with Barbara Rose, 1968, Barbara Rose Papers, 1962–circa 1969, Archives of American Art, Smithsonian Institution.

81. Ivan Karp, quoted in Amy Goldin, "Requiem for a Gallery," *Arts Magazine*, January 1966, 26.

82. Ivan Karp, in conversation with the author, New York, NY, March 20, 1996.

83. Richard Bellamy, letter to Dorothy C. Miller, October 22, 1956. Hansa Gallery subject file. The Museum of Modern Art Archives, New York, NY.

84. "Quite some activity, centering around the Hansa," wrote Robert Smithson, the future sculptor of *Spiral Jetty*, then not yet twenty. Robert Smithson, in Eugenie Tsai, *Robert Smithson Unearthed: Drawings, Collages, Writings* (New York: Columbia University Press, 1991), 40n24.

85. Allan Kaprow, George Segal, Miles Forst, Felix Pasilis, and Wolf Kahn.

86. March 10–April 28, 1957.

87. "Vivid Exhibition by Younger Painters Marks 10th Anniversary of Museum," *New York Times*, March 14, 1957.

88. Leo Steinberg, introduction to *Artists of the New York School: Second Generation* (New York: Jewish Museum, 1957), 4.

89. Richard Bellamy, in conversation with Billy Klüver and Julie Martin, in "Richard Bellamy," *Art in America*, November 2014, 127.

90. Ibid.

91. Oral History Interview with Leo Castelli, 1969 May, Archives of American Art, Smithsonian Institution. This is also the source for the following paragraph.

92. Ileana Sonnabend, in Annie Cohen-Solal, *Leo and His Circle* (New York: Alfred A. Knopf, 2010), 223.

93. Leo Castelli, in de Antonio and Tuchman, *Painters Painting*, 90.

94. Oral History Interview with Leo Castelli, 1969 May, Archives of American Art, Smithsonian Institution.

95. In 1948, during their student days at Hans Hofmann's school in Greenwich Village, and before she met Stankiewicz, Follett and Sam Hunter had a brief romantic relationship. "We all thought she was 'too much like Miró,' not enough Hofmann brushstroke and 'push *und* pull.' Of course, it turned out she was a true and worthy original." Sam Hunter, e-mail to the author, May 9, 2002.

96. Allan Kaprow, interview with Susan Hapgood, in *Neo-Dada: Redefining Art, 1958–62* (New York: Universe, 1994), 116.

97. Larry Rivers, *What Did I Do?* (New York: HarperCollins, 1992), 172.

98. Lucas Samaras, telephone conversation with the author, April 22, 2003.

99. By her own account, she advised him "to weld the parts together, which he later did so successfully, while I myself kept my work flat on plywood." Jean Follett, in Charlotte Streifer Rubinstein, *American Women Sculptors* (New York: G. K. Hall, 1990), 343. Veterans, they used their GI Bill benefits to finance a year in Paris.

100. Robert Frank, in conversation with the author, New York, NY, May 24, 2002.

101. Lucas Samaras, telephone conversation with the author, April 22, 2003.

102. Richard Bellamy, interview with Susan Hapgood, July 21, 1991. Transcript courtesy of Susan Hapgood.

103. Hapgood, *Neo Dada*, 61; Sam Hunter, *George Segal* (New York: Rizzoli, 1989), 17.

104. Richard Brown Baker, cited in Richard Bellamy, interview with Susan Hapgood, July 21, 1991. Transcript courtesy of Susan Hapgood.

105. Deborah VanDetta, "Jean Follett: Assemblage Artist of the 1950s" (unpublished M.A. thesis, Rutgers University, 1999); Martha Edelheit, e-mail to the author, November 18, 2010.

106. Alfred Leslie, telephone conversation with the author, February 3, 2010.

107. Jean Follett described her fragile finances in nearly all of her extant correspondence with Dick, letters written in 1962 and 1965. Richard Bellamy Papers, III.A.24. The Museum of Modern Art Archives, New York, NY.

5. PROVINCETOWN, 1957

1. https://buildingprovincetown.wordpress.com/2010/01/04/15-howland
-street/ (accessed February 1, 2015).

2. Jackie Ferrara, telephone conversation with the author, January 16, 2015.

3. Yvonne Andersen, e-mail to the author, June 18, 2011.

4. www.nps.gov/caco/parkmgmt/upload/Chapter7-9.pdf, February 2, 2015.

5. Jim Bumgardner, telephone conversation with the author, December 12, 2014.

6. Oral History Interview with George Segal, 1973 November 26, Archives of
American Art, Smithsonian Institution.

7. Lois Karp, telephone conversation with the author, January 31, 2002.

8. Sheindi Bellamy, in conversation with the author, London, England, April 15,
2001; Richard Bellamy, résumé, Richard Bellamy Papers, II.B.28. The Museum
of Modern Art Archives, New York, NY.

9. Jim Bumgardner, telephone conversation with the author, December 12, 2014.

10. Tony Vevers, "Abstract Expressionism in Provincetown," in *New York–Provincetown:
A 50s Connection* (Provincetown, MA: Provincetown Art Association, 1994), 7.

11. Jim Bumgardner, telephone conversation with the author, December 12, 2014.

12. Emilio Cruz, e-mail to the author, April 30, 2001.

13. Richard Bellamy, letter to Virginia Wright, 1977. Richard Bellamy Papers, I.A.515.
The Museum of Modern Art Archives, New York, NY.

14. "Art: A Place in the Sun," *Time*, July 29, 1957.

15. Judith Stein, "Figuring Out the Fifties: Aspects of Figuration and Abstraction in
New York, 1950–1962," in Paul Schimmel and Judith Stein, eds., *The Figurative
Fifties: New York Figurative Expressionism* (New York: Rizzoli International; New-
port Harbor Art Museum, 1988), 37.

16. "Art: A Place in the Sun."

17. Pat Lipsky, e-mail to the author, April 22, 2009. Although Dick's employment
details are unknown, he told an interviewer that it was at a Hofmann school night
class in New York early in 1950, presumably while working as a model, that he
first saw the paintings of Myron Stout, an artist whose work he would champion
for the rest of his life. Richard Bellamy, in Judith Wilson, "Richard Bellamy [an
interview]," *Issue: A Journal for Artists* 4 (Fall 1985): 20. Stout studied with
Hofmann from November 14, 1949, to January 27, 1950, among other times.
Alison Green, e-mail to the author, November 1, 2002.

18. Jim Bumgardner, telephone conversation with the author, December 12, 2014.

19. Richard Bellamy, interviewed by Billy Klüver and Julie Martin, March 4, 1991.

20. Yvonne Andersen, interviewed by Charles Giuliano, May 13, 2013, www
.berkshirefinearts.com/05-13-2013_provincetown-s-legendary-sun-gallery.htm.

21. The couple lived in the back of the small gallery, whose variable proportions
could be changed by adjusting a partition wall.

22. Red Grooms, in Judith Stein, "Red Grooms: The Early Years (1937–1960)," in
Red Grooms: A Retrospective, 1956–1984 (Philadelphia: Pennsylvania Academy of
the Fine Arts, 1985), 32.

23. Judith Stein, "Figuring Out the Fifties," 41.

24. The operation took place in the spring of 1954. Dody Müller, "Jan Müller's Life,"
in *Jan Müller, 1922–1958* (New York: Solomon R. Guggenheim Museum, 1962),
https://archive.org/stream/janmller00solo#page/n11/mode/2up (accessed Feb-

ruary 19, 2015). During the summer of 1953 in Provincetown, Hofmann himself organized an exhibition whose proceeds covered the cost of the surgery. Richard Bellamy, interviewed by Billy Klüver and Julie Martin, March 4, 1991.

25. Richard Bellamy, interviewed by Billy Klüver and Julie Martin, March 4, 1991.

26. Robert Frank, in conversation with the author, New York, NY, May 24, 2002.

27. Jackie Ferrara, in conversation with the author, New York, NY, September 5, 2002. In the summer of 1957, *Time* ["Art: A Place in the Sun," *Time*, July 29, 1957] described the skimpy swimsuit as a uniform for the "beard, beret and bikini set of latter-day painters."

28. Gutman would be crucial to the financing of Alfred Leslie and Robert Frank's *Pull My Daisy* and to Carolee Schneemann's performance *More Meat Joy* (1964). Others who would benefit from his kindness at crucial stages of their careers include Robert Beauchamp, Bob Thompson, Emilio Cruz, George Segal, Red Grooms, Mimi Gross, and Dorothea Rockburne, and the dancers Trisha Brown, Simone Forti, and Twyla Tharp. See Judith Stein, "Object Lessons," *Picturing the Modern Amazon* (New York: Rizzoli International, 2000), 24–27.

29. April Kingsley, "Art on the Beach: Provincetown People and Places," *Art Express*, March–April 1982, 46.

30. Yvonne Andersen, e-mail to the author, February 9, 2015.

31. Red Grooms, telephone conversation with the author, January 20, 2010.

32. Mimi Gross, in conversation with the author, New York, NY, April 7, 1999.

33. Dorothy Rouse-Bottom, telephone conversation with the author, June 15, 2006.

34. Jim Bumgardner, telephone conversation with the author, December 12, 2014.

35. Sheindi Bellamy, in conversation with the author, London, England, April 15, 2001. Unless otherwise noted, this is the source for the information in the following paragraphs.

36. "Ratner's Closes, For the Last Time," *LowerManhattan.info*, December 16, 2004, www.lowermanhattan.info/news/ratner_s_closes__98492.aspx (accessed July 2005).

37. Sheindi Bellamy, in conversation with the author, New York, NY, October 19, 2009.

38. Andrew Tatarsky, telephone conversation with the author, January 25, 2015.

39. Christopher Hitchens, "Inside the Orgone Box," *New York Times Sunday Book Review*, September 23, 2011, 26.

40. Ibid.

41. Adele Mailer, *The Last Party* (New York: Barricade Books, 2004), 41.

42. Sheindi Bellamy, in conversation with the author, New York, NY, September 13, 2012.

43. June Ekman, in conversation with the author, New York, NY, March 21, 2015.

44. Dick described his group as "the Provincetown Greenbergs," a name assigned by Richard Stankiewicz. Richard Bellamy, interviewed by Billy Klüver and Julie Martin, March 4, 1991.

45. Susan Sontag, "Notes on 'Camp,'" *Partisan Review*, Fall 1964, 515–30.

46. Pat Lipsky, telephone conversation with the author, March 7, 2004.

47. www.softspokenfilms.com/images/7-8-pressbook.pdf.

48. Hettie Jones, *How I Became Hettie Jones* (New York: Dutton, 1991), 193.

49. Robert Frank, in conversation with the author, New York, NY, May 24, 2002.

50. Jill Johnston, *Mother Bound* (New York: Alfred A. Knopf, 1983), 126.
51. Ibid.
52. Jim Bumgardner, telephone conversation with the author, December 12, 2014.
53. Sheindi Bellamy, telephone conversation with the author, April 4, 2004.
54. Alexander King, *Mine Enemy Grows Older* (1958), quoted in http://neglectedbooks
 .com/?p=246 (accessed February 7, 2015).
55. www.sobernation.com/cunning-baffling-and-powerful/.
56. Sheindi Bellamy, in conversation with the author, New York, NY, October 19,
 2009.
57. Dorothea Rockburne, in conversation with the author, April 5, 2003.
58. Jackie Ferrara, telephone conversation with the author, January 16, 2015.

6. HIPSTERS, BEATNIKS, BOHEMIANS, AND SQUARES

1. "Art: The Wild Ones," *Time*, February 20, 1956, http://content.time.com/time
 /magazine/article/0,9171,808194,00.html (accessed June 2003).
2. Herb Caen, *San Francisco Chronicle*, April 2, 1958.
3. Joyce Johnson, *Minor Characters* (New York: Houghton Mifflin, 1987), 188. *Play-
 boy* dedicated its July 1, 1959, issue to the Beats.
4. Richard Bellamy, résumé, Richard Bellamy Papers, II.B.28. The Museum of
 Modern Art Archives, New York, NY.
5. Barbara Rose, telephone conversation with the author, April 22, 2003.
6. Victor di Suvero, telephone conversation with the author, September 24, 2011.
7. Michael Heizer, telephone conversation with the author, June 3, 2003.
8. Barbara Rose, telephone conversation with the author, April 22, 2003.
9. Paul O'Neil, "The Only Rebellion Around," *Life*, December 14, 1959, 114.
10. Ibid., 119.
11. One of the photographer Bert Stern's outtakes appeared on the front of the
 jacket of Francis J. Rigney and L. Douglas Smith, *The Real Bohemia: A Sociological
 and Psychological Study of the "Beats"* (New York: Basic Books, 1961).
12. The suggestively titled film chronicles a day in the life of a railroad brakeman
 (Larry Rivers), who is married to a painter, played by Delphine Seyrig in her
 debut performance. Seven-year-old Pablo, Robert and Mary's son, plays their
 child. The painter Alice Neel stars as Dick's mother.
13. Robert Frank, in conversation with the author, New York, NY, May 24, 2002.
 Frank would again work with Dick on *O.K. End Here* (1963), a thirty-minute film
 about a day in the lives of a man and a woman who live together in New York
 City. Dick, Sheindi, Myron Stout, Barbara and Miles Forst, Alice Neel, and
 Walter Gutman are among those who make uncredited appearances in a bar and
 restaurant scene at its conclusion.
14. Emile de Antonio, in *Fire in the East: A Portrait of Robert Frank*, a film written, di-
 rected, and edited by Philip Brookman and Amy Brookman, MFA Houston films,
 1986.
15. Alfred Leslie, in "Jack Kerouac and the Beats, Off the Road and in a Film," *New
 York Times*, July 12, 2000, E3.
16. Jack Kerouac, *The Subterraneans* (New York: Grove Press, 1958), 1.
17. Michael Heizer, telephone conversation with the author, June 3, 2003.

18. Richard Brown Baker, diary entry, January 20, 1958. Richard Brown Baker Papers. Yale Collection of American Literature. Beinecke Rare Book and Manuscript Library. Unless otherwise noted, this is the source for this and the following paragraph.
19. Robert Rosenblum, in Roni Feinstein, *Circa 1958: Breaking Ground in American Art* (Chapel Hill: Ackland Art Museum, University of North Carolina, 2008), 2.
20. Cohen-Solal, *Leo and his Circle*, 363.
21. Goldin, "Requiem for a Gallery," 26.
22. Pat Lipsky, telephone conversation with the author, March 7, 2004.
23. Paul Resika, "A Painter's Beginnings: An Interview with Paul Resika," *Linea*, Spring 2010, 13, www.theartstudentsleague.org/LinkClick.aspx?fileticket=Iye1AGqQYfM%3D&tabid=96.
24. Oral History Interview with Richard Bellamy, 1963 August 5, Archives of American Art, Smithsonian Institution.
25. Richard Bellamy, interview with Billy Klüver and Julie Martin, March 4, 1991.
26. Robert Rauschenberg, untitled statement, in Dorothy C. Miller, ed., *Sixteen Americans*, with statements by artists and others (New York: Museum of Modern Art, 1959), 58.
27. Allan Kaprow, "The Legacy of Jackson Pollock (1958)," in Allan Kaprow, *Essays on the Blurring of Art and Life*, Jeff Kelley, ed. (Berkeley and Los Angeles: University of California Press, 1993), 9.
28. Jeff Kelley, *Childsplay: The Art of Allan Kaprow* (Berkeley: University of California Press, 2004), 21.
29. Mica Nava, in conversation with the author, London, England, May 30, 2001.
30. Richard Brown Baker, in Oral History Interview with Richard Bellamy, 1963 August 5, Archives of American Art, Smithsonian Institution.
31. See Joan Marter, ed., *Off Limits: Rutgers University and the Avant-Garde, 1957–1963* (New Brunswick, NJ: Rutgers University Press, 1999).
32. Allan Kaprow, interview with John Held Jr., Dallas Public Library Cable Access Studio, 1988.
33. Claes Oldenburg, in conversation with the author, New York, NY, April 26, 2002.
34. Wolf Kahn, telephone conversation with the author, August 9, 2000.
35. Fielding Dawson, "The March" (1970), http://text.no-art.info/en/dawson_march.html (accessed November 26, 2013).

7. AN ERA'S END

1. Oral History Interview with Richard Bellamy, 1963 August 5, Archives of American Art, Smithsonian Institution.
2. Martha Edelheit, telephone conversation with the author, March 20, 2010.
3. Oral History Interview with Richard Bellamy, 1963 August 5, Archives of American Art, Smithsonian Institution.
4. Fay Lansner, in Miriam Schapiro, ed., *Anonymous Was a Woman* (Valencia, CA: Feminist Art Program, California Institute of the Arts, 1974), 98.
5. Oral History Interview with Ivan Karp, 1963, Archives of American Art, Smithsonian Institution.
6. Jane Wilson, in conversation with the author, New York, NY, February 4, 2002.

7. Miles Forst, paraphrased by Alfred Leslie, in conversation with the author, New York, NY, July 6, 2000.

8. "The Corporate Splurge in Abstract Art," *Fortune*, April 1960, 139–47.

9. Mark Rothko, in James E. B. Breslin, *Mark Rothko: A Biography* (Chicago: University of Chicago Press, 1993), 376.

10. Robert Frank, *Les Américains*, edited by Robert Delpire, text (in French) by Alain Bosquet, cover by Saul Steinberg (Paris: Delpire, 1958).

11. Ivan Karp, telephone conversation with the author, April 30, 2010.

12. Mary Frank, in conversation with the author, New York, NY, March 20, 1996.

13. Robert Frank, in conversation with the author, New York, NY, May 24, 2002. Unless otherwise noted, this is the source of information and Frank's quotations about the film.

14. Cited as an untitled home movie, Philip Brookman, "In the Margins of Fiction: From Photographs to Films," in *Robert Frank: New York to Nova Scotia*, Anne Wilkes Tucker, ed. (Houston, TX: Museum of Fine Arts, 1986), 85.

15. Al Hansen, *Incomplete Requiem for W. C. Fields* (New York: Something Else Press, 1966), 5.

16. Mary Frank, in conversation with the author, Philadelphia, February 10, 2002.

17. Hansen, *Incomplete Requiem for W. C. Fields*, 5.

18. Robert Frank, in conversation with the author, New York, NY, May 24, 2002.

19. Judith Stein, "Figuring Out the Fifties," in *The Figurative Fifties*, 37.

20. Dorothy Gees Seckler, *Provincetown Painters, 1890's–1970's* (Provincetown, MA: Everson Museum of Art, Provincetown Art Association, 1977), 82.

21. *The Sun Gallery*, Exhibition Catalogue (Provincetown: Art Association and Museum, 1981), 30.

22. "Art Town, 1958," *Time*, August 18, 1958.

23. Oral History Interview with Walter P. Chrysler, 1964 September 5, Archives of American Art, Smithsonian Institution.

24. "Walter Chrysler Jr.," *Our History*, Chrysler Museum of Art, www.chrysler .org/about-the-museum/our-history/walter-chrysler-jr/ (accessed December 15, 2012).

25. Henry Geldzahler, interview with Christopher Busa, "Henry Geldzahler, Famous Curator," *Provincetown Arts* 7 (1991): 51.

26. Calvin Tomkins, "Profiles: Henry Geldzahler," *New Yorker*, November 6, 1971, 66.

27. Ibid. The Happening was entitled *A Play Called Fire*. Mimi Gross (e-mail to the author, June 4, 2010) believes he may have misremembered the year, and which Happening he saw.

28. Judith Stein, "Red Grooms: The Early Years (1937–1960)," 33.

29. Oral History Interview with Richard Bellamy, 1963 August 5, Archives of American Art, Smithsonian Institution.

30. Richard Bellamy, in de Coppet and Jones, *The Art Dealers*, 122.

31. Oral History Interview with Ivan C. Karp, 1969 March 12, Archives of American Art, Smithsonian Institution.

32. Miles Forst, interview with Billy Klüver and Julie Martin, 1993.

33. Lois Karp, telephone conversation with the author, October 27, 2003.

34. Oral History Interview with Ivan Karp, 1963 October 18, Archives of American Art, Smithsonian Institution.

35. Sheindi Bellamy, in conversation with the author, New York, NY, November 23, 2003.
36. Richard Bellamy, interview with Billy Klüver and Julie Martin, March 4, 1991.
37. Fay Lansner, in Schapiro, ed., *Anonymous Was a Woman*, 99.
38. Ibid.
39. Jane Wilson, in conversation with the author, New York, NY, February 4, 2002.
40. Fay Lansner, in Schapiro, ed., *Anonymous Was a Woman*, 100. This is the source of information for the rest of the paragraph.
41. Oral History Interview with Richard Bellamy, 1963 August 5, Archives of American Art, Smithsonian Institution.
42. Goldin, "Requiem for a Gallery," 26.
43. Oral History Interview with George Segal, 1973 November 26, Archives of American Art, Smithsonian Institution.
44. Dick and Segal were still trying to raise funds in the months after it closed. See Richard Bellamy, letter to George Segal, July 30 [1959], Correspondence; 1950s–1960s George Segal Papers (C1303), Box 46, Folder 3, Manuscripts Division, Department of Rare Books and Special Collections, Princeton University Library.
45. "Art: Big Splash," *Time*, May 18, 1959, 72.
46. Richard Bellamy, interview with Carey Lovelace, October 24, 1984, courtesy of Carey Lovelace.
47. Leo Castelli, in conversation with the author, New York, NY, March 6, 1996.
48. Oral History Interview with Leo Castelli, 1969 May, Archives of American Art, Smithsonian Institution.
49. Leo Castelli, in conversation with Barbara Rose, 1968, Barbara Rose Papers 1962–circa 1969, Archives of American Art, Smithsonian Institution, transcription courtesy of Midori Yamamura.
50. Paul Brach, in conversation with the author, Wainscott, NY, July 8, 2000.

8. THE REPUBLIC OF DOWNTOWN

1. Richard Bellamy, interview with Billy Klüver and Julie Martin, March 4, 1991.
2. Charles Ginnever, in conversation with the author, Putney, VT, July 22, 2000.
3. Mark di Suvero, interview with Leonard Lopate, June 15, 2005, WNYC Radio, www.wnyc.org/story/51052-the-good-the-big-and-the-young/ (accessed October 26, 2015).
4. Donald Judd, "Local History," *Arts Magazine Yearbook* 7 (1964): 30.
5. Jim Dine, in "The Smiling Workman," *Time*, February 2, 1962, 44.
6. Mark di Suvero, telephone conversation with the author, December 2, 2011.
7. Richard Bellamy, interview with Amy Newman, February 7, 1996. Richard Bellamy Papers, II.B.31. The Museum of Modern Art Archives, New York, NY.
8. Mark di Suvero, in conversation with John Yau, *Brooklyn Rail*, July/August 2005, www.brooklynrail.org/2005/07/art/s (accessed July 12, 2005).
9. Born to Venetian parents in Shanghai in 1933, Mark was eight when he and his family moved to the United States.
10. Victor di Suvero, telephone conversation with the author, September 24, 2011.
11. Richard Bellamy, in de Coppet and Jones, *The Art Dealers*, 123. His other great hero was de Kooning.

12. Ibid., 121.

13. Richard Bellamy, interview with Billy Klüver and Julie Martin, March 4, 1991.

14. Sheindi Bellamy, e-mail to the author, October 12, 2011.

15. Oral History Interview with Ivan Karp, 1969 March 12, Archives of American Art, Smithsonian Institution.

16. Richard Bellamy, interview with Billy Klüver and Julie Martin, March 4, 1991.

17. See exhibition history in Harry Rand, *The Martha Jackson Memorial Collection* (Washington, D.C.: Smithsonian Institution Press, 1985), 71–82.

18. Richard Bellamy, interview with Billy Klüver and Julie Martin, March 4, 1991.

19. The Howard Wise Gallery of Present Day Painting and Sculpture was the gallery he founded in Cleveland in 1957.

20. Frank Gillette, in Marita Sturken, "TV as a Creative Medium: Howard Wise and Video Art," *AfterImage* 11, no. 10 (May 1984): 5.

21. Lee Bontecou, telephone conversation with the author, May 30, 2003.

22. Oral History Interview with Ivan Karp, 1969 March 12, Archives of American Art, Smithsonian Institution; Oral History Interview with Leo Castelli, 1969 July, Archives of American Art, Smithsonian Institution. Lee Bontecou's first show at Castelli's ran from November 9 to December 3, 1960.

23. A. Alfred Taubman, in conversation with the author, New York, NY, August 21, 2013.

24. Frank Stella, in *Neil Williams: Works from Brazil, 1982–1988* (20th São Paulo International Biennial, 1989), 8.

25. Frank Stella, in conversation with the author, New York, NY, September 28, 2006.

26. Richard Bellamy, interview with Billy Klüver and Julie Martin, March 4, 1991.

27. Frank Stella, in conversation with the author, New York, NY, September 28, 2006.

28. It was the March Gallery and not the erroneously transcribed "Mars" Gallery cited in Julie Sylvester, *John Chamberlain: A Catalogue Raisonné of the Sculpture, 1954–1985* (Manchester, VT: Hudson Hills Press, 1986), 14.

29. Chamberlain exhibited at the Hansa with Robert Whitman and Lucas Samaras in *Three Men Drawings*, May 12–31, 1958, shortly after his two-man show at the cooperative Davida Gallery (245 Fifth Avenue), April 9–May 5, 1958. He again showed at the Hansa, in *Contemporary Americans*, November 3–22, 1958, a large group display of members and invited artists, and in the gallery's final show, *Contemporary Americans*, May 18–June 6, 1959.

30. James Rosenquist, *Painting Below Zero: Notes on a Life in Art* (New York: Alfred A. Knopf, 2009), 74.

31. Jeanie Blake, in conversation with the author, East Hampton, NY, July 8, 2000.

32. Sylvester, *John Chamberlain: A Catalogue Raisonné*, 15.

33. Richard Bellamy, interview with Billy Klüver and Julie Martin, March 4, 1991. As Sheindi remembered, the loft was in an industrial building on Broadway and Waverly Place, near New York University.

34. Ivan Karp, in conversation with the author, New York, NY, January 16, 2002.

35. Oral History Interview with Ivan Karp, 1969 March 12, Archives of American Art, Smithsonian Institution.

36. Ibid.

37. Phyllis Tuchman, "An Interview with John Chamberlain," *Artforum*, February 1972, 39.

38. Richard Bellamy, interview with Billy Klüver and Julie Martin, March 4, 1991.

39. Alexi Worth, "Octopussarianism: Ten Alfred Leslie Years," *Sienese Shredder* 2 (2008): 254.

40. Alfred Leslie, *The Hasty Papers* (Austin, TX: Host Publications, 1999), a reprint of the rare paper edition.

41. Emile de Antonio, "Pontus Hultén and Some 60s Memories in New York," in catalogue, *New York Collection for Stockholm* (Stockholm: Modena Museet, 1973), unpaged.

42. Leslie, *The Hasty Papers*, 9.

43. Richard Bellamy, letter to Robert Beauchamp and Jackie Ferrara, January 13, 1960, in the collection of Jackie Ferrara.

44. Francis Davis, *Like Young: Jazz and Pop, Youth and Middle Age* (Cambridge, MA: Da Capo Press, 2001), 137.

45. In 1916, the grand master of Dada, Marcel Duchamp, and the painter John Sloan convened a group of friends to picnic above the trees in Washington Square Park at the foot of Fifth Avenue. They reached the top of the landmark arch through a hidden stairway and seated themselves on hot-water-bottle cushions for a fete punctuated by poetry read aloud and the pop of cap pistols. As it ended, a toast rang out to Greenwich Village, a "free republic, independent of uptown." Sally Banes, *Greenwich Village 1963: Avant-Garde Performance and the Effervescent Body* (Durham, NC: Duke University Press, 1993), 14.

46. Ivan Karp, in conversation with Barbara Rose, 1968, Barbara Rose Papers 1962–circa 1969, Archives of American Art, Smithsonian Institution.

47. Joellen Bard, *Tenth Street Days: The Co-ops of the 50's* (New York: Education, Art and Service, 1977), 51.

48. Stein, "Red Grooms: The Early Years (1937–1960)," 34; Judith Stein, "Jay Milder: Urban Visionary," in *Jay Milder: Retrospective, 1958–1991* (Brooklyn, CT: New England Center for Contemporary Art, 1991).

49. Mica Nava (née Michaela Weisselberg), e-mail to the author, October 20, 2011.

50. Meyer Levin, "Exhibition by Young Artists," *Philadelphia Inquirer*, January 18, 1959, D5. This is the source for the rest of the paragraph.

51. Red Grooms, fax to author, November 19, 2002.

52. Patty Mucha (Pat Oldenburg), in conversation with the author, Barnet, VT, September 2, 1999.

53. Richard Bellamy, in de Coppet and Jones, *The Art Dealers*, 131.

54. Fred McDarrah, *The Artist's World in Pictures* (New York: E. P. Dutton, 1961), 184.

55. Red Grooms, in Stein, "Red Grooms: The Early Years (1937–1960)," 35.

56. Elly Dickason, in C. Carr, "Bringing Down the House: A Historical Art Space Falls to the Disney of Downtown, NYU," *Village Voice*, July 25, 2000, www.villagevoice .com/2000-07-25/news/bringing-down-the-house/ (accessed August 2001).

57. Dan Flavin, "'. . . In Daylight or Cool White.' An Autobiographical Sketch," *Artforum*, December 1965, 22.

58. *East New York Shrine* (CL 9) is the fourth in a series of ten, 1962–65.

59. Richard Bellamy, interview with Susan Hapgood, July 21, 1991, courtesy of Susan Hapgood.

60. Claes Oldenburg, in Barbara Rose, *Claes Oldenburg* (New York: Museum of Modern Art, 1979), 33.

61. Patty Mucha, "Sewing in the Sixties," *Art in America*, November 2002, 81. See also Rosenquist, *Painting Below Zero*, 122.

62. James Rorimer, in Barbara Goldsmith, "How Henry Made 43 Artists Immortal," *New York*, October 13, 1969, 49.

63. Peter Selz, in "The Pleasures of Art: Peter Selz with Jarrett Earnest," *Brooklyn Rail*, June 2011, www.brooklynrail.org/2011/06/art/the-pleasures-of-art-peter -selz-with-jarrett-earnest (accessed July 7, 2011).

64. Pamela M. Lee, *Chronophobia: On Time in the Art of the 1960s* (Cambridge, MA: MIT Press, 2006), 134.

65. Alfred Leslie, e-mail to the author, August 27, 2011.

66. Lee, *Chronophobia*, 134.

67. Ibid., 137.

68. D. A. Pennebaker, "Breaking It Up at the Museum," 1960 film, *Pennebaker Hegedus Films Online*, http://phfilms.com/films/breaking-it-up-at-the-museum/ (accessed November 1, 2011).

69. Billy Klüver, in conversation with the author, New Jersey, February 1, 1999.

70. Mildred L. Glimcher, *Happenings: New York, 1958–1963* (New York: Monacelli Press, 2012), 36.

71. Pat Passlof remembered that it was Dick who invited her to participate in a painting show at the Reuben (January 29–February 18, 1960). Pat Passlof, telephone conversation with the author, January 21, 2003.

72. Alfred Leslie, e-mail to the author, March 25, 2004.

73. Lawrence Alloway, *Eleven from the Reuben Gallery* (New York: Solomon R. Guggenheim Museum, 1965), unpaged.

74. Al Hansen, *A Primer of Happenings & Time Space Art* (New York: Ultramarine Publishing, 1965), 60.

75. In private life Betty Parsons's life partner, Constable wrote a monthly in-house newsletter on cultural trends, *Rosie's Bugle*. "Odd Observations," *Village Voice*, October 1, 1964, 2.

76. Claes Oldenburg, in conversation with the author, New York, NY, April 26, 2002.

9. THE SECRET SHARER

1. Calvin Tomkins, "Moving with the Flow," *New Yorker*, November 6, 1971, 59.

2. Robert Scull, in "At Home with Henry," 68.

3. Ivan Karp, in conversation with the author, New York, NY, March 20, 1996.

4. Jane Kramer erroneously cited 1961 as the date the two first met at a "junk sculpture" opening. "Profiles: Man Who Is Happening Now," *New Yorker*, November 26, 1966, 83.

5. Ibid.

6. Ibid., 84.

7. Richard Bellamy, testifying for the defense (Robert Scull), in Scull's divorce

proceedings, undated court transcript, 2200. Richard Bellamy Papers, II.E.5. The Museum of Modern Art Archives, New York, NY.

8. Richard Bellamy, interview with Billy Klüver and Julie Martin, March 4, 1991.
9. Richard Bellamy, letter to Robert Beauchamp, April 1960, in the collection of Jackie Ferrara.
10. John Duka, "Back on Top with the Mom of Pop Art," *New York*, June 9, 1986, 62.
11. Scull-Redner engagement announcement, *New York Times*, August 8, 1943, L37; Meyer Skulnik death notice, *New York Times*, March 22, 1960, 37.
12. Stephanie Scull, in conversation with the author, Hertfordshire, England, June 11, 2010.
13. Robert Morris, e-mail to the author, December 12, 2011; Robert Morris, "The Green Gallery," unpublished manuscript (1998).
14. Kramer, "Man Who Is Happening Now," 95.
15. Rosenquist, *Painting Below Zero*, 164.
16. Marie Brenner, "The Latter Days of Ethel Scull," *New York*, April 6, 1981, 24.
17. Jonathan Scull, e-mail to the author, January 31, 2015. It's family lore that he worked on submarines.
18. Ethel Scull, in Brenner, "The Latter Days of Ethel Scull," 24.
19. Oral History Interview with Robert Scull, 1972 June 15, Archives of American Art, Smithsonian Institution.
20. Ethel Scull, in Kramer, "Man Who Is Happening Now," 92.
21. Ethel Scull, in Duka, "Back on Top with the Mom of Pop Art," 64.
22. Kramer, "Man Who Is Happening Now," 92.
23. Wolfe, "Bob and Spike," 176.
24. Brenner, "The Latter Days of Ethel Scull," 24, 26.
25. Grace Glueck, "Ethel Scull, a Patron of Pop and Minimal Art, Dies at 79," *New York Times*, September 1, 2001, C15; Brenner, "The Latter Days of Ethel Scull," 26.
26. Allene Talmey, "Art Is the Core," *Vogue*, July 1964, 125.
27. Grace Glueck, "Robert Scull, Prominent Collector of Pop Art," *New York Times*, January 3, 1986.
28. Ethel Scull, in Brenner, "The Latter Days of Ethel Scull," 26.
29. Kramer, "Man Who Is Happening Now," 82.
30. Robert Morris, "The Green Gallery," unpublished manuscript (1998).
31. Robert Scull, in de Antonio and Tuchman, *Painters Painting*, 110.
32. John B. Myers, *Tracking the Marvelous: A Life in the New York Art World* (New York: Random House, 1983), 216–17.
33. Jonathan Scull, in conversation with the author, New York, NY, January 22, 2009.
34. Ivan Karp, in de Coppet and Jones, *The Art Dealers*, 140.
35. Leo Castelli, in Edward J. Vaughn, "America's Pop Collector," Ph.D. diss., University of Michigan, 1990, 336.
36. Frank Stella, in conversation with the author, New York, NY, September 28, 2006.
37. Jonathan Scull, e-mail to the author, October 26, 2015.
38. Robert Whitman, in conversation with the author, New York, NY, February 21, 2003.
39. Alfred Leslie, telephone conversation with the author, October 31, 2008.
40. Alex Katz, telephone conversation with the author, October 25, 2007.
41. Lester Johnson, telephone conversation with the author, April 29, 1999.

42. Richard Bellamy, interview with Billy Klüver and Julie Martin, March 4, 1991.
43. Goldin, "Requiem for a Gallery," 27.
44. Ibid.
45. Richard Bellamy, letter to Robert Beauchamp, April 1960, in the collection of Jackie Ferrara.
46. Alanna Heiss, in conversation with the author, MoMA PS 1, Long Island City, NY, October 17, 2000.
47. Lucas Samaras, in La Prade, *Breaking Through*, 104.
48. Jonathan Scull, telephone conversation with the author, August 2, 2011.
49. Rosenquist, *Painting Below Zero*, 323.
50. Robert Scull, in Vaughn, "America's Pop Collector," 318.
51. Michael Steiner, telephone conversation with the author, March 8, 2004.
52. Robert Morris, Richard Bellamy Memorial Service, MoMA PS 1, Long Island City, NY, May 13, 1998.
53. The videotape of the eulogy has been lost. Neil Jenney, in conversation with the author, New York, NY, May 20, 2002.
54. Oral History Interview with Henry Geldzahler, 1970 January 27, Archives of American Art, Smithsonian Institution.

10. "OUR GREENEST DAYS"

1. Richard Bellamy, interview with Billy Klüver and Julie Martin, March 4, 1991.
2. See photograph of 17 West Fifty-Seventh Street, J. & T. Cousins Building, December 1, 1921, Museum of the City of New York. X2010.7.1.5526.
3. Certificate of Occupancy #6134, Borough of Manhattan, City of New York, 1918.
4. "Finest Sable Coat Cost Buyer $60,000," *New York Times*, November 1, 1921, 20.
5. "Fifty-Seventh Street: A Tight Bottleneck for Art," *Fortune*, September 1946, 145.
6. Ivan Karp, in conversation with the author, New York, NY, January 16, 2002.
7. Oral History Interview with Ivan Karp, 1963, Archives of American Art, Smithsonian Institution.
8. Ibid.
9. Ann Wilson Lloyd, "A 1960 Perspective on the Sixties: Ivan Karp and Lewis Pollock," *Provincetown Arts* 6 (1990): 28.
10. Oral History Interview with Ivan Karp, 1963, Archives of American Art, Smithsonian Institution.
11. Barbara Rose, telephone conversation with the author, April 22, 2003.
12. Oral History Interview with Ivan Karp, 1963, Archives of American Art, Smithsonian Institution.
13. Ivan Karp, in conversation with the author, New York, NY, January 16, 2002.
14. Oral History Interview with Ivan Karp, 1963, Archives of American Art, Smithsonian Institution.
15. Ivan Karp, in conversation with the author, New York, NY, January 16, 2002.
16. Oral History Interview with Ivan Karp, 1969, Archives of American Art, Smithsonian Institution. Karp initially named his short-lived Provincetown gallery O.K. Harris.
17. Richard Bellamy, interview with Billy Klüver and Julie Martin, March 4, 1991.
18. Claes Oldenburg, in conversation with the author, New York, NY, April 26, 2002.

19. Richard Bellamy, interview with Billy Klüver and Julie Martin, March 4, 1991.
20. Richard Bellamy, letter to Mr. Wilbur C. Springer III, January 18, 1990, courtesy of Martha V. Henry. Bellamy explains that "Ivan Karp and I . . . often titled Jan's paintings with his assent."
21. Allan Kaprow, "Happenings in the New York Scene" (1961), in Kaprow, *Essays on the Blurring of Art and Life*, Jeff Kelley, ed., 22.
22. The accident occurred on March 26, 1960. Pat Passlof, telephone conversation with the author, August 19, 2000.
23. Mark di Suvero, in Monroe Denton, "A Catalogue Raisonné of the Sculpture of Mark di Suvero (Volumes I–IV)," Ph.D. diss. (City University of New York, 1994), 7.
24. Mark di Suvero, in Joan Simon, "Urbanist at Large," *Art in America*, November 2005, 159.
25. Victor di Suvero, telephone conversation with the author, September 24, 2011.
26. Mark di Suvero, in Simon, "Urbanist at Large," 159.
27. Virginia Wright, letter to the author, October 24, 2011.
28. Mark di Suvero, in Simon, "Urbanist at Large," 159.
29. Mark di Suvero, "Forward," in Oliver Andrews, *Living Materials: A Sculptor's Handbook* (Berkeley: University of California Press, 1983), vi.
30. Michael Cantwell, "A Tale of Two Artists," *The Coler Report*, Coler Memorial Hospital, August 1981, unpaged.
31. Walter De Maria, in conversation with the author, New York, NY, March 19, 2003. Unless otherwise noted, this is the source for the rest of the paragraph.
32. Jonathan Scull, in conversation with the author, New York, NY, January 22, 2009.
33. Richard Bellamy, interview with Sam Green, 1994, transcription courtesy of the Emily Hall Tremaine Foundation.
34. Jonathan Scull, in conversation with the author, New York, NY, January 22, 2009.
35. Mark di Suvero, Audio Guide transcript, "Hankchampion, 1960," Mark di Suvero Collection, Whitney Museum of American Art, http://whitney.org/WatchAndListen?play_id=418 (accessed November 5, 2015).
36. Three months before the opening, Dick wrote to Robert Beauchamp in Florence hoping to find an Italian foundry that would cast the hands quickly and cheaply. Richard Bellamy, letter to Jackie Ferrara and Robert Beauchamp, June 1960, in the collection of Jackie Ferrara. Nothing came of it. After purchasing the wax models, Scull paid to cast them in bronze. Richard Bellamy, interview with Billy Klüver and Julie Martin, March 4, 1991.
37. Richard Artschwager, in conversation with the author, New York, NY, February 20, 2001.
38. Richard Artschwager, in Jan McDevitt, "The Object: Still Life; Interviews with the New Object Makers, Richard Artschwager and Claes Oldenburg on Craftsmanship, Art and Function," *Craft Horizons* 25, no.5 (September 1965): 54.
39. Marion Brown, in Mort Naizlish, "Interview with Marion Brown," *Jazz & Pop*, October 1967, 13.
40. Judith Stein, "Art's Wager: Richard Artschwager and the New York Art World of the Sixties," in *Richard Artschwager: Up and Across* (Nuremberg: Neues Museum; London: Serpentine Gallery, 2001).

41. Oral History Interview with Carl Andre, 1972, Archives of American Art, Smithsonian Institution.

42. Charles Ginnever, George Sugarman, and Anthony Caro also dispensed with pedestals at about the same time.

43. Sidney Geist, "A New Sculptor: Mark di Suvero," *Arts Magazine*, December 1960, 40.

44. Mark di Suvero, telephone conversation with the author, December 2, 2011.

45. Pat Passlof, telephone conversation with the author, August 19, 2000.

46. Mark di Suvero, telephone conversation with the author, December 2, 2011. Passlof would have her own solo show at the Green in March 1961.

47. Ibid.

48. Richard Bellamy, "di Suvero," undated memo to Marie Dickson, likely July 24, 1961. Richard Bellamy Papers, II.B.26. The Museum of Modern Art Archives, New York, NY.

49. Richard Bellamy, interview with Billy Klüver and Julie Martin, March 4, 1991. See also Richard Bellamy, undated court transcript. Richard Bellamy Papers, II.E.5. The Museum of Modern Art Archives, New York, NY.

50. Richard Bellamy, interview with Sam Green, 1994, transcription courtesy of the Emily Hall Tremaine Foundation. This is the information source for the paragraph.

51. Elizabeth McGowan, "Paul Harris/Mark di Suvero," *Art News*, October 1960, 55.

52. In 1964 Gregory Peck would play a character loosely based on Sabater's life in the film *Behold a Pale Horse*.

53. Ann Wilson Lloyd, "Gazed into Like Crystal," *Mark di Suvero Retrospective* (Nice, France: Musée d'Art Moderne et d'Art Contemporain, 1991), 133.

54. Fairfield Porter, "Art," *Nation*, May 20, 1961, 446.

55. Richard Bellamy, interview with Amy Newman, February 7, 1996. Richard Bellamy Papers, II.B.31. The Museum of Modern Art Archives, New York, NY.

56. Mark di Suvero, telephone conversation with the author, December 2, 2011.

57. Mark di Suvero, in Jean Kennedy Smith and George Plimpton, *Chronicles of Courage: Very Special Artists* (New York: Random House, 1993), 58.

58. Ibid.

59. Mark di Suvero, in Simon, "Urbanist at Large," 59.

60. Jill Johnston, "Four Sculptors, Four Styles," *Art News*, Summer 1963, 36. See also undated press release, "Mark di Suvero Shows Major Work in Benefit Exhibition for Welfare Island Painters," Green Gallery, [1963]. Richard Bellamy Papers, II.B.28. The Museum of Modern Art Archives, New York, NY.

61. Richard Bellamy, letter to Virginia Wright, June 11, 1965. Richard Bellamy Papers, I.A.515. The Museum of Modern Art Archives, New York, NY.

62. Richard Bellamy, undated court transcript, 2239. Richard Bellamy Papers, II.E.5. The Museum of Modern Art Archives, New York, NY.

63. Mark di Suvero, in conversation with the author, Long Island City, NY, February 3, 2010.

64. Mark di Suvero, telephone conversation with the author, December 2, 2011.

65. Ibid.

66. Robert Creeley, in conversation with the author, Johnson, VT, October 3, 2003.

67. Charles Ginnever, e-mail to the author, May 24, 2012.

68. Mark di Suvero, in conversation with the author, Long Island City, NY, February 3, 2010.
69. International Program Records V.ICE-F-96-63.6. The Museum of Modern Art Archives, New York, NY.
70. Mark di Suvero, in conversation with the author, Long Island City, NY, February 3, 2010.
71. Oral History Interview with George Segal, 1973 November 26, Archives of American Art, Smithsonian Institution.
72. Sidney Tillim, "In the Galleries: George Segal," *Arts Magazine*, December 1960, 54.
73. Oral History Interview with George Segal, 1973 November 26, Archives of American Art, Smithsonian Institution.
74. Helen Segal, in conversation with the author, East Brunswick, NJ, April 30, 2002.
75. Projected to take six weeks, the filming went on for six months, during which time the filmmaker lived in Segal's basement. George Segal, in Marter, ed., *Off Limits*, 145.
76. The second, *Mr. Z*, designed for a single actor—Zero Mostel—never happened. The actor wanted to do the film but had just taken another assignment. Walter Gutman, "My Pioneer Days in Underground Movies," *Penthouse*, August 1970, 28. For an alternative account of the three films, see Alfred Leslie, in "Alfred Leslie with Phong Bui," *Brooklyn Rail*, October 5, 2015, www.brooklynrail.org /2015/10/art/alfred-leslie-with-phong-bui (accessed October 11, 2015).
77. Alfred Leslie, e-mail to the author, September 18, 2007.
78. Blaine Allan, "The Making (and Unmaking) of 'Pull My Daisy,'" *Film History* 2, no.3 (September–October 1988): 185–205.
79. Frank had seen several of Red Grooms's Happenings and considered casting Grooms as Jesus, but in the end he gave that part to the fledgling actor. Red Grooms, telephone conversation with the author, January 20, 2010.
80. Jonas Mekas, in Wheeler W. Dixon, *The Exploding Eye: A Re-visionary History of 1960s American Experimental Cinema* (New York: State University of New York Press, 1997), 65. Mekas placed it on a par with Jean-Luc Godard's *Breathless* and Federico Fellini's *L'Avventura*. "Films of the Year," *Film Quarterly* 15, no. 2 (Winter 1961–62): 37.
81. Andrew Sarris, in Tom Gunning, "'Loved Him, Hated It:' An Interview with Andrew Sarris," in David E. James, ed., *To Free the Cinema: Jonas Mekas & the New York Underground* (Princeton, NJ: Princeton University Press, 1992), 72.
82. Sam Hunter, *George Segal*, 32.
83. Oral History Interview with George Segal, 1973 November 26, Archives of American Art, Smithsonian Institution.
84. "The Corporate Splurge in Abstract Art," *Fortune*, April 1960, 141.
85. George Segal, "Perspectives on American Sculpture 2: The Sense of 'Why Not?': George Segal on His Art," *Studio International*, October 1967, 147.
86. Hunter, *George Segal*, 32.
87. George Segal, in *George Segal: American Still Life*, directed by Amber Edwards, New Jersey Public Television, 2001. It's unlikely Segal learned of the new material from George Brecht. See Jan van der Marck, introduction to *George Segal: 12 Human Situations* (Chicago: Museum of Contemporary Art, 1968), unpaged.
88. George Segal, in *George Segal: American Still Life*.

89. George Segal, in Sally Banes, ed., *Reinventing Dance in the 1960s: Everything Was Possible* (Madison: University of Wisconsin Press, 2003), 8.

90. Created in 1961, it was misdated "1960" on the invitation to Segal's May 1962 show at the Green. Richard Bellamy Papers, II.B.28. The Museum of Modern Art Archives, New York, NY.

91. George Segal, in *George Segal: American Still Life*.

92. Richard Bellamy, interview with Billy Klüver and Julie Martin, March 4, 1991.

93. Richard Bellamy, undated court transcript, 2217. Richard Bellamy Papers, II.E.5. The Museum of Modern Art Archives, New York, NY.

94. Sheindi Bellamy, in conversation with the author, London, England, April 15, 2001.

95. Richard Bellamy, undated court transcript, 2211. Richard Bellamy Papers, II.E.5. The Museum of Modern Art Archives, New York, NY.

96. Richard Bellamy, undated court transcript, 2216. Richard Bellamy Papers, II.E.5. The Museum of Modern Art Archives, New York, NY.

97. Richard Bellamy Papers, II.B.26. The Museum of Modern Art Archives, New York, NY. Unlike his other correspondence, it was written on a blank sheet of paper, likely before the printed stationery arrived.

98. Calvin Tomkins, *Off the Wall* (Garden City, NY: Doubleday & Company, 1980), 179.

99. Richard Bellamy, in de Coppet and Jones, *The Art Dealers*, 126.

100. Jane Kramer, "Man Who Is Happening Now," 84.

101. Richard Bellamy, in unpublished transcript of Scull's divorce trial, 2204. Richard Bellamy Papers II.E.5. The Museum of Modern Art Archives, New York, NY.

102. Ivan Karp, in conversation with the author, New York, NY, January 16, 2002.

103. Walter De Maria, in conversation with the author, New York, NY, March 19, 2003.

104. Mark di Suvero, in conversation with the author, Long Island City, NY, August 15, 2002.

105. Robert Scull, in Oral History Interview with Ivan Karp, 1969 March 12, Archives of American Art, Smithsonian Institution. Nancy Fish recollected that James Michener may have helped fund the Green; Nancy Fish telephone conversation with the author, March 23, 2011.

106. Dick recalled speculating at the time that Ethel believed that if their support was public, it would jeopardize their admission to MoMA's prestigious International Council. Richard Bellamy, undated court transcript, 2214. Richard Bellamy Papers, II.E.5. The Museum of Modern Art Archives, New York, NY.

107. Kramer, "Man Who Is Happening Now," 84.

108. Marie Dickson, in Kramer, "Man Who Is Happening Now," 94.

109. Jackie Ferrara, e-mail to the author, February 1, 2012.

110. Richard Bellamy, in de Coppet and Jones, *The Art Dealers*, 132.

111. Sheindi Bellamy, in conversation with the author, New York, NY, November 23, 2003.

112. Sheindi Bellamy, in conversation with the author, London, England, April 15, 2001.

113. Frank Stella, in conversation with the author, New York, NY, September 28, 2006.

114. Sherman Drexler, "In Conversation: Sherman Drexler with Phong Bui," *Brooklyn Rail*, July/August 2009, www.brooklynrail.org/2009/07/art/sherman-drexler -with-phong-bui (accessed July 15, 2009).

115. Emilio Cruz, e-mail to the author, April 21, 2001.

116. Sheindi was a "master of mashed potatoes," Dick wrote to Robert Beauchamp and Jackie Ferrara. Letter, January 13, 1960, in the collection of Jackie Ferrara.

117. June Ekman, in conversation with the author, New York, NY, January 30, 2010.

118. Dorothea Rockburne, telephone conversation with the author, April 5, 2003.

119. Barbara Rose, telephone conversation with the author, April 22, 2003.

120. Andrew Tatarsky, telephone conversation with the author, January 25, 2015.

121. Dorothea Rockburne, telephone conversation with the author, April 5, 2003.

122. Ibid.

123. Ruth Noble, telephone conversation with the author, February 26, 2003.

124. Daisy Youngblood, "Daisy Youngblood on Dick Bellamy," photocopied statement, McKee Gallery, New York, 1999.

125. Jill Johnston, in conversation with the author, London, England, October 7, 2000.

126. Alanna Heiss, in conversation with the author, Long Island City, NY, October 17, 2000.

127. Ronnie Landfield, in conversation with the author, New York, NY, March 31, 2006.

128. Yvonne Rainer Papers, 1933–2006, Getty Research Institute: Research Library, Accession no. 2006.M.24. Rainer's collaborative duet *Grass*, with Dariusz Hockman, was presented at the Maidman Playhouse, New York, NY, on March 5, 1962, and was dedicated to the daredevil circus performers the Great Wallendas.

129. Jill Johnston, in conversation with the author, London, England, October 7, 2000.

130. Yvonne Rainer, in conversation with the author, New York, NY, November 27, 2001.

131. Richard Bellamy, letter to Robert Beauchamp and Jackie Ferrara, January 13, 1960, in the collection of Jackie Ferrara.

132. Richard Bellamy, letter to Patrick Lannan Jr., September 24, 1996. Richard Bellamy Papers, I.A.260. The Museum of Modern Art Archives, New York, NY.

133. Robert Frank, in conversation with the author, New York, NY, May 24, 2002.

134. Jill Johnston, quoted by Ingrid Nyeboe, e-mail to the author, February 6, 2016.

135. Sheindi Bellamy, in conversation with the author, New York, NY, November 23, 2003.

136. George Preston, in conversation with the author, New York, NY, November 7, 2011.

137. Fred W. McDarrah and Gloria S. McDarrah, *Beat Generation: Glory Days in Greenwich Village* (New York: Schirmer Books, 1996).

138. Frank Stella, in conversation with the author, New York, NY, September 28, 2006; Sheindi Tokayer, in conversation with the author, New York, NY, November 7, 2011.

139. George Preston, in conversation with the author, New York, NY, November 7, 2011.

140. La Prade, *Breaking Through*, 151n138.

141. Allan Stone, in "Alfred Leslie: Nix on Nixon," *Christie's Online*, November 12, 2007, www.christies.com/lotfinder/paintings/alfred-leslie-nix-on-nixon-4989631 -details.aspx?from=searchresults&intObjectID=4989631&sid=bfa2e0a2-60c9 -4ccb-9640-ddd47d8fa5ac (accessed December 2007).

142. Alfred Leslie, e-mail to the author, August 27, 2011.

143. Sheindi Bellamy, e-mail to the author, February 8, 2012.

144. Barbara Rose, "Homage to the Sixties: The Green Gallery Revisited," *New York*, March 20, 1972, 72.

145. Robert Morris, "The Green Gallery," unpublished manuscript (1998). This is the source for the Morris quotations in this paragraph.

146. Lucas Samaras, in La Prade, *Breaking Through*, 105.

147. Claes Oldenburg, in La Prade, *Breaking Through*, 80.

148. Barbara Rose, *Claes Oldenburg*, 200.

149. Richard Bellamy, in de Coppet and Jones, *The Art Dealers*, 133.

150. Sheindi Bellamy, in conversation with the author, April 14, 2001, London, England.

151. Carl Andre, "In Conversation," *Brooklyn Rail*, February 1, 2012, www.brooklynrail .org/2012/02/art/carl-andre-with-michle-gerber-klein-and-phong-bui (accessed July 30, 2014).

152. Richard Bellamy, in de Coppet and Jones, *The Art Dealers*, 133.

11. SEEING AND UNSEEING

1. "The 'Million-Dollar' Rembrandt Tops Week's Auction Offerings," *New York Times*, November 12, 1961, 124.

2. Stuart Preston, "Old Masters on View at Parke-Bernet," *New York Times*, November 11, 1961, 49.

3. www.britishpathe.com/video/painting-is-sold-for-2-300-000 (accessed June 29, 2014).

4. Sanka Knox, "Museum Gets Rembrandt for 2.3 Million," *New York Times*, November 16, 1961, 1.

5. "That $2 Million Rembrandt," *New York Times*, November 18, 1961, 22.

6. John Canaday, "Rembrandt's Grandeur," *New York Times*, November 26, 1961, SM34.

7. John Marion, in Grace Glueck, "Rising Art Prices Worry Museums," *New York Times*, October 17, 1987, 13.

8. "Under the Boom," *Time*, December 1, 1958, 66.

9. "The Solid-Gold Muse," *Time*, November 24, 1961, 62.

10. James Rosenquist, telephone conversation with the author, August 7, 2002.

11. Paul Cumming (Interviewer), Oral History Interview with Henry Geldzahler, 1970 February 16, Archives of American Art, Smithsonian Institution.

12. Irving Sandler, *American Art of the 1960s* (New York: Harper & Row, 1988), 113.

13. Richard Bellamy, in de Coppet and Jones, *The Art Dealers*, 121.

14. Barbara Rose, telephone conversation with the author, April 22, 2003.

15. David Whitney, unpaged notebook, box 2, David Grainger Whitney Trust, bequest, 2005, Menil Archives, Menil Collection, Houston, TX.

16. Larry Poons, in conversation with the author, New York, NY, September 16, 2003.

17. Richard Bellamy, interview with Billy Klüver and Julie Martin, March 4, 1991.

18. Although Bellamy recalled that the sessions happened in 1960–61, Geldzahler said he was going around to studios with Ivan Karp and Richard Bellamy in 1959, '60, and '61. Henry Geldzahler, *Making It New* (New York: Turtle Point Press, 1994), 339.

19. Allan Stone, in conversation with the author, Seal Cove, Mount Desert, ME, July 29, 1999.

20. Ibid.

21. Oral History Interview with Robert Scull, 1972, Archives of American Art, Smithsonian Institution.

22. Oral History Interview with Henry Geldzahler, 1970 February 16, Archives of American Art, Smithsonian Institution.

23. Sheindi Bellamy, in conversation with the author, New York, NY, June 7, 2000.

24. Oral History Interview with Henry Geldzahler, 1970 February 16, Archives of American Art.

25. Holland Cotter, "Where City History Was Made, a 50's Group Made Art History," *New York Times*, January 5, 1993.

26. Rosenquist, *Painting Below Zero*, 60.

27. James Rosenquist, in G. R. Swenson, "What Is Pop Art?," *Art News*, February 1964, 64.

28. Rosenquist, *Painting Below Zero*, 94.

29. Robert Scull, in Suzi Gablik, "Protagonists of Pop," *Studio International*, July/August 1969, 11.

30. Jay Milder, telephone conversation with the author, July 20, 2000.

31. Rosenquist, *Painting Below Zero*, 118.

32. Oral History Interview with Leo Castelli, 1969 May 14, Archives of American Art, Smithsonian Institution.

33. Richard Bellamy, interview with Amy Newman, February 7, 1996. Richard Bellamy Papers, II.B.31. The Museum of Modern Art Archives, New York, NY.

34. Alfred Leslie, in conversation with the author, New York, NY, February 19, 2001.

35. Richard Bellamy, in Gablik, "Protagonists of Pop," 10.

36. Sheindi Bellamy, in conversation with the author, New York, NY, June 7, 2000. This is the source for this paragraph.

37. Wallace Stevens, "Notes Toward a Supreme Fiction," 1942, reprinted in *The Collected Poems of Wallace Stevens* (New York: Vintage Books, 1990), 385.

38. Richard Bellamy, in Gablik, "Protagonists of Pop," 10.

39. Michael Lobel, *Image Duplicator: Roy Lichtenstein and the Emergence of Pop Art* (New Haven, CT: Yale University Press, 2002), 4–5.

40. Harold Rosenberg, *The De-Definition of Art* (Chicago: University of Chicago Press, 1983), 116.

41. Tadaaki Kuwayama, in conversation with the author, New York, NY, January 26, 2002. This is also the source of information for the next paragraph.

42. Richard Smith, in conversation with the author, New York, NY, December 27, 2001.

43. Richard Bellamy, in *Richard Smith: The Green Gallery Years* (New York: Richard L. Feigen, 1992), 51.

44. Ibid., 33.

45. Ibid., 39.

46. He presented it to Dick before returning to England that summer. Richard Smith, telephone conversation with the author, March 14, 2012.

47. *Fotodeath* was presented in February 1961 at the Reuben Gallery. Claire Wesselmann, e-mail to the author, April 19, 2012.

48. Tom Wesselmann, in conversation with the author, New York, NY, May 24, 2002.

49. Tom Wesselmann, in "Tom Wesselmann," *Remembering Judson House* (New York: Judson Memorial Church, 2000), 305.

50. David McCarthy, "Tom Wesselmann and the Americanization of the Nude, 1961–1963," *Smithsonian Studies in American Art* 4, nos. 3/4 (Summer–Autumn, 1990): 121.

51. Ibid., 106.

52. Oral History Interview with Tom Wesselmann, 1984 January 3–February 8, Archives of American Art, Smithsonian Institution.

53. Brian O'Doherty, "This Week Around the Galleries," *New York Times*, December 31, 1961, X10. The artist's future wife, Claire, designed the invitation, an ebullient foretaste of Tom's unconventional imagery. "The Great American Nude" is in old-fashioned letterpress typography, each chubby, tromploid letter sporting a different decorative fill.

54. May 25–June 23, 1961. Jackson's friend Rosalind Constable would likely have had a hand in selecting the artists.

55. Claes Oldenburg, "Inventory of Store Dec. 1961," *Store Days* (New York: Something Else Press, 1967), 31.

56. Frank O'Hara, in *Frank O'Hara Art Chronicles, 1954–1966* (New York: George Braziller, 1975), 9.

57. "The Origin of Andy Warhol's Soup Cans, or The Synthesis of Nothingness," www.warholstars.org/art/warhol/soup.html (accessed October 26, 2015).

58. Oldenburg, *Store Days*, 150.

59. Claes Oldenburg, in conversation with the author, New York, NY, April 26, 2002. This is the source for the following paragraph.

60. Defamiliarization, or *ostranenie*, was coined in 1917 by Viktor Shklovsky in his essay "Art as Device." See Viktor Shklovsky, "Art as Technique," www.vahidnab.com/defam.htm (accessed November 12, 2013).

61. Ellen H. Johnson, *Modern Art and the Object* (New York: Harper & Row, 1976), 146–47.

62. Invitation card, reproduced in Achim Hochdörfer, ed., *Claes Oldenburg: The Sixties* (New York: Prestel, 2012), 80. The series ran from February to May 1962.

63. Claes Oldenburg, in Harris Rosenstein, "Climbing Mt. Oldenburg," *Art News*, February 1966, 25.

64. Billy Klüver, www.w2vr.com/archives/Kluver/01_StoreDaysI.html (accessed December 11, 2015).

65. Glimcher, *Happenings: New York, 1958–1963*, 212.

66. Sheindi [Charlotte] performed in *Store Days II*, March 2–3, 1962, as did Jackie Ferrara, Henry Geldzahler, Pat Oldenburg, and Lucas Samaras, among others.

67. Susan Sontag, "Happenings: An Art of Radical Juxtaposition," in *Against Interpretation and Other Essays* (New York: Farrar, Straus & Giroux, 1966), 268.

68. Claes Oldenburg, in conversation with the author, New York, NY, April 26, 2002.

69. Claes Oldenburg, in conversation with Robert Ayers, "A Sky Filled with Shooting Stars," 2009, www.askyfilledwithshootingstars.com/wordpress/?p=1371 (accessed September 12, 2011).

70. Kelley, *Childsplay: The Art of Allan Kaprow*, 46.

71. Glimcher, *Happenings: New York, 1958–1963*, 115.

72. Sheindi appeared in Robert McElroy's photos of the event, but is not listed in

the cast, which included Claire and Tom Wesselmann and Pat Oldenburg. Glimcher, *Happenings: New York, 1958–1963*, 211.

73. Robert Whitman, in Sally Banes, *Greenwich Village 1963*, 189.

74. Julie Martin, e-mail to the author, July 8, 2013.

75. Jill Johnston, "Environment, Uptown," *Village Voice*, January 4, 1961, 6.

76. Attendees included Kusama, Judd, Warhol, and Chamberlain, as well as the curators Henry Geldzahler, Allan Solomon, and Billy Klüver. See photographs, Germano Celant, cur., *Claes Oldenburg: An Anthology* (New York: Guggenheim Museum Publications, 1995), 164–69.

77. Claes Oldenburg, in conversation with the author, New York, NY, April 26, 2002.

78. Mucha, "Sewing in the Sixties," 81.

79. Claes Oldenburg, in conversation with the author, New York, NY, April 26, 2002.

80. John Canaday, "Art Out of Anything," *New York Times*, October 1, 1961, SM52.

81. Donald Judd, "Lucas Samaras," *Arts Magazine*, February 1962, 44.

82. Lucy Lippard, *Pop Art* (New York: Frederick A. Praeger, 1966), 72.

83. Avis Berman, "The Transformations of Roy Lichtenstein: An Oral History," in Michael Juul Holm, Poul Erik Tøjner, and Martin Caiger-Smith, eds., *Roy Lichtenstein: All About Art* (Humlebæk, Denmark: Louisiana Museum of Modern Art, 2003), 132.

84. Marvin Elkoff, "The American Painter as a Blue Chip," *Esquire*, January 1965, 112.

85. Ibid.

86. Richard Bellamy, in de Coppet and Jones, *The Art Dealers*, 126.

87. Richard Bellamy, in Gablik, "Protagonists of Pop," 11.

88. Leo Castelli, in Calvin Tomkins, "A Good Eye and a Good Ear," *New Yorker*, May 26, 1980, 12.

89. Richard Bellamy, in Amy Newman, *Challenging Art: Artforum, 1962–1974* (New York: Soho Press, 2003), 25.

90. Richard Bellamy, interview with Billy Klüver and Julie Martin, March 4, 1991.

91. Jim Rosenquist, in Matthew Rose, "Today's Masters: Signs of His Times," *Art and Antiques*, May 1, 2008.

92. Richard Brown Baker, in Grace Glueck, "Seven for São Paulo," *New York Times*, May 23, 1965, X18.

93. Sam Green, in conversation with the author, Philadelphia, December 3, 2003.

94. James Rosenquist, in Kathleen L. Housley, *Emily Hall Tremaine: Collector on the Cusp* (New Haven, CT: Emily Hall Tremaine Foundation, 2001), 165.

95. Richard Bellamy, interview with Sam Green, 1994, transcription courtesy of the Emily Hall Tremaine Foundation.

96. Vladimir Nabokov, *Lolita*, in Sidney Tillim, "Month in Review," *Arts Magazine*, February 1962, 34.

97. Claes Oldenburg, "Notes," 1961, quoted in "Chronology," Hochdörfer, ed., *Claes Oldenburg: The Sixties*, 286.

98. Claes Oldenburg, in Rose, *Claes Oldenburg*, 65.

99. Sidney Tillim, "The Fine Art of Acquiring Fine Art," *Playboy*, January, 1962, 90.

100. Stephen Leacock, "Gertrude the Governess; or, Simple Seventeen," *Nonsense Novels* (New York: John Lane, 1920), 73. The story's first sentence famously begins, "It was a wild and stormy night . . . ," 71.

101. Oral History Interview with Everett Ellin, 2004 April 27, Archives of American Art, Smithsonian Institution.

102. Clement Greenberg recommended him for the job. Everett Ellin, telephone conversation with the author, April 5, 2002.

103. William Rubin, "The International Style: Notes on the Pittsburgh Triennial," *Art International*, November 20, 1961, 30.

104. Oral History Interview with Everett Ellin, 2004 April 27, Archives of American Art, Smithsonian Institution.

105. Rosalyn Drexler, "In Conversation: Rosalyn Drexler with John Yau," *Brooklyn Rail*, July/Aug 2007, http://www.brooklynrail.org/2007/07/art/rosalyn-drexler -with-john-yau (accessed June 11, 2015).

106. Carolee Schneemann, telephone conversation with the author, January 26, 2003.

107. Mimi Gross, in conversation with the author, New York, NY, July 30, 2000. See Pat Lipsky, www.theawl.com/2015/10/the-shoes-under-the-art-world.

108. Jules Langsner, "Joan Jacobs," *Art News*, January 1962, 18. *The New York Times* dismissed her work as "no more than discreetly surrounded traffic signs . . . too large and lack[ing] power." Brian O'Doherty, "Art: Exhibition of Rugs," *New York Times*, January 23, 1962, 51.

109. Judd found her "thoroughly competent, but also pretty unconvincing." Donald Judd, "Joan Jacobs," *Arts Magazine*, December 1963, 64.

110. Joni Jacobs Nelson's trade publication obituaries, courtesy of the American Saddlebred Museum, Lexington, KY.

111. Wallace Stevens, "Final Soliloquy of the Interior Paramour," *The Collected Poems of Wallace Stevens* (New York: Vintage Books, 1990), 524.

112. Richard Bellamy, in conversation with Barbara Rose, 1968. Barbara Rose Papers 1962–circa 1969, Archives of American Art, Smithsonian Institution.

113. Richard Bellamy, interview with Billy Klüver and Julie Martin, March 4, 1991.

114. Fredericka Hunter, letter to the author, May 29, 2002.

115. Roberta Smith, "Richard Bellamy, Art Dealer, Is Dead at 70," *New York Times*, April 3, 1998, D17.

116. Jill Johnston, quoting Sheindi Bellamy. Richard Bellamy Memorial Service, MoMA PS 1, Long Island City, NY, May 13, 1998. Dick was notable for his "conspicuous self-effacement." Max Kozloff, in conversation with the author, April 29, 2010.

117. Lydia Hu Bellamy, in Curtis Bellamy, letter to Dick Bellamy, March 17, 1965, in the collection of Miles Bellamy.

118. Alfred Leslie, in conversation with the author, New York, NY, June 28, 2000.

119. Walter De Maria, in conversation with the author, New York, NY, March 19, 2003.

120. Denise Corley, Richard Bellamy Memorial Service, MoMA PS 1, Long Island City, NY, May 13, 1998.

121. Pat Patterson, telephone conversation with the author, August 25, 2004.

122. Kunié Sugiura, in conversation with the author, New York, NY, June 21, 2000.

123. Kristin Jones, in conversation with the author, March 19, 1999.

124. Richard Bellamy, letter to Bob Beauchamp and Jackie Ferrara, June 1960, in the collection of Jackie Ferrara.

125. Richard Bellamy, in de Coppet and Jones, *The Art Dealers*, 126.

126. Sheindi Bellamy, in conversation with the author, London, England, April 15, 2001. Unless otherwise noted, this is the information source for this paragraph.

127. Calvin Tomkins, in conversation with the author, New York, NY, January 22, 2009.

128. Charles Ginnever, in conversation with the author, Putney, VT, July 22, 2000.

129. Julie Finch, in conversation with the author, New York, NY, July 19, 2012.

130. Robert Morris, "The Green Gallery," unpublished manuscript (1998).

131. Jeanie Blake, in conversation with the author, East Hampton, NY, July 8, 2000.

132. Sheindi Bellamy, in conversation with the author, New York, NY, June 7, 2000.

133. Bill Berkson, in conversation with the author, Northeast Harbor, ME, July 28, 1999.

134. Michael Kimmelman, "Rauschenberg, the Irrepressible Ragman of Art," *New York Times*, August 27, 2000, 26.

135. Claes Oldenburg, in conversation with the author, New York, NY, April 26, 2002.

136. Richard Bellamy, in de Coppet and Jones, *The Art Dealers*, 126. Sheindi remembered that once, he entered treatment "so he'd be sober for an important meeting," e-mail to the author, September 17, 2003.

137. Morris Kaplan, " 'Drying-Out' Hospital for Problem Drinkers Closes," *New York Times*, June 6, 1965, 114.

138. Dick's treatment included medication, nursing, psychiatric consultation, hydrotherapy, and massage.

139. Harry Minetree, "R. Brinkley Smithers, Alcoholism's Sober Philanthropist," *Town & Country Magazine*, May 1986. www.locustvalley.com/business/Families%20 of%20Distinction/Smithers.html (accessed July 2009).

140. David Whitney, in conversation with the author, New York, NY, January 6, 2004.

141. Sheindi Tokayer, in conversation with the author, London, England, April 16, 2001.

142. Larry Poons, in conversation with the author, New York, NY, September 16, 2003.

143. Emily Mason, telephone conversation with the author, July 20, 2000.

144. Richard Bellamy, in de Coppet and Jones, *The Art Dealers*, 126.

145. Richard Bellamy, in Newman, *Challenging Art*, 25.

146. Richard Bellamy, interview with Billy Klüver and Julie Martin, March 4, 1991.

147. David Whitney, unpaged notebook, box 2, David Grainger Whitney Trust, bequest, 2005, Menil Archives, Menil Collection, Houston, TX.

148. Richard Bellamy, in de Coppet and Jones, *The Art Dealers*, 126.

149. Richard Bellamy, interview with Billy Klüver and Julie Martin, March 4, 1991. This is the source for the rest of the paragraph.

12. POP GOES THE WEASEL

1. Max Kozloff, " 'Pop' Culture, Metaphysical Disgust, and the New Vulgarians," *Art International*, March 1962.

2. Philip Johnson, in "Pop Art—Cult of the Commonplace," *Time*, May 3, 1963.

3. Leon Kraushar, in John Rublowsky, *Pop Art* (New York: Basic Books, 1965), 157.

4. Andy Warhol, in Ellen Johnson, ed., *American Artists on Art* (New York: Harper & Row, 1982), 86.

5. John F. Lyons, "Art Galleries Profit by Showing in Banks, Theaters and Stores," *Wall Street Journal*, January 8, 1964, 1. This is the source of the information and quotes following.

6. Emily Tremaine, "Her Own Thoughts," *The Tremaine Collection: 20th Century Masters: The Spirit of Modernism* (Hartford, CT: The Wadsworth Atheneum, 1984), 29.

7. Roy Lichtenstein, in "The Story of Pop," *Newsweek*, April 25, 1966.

8. Marina Pacini, "Who but the Arts Council," *Archives of American Art Journal* 27, no. 4 (1987): 11.

9. Cheryl Harper, *A Happening Place* (Philadelphia: Jewish Community Centers of Greater Philadelphia, 2003), 7.

10. Joan Kron, e-mail to the author, April 9, 2005.

11. The organizers conceived of the catalogue as a short dictionary. Kaprow wrote the unattributed, serious entries; Klüver dreamed up the flippant ones. Jean Tinguely, Rauschenberg, and Oldenburg also contributed. *Art 1963–A New Vocabulary* (Philadelphia: Fine Arts Committee of the Arts Council of the YM/YWHA, 1962).

12. Harper, "Banners," *A Happening Place*, 26.

13. Donald Judd, "New York Reports: In the Galleries, George Segal," *Arts Magazine*, September 1962, 55.

14. Advertisement, *New York Post*, May 13, 1962, unpaged clipping.

15. "Proposed Facade Venus Is Art, but Not Legal; She Goes over the Line," *New York Times*, June 22, 1949, 33.

16. Bagley Wright, in conversation with the author, London, England, March 29, 2001.

17. Sam Green, in conversation with the author, New York, NY, March 19, 2003. Warhol also wanted the Castelli Gallery to represent him.

18. Andy Warhol and Pat Hackett, *POPism: The Warhol Sixties* (New York: Harcourt Brace, 1980), 26.

19. Richard Bellamy, in de Coppet and Jones, *The Art Dealers*, 125.

20. Richard Bellamy, interview with Billy Klüver and Julie Martin, March 4, 1991.

21. Robert Scull, in de Antonio and Tuchman, *Painters Painting*, 117.

22. Previously, galleries such as Alan Stone kept a few Warhols to show to clients in their back rooms, but none had yet put them on public display.

23. Richard Bellamy, interview with Billy Klüver and Julie Martin, March 4, 1991.

24. Ibid.

25. Likely *Small Campbell's Soup Can (Tomato)* and *Red Airmail Stamps*; both were listed with a Green Gallery provenance in the 1973 Scull auction catalogue.

26. Alfred Leslie, e-mail to the author, July 4, 2012.

27. "For Movement's Sake," *Newsweek*, March 13, 1961, 92–93. For unknown reasons, *The Jolly* was part of Hultén's catalogue but absent from the show.

28. Judith Stein, "Alfred Leslie: An Interview," *Art in America*, January 2009, 95.

29. Robert Morris, in W.J.T. Mitchell, "Golden Memories, Interview with Sculptor Robert Morris," *Artforum*, April 1994, 133.

30. Oral History Interview with Robert Morris, 1968 March 10, Archives of American Art, Smithsonian Institution.

31. Robert Morris, "Studios," in *Robert Morris, Ten Works, Five Decades*, 16–17.

32. Katy Siegel, "Robert Morris," *Artforum*, April 1, 2001, 27. In another account by the artist, Bellamy left without saying a word. Morris, "Studios," *Robert Morris, Ten Works, Five Decades*, 17.

33. Yvonne Rainer, in Allen Hughes, "A Place and Time to Find New Ways to Move," *New York Times*, June 3, 2001, AR1.

34. Robert Morris, in Mitchell, "Golden Memories," 133.

35. Robert Morris, in conversation with Simon Grant, *Tate Etc.*, September, 1, 2008, www.tate.org.uk/tateetc/issue14/interviewmorris.htm (accessed November 14, 2013).

36. Sally Banes, *Democracy's Body: Judson Dance Theater, 1962–1964* (Durham, NC: Duke University Press, 1993), 17.

37. In late December 1961, Forti participated in *Ball*, the theater piece/performance by Robert Whitman, her second husband.

38. Yayoi Kusama, in Christopher Benfey, "The Order of Things," *Slate*, July 23, 1998, www.slate.com/articles/arts/art/1998/07/the_order_of_things.html (accessed December 6, 2015).

39. Yayoi Kusama, "*Pīpuru* [People]," *Geijutsu Shinchō*, June 1959, 31. Reference and translation courtesy of Midori Yamamoto.

40. Richard Bellamy, draft of undated letter to Ad Reinhardt, circa 1965. Richard Bellamy Papers, III.A.89. The Museum of Modern Art Archives, New York, NY.

41. Richard Bellamy, postcard to Yayoi Kusama, dated August 18, 1960, postmarked September 4, 1960, New York, NY, Yayoi Kusama File, Blanton Museum Archives, University of Texas, Austin. Copy courtesy of Midori Yamamura.

42. In a letter to the author, June 29, 1999, Kusama recalled that when she visited the Green late in 1960, Dick invited her to be a part of the upcoming group show, but there is no record that she accepted.

43. The visit occurred in May 1962. Midori Yamamoto, e-mail to the author, February 21, 2011. Yamamoto, who wrote her doctoral thesis on Kusama, generously shared information she gained from the artist's journals that detailed her visitors and work schedule.

44. Yayoi Kusama, in Grady Turner, "Yayoi Kusama," *Bomb*, Winter 1999, 67.

45. Yayoi Kusama, in conversation with Midori Matsui, *Index* (1998), www.indexmagazine.com/interviews/yayoi_kusama.shtml (accessed November 25, 2013).

46. Yayoi Kusama, *Infinity Net: The Autobiography of Yayoi Kusama* (London: Tate Publishing, 2011), 70.

47. Interview with Donald Judd, December 8, 1988, Yayoi Kusama File, 1001/36, Blanton Museum Archives, University of Texas, Austin, courtesy of Midori Yamamura.

48. Yayoi Kusama, letter to Richard Bellamy, January 29, 1963, courtesy of Midori Yamamura.

49. "Something New Is Cooking," *Life*, June 15, 1962, 115–16.

50. Claes Oldenburg, in conversation with the author, New York, NY, April 26, 2002.

51. Mucha, "Sewing in the Sixties," 79.

52. Gene Baro, *Claes Oldenburg: Drawings and Prints* (Secaucus, NJ: Wellfleet Press, 1988), 116, 118.

53. Mucha, "Sewing in the Sixties," 79.

54. Claes Oldenburg, in Baro, *Claes Oldenburg: Drawings and Prints*, 120.

55. Robert Breer, telephone conversation with the author, May 30, 2003.

56. Mucha, "Sewing in the Sixties," 81.

57. Kusama, *Infinity Net*, 39.

58. Kusama, "Scenario," in "The Love Story of Tokyo Lee," unpublished manuscript of an autobiographical musical, circa 1970, 29, collection of the artist. Kusama's heroine "invented soft sculpture"; her boyfriend, an art critic, is "aghast" at this new work that requires "compulsive, non-stop labor" and begs her to behave like a "normal avant-garde artist."

59. Richard Artschwager, in conversation with the author, London, England, May 2, 2001. This is the source for the rest of the paragraph.

60. "Cold War: Cuban Missile Crisis, Revelations from the Russian Archives," Library of Congress Online, July 22, 2010, www.loc.gov/exhibits/archives/colc.html (accessed June 22, 2012).

61. Larry Poons, telephone conversation with the author, December 14, 2011.

62. At the time, Dick did not read a daily newspaper. Sheindi Tokayer, e-mail to the author, June 22, 2012. Dick remembered Donald Judd as an anti–Vietnam War protester "walking down Fifth Avenue in a couple of marches, but I was pretty much not part of that." Richard Bellamy, interview with Amy Newman, February 7, 1996. Richard Bellamy Papers, II.B.31. The Museum of Modern Art Archives, New York, NY.

63. Philip Wofford, in La Prade, *Breaking Through*, 49–50.

64. Richard Bellamy, in "State of the Market," *Time*, June 21, 1963, 62.

65. Janis's friend, the French collector and gallerist Denise René, had pressed him to do a show of the younger European artists. Oral History Interview with Eleanor Ward, 1972 February 8, Archives of American Art, Smithsonian Institution.

66. Harold Rosenberg, "The Game of Illusion," *New Yorker*, November 24, 1962, 166.

67. Ibid., 162.

68. Sidney Tillim, "The New Realists," *Arts Magazine*, December 1962, 43.

69. Brian O'Doherty, "Avant-Garde Revolt: 'New Realists' Mock U.S. Mass Culture," *New York Times*, October 31, 1962, 41.

70. Walter Hopps, in Jean Stein, *Edie: American Girl* (New York: Grove Press, 1994), 198.

71. T[homas] B. H[ess], "Reviews and Previews: 'New Realists,'" *Art News*, December 1962, 12.

72. Bruce Altshuler, *The Avant-Garde in Exhibition* (Berkeley: University of California Press, 1998), 214.

73. Claes Oldenburg, in conversation with the author, New York, NY, April 26, 2002.

74. Victor Bockris, *Warhol: The Biography* (New York: Da Capo Press, 2003), 155.

75. Musa Mayer, *Night Studio: A Memoir of Philip Guston* (New York: Alfred A. Knopf, 1988), 102.

76. Oral History Interview with Tom Wesselmann, 1984 January 3, Archives of American Art, Smithsonian Institution.

77. William C. Seitz, *Art in the Age of Aquarius* (Washington, D.C.: Smithsonian Institution Press, 1992), 100.

78. Leo Steinberg, "A Symposium on Pop Art," *Arts Magazine*, April 1963, 44.

79. In answer to a questionnaire sent out in 1968 by Barbara Rose and Irving Sandler in preparation for articles in *Art in America*. Barbara Rose Papers 1962–circa 1969, Archives of American Art, Smithsonian Institution.

80. Robert Whitman, in conversation with the author, New York, NY, February 21, 2003.

81. Oral History Interview with Robert Beauchamp, 1975 January 16, Archives of American Art, Smithsonian Institution.

82. Richard Bellamy, in de Coppet and Jones, *The Art Dealers*, 125.

83. Mark di Suvero, in Simon, "Urbanist at Large," 160.

84. Linda Dalrymple Henderson, "Park Places: Its Art and History," in *Reimagining Space: The Park Place Gallery Group in 1960s New York* (Austin, TX: Blanton Museum of Art, University of Texas, 2008), 11.

85. Mark di Suvero, in conversation with the author, New York, NY, August 15, 2002.

86. Ibid.

87. Miles Bellamy, in conversation with the author, Brooklyn, NY, February 23, 2001.

88. Marty Greenbaum, telephone conversation with the author, September 10, 2002.

89. See Roni Feinstein, *Circa 1958: Breaking Ground in American Art* (Chapel Hill, NC: Ackland Art Museum, University of North Carolina, 2008), 94.

90. Donald Judd, "In the Galleries: Ronald Bladen," *Arts Magazine*, February 1963.

91. Amy Newman, *Challenging Art: Artforum, 1962–1974*, 27.

92. Grace Glueck, "Dealer Switching: Rising Stars Have a Way of Going Off into New Orbits," *New York Times*, October 4, 1964, X23.

93. Richard Bellamy, letter to Richard Brown Baker, undated. Richard Bellamy Papers, I.A.20. The Museum of Modern Art Archives, New York, NY.

94. His diary entry for March 10, 1963, records, "Tell Bellamy I want to leave gallery." Claes Oldenburg, in Achim Hochdörfer, Maartje Oldenburg, and Barbara Schröder, eds., *Claes Oldenburg: Writing on the Side, 1956–1969* (New York: Museum of Modern Art, 2013), 200.

95. Claes Oldenburg, in conversation with the author, New York, NY, April 26, 2002.

96. Sidney Tillim, in conversation with the author, New York, NY, February 21, 2001.

97. Oldenburg's discontent and Dick's reaction is reflected in an invoice for three drawings that Dick later sent to Joseph Hirshhorn: "Since artist is obsessed, exact titles may be furnished by him at a later date." Invoice to Joseph Hirshhorn, December 29. 1969, Richard Bellamy Papers, II.C.5. The Museum of Modern Art Archives, New York, NY.

98. Richard Artschwager, in conversation with the author, New York, NY, February 20, 2001.

99. Ivan Karp, in conversation with the author, New York, NY, March 20, 1996.

100. Oral History Interview with Tom Wesselmann, Archives of American Art, 1984 January 3. Unless otherwise noted, this is the source for the paragraph.

101. John Russell, "Lessons in Spotting Art That Lasts," *New York Times*, November 16, 1975, 174.

102. Barbara Rose, "Artful Dodger," *Artforum*, Summer 1998, 31.

13. TOMORROW IS YESTERDAY

1. Jack Tworkov, in Mira Schor, ed., *The Extreme of the Middle: Writings of Jack Tworkov* (New Haven, CT: Yale University Press, 2009), 141. Jason Andrew kindly shared this reference.

2. Richard Bellamy, interview with Amy Newman, February 7, 1996. Richard Bellamy Papers, II.B.31. The Museum of Modern Art Archives, New York, NY.

3. Interview with Donald Judd, December 8, 1988, Yayoi Kusama File, 1001/36, Blanton Museum Archives, University of Texas, Austin.

4. Richard Bellamy, in de Coppet and Jones, *The Art Dealers*, 124.

5. James Meyer, *Minimalism: Art and Polemics of the Sixties* (New Haven, CT: Yale University Press, 2000), 47, 50.

6. Julie Finch, in conversation with the author, New York, NY, July 19, 2012.

7. One friend called the floor piece "the barn door," and the relief with the narrow opening "the beak." Doris Thistlewood, letter to Donald Judd, January 15, 1963, Judd Foundation Archives, Marfa, TX.

8. Donald Judd, in conversation with Phyllis Tuchman, unpublished transcription, 1976, courtesy of Phyllis Tuchman.

9. Tiffany Bell and Michael Govan, *Dan Flavin: The Complete Lights, 1961–1996* (New Haven, CT: Yale University Press, 2004), 26.

10. Ibid., 191.

11. Dan Flavin, in Jeffrey S. Weiss, ed., *Dan Flavin: New Light* (New Haven, CT: Yale University Press, 2006), 4.

12. Oral History Interview with Virginia Dwan, 1984 March 21–June 7, Archives of American Art, Smithsonian Institution.

13. Brian O'Doherty, "Three Artists: Getting in and out of Corners," *New York Times*, November 17, 1963, X15.

14. Barry Schwabsky, "First Break, Larry Poons," *Artforum*, February 2003, 23.

15. Richard Bellamy, in La Prade, *Breaking Through*, 199.

16. Richard Bellamy, in conversation with Barbara Rose, 1968, Barbara Rose Papers 1962–circa 1969, Archives of American Art, Smithsonian Institution.

17. Larry Poons, in Erik La Prade, "The Epitome Café: An Interview with Larry Poons," *Long Shot* 14 (1993): 60.

18. Goldin, "Requiem for a Gallery," 28.

19. Schwabsky, "First Break, Larry Poons," 23.

20. La Prade, "The Epitome Café," 58.

21. Larry Poons, in La Prade, "The Epitome Café," 62.

22. Robert Scull, in de Antonio and Tuchman, *Painters Painting*, 112–13.

23. Ibid., 113. Off-camera, Poons interrupts to say, "Robert Scull never walked up to me and said, 'Here, Larry, I want to help you.' He did it through Dick, and it was a dealer, and it was business."

24. This is the position in Rudy Burckhardt's installation photograph. *Card File* is in the Dwan Collection.

25. Richard Bellamy, interview with Amy Newman, February 7, 1996. Richard Bellamy Papers, II.B.31. The Museum of Modern Art Archives, New York, NY.

26. Oral History Interview with Robert Morris, 1968, Archives of American Art, Smithsonian Institution.

27. Donald Judd, in James Meyer, *Minimalism*, 280n32.

28. Sidney Tillim, "Month in Review," *Arts Magazine*, March 1963, 61.

29. Lucas Samaras, in Joan Siegfried, *Lucas Samaras: Boxes* (Chicago: Museum of Contemporary Art, Chicago, 1971).

30. Jill Johnston, "New Works," *Art News*, March 1963, 50. Kusama also showed her sticker collages.

31. Andrejevic, from Yugoslavia, initially spelled his name as "Andreyevich."

32. Dick particularly encouraged Milet to emphasize erotic innuendos of common objects. Hanford Yang, telephone conversation with the author, July 15, 2012.

33. Dick installed it against a dark, tar-papered corner. Donald Judd, interviewed by Lucy R. Lippard, April 10, 1968, transcription, 113. Lucy R. Lippard papers, 1940s–2006, Box 32, Archives of American Art, Smithsonian Institution.

34. Rosenquist, *Painting Below Zero*, 137. This prestigious show (May 22–August 18, 1963) included Sally Hazelet Drummond, also in the Green's stable.

35. March 14–June 12, 1963.

36. Isaac Witkin, in conversation with the author, Philadelphia, January 22, 2003. See also Alan Solomon, "Bennington Artists: The Green Mountain Boys," *Vogue*, August 1, 1966, 104–109, 151–52.

37. Barbara Rose, telephone conversation with the author, April 22, 2003.

38. Richard Artschwager, speech in honor of Alanna Heiss, the Sculpture Center Benefit, December 9, 2000, in Judith Stein, "Art's Wager: Richard Artschwager and the New York Art World of the Sixties," *Richard Artschwager: Up and Across*, 97.

39. *Art in America*, no. 1, 1963, 109.

40. Robert Morris, e-mail to the author, May 28, 2002.

41. Donald Judd, "Local History," *Arts Magazine Yearbook* 7 (1964): 26.

42. Hanford Yang, telephone conversation with the author, July 15, 2012.

43. Larry Poons, interviewed by John Zinsser, *Journal of Contemporary Art*, Fall/Winter 1989, reprinted in *Larry Poons: Paintings, 1963–1990* (New York: Salander-O'Reilly Galleries, 1990), 23.

14. DARK GREEN

1. Richard Bellamy, in "State of the Market," *Time*, June 21, 1963, 62.

2. Glueck, "Dealer Switching," X23.

3. The earliest extant receipt, to James Rosenquist, dated February 1963, noted that it was for "payment advanced in 1962." Richard Bellamy Papers, II.B.26. The Museum of Modern Art Archives, New York, NY.

4. Ivan Karp, in conversation with the author, New York, NY, January 16, 2002.

5. Emilio Cruz, e-mail to the author, April 21, 2001. Unless otherwise noted, this is the source for the rest of the paragraph.

6. Richard Bellamy, letter to Robert Beauchamp and Jackie Ferrara, January 13, 1960, in the collection of Jackie Ferrara.

7. Sheindi Bellamy, in conversation with the author, London, England, April 15, 2001.

8. Oral History Interview with Leo Castelli, 1969, Archives of American Art, Smithsonian Institution.

9. Oral History Interview with Tom Wesselmann, 1984 January 3–February 8, Archives of American Art, Smithsonian Institution.

10. Rosenquist, *Painting Below Zero*, 148.

11. Sheindi Bellamy, telephone conversation with the author, September 27, 2012.

12. Sherman Drexler, telephone conversation with the author, January 28, 2002.

13. Sherman Drexler, telephone conversation with the author, August 2, 2000.

14. June Ekman, in conversation with the author, New York, NY, March 21, 2015; Marcia Marcus, in conversation with the author, New York, NY, June 28, 2000.

15. March 4, 1963, program courtesy of Erik La Prade.

16. Cast list courtesy of Erik La Prade.
17. Yoko Ono, *Bicycle Piece for Orchestra* (1962), in *Grapefruit: A Book of Instructions and Drawings* (1964) (New York: Simon & Schuster, 2000), unpaged.
18. *Bicycle Piece* was one of several pieces on the program of a Fluxus concert at the Bridge Theater, New York, NY, on October 31, 1965, that also included Nam Jun Paik and Charlotte Moorman performing *Don't Trade Here*. Peter Moore's photographs and concert program, courtesy of Barbara Moore.
19. Banes, *Democracy's Body,* 40.
20. Sally Gross, in ibid., 75.
21. Yvonne Rainer, in Sasha Anawalt, "Minimalist Movement," *Los Angeles Times,* May 2, 2004.
22. Dore Ashton, in conversation with the author, New York, NY, February 22, 2001.
23. Michael Fried, "New York Letter," *Art International,* December 1963, 68.
24. Dick may have learned about the artist from Donald Judd, who soon described him as "one of the best artists around." Donald Judd, "H. C. Westermann," *Arts Magazine,* October 1963, 57–58.
25. Sidney Tillim, in conversation with the author, New York, NY, February 21, 2001. Dick was Tillim's dealer in the post-Green years, although by then, there was no real market for his realist art.
26. "James Lee Byars: Letters from the World's Most Famous Unknown Artist," Mass MoCA, January 2004, www.massmoca.org/event_details.php?id=44 (accessed November 26, 2013).
27. Bellamy/Byars projects include *Four in a Dress* (1967); the fictitious *Museum of Human Attention* (1968); and *Seven Gold Men Smell Seven Cultural Institutions* (1980). Viola Michely, e-mail to the author, February 11, 2001; Steven Harvey, telephone conversation with the author, January 23, 2002.
28. Barbara Flynn, Richard Bellamy Memorial Service, MoMA PS 1, Long Island City, NY, May 13, 1998.
29. The Byars scholar Shinobu Sakagami has determined that the performance occurred on November 16, 1963, e-mail to the author, March 1, 2016. She noted that published descriptions that the walls were painted black, as mentioned by James Elliott in *The Perfect Thought: Works by James Lee Byars* (Berkeley: University Art Museum, University of California, 1990), 77, likely reflected Byars's aspiration and not what actually happened at the Green. It's no small task to restore black walls to white. Peter Moore's contact sheet of a Byars performance at the Green (I.5, The James Lee Byars–Dorothy Miller Correspondence, Museum of Modern Art Archives, New York, NY) is stamped November 21, 1963, and shows large paintings against white walls in the background, the photos presumably taken during the November Larry Poons show. In a narrative titled "Accomplishments" (I.1, The James Lee Byars–Dorothy Miller Correspondence, Museum of Modern Art Archives, New York, NY), Byars mentions, "Back in NY Oct [1963] for performances at Green and Castelli," and, "Am in NY currently [1964] having a series of [simultaneous] October shows [on October 25], . . . at the Castelli, Elkon, Green, Kornblee, and Willard galleries." And in January 1964 a report mentioned a performance "a few weeks ago" (John Wilcock, "The Village Square: An Outsider's View of the 'In' Art Scene (3)," *Village Voice,* January 23, 1964).
30. *Cronología* (Valencia, Spain: IVAM Centre del Carme, 1994), 229.

31. Viola Michely, e-mail to the author, February 11, 2001.

32. "Some Thoughts on Improvisation," in *Yvonne Rainer, Work 1961–1973* (Halifax: Press of the Nova Scotia College of Art and Design, 1974), 298–301.

33. Yvonne Rainer, e-mail to the author, December 8, 2003.

34. A short piece of footage (forty feet) is extant. Callie Angell, e-mail to the author, January 4, 2001. Peter Moore took multiple photographs. Barbara Moore, e-mail to the author, February 19, 2016.

35. John Wilcock, "The Village Square." Sitwell's "Four in the Morning," in which black and white imagery predominates, may have been one of the selections.

36. J[ill] J[ohnston], "Reviews and Previews: New Names This Month—Robert Morris," *Art News*, October 1963, 14–15; Brian O'Doherty, "Art: Connoisseurs Face Busy Season—Robert Morris," *New York Times*, October 19, 1963, 22; Barbara Rose, "New York Letter," *Art International*, December 1963, 61–64; S[idney] T[illim], "In the Galleries: New York Exhibition–Robert Morris," *Arts Magazine*, December 1963, 61–62.

37. Brian O'Doherty, "Morris' Pop Humor Is Shown at Green," *New York Times*, October 19, 1963, 17.

38. Robert Morris, in *Robert Morris*. Michael Blackwood, 1994. Film.

39. Richard Bellamy, letter to Virginia Wright, December 12, 1963. Richard Bellamy Papers, I.A.515. The Museum of Modern Art Archives, New York, NY.

40. Jill Johnston, "Well Hung," *Village Voice*, February 29, 1968, in *Marmalade Me* (Middletown, CT: Wesleyan University Press, 1998), 147.

41. Richard Bellamy, letter to Virginia Wright, November 21, 1963. Richard Bellamy Papers, I.A.515. The Museum of Modern Art Archives, New York, NY. Duchamp visited the Green on other occasions, to see George Segal's work, for example, and to attend performances such as Bob Whitman's. See Richard Bellamy, interview with Susan Hapgood, July 21, 1991, transcript courtesy of Susan Hapgood.

42. "Art Tour, the Galleries," *New York Herald Tribune*, October 19, 1963.

43. The widely held belief that delayed payment for *Litanies*, on view through November 2, 1963, triggered the creation of "Document (Statement of Aesthetic Withdrawal)," dated November 15, 1963, is not consistent with the factual record. MoMA's internal files suggest that Johnson purchased *Litanies* in 1964.

44. David Whitney, in conversation with the author, New York, NY, January 6, 2004.

45. Adam Scull, in conversation with the author, New York, NY, April 12, 2010.

46. James Waring, "Art Chronicle," *Floating Bear*, March 1964.

47. The filmmaker and photographer Hollis Frampton took the picture.

48. The Ferus Gallery in Los Angeles also pioneered this practice.

49. John Canaday, "Don Judd," *New York Times*, December 21, 1963, 19.

50. Irving Sandler, "Donald Judd," *New York Post*, January 5, 1964.

51. Elkoff, "The American Painter as a Blue Chip," 112.

52. Harry Arouh, "Art for Whose Sake?," *Eye on New York*. Today available as a DVD, it originally aired on CBS in New York on March 17 and March 21, 1964, and on January 12, 1965.

53. Castelli remembered this taking place in 1963. Oral History Interview with Leo Castelli, 1969, Archives of American Art, Smithsonian Institution. Unless otherwise noted, this is the source for this and the following paragraph.

54. Green Gallery invoice, dated August 14, 1963, postmarked June 14, 1963,

George Segal Papers, CI.303, box 46, folder 7, Manuscripts Division, Department of Rare Books and Special Collections, Princeton University Library. Dick must have had reasons for seemingly keeping the "present value" for Segal's works artificially low on the invoice. He priced *Woman in a Restaurant Booth*, today in the Museum of Modern Art, at $125, and *Man on a Bicycle*, today in Stockholm's Moderna Museet, at $100.

55. Mark di Suvero, via Ivana Mestrovic, e-mail to the author, July 28, 2014.
56. Richard Bellamy, letter to Adam Aronson, December 7, 1963. Richard Bellamy Papers, V.1. The Museum of Modern Art Archives, New York, NY.
57. Adam Aronson, telephone conversations with the author, July 24 and August 4, 2003. Although Aronson called it the Mark Twain Bank, it is referred to as the "South County State Bank" in John F. Lyons, "Art Galleries Profit by Showing in Banks, Theaters and Stores," *Wall Street Journal*, January 8, 1964, 1.
58. Lyons, "Art Galleries Profit by Showing in Banks," 1. The *Journal* noted that other gallerists were displaying art in the department store windows of Saks Fifth Avenue, and at Sherry Wine & Spirits, a liquor store in a stylish section of New York's Upper East Side.
59. Robert E. Koebbe, "It's Called Pop Art," *St. Louis Globe-Democrat*, November 15, 1963.
60. The exhibition subsequently traveled to Switzerland, but not before some of the work was damaged by disgruntled St. Louis artists hostile to pop art. Adam Aronson, telephone conversation with the author, July 24, 2003.
61. Julie Finch, in conversation with the author, New York, NY, July 19, 2012.
62. Sheindi Bellamy, telephone conversation with the author, August 11, 2003.
63. Michael Feingold, "Al Carmines (1936–2005)," *Village Voice*, August 30, 2005, www.villagevoice.com/2005-08-30/theater/al-carmines-1936-ndash-2005/ (accessed November 26, 2013).
64. Sheindi again played the role for a 1966 revival at Judson; Nancy Christopherson designed the costumes. Program courtesy of Erik La Prade.
65. "Home Movies, July 7, 1964," Performing Arts Archive Online, www.performingartsarchive.com/Other-shows/Home-Movies_1964/Home-Movies_1964.htm (accessed November 30, 2012). *Home Movies* opened at the Judson Memorial Church in March 1964 and transferred to the Provincetown Playhouse in mid-May. In a review originally published in the *Partisan Review*, Susan Sontag singled out Sheindi and Reverend Carmines, complimenting their bouncy tango, and the "winsome strip tease" by Fred Herko, who just a few months later would commit suicide by dancing out a window. Sontag, "Going to Theater, Etc.," *Against Interpretation*, 158–59.
66. Sheindi Bellamy, in conversation with the author, London, England, April 14, 2001.
67. John Chamberlain, in conversation with the author, Shelter Island, NY, July 1, 2002. Unless otherwise noted, this is the source for this and the following paragraph.
68. June Ekman, in conversation with the author, New York, NY, March 21, 2015.
69. Incident occurred on June 10, 1964. "Chronology," *John Chamberlain: Choices* (New York: Solomon R. Guggenheim Museum, 2012), 200.
70. Sheindi Tokayer, in conversation with the author, London, England, April 15, 2001.

71. Josh Greenfield, "Sort of the Svengali of Pop," *New York Times*, May 8, 1966, 34.

72. Multiple dealers represented the other four: Kenneth Noland, Claes Oldenburg, Jim Dine, and Morris Louis.

73. He had on a light blue seersucker when his cousin met him by chance in Paris that summer. Joe David Bellamy, e-mail to Miles Bellamy, January 5, 2011.

74. Nancy Fish, "The Greatest Possible Happiness," unpublished manuscript, courtesy of Nancy Fish, who is currently writing a memoir covering these times.

75. Harriet Vyner, *Groovy Bob: The Life and Times of Robert Fraser* (London: Faber and Faber, 1999).

76. Dick frequented the Fraser Gallery on subsequent trips to Europe. John Stoller, in conversation with the author, London, England, July 3, 2001.

77. Calvin Tomkins, "Venice, 1964," in *Off the Wall* (New York: Doubleday, 1980), 1–11.

78. Allene Talmey, "Art Is the Core," *Vogue*, July 1964, 116–23, 125.

79. Without details, Dick told a critic that he assumed full financial responsibility for the gallery "in 1964." Goldin, "Requiem for a Gallery," 27.

80. Richard Bellamy, in de Coppet and Jones, *The Art Dealers*, 127.

81. Nancy Fish, telephone conversation with the author, October 12, 2012.

82. Fish, "The Greatest Possible Happiness."

83. Lewis Winter, in conversation with the author, New York, NY, July 8, 2011.

84. Larry Poons, in conversation with the author, New York, NY, September 16, 2003.

85. Sheindi Bellamy, in conversation with the author, London, England, April 15, 2001. Unless otherwise noted, this is the source for this and the following paragraph.

86. June Ekman, in conversation with the author, New York, NY, March 21, 2015.

87. Sheindi Bellamy, in conversation with the author, London, England, April 14, 2001.

15. WRONG MAN AT THE RIGHT TIME

1. Rosenquist, *Painting Below Zero*, 148. Rosenquist did not specify the year.

2. Hanford Yang, telephone conversation with the author, July 15, 2012.

3. Lucas Samaras, telephone conversation with the author, April 22, 2003.

4. Lucas Samaras, in conversation with the author, New York, NY, May 22, 2003.

5. Sheindi Bellamy, in conversation with the author, New York, NY, May 29, 2003.

6. Jeanie Blake, in conversation with the author, East Hampton, NY, July 8, 2000.

7. In 1981 Dick rehired Jeanie, and she stayed on for the next fifteen years.

8. Sam Green, in conversation with the author, New York, NY, March 19, 2003. This is the source for the remainder of the paragraph.

9. In later years he would tell how he had applied for the ICA job on Wesleyan stationery that listed "Samuel Green"—his father's name as well—as chairman of the art department. "Sam Green with Judith Stein," *Forty Years at the Institute of Contemporary Art, University of Pennsylvania* (Philadelphia, Institute of Contemporary Art, 2005), 12.

10. Sally Dennison, who also studied at RISD, was the Green's front man that fall. She left to work for Michelangelo Antonioni and became his production assistant and casting director for *Zabriskie Point*.

11. Walter De Maria, telephone conversation with the author, May 27, 2003.

12. Arne Glimcher, in conversation with the author, New York, NY, May 22, 2003.

13. Lucas Samaras, telephone conversation with the author, April 22, 2003.

14. Grace Glueck, "Artifacts," *New York Times*, October 4, 1964, 23.
15. Robert Hughes, "Art: Menaced Skin," *Time*, November 27, 1972, 65.
16. David Whitney, in conversation with the author, New York, NY, January 6, 2004.
17. Introduced to Lozano's work by Dick, Sam Green included three of her drawings (*Hard*, *Stiff*, and *Tight*) in *The New Art* (March 1–22, 1964), a group show he curated at the George W. and Harriet B. Davison Art Center, Wesleyan University, Middletown, CT.
18. Dick and Sheindi owned Lenny Bruce recordings. Andrew Tatarsky, telephone conversation with the author, January 25, 2015.
19. "List of Titles of Paintings," Iris Müller-Westermann, ed., *Lee Lozano* (Stockholm: Moderna Museet, 2010), 43.
20. Lee Lozano, in Müller-Westermann, ed., *Lee Lozano*, 42.
21. Reproduced in http://pastelegram.org/reviews/99 (accessed November 12, 2013).
22. Alanna Heiss, in Dorothy Spears, "Lee Lozano, Surely Defiant, Drops In," *New York Times*, January 5, 2011, AR23.
23. Arthur Danto, "The Art World," *Journal of Philosophy* 61, no. 19 (October 1964): 573.
24. Ibid., 584.
25. Eleanor Ward, in David Bourdon, *Warhol* (New York: Harry N. Abrams, 1995), 186.
26. Robert Morris, "Notes on Sculpture, Part 1," *Artforum*, February 1966, 228.
27. Harold Rosenberg, *The De-definition of Art* (New York: Collier Books, 1972), 12.
28. Lewis Winter, in conversation with the author, New York, NY, July 8, 2011.
29. Dan Flavin, ". . . In daylight or cool white," *Artforum*, December 1965, 24.
30. Dan Flavin, in *Dan Flavin: 1964 Green Gallery Exhibition* (New York: Zwirner & Worth, 2008), unpaged. This is the source for the rest of the paragraph.
31. David Bourdon, "Art: Dan Flavin," *Village Voice*, November 26, 1964, 11.
32. *The New Yorker Album of Art & Artists* (Greenwich, CT: New York Graphic Society, 1970), unpaged.
33. John Wesley, in conversation with the author, New York, NY, April 21, 2010.
34. John Wesley, in conversation with the author, New York, NY, November 28, 2001.
35. Jonathan Scull, in conversation with the author, New York, NY, January 22, 2009.
36. Sheindi Bellamy, telephone conversation with the author, October 17, 2000. Willem de Kooning and Ruth Kligman were two of the other guests.
37. Julie Finch, in conversation with the author, New York, NY, July 22, 2012.
38. Andy Warhol and Pat Hackett, *POPism: The Warhol Sixties*, 109.
39. "Tenant on 5th Ave. Wins $890 Rent Cut for Loss of Room," *New York Times*, April 23, 1964, 41.
40. Oral History Interview with Robert Scull, 1972 June, Archives of American Art, Smithsonian Institution.
41. Adam Scull, in conversation with the author, New York, NY, April 12, 2010.
42. Sheindi Bellamy, e-mail to the author, October 30, 2012.
43. Jonathan Scull, telephone conversation with the author, August 2, 2011.
44. Talmey, "Art Is the Core," 123.
45. Adam Scull, in conversation with the author, New York, NY, April 12, 2010.

46. Julie Finch, in conversation with the author, New York, NY, July 22, 2012.

47. Jonathan Scull, in conversation with the author, New York, NY, January 22, 2009.

48. Jonathan Scull, e-mail to the author, October 20, 2012.

49. Scull paid $1,125.00 for *Henry's Piece*. "1963: [George Segal's] Share of Sales Through June 1963." Richard Bellamy Papers, II.B.26. The Museum of Modern Art Archives, New York, NY.

50. David Whitney, unpaged notebook, box 2, David Grainger Whitney Trust, bequest, 2005, Menil Archives, Menil Collection, Houston, TX.

51. Oral History Interview with Robert Scull, 1972 June 15, Archives of American Art, Smithsonian Institution.

52. Judith Goldman, *Robert & Ethel Scull: Portrait of a Collection* (New York: Acquavella, 2010), 43.

53. "The Casting of Ethel Scull," *Time*, April 1, 1966, 77.

54. Suzy Knickerbocker, "The Smart Set: Scull Home Pop Art Heaven," *Palm Beach Daily News*, January 9, 1966.

55. Helen Segal, in conversation with the author, Long Island, NY, April 30, 2002.

56. "The Casting of Ethel Scull," 77.

57. Andy Warhol, in "At Home with Henry," 68.

58. Ethel Scull, in de Antonio and Tuchman, *Painters Painting*, 123.

59. Ibid., 124.

60. Frank Stella, in conversation with the author, New York, NY, September 28, 2006.

61. Arne Glimcher, in conversation with the author, New York, NY, May 22, 2003.

62. Wolfe's assessment was included in a 1964 newspaper article that was part admiring, part snide, reprinted as "Bob and Spike" in *The Pump House Gang*, 179.

63. "It was a who's who guest list, though I don't remember *who* exactly," Gerard Malanga, *Archiving Warhol: Writings & Photographs* (London: Creation Books, 2002), 148. He misremembered the event as occurring after Warhol's earlier exhibition of Brillo boxes.

64. David Patrick Columbia, "The Day the Factory Died," *New York Social Diary*, September 6, 2006, www.newyorksocialdiary.com/socialdiary/2006/09_06_06 /socialdiary09_06_06.php (accessed June 15, 2008).

65. Warhol and Hackett, *POPism: The Warhol Sixties*, 110.

66. Brian O'Doherty, "Morris' Pop Humor Is Shown at Green," *New York Times*, October 19, 1963, 17.

67. Leo Castelli, in conversation with the author, New York, NY, March 6, 1996.

68. David Zwirner, quoted in Nick Paumgarten, "Dealer's Hand," *New Yorker*, December 2, 2013, 38.

69. Oral History Interview with Carl Andre, 1972, Archives of American Art, Smithsonian Institution.

70. Donald Judd, "In the Galleries: Robert Morris," *Arts Magazine*, February 1965, 54.

71. Robert Morris, in Michael Archer, *Art Since 1960* (London: Thames and Hudson, 1997), 60.

72. Oral History with Richard Bellamy, 1963, Archives of American Art, Smithsonian Institution.

73. Spoerri was still in Europe in 1962 when Sidney Janis included his work in *New Realists*.

74. Judith Stein, "Spoerri's Habitat," *Art in America*, July 2002, 62–65, 109. Unless otherwise noted, this is the source for the rest of the paragraph.

75. Allan Stone previously showed thirty-one of these at his gallery; Daniel Spoerri, telephone conversation with the author, April 20, 2001.

76. Paula Cooper, in La Prade, *Breaking Through*, 190.

77. Richard Tuttle, in Judith Stein, "An Interview with Richard Tuttle," *Sienese Shredder* 1 (Winter 2006–2007): 20.

78. Daniel Spoerri, telephone conversation with the author, April 20, 2001.

79. David Whitney, unpaged notebook, David Grainger Whitney Trust, bequest, 2005. Menil Archives, Menil Collection, Houston, Texas. This is the source for the information and quotations following.

80. Dan Flavin, journal entry, reprinted in *Dan Flavin: The 1964 Green Gallery Exhibition*, unpaged.

81. Ibid.

82. Joseph Kosuth, in conversation with the author, Venice, Italy, June 5, 1999; Alanna Heiss, in conversation with the author, Long Island City, NY, October 17, 2000.

83. Curated by Robert Littman, director of the Emily Lowe Gallery; a partial checklist and photos survive in Hofstra's archives.

84. Memo, February 11, 1972, Emily Lowe Gallery archives.

85. David Shirey, "Art: Exhibition Pays Tribute to Art Gallery of the 1960's," *New York Times*, February 22, 1972; David Shirey, "Art: Former Avant-Garde Gallery Remembered in Hofstra Show," *New York Times*, February 27, 1972; Barbara Rose, "Homage to the Sixties: The Green Gallery Revisited," *New York*, March 20, 1972, 72.

86. Robert Littman, fax to the author, August 26, 1999.

87. Daisy Youngblood, "Daisy Youngblood on Dick Bellamy," photocopied statement, McKee Gallery, New York, NY, 1999.

88. Grace Glueck, "Art in Review; Daisy Youngblood," *New York Times*, May 7, 1999, E34.

89. Jeanie Blake, in conversation with the author, East Hampton, NY, July 8, 2000.

90. Sue Grody, telephone conversation with the author, January 19, 2004. The party at the Grodys' followed a dance performance in Hartford, CT, on March 6, 1965.

91. See Jill Johnston, *Mother Bound* (New York: Alfred A. Knopf, 1983), 159–61; "Could This Be Buffalo?," *Life*, April 23, 1965, 63.

92. Jo Baer, in conversation with the author, Amsterdam, the Netherlands, December 9, 2000.

93. Jo Baer, telephone conversation with the author, September 19, 2006.

94. Alanna Heiss, in conversation with the author, New York, NY, October 17, 2000.

95. Jane Wilson, in conversation with the author, New York, NY, February 4, 2002.

96. Sally Gross, in conversation with the author, New York, NY, August 15, 2000.

97. June Ekman, in conversation with the author, New York, NY, March 21, 2015.

98. Sheindi Bellamy, in conversation with the author, London, England, April 15, 2001.

99. Sidney Tillim, in conversation with the author, New York, NY, February 21, 2001.

100. Sally Gross, in conversation with the author, New York, NY, August 15, 2000.

101. Mark di Suvero, in conversation with the author, Long Island City, NY, August 15, 2002.

102. Alfred Leslie, telephone conversation with the author, December 12, 2007.

103. Ruth Noble, telephone conversation with the author, February 26, 2003.

104. Sheindi Bellamy, in conversation with the author, London, England, April 15, 2001.

105. Ibid.

106. Barbara Flynn, in conversation with the author, Provincetown, MA, September 21, 2003.

107. Sidney Tillim, in conversation with the author, New York, NY, February 21, 2001.

16. FADE TO BLACK

1. Joan Jonas, in conversation with the author, New York, NY, May 12, 2000. Whitney hired Jonas, the future video pioneer, as a part-time receptionist and typist in January.

2. Whitney may have designed the new masthead; see ad with similar design for his own gallery, *New York Times*, April 27, 1969.

3. Richard Bellamy, letter to David Whitney, April 18, 1978. Richard Bellamy Papers, I.A.504. The Museum of Modern Art Archives, New York, NY.

4. Scott Burton, "Ralph Humphrey: A Different Stripe," in David J. Getsy, ed., *Scott Burton, Collected Writings on Art & Performance, 1965–1975* (Chicago: Soberscove Press, 2012), 100.

5. N[eil] A. L[evine], "Reviews and Previews: Ralph Humphrey," *Art News*, June 1965, 16.

6. Klaus Kertess, in Bill Bartman, "In Conversation: Dorothea Rockburne and Klaus Kertess," *Brooklyn Rail*, December 2004/January 2005. See also Erik La Prade, "Viva the Green Gallery!" *Reading Room* 7 (2007).

7. Ibid.

8. Brice Marden, quoted in Saul Ostrow, *Bomb*, Winter 1988, 33, http://bombmagazine.org/article/985/brice-marden (accessed December 9, 2015).

9. Charles A. Riley, *The Saints of Modern Art* (Lebanon, NH: University Press of New England, 1998), 124.

10. Robert Hughes, "David Smith, Sculptures," *Nothing If Not Critical* (New York: Penguin Books, 1992), 207.

11. It was the seventh (CL 59) of Flavin's series of "monuments" for Tatlin.

12. The dedication to Smith may have preceded the sculptor's death. Tiffany Bell and Michael Govan, "Dan Flavin Interviewed by Tiffany Bell," *Dan Flavin: A Retrospective* (Washington, D.C.: National Gallery of Art, 1982), 198.

13. Goldin, "Requiem for a Gallery," 28.

14. A. Albert Taubman, in conversation with the author, New York, NY, August 21, 2013.

15. Richard Bellamy, letter to Virginia Wright, June 11, 1965. Richard Bellamy Papers, I.A.515. The purchase price was $6,000, carbon receipt. Richard Bellamy Papers II.B.26. The Museum of Modern Art Archives, New York, NY. Check deposited June 11, 1965.

16. Oral History Interview with Henry Geldzahler, 1970 January 27, Archives of American Art, Smithsonian Institution.

17. Walter De Maria, in conversation with the author, New York, NY, May 27, 2003.

18. Larry Poons, in conversation with the author, New York, NY, September 16, 2003.

19. Kramer, "Man Who Is Happening Now," 84.

20. De Coppet and Jones, *The Art Dealers*, 126.

21. Fred Gutzeit, telephone conversation with the author, March 31, 2009.

22. Jill Johnston, in Adam Szymczyk, ed., "Lee Lozano, Green Gallery, 1965," in *Lee Lozano: Win First Don't Last/Win Last Don't Care* (Basel, Switzerland: Kunsthalle Basel and Van Abbemuseum, 2006). Because of this text, some exhibition chronologies mistakenly include a 1965 exhibition at the Green.

23. Hanford Yang, telephone conversation with the author, July 15, 2012.

24. Oral History Interview with Walter De Maria, 1972 October 4, Archives of American Art, Smithsonian Institution. Paula Cooper would show the drawings at her new space on the Upper East Side.

25. Ibid.

26. Dan Flavin, letter to Donald Judd, August 17, 1965, Donald Judd Archives, Marfa, TX.

27. Kramer, "Man Who Is Happening Now," 84.

28. Oral History Interview with Leo Castelli, 1969, Archives of American Art, Smithsonian Institution.

29. Richard Feigen, in conversation with the author, New York, NY, May 22, 2003.

30. Arne Glimcher, in conversation with the author, New York, NY, May 22, 2003.

31. Klaus Kertess, in conversation with the author, East Hampton, NY, June 30, 2002.

32. Rosalind Constable, "The Gallery of the Year," *New York*, May 20, 1968, 39–40.

17. GOLDOWSKY DAYS

1. Marvin Elkoff, "The American Painter as a Blue Chip," *Esquire*, January 1965, 36–42.

2. Milton Esterow, "Rush for Art Turning into a Stampede," *New York Times*, March 14, 1966, 1.

3. John Russell, "Mark di Suvero Is Back in Town," *New York Times*, April 10, 1983, H31.

4. Richard Bellamy, in de Coppet and Jones, *The Art Dealers*, 127. Unless otherwise noted, this is the source of other information about the Goldowsky space.

5. Richard Bellamy, undated court transcript, 2209. Richard Bellamy Papers, II.E.5. The Museum of Modern Art Archives, New York, NY.

6. Mark di Suvero, in conversation with the author, Long Island City, NY, February 7, 1999.

7. Richard Bellamy, letter to Adam Aronson, March 16, 1966. Richard Bellamy Papers, V.1. The Museum of Modern Art Archives, New York, NY.

8. Sanford Schwartz, unpublished statement, 1998.

9. Copy of letter to Richard Brown Baker, November 12, 1965. Richard Bellamy Papers, I.A.20. The Museum of Modern Art Archives, New York, NY. The original is in Brown Baker archives at Yale University.

10. Denise Corley, in conversation with the author, South Hampton, NY, June 28, 2002.

11. Knight Landesman, in conversation with the author, Venice, Italy, June 9, 1999.

12. Kasper König, in conversation with the author, Venice, Italy, June 12, 1999.

13. Dick Bellamy, in de Coppet and Jones, *The Art Dealers,* 127.

14. Barbara Goldowsky, in conversation with the author, East Hampton, NY, August 4, 2007.

15. Dan Christensen, in conversation with the author, Springs, Long Island, NY, June 30, 2002.

16. He helped found the Amalgamated Clothing and Textile Workers Union, and was a Socialist alderman in New York in the thirties. Barbara Goldowsky, "Morris Goldowsky," 2004, Goldowsky.com, http://goldowsky.com/family/morris/intro.html (accessed November 26, 2013).

17. Dan Christensen, in conversation with the author, Springs, Long Island, NY, June 30, 2002.

18. Noah's partnership with Bud Holland ended in 1961.

19. Mark di Suvero, in conversation with the author, Long Island City, NY, August 15, 2002.

20. Walter De Maria, in conversation with the author, New York, NY, March 19, 2003.

21. Stephanie Chrisman Duran, telephone conversation with the author, June 7, 2015.

22. Virginia Wright bought a small Pollock work on paper from Noah "because of Dick's association there." Virginia Wright, in conversation with the author, Seattle, January 31, 2003.

23. Acting on Scull's suggestion, Dick and Klaus Kertess visited Eva Hesse's studio in 1966; Lucy Lippard, *Eva Hesse* (New York: Da Capo Press, 1992), 67.

24. Michael Heizer, telephone conversation with the author, June 3, 2003. Unless otherwise noted, this is the source for the paragraph.

25. Barbara Brown, in conversation with the author, Venice, CA, April 30, 2004.

26. Peter Frank, "Yoko Ono as an Artist," *Art Commotion: Visual Arts,* www.artcommotion.com/Issue2/VisualArts/ (accessed November 26, 2013); Peter Frank, "Ken Friedman, A Life in Fluxus," in Holly Crawford, ed., *Artistic Bedfellows: Histories, Theories and Conversations in Collaborative Art Practices* (Lanham, MD: University Press of America, 2008), 145.

27. Alexandra Munroe, *Yes: Yoko Ono* (New York: Harry N. Abrams, 2000), 45.

28. Yoko Ono, letter to Richard Bellamy care of Goldowsky, in *Grapefruit: A Book of Instructions and Drawings,* unpaged.

29. Yoko Ono, letter to Richard Bellamy, December 14, 1966. Richard Bellamy Papers, III.A.63. The Museum of Modern Art Archives, New York, NY.

30. Munroe, *Yes: Yoko Ono,* 286.

31. Ibid., 287.

32. Yoko Ono, letter to the author, April 2, 2001.

33. Yoko Ono, letter to Richard Bellamy, December 14, 1966. Richard Bellamy Papers, III.A.63. The Museum of Modern Art Archives, New York, NY.

34. John Lennon (1970), quoted in Jann S. Wenner, "The Ballad of John and Yoko," in Munroe, *Yes: Yoko Ono,* 58.

35. Richard Bellamy, quoted in Paul Taylor, "Yoko Ono's New Bronze Age at the Whitney," *New York Times,* February 5, 1989, H31.

36. Yoko Ono, "To the Wesleyan People," January 23, 1966, reprinted in Munroe, *Yes: Yoko Ono,* 289.

37. Dick may have worked with his former assistant Sam Green, whose father, Sam Green Sr., was dean of Wesleyan's fine arts school.

38. Michael Brenson, in conversation with the author, Philadelphia, April 30, 2015.

39. Grace Glueck, "Bright 3-Man Exhibition: Mark di Suvero Heads List of Sculptors Showing at the Goldowsky Gallery," *New York Times,* March 2, 1968, 26.

40. Robert Pincus-Witten's contemporary review of Serra's first show in New York omitted Dick's name (*Artforum,* April 1968, 63–65), and only "the Noah Goldowsky Gallery" is mentioned in Serra's own exhibition history. See Lynne Cook and Kynaston McShine, *Richard Serra Sculpture: Forty Years* (New York: Museum of Modern Art, 2007), 406; *Richard Serra Drawing: A Retrospective* (Houston, TX: Menil Collection, 2011), 207.

41. Richard Serra, in conversation with the author, February 26, 2002, New York, NY. Unless otherwise noted, this is the source for the quotations in the rest of the paragraph.

42. Robert Creeley, in conversation with the author, Johnson, VT, October 3, 2003.

43. In 1966, at the invitation of Henry Geldzahler, Dick served on the National Endowment for the Arts' "first panel of experts." Richard Bellamy, letter to Justice Silverman, February 1998, Richard Bellamy Papers, I.A.300. The Museum of Modern Art Archives, New York, NY. Dick also advised PS 1 and the Dia Art Foundation in their early years.

44. Suzaan Boettger, *Earthworks: Art and the Landscape of the Sixties* (Berkeley: University of California Press, 2002).

45. Paula Cooper, in conversation with the author, New York, NY, October 19, 2000.

46. Michael Heizer, "The Art of Michael Heizer," *Artforum,* December 1969, 34.

47. Michael Heizer, telephone conversation with the author, June 3, 2003.

48. Michael Govan, "Michael Heizer, Introduction," www.diaart.org/exhibitions /introduction/83.

49. Ibid.

50. Robert Scull, in Grégoire Müller, "Points of View, A Taped Conversation," *Arts Magazine,* November 1970, 37.

51. Robert Zakanitch, telephone conversation with the author, June 8, 2000.

52. Rafael Ferrer, in conversation with the author, New York, NY, October 1, 1999.

53. After meeting John Baldessari, whose work did not move him, Dick introduced him to Lawrence Weiner, Mel Bochner, Sol LeWitt, and Bruce Nauman, who became lifelong friends. www.artnet.com/Magazine/features/davis/davis12-7 -04.asp (accessed December 20, 2015).

54. Oral History Interview with Leo Castelli, 1969 May 14, Archives of American Art, Smithsonian Institution.

55. David Rabinowitch, in conversation with the author, New York, NY, February 26, 2002.

56. Bruce Nauman, in conversation with the author, Philadelphia, November 19, 2009.

57. Nauman showed *Plaster Cast Based on Neon Templates* (1966) and various latex

pieces in the first *From Arp to Artschwager*. Constance Lewallen et al., *A Rose Has No Teeth* (Berkeley: University of California Press, 2007), 198.

58. Frank Stella, in conversation with the author, New York, NY, September 28, 2006.

59. Oral History Interview with Leo Castelli, 1969 May 14, Archives of American Art, Smithsonian Institution.

60. The group included Dan Christensen, Peter Young, Ronnie Landfield, and Pat Lipsky, as well as William Pettet, Ken Showell, Ronald Davis, David Novros, and Philip Wofford, among others.

61. Larry Aldrich, "Statement of the Exhibition," *Lyrical Abstraction*, exhibition catalogue, (New York: Whitney Museum of American Art, 1971), unpaged.

62. Christensen dated it to early 1966; Dan Christensen, in conversation with the author, East Hampton, NY, June 30, 2002.

63. Dick and co-curators Lucy Lippard and Leah Sloshberg would include Blakelock in *Focus on Light* at the New Jersey State Museum, a selection of ninety artists from pointillists to Day-Glo painters. Grace Glueck, "Art Notes: Light Across the River," *New York Times*, May 28, 1967, D20.

64. Dan Christensen, in conversation with the author, East Hampton, NY, June 30, 2002.

65. There were twenty-five works by Balthus, Brauner, de Kooning, Dominguez, Grosz, Herbin, Klee, Léger, Matisse, Mondrian, and Picasso, "starting Nov 15 [year unknown]." Typed notice, in the collection of Barbara Goldowsky.

66. Richard Bellamy, in de Coppet and Jones, *The Art Dealers*, 127.

67. So does *A to D*, the title of a selection of sculpture by artists associated with the Park Place group shown at Noah's in 1964. Paula Cooper, in conversation with the author, New York, NY, October 19, 2000.

68. Sidney Tillim, in conversation with the author, New York, NY, February 21, 2001.

69. Stephanie Chrisman Duran, telephone conversation with the author, June 7, 2015. She helped Dick with office work in 1966–67.

70. Recorded dates for the first (June 30–September 5, 1966) and the second (June 15–September 30, 1967) are documented; the third was on view in summer 1968. Some had undocumented extensions. In a letter Dick wrote to Judd in August 1966, he noted, "one end [of *Varian*,] came off and needs re-soldering. Want to put in [continuation?] here of Arp to Artschwager September–October 15. Will re-juice some entries." Letter, Donald Judd Archives, Marfa, TX.

71. Keith Sonnier, in conversation with the author, Bridgehampton, NY, June 29, 2002.

72. Idelle Weber, telephone conversation with the author, December 12, 2011.

73. Neil Jenney, in conversation with the author, New York, NY, May 20, 2002.

74. *Richard Artschwager, Myron Stout, Peter Young*, March–February, 1967.

75. LoGiudice produced Christo and Jeanne-Claude's first wrapped building in the United States—Chicago's Museum of Contemporary Art (1969); see http://joe loguidice.blogspot.com/ (accessed November 26, 2013).

76. Joe LoGiudice, letter to George [Richard] Bellamy, January 14, 1974. Richard Bellamy Papers, II.C.18. The Museum of Modern Art Archives, New York, NY.

77. Richard Artschwager, in conversation with the author, New York, NY, February 20, 2001; Mark di Suvero, in conversation with the author, New York, NY, August 15, 2002; Peter Young, in conversation with the author, Bisbee, AZ, September 10, 2011.

78. Jo Baer, e-mail to the author, April 18, 2015.
79. Jo Baer, in Judith Stein, "The Adventures of Jo Baer," *Art in America*, May 2003, 104.
80. Jo Baer, in David Rhodes, "Jo Baer," *Brooklyn Rail*, July 15, 2013, www.brooklynrail .org/2013/07/artseen/jo-baer-1.
81. Jo Baer, "Letters," *Artforum*, September 1967, 5–6; Jo Baer, "Letters," *Artforum*, April 1969, 4–5.
82. Jo Baer, e-mail to the author, February 6, 2003. Unless otherwise noted, this is the source for the following two paragraphs.
83. Carole Selz, in conversation with the author, Berkeley, CA, February 3, 2003. Jo Baer put this action out of her mind after she moved to New York. Lyn Kien-holz conjectured that Ferus cofounder Ed Kienholz, her own mischievous future husband, who was also a good friend of Jo's, might have put her up to it. Jo Baer, who barely remembered the action, agreed that she is probably right. Lyn Kien-holz and Jo Baer, in conversation with the author, Los Angeles, April, 2004.
84. Jean Leering, telephone conversation with the author, April 26, 2001.
85. artforum.com/uploads/guide.003/id02054/press_release.pdf.
86. Keith Sonnier, in conversation with the author, Bridgehampton, NY, June 29, 2002. Other examples include the painter John Tweddle, whom Dick met as an exhibition juror at the Atlanta School of Art in 1967 and thereafter represented. Dick also facilitated the early career of the multimedia artists Kristin Jones and Andrew Ginzel, whom he first encountered when he was the sole dealer invited by Yale M.F.A. students for their Visiting Artist Program in 1982.
87. Ibid.
88. Gary Kuehn, in conversation with the author, Newark, NJ, February 19, 1999.
89. Jean Leering, telephone conversation with the author, April 26, 2001.
90. "Harald Szeemann," *Ubu Web: Historical*, www.ubu.com/historical/szeemann/index .html (accessed November 26, 2013). Bellamy was the undocumented guide leading Szeemann to others as well, including Artschwager and Sonnier.
91. John Weber, in de Coppet and Jones, *The Art Dealers*, 198.
92. Rolf Ricke, in conversation with the author, New York, NY, September 19, 1999.
93. They included di Suvero, Stout, Leslie, Baer, and Kuwayama.
94. Invoices, 1971. Richard Bellamy Papers, II.C.7. The Museum of Modern Art Archives, New York, NY.
95. Timothy Baum, telephone conversation with the author, August 4, 2015.
96. *Plus by minus*, Albright-Knox Art Gallery, Buffalo, NY, March 3–April 14, 1968.
97. Tadaaki Kuwayama, in conversation with the author, New York, NY, January 26, 2002. This is the source for the rest of the paragraph.
98. "The Back Room at Max's Kansas City," Max's Kansas City Online, classic .maxskansascity.com/Warhol (accessed October 26, 2015).
99. Barbara Zucker, e-mail to the author, March 31, 2001.
100. Jo Baer, e-mail to the author, February 6, 2003.
101. Bebe Buell, in Ruth La Ferla, "When Style Was Perfected at Max's Kansas City," *New York Times*, September 10, 2010.
102. The artist and writer Willoughby Sharp and the punk novelist Kathy Acker smoked opium with Dick. Willoughby Sharp, e-mail to the author, January 22, 2002.
103. Peter Young, in conversation with the author, Bisbee, AZ, September 10, 2011.

104. Andy Tatarsky, in conversation with the author, New York, NY, June 20, 2000.

105. Robert Lowell, "Central Park," *New York Review of Books*, October 14, 1965.

106. Fredericka Hunter, in conversation with the author, New York, NY, May 20, 2002.

107. Bill Anastasi, telephone conversation with the author, March 9, 2004.

108. Richard Bellamy, in de Coppet and Jones, *The Art Dealers,* 128. Unless otherwise noted, this is the source for the paragraph.

109. John Wesley, in conversation with the author, New York, NY, November 28, 2001.

110. Richard Bellamy, in de Coppet and Jones, *The Art Dealers*, 129.

111. Jeanie Blake, e-mail to the author, October 25, 2000.

112. Richard Bellamy, letter to Virginia Wright, March 6, 1974. Richard Bellamy papers, I.A.515. The Museum of Modern Art Archives, New York, NY.

113. John Wesley, in conversation with the author, New York, NY, November 28, 2001.

114. Tadaaki Kuwayama, in conversation with the author, New York, NY, January 26, 2002.

115. Reese Paley, e-mail to the author, November 14, 2012.

116. Richard Bellamy, in de Coppet and Jones, *The Art Dealers*, 127.

18. 1973 AND ALL THAT

1. Walter De Maria, telephone conversation with the author, May 14, 2008. Although Dick later wrote James Michener, "I was holed up for about 7 years on 25th & Park Ave. S.," the dates are not known. Letter, January 10, 1982. Richard Bellamy Papers, I.A.309. The Museum of Modern Art Archives, New York, NY.

2. Dick moved in right above David Budd, a painter he'd shown at Noah's.

3. Sanford Schwartz, in conversation with the author, New York, NY, June 23, 2011.

4. In 1978 Dick gave the Canadian-born sculptor David Rabinowitch two shows, one for his sculpture and one for his drawings.

5. David Bourdon, "What's Up in Art: Follow the Clan," *Life*, May 1, 1970, 73.

6. Peter Young and Dan Christensen were foremost among them.

7. David Whitney, in Grace Glueck, "Looking Up with the Arts," *New York Times*, October 5, 1969, D28.

8. Mark di Suvero, letter to Richard Bellamy, undated (circa 1978). Richard Bellamy Papers, III.N.76. The Museum of Modern Art Archives, New York, NY.

9. Richard Bellamy, letter to David Whitney, April 30, 1989. Richard Bellamy Papers, I.A.504. The Museum of Modern Art Archives, New York, NY.

10. Richard Bellamy, letter to Leon Arkus, May 4, 1979. Richard Bellamy Papers, I.A.504. The Museum of Modern Art Archives, New York, NY.

11. Judith Stein, "A Bond of Steel: di Suvero and Bellamy," *Art in America*, November 2005, 150–55.

12. Sally Gross, in conversation with the author, New York, NY, November 12, 1998.

13. Courtesy of Barbara Goldowsky. Likely Noah's accountant helped prepare this.

14. http://alfredleslie.com/books/index.html?coolman (accessed October 26, 2015); Judith Stein, "Telling History: A Narrative Chronology of Alfred Leslie's 'The Killing Cycle,'" *Alfred Leslie* (St. Louis: St. Louis Art Museum, 1991), 12.

15. Michelle O'Donnell, "Oct. 17, 1966, When 12 Firemen Died," *New York Times*, October 17, 2006.

16. Jennifer Dunning, "Last of April, First of May," *Dance Magazine*, July 1976.

17. Leslie Satin, "Sally Gross, Suddenly," *PAJ: A Journal of Performance and Art* 22, no. 1 (January 2000): 16n7.

18. Michael Blackwood's film *Sally Gross: A Life in Dance* (2001) opens with an unidentified excerpt of the first part of *Friends* that Sally re-created for Blackwood's camera.

19. Elizabeth Weatherford, in conversation with the author, New York, NY, 1999.

20. Jennifer Dunning, "Sally Gross: Cool Postmodernism," *New York Times*, June 5, 1987.

21. Jennifer Dunning, "From a Weekly Routine, a Rare Sense of Kinship," *New York Times,* January 21, 2001.

22. Lenore Jaffee, telephone conversation with the author, January 30, 2015.

23. Sidney Tillim, in conversation with the author, New York, NY, February 21, 2001.

24. John Wesley, in conversation with the author, New York, NY, November 28, 2001.

25. Alanna Heiss, in conversation with the author, Long Island City, NY, October 17, 2000.

26. Goldin, "Requiem for a Gallery," 25.

27. Jonathan Scull, in conversation with the author, New York, NY, January 22, 2009.

28. Michael Steiner, telephone conversation with the author, March 8, 2004.

29. Ethel Scull, in Marie Brenner, "The Latter Days of Ethel Scull," *New York*, April 6, 1981, 22.

30. Judy Klemesrud, "Society Wears Its Dreams to Go to a Party," *New York Times*, November 12, 1966, 19.

31. Virginia Lee Warren, "A Boutique That's All Wrapped Up in Politics," *New York Times*, June 4, 1968, 50.

32. Angela Taylor, "Cartridge Belt Cute? Well, It's a Fashion," *New York Times*, December 9, 1970, 68.

33. Robert Scull, in "The New Art: It's Way, Way Out," *Newsweek*, July 29, 1968, 56.

34. Judith Goldman, *Robert and Ethel Scull: Portrait of a Collection* (New York: Acquavella Galleries, 2010), 44.

35. Robert Scull, in Kramer, "Man Who Is Happening Now," 64.

36. Sanka Knox, "Abstract Paintings by Expressionists Sold for $284,000," *New York Times*, October 14, 1965, 52.

37. "Odd Ball In," *Newsweek*, October 25, 1965.

38. Robert Scull, in Grégoire Müller, "Points of View: A Taped Conversation with Robert C. Scull," *Arts Magazine*, November 1970, 37.

39. John Gruen, "The Pop Scene: Those Detractors Just Irritate but Do Not Fracture the Sculls," *World Journal Tribune*, March 9, 1967.

40. Grace Glueck, "Robert Scull, Prominent Collector of Pop Art," *New York Times*, January 3, 1986, B5.

41. Dorothy Seiberling, "Scull's Angles: Going Once, Going Twice . . . ," *New York*, September 17, 1973, 58.

42. Robert Scull, in Grace Glueck, "Art Notes: Auction Where the Action Is," *New York Times*, November 15, 1970, D26.

43. Sanka Knox, "Painting by Lichtenstein Brings a Record $75,000 at Auction," *New York Times*, November 19, 1970, 40.

44. When eventually sold at auction following Bob Scull's death in 1986, the Johns realized $1,760,000 for his estate. Rita Reif, "Rosenquist Painting Sells for Record Price," *New York Times*, November 12, 1986.

45. Barbara Rose, "Profit Without Honor," *New York*, November 5, 1973, 81.

46. Richard Bellamy, undated court transcript, 2207. Richard Bellamy Papers, II.E.5. The Museum of Modern Art Archives, New York, NY.

47. Bina Bernard, "The Sculls Go Pop to the Top," *People*, May 20, 1974, http://www .people.com/people/archive/article/0,,20064082,00.html (accessed November 11, 2012).

48. Robert Scull, in Seiberling, "Scull's Angles: Going Once, Going Twice . . . ," 58.

49. Ethel Scull, in Marie Brenner, "The Latter Days of Ethel Scull," *New York*, April 6, 1981, 22.

50. Adam Scull, "Mom and Pop Art: Part I," EatSleepWrite.net, http://eatsleepwrite .net/momandpopart1 (accessed September 8, 2009).

51. Israel Shenker, "Amy Vanderbilt Instructs Scull's Angels in Etiquette," *Nashua Telegraph*, September 25, 1973. Papers all over the country carried the *New York Times* and UPI wire service story.

52. Lee Eastman, in Rose, "Profit Without Honor," 81.

53. Edward J. Vaughn, telephone conversation with the author, May 7, 2013.

54. Leo Castelli, in Edward J. Vaughn, *America's Pop Collector* (Ph.D. diss., University of Michigan, 1990), 121.

55. Ibid., 332.

56. Ibid., 360.

57. Ibid., 363.

58. Ethel Scull, in Brenner, "The Latter Days of Ethel Scull," 22. Unless otherwise noted, this is the source for the rest of the paragraph.

59. John Duka, "Back on Top with the Mom of Pop Art," *New York*, June 9, 1986, 62–68.

60. Amy Cappellazzo, in "Art and Its Markets: A Roundtable Discussion," *Artforum*, April 2008, 295.

61. Tobias Meyer, in Jerry Saltz, "Seeing Dollar Signs," *Village Voice*, January 16, 2007.

62. Howard Rachofsky, quoted in Kelly Crow, "The Gagosian Effect," *Wall Street Journal*, April 1, 2011.

63. Richard Bellamy, letter to Martha Baer, April 30, 1996. Richard Bellamy Papers, I.B.12. The Museum of Modern Art Archives, New York, NY.

64. Richard Bellamy, letter to George Segal, July 30 [1959], George Segal Papers (C1303), Box 46, Folder 3, Manuscripts Division, Department of Rare Books and Special Collections, Princeton University Library.

65. Richard Bellamy, letter to George Segal, August 17 [1959], George Segal Papers (C1303), Box 46, Folder 3, Manuscripts Division, Department of Rare Books and Special Collections, Princeton University Library.

66. Richard Bellamy, letter to Henry Geldzahler, February 21, 1990. Richard Bellamy Papers, I.A.168. The Museum of Modern Art Archives, New York, NY.

67. Richard Bellamy, letter to Virginia Wright, December 12, 1963. Richard Bellamy Papers, I.A.515. The Museum of Modern Art Archives, New York, NY.

68. Richard Bellamy, letter to Thomas Armstrong, January 27, 1977. Richard Bellamy Papers, I.A.505. The Museum of Modern Art Archives, New York, NY.

69. Richard Bellamy, letter to Peter Ludwig, February 10, 1982. Richard Bellamy Papers, I.A.277. The Museum of Modern Art Archives, New York, NY.

70. Richard Bellamy, letter to Calvin Tomkins, 1982. Calvin Tomkins Papers, I.26. The Museum of Modern Art Archives, New York, NY.

71. Richard Bellamy, letter to Jack Kroll, May 14, 1990. Richard Bellamy Papers, I.A.348. The Museum of Modern Art Archives, New York, NY.

72. Richard Bellamy, letter to A. Alfred Taubman, February 18, 1981. Richard Bellamy Papers, I.A.467. The Museum of Modern Art Archives, New York, NY.

73. Richard Bellamy, letter to Paul Richard, February 23, 1988. Richard Bellamy Papers, I.B.3. The Museum of Modern Art Archives, New York, NY.

74. Grace Glueck, "Serra Work Stirs Downtown Protest," New York Times, September 25, 1981.

75. Richard Bellamy, letter to the editor of The New York Times, September 29, 1981. Richard Bellamy Papers, I.A.435. The Museum of Modern Art Archives, New York, NY.

19. BEL AMI

1. The exact dates are not known. Dick, interviewed by Calvin Tomkins on October 27, 1982, estimated that he left Park Avenue South "about seven years ago." Calvin Tomkins Papers, III.30. The Museum of Modern Art Archives, New York, NY. Yet in 1977, Dick referred to shuttling back and forth "between home & headquarters" (Sixty-Ninth Street; Park Avenue South). Richard Bellamy, letter to Virginia Wright, 1977. Richard Bellamy Papers, I.A.515. The Museum of Modern Art Archives, New York, NY.

2. Grégoire Müller, e-mail to the author, October 20, 2013. Müller recalled that Scull even may have shored up his operation financially, at least at the onset. Yet Dick told Calvin Tomkins he had no backers. See Richard Bellamy, interview with Calvin Tomkins, October 27, 1982. Calvin Tomkins Papers, III.30. The Museum of Modern Art Archives, New York, NY.

3. Peter Young, in conversation with the author, Bisbee, AZ, September 10, 2011.

4. Richard Bellamy, letter to Alfred Taubman, February 18, 1981. Richard Bellamy Papers, I.A.467. The Museum of Modern Art Archives, New York, NY.

5. John Russell, "Mark di Suvero Is Back in Town," New York Times, April 10, 1983, H31.

6. Walter De Maria, in conversation with the author, New York, NY, March 19, 2003.

7. Rosenquist, Painting Below Zero, 324.

8. A Silent Movie, Mel Brooks, director, Crossbow Productions, 1976.

9. Alanna Heiss, in conversation with the author, Long Island City, NY, October 17, 2000.

10. Russell, "Mark di Suvero Is Back in Town," H31.

11. Mark di Suvero, in conversation with the author, Long Island City, NY, August 15, 2002.

12. Susie Schlesinger, in conversation with the author, Berkeley, CA, May 28, 2004.

13. Denise Corley, in conversation with the author, South Hampton, NY, June 28, 2002.

14. Richard Bellamy, undated letter to Christophe de Menil. Richard Bellamy Papers, I.A.108. The Museum of Modern Art Archives, New York, NY.

15. Jill Johnston, Richard Bellamy Memorial Service, MoMA PS 1, Long Island City, NY, May 13, 1998.
16. Alfred Leslie, in conversation with the author, Philadelphia, April 1, 2002.
17. Tehching Hsieh, e-mail to the author, May 14, 2009.
18. Linda Montano, e-mail to the author, May 18, 2009.
19. Miles Bellamy, e-mail to the author, June 11, 2015.
20. Sophie Calle, in conversation with the author, Paris, France, June 20, 2003. This is the source for the rest of the paragraph.
21. Sophie Calle, *Suite Venitienne/Please Follow Me* (Seattle: Bay Press, 1988).
22. Alfred Leslie, in conversation with the author, New York, NY, April 9, 1998.
23. Denise Corley, Richard Bellamy Memorial Service, MoMA PS 1, Long Island City, NY, May 13, 1998.
24. Some had titles similar to shows at Goldowsky's: *Andrejevic to Young* (October 20–December 5, 1981); *Baer to Stout* (October 26–December 18, 1982).
25. The Clocktower Oral History Project, http://clocktower.org/show/richard-nonas (accessed June 10, 2015).
26. Others included Neil Jenney, Mary Corse, Richard Nonas, Myron Stout, Jo Baer, Manny Farber, and David Rabinowitch.
27. Grace Glueck, "Alfred Leslie's Black-and-White Watercolors," *New York Times*, November 7, 1983; Alfred Leslie, *100 Views Along the Road* (New York: Timken, 1988).
28. Michael Brenson, "Can Political Passion Inspire Great Art?," *New York Times*, April 29, 1984, H1.
29. Richard Bellamy, in Wilson, "Richard Bellamy," *Issue*, 22.
30. Vivien Raynor, "Contemporary Paintings and Sculpture II," *New York Times*, June 25, 1982.
31. Ibid.
32. Jan Müller, *Major Paintings: 1956–1957* (New York: Oil & Steel Gallery, 1985), included an artist's statement and essays by Thomas Messer, Martica Sawin, and Meyer Schapiro.
33. Douglas C. McGill, "Galleries in Emerging Art Neighborhoods," *New York Times*, February 18, 1985, C9. Her shows included Nancy Spero, *New Paintings, 1979–1983*; and *Work by Young Photographers from Germany* (Thomas Struth, Thomas Ruff, Axel Huette, Petra Wunderlich), 1983.
34. Barbara Flynn, in conversation with the author, Venice, Italy, June 6, 2001. Unless otherwise noted, this is the source for the following two paragraphs.
35. Mark di Suvero, in conversation with the author, Long Island City, NY, August 15, 2002.
36. Miles Bellamy, in conversation with the author, Brooklyn, NY, February 23, 2001.
37. Barbara Flynn, e-mail to the author, June 11, 2015.
38. Ibid.
39. Ibid.
40. His vocalizations, overheard late at night, may reflect a drug flashback. Steven Beyer, in conversation with the author, Philadelphia, May 8, 1998.
41. Alfred Leslie, in conversation with the author, Philadelphia, April 23, 2002.
42. David Rabinowitch's *Tyndale Constructions in Five Planes with West Fenestration: Sculpture for Max Imdahl* stayed on view for seven months.

43. Henry Geldzahler, "Myron Stout, Pathways and Epiphanies," in *Myron Stout* (New York: Oil & Steel Gallery, 1990), 7.

44. Michael Brenson, "Works of Myron Stout," *New York Times*, November 2, 1990.

45. Richard Bellamy, "Preface and Acknowledgments," Geldzahler, *Myron Stout*, 4.

46. In its place he offered *Contemporary Painting and Sculpture* (April 10–27, 1962), juxtaposing a few Stouts with art by expressionist sculptors and painters who shared his sensuality of touch but not his interest in pure forms.

47. Barbara Flynn, *Alfred Leslie: The Grisaille Paintings, 1962–67* (New York: Barbara Flynn and Richard Bellamy, 1991).

48. Sally Gross, in conversation with the author, New York, NY, November 12, 1998.

49. "Sally Gross: Parallels, Vectors, Chair, and Scoring with music by Peter Griggs," *New York*, June 21, 1981, 81; Jennifer Dunning, "In the Arts: Critics' Choices," *New York Times*, February 20, 1983, G3. See also "Sally Gross: Solos and Duets," *Dance Heritage Coalition*, archive.danceheritage.org/assets/59944d3a-c6d2-4d98-a62f -4bbbb6c64caf (accessed November 26, 2013).

50. Richard Bellamy, letter to Peter Young, August 26, 1974. Richard Bellamy Papers, III.P.11. The Museum of Modern Art Archives, New York, NY.

51. Dan Christensen, in conversation with the author, Springs, Long Island, NY, June 30, 2002.

52. Barbara Flynn, in conversation with the author, Venice, Italy, June 6, 2001. One such occasion was February 4, 1980, the night the Whitney opened a Myron Stout retrospective. As a friend watched, a drunken Dick stumbled into one of Noguchi's sculptures also on view, and sent it tumbling. Dick then reassembled it, more or less. Jim Bumgardner, telephone conversation with the author, December 12, 2014.

53. Sharon Flescher, "The Art Scene in Long Island City," *Arts Magazine*, December 1987, 24.

54. Richard Bellamy, thinly veiled, in Pat Lipsky, "The Last Act," *East Hampton Star*, June 10, 2010, patlipsky.com/writing/the-last-act.

55. Denise Corley, telephone conversation with the author, June 12, 2015.

56. Richard Bellamy, in Wilson, "Richard Bellamy," *Issue*, 22.

57. Flescher, "The Art Scene in Long Island City," 20.

58. Alfred Leslie, unpublished diary entry, March 19, 1972, in the collection of Alfred Leslie.

59. Mark di Suvero, in conversation with the author, New York, NY, August 15, 2002.

60. Walter De Maria, in conversation with the author, New York, NY, March 19, 2003.

61. Denise Corley, in conversation with the author, South Hampton, NY, June 28, 2002.

62. Richard Bellamy, letter to A. Alfred Taubman, February 18, 1981. Richard Bellamy Papers, I.A.467. The Museum of Modern Art Archives, New York, NY.

63. Richard Nonas, in conversation with the author, New York, NY, February 28, 2003.

64. Mark di Suvero, telephone conversation with the author, December 2, 2011.

65. Miles Bellamy, in conversation with the author, Brooklyn, NY, February 23, 2001.

66. Barbara Flynn, in conversation with the author, Provincetown, MA, September 21, 2003.

67. Susie Schlesinger, in conversation with the author, Berkeley, CA, May 28, 2004.

68. Denise Corley, Richard Bellamy Memorial Service, MoMA PS 1, Long Island City, NY, May 13, 1998.

69. Bagley Wright, in conversation with the author, Seattle, January 31, 2003.

70. Alanna Heiss, in conversation with the author, Long Island City, NY, October 17, 2000.

71. Robert Zakanitch, telephone conversation with the author, June 8, 2000.

72. Mark di Suvero, letter to Richard Bellamy, postmarked May 19, 1972. Richard Bellamy Papers, III.N.82. The Museum of Modern Art Archives, New York, NY.

73. David Reichert, unpublished diary entry, July 6, 1977, courtesy of David Reichert.

74. Sheindi Bellamy, telephone conversation with the author, April 17, 2004.

75. Johan Huizinga, *Homo Ludens: A Study of the Play Element in Culture* (Boston: Beacon Press, 1955), 13.

76. Kristin Jones, in conversation with the author, Philadelphia, November 8, 2014.

77. Andrew Tatarsky, telephone conversation with the author, January 25, 2015.

78. Richard Nonas, in conversation with the author, New York, NY, February 28, 2003.

79. Murray Reed, e-mail to the author, January 2, 2002.

80. Walter De Maria, in conversation with the author, New York, NY, March 19, 2003.

81. Pat Lipsky, telephone conversation with the author, March 7, 2004.

82. Denise Corley, telephone conversation with the author, June 12, 2015. Pat Lipsky recalled that Mark, by then exclusively represented by Larry Gagosian, asked Dick to begin removing his files from the pier, and that the process was under way when Dick died. Pat Lipsky, "The Last Act."

83. Miles Bellamy, e-mail to the author, December 3, 2013.

84. Fredericka Hunter, in conversation with the author, New York, NY, May 20, 2002.

85. Miles Bellamy, in conversation with the author, Brooklyn, NY, February 23, 2001.

86. Susie Schlesinger, in conversation with the author, Berkeley, CA, May 28, 2004.

87. Sally Gross, in conversation with the author, New York, NY, November 12, 1998.

88. Denise Corley, telephone conversation with the author, June 12, 2015.

89. Sally Gross, in conversation with the author, New York, NY, August 15, 2000.

90. Dick loved to fish but had no stomach for baiting hooks; in high school, Al Richardson did it for him. Albert Richardson, e-mail to the author, January 4, 2002.

91. Richard Bellamy, letter to Harry Wilks, March 11, 1998. Richard Bellamy Papers, I.A.508. The Museum of Modern Art Archives, New York, NY.

92. Lipsky, "The Last Act."

POSTSCRIPT

1. Rosenquist, *Painting Below Zero*, 121.

2. Allan Stone, in conversation with the author, Seal Cove, Mount Desert, ME, July 29, 1999; "Al Hansen Talks to Jan van Raay," *Artzien* 1, no. 9 (September 1979); Oral History Interview with Connie Glenn, 1990 March 16, Archives of American Art, Smithsonian Institution.

3. Robert S. Gallagher, "Wrecker, Spare That Frieze!," *American Heritage* magazine, August 1967. Karp put others on display at the Anonymous Arts Museum in his country home in Charlotteville, NY.

ACKNOWLEDGMENTS

In the "living," or formation, photographs that were popular during World War I, you can see the faces of just a portion of the legions of soldiers or nurses who when arranged and photographed from above, formed images of Old Glory, or a portrait of Woodrow Wilson. I thought of these group photos as I singled out people to acknowledge, knowing that there were many unnamed others who helped me create my picture of Dick Bellamy: library, museum, and gallery staff, and people I met by chance, karmic connections to information I might never have found on my own.

The Richard Bellamy Papers in the Museum of Modern Art Archives were my primary research source. I am deeply indebted to MoMA archivists Michelle Elligott, Michelle Harvey, and Jonathan Lill, who were unfailingly accommodating, as were archivists Geraldine Aramanda, Menil Archives; Caitlin C. Murray, Judd Foundation; Marisa Bourgoin, Elizabeth Botten, Joy Weiner, and Catherine Stover Gaines, of the Archives of American Art; Rachel Selekman, Archivist and Project Coordinator, Dan Flavin Estate; Karen Underhill, Special Collections and Archives Department, Northern Arizona University; AnnaLee Pauls, Department of Rare Books and Special Collections, Princeton University Library, and Wyoming, Ohio, historian Annie Lou Helmsderfer. My work is the richer for Julie Martin's expertise and kindness in sharing her and Billy Klüver's interview recordings. Blaine Allan, Susan

Hapgood, Erik La Prade, Carey Lovelace, Michael Several, and Phyllis Tuchman, as well as the Emily Hall Tremaine Foundation, generously shared transcripts and tapes of interviews. Mildred Glimcher, Jackie Ferrara, Jim Bumgardner, Peter Duveen, and Martha Henry entrusted me with key photographs and letters. I am thankful for the largesse of Nancy Fish, who shared portions of her unpublished novel. Midori Yamamura, often my accomplice in solving mysteries, graciously shared her research materials. With notable generosity, Amy Gold, Alison Green, Jennifer Liese, and Deborah VanDetta shared unpublished scholarly studies. John Cohen went the extra mile in printing his previously unknown photos.

Without the immeasurable kindness and ongoing support of Miles Bellamy, Sheindi Bellamy, Alfred Leslie, Lucas Samaras, and Jonathan Scull, this book could not have been written. For more than a decade they responded with good cheer to cascades of queries, as did Yvonne Andersen, Jeanie Blake, Barbara Flynn, Jeanne Christopherson, June Ekman, Mimi Gross, Jo Baer, Robert Morris, Mark di Suvero, and Pat Lipsky. Family members Rebecca Hu Soong, Susan Soong, Dr. Fritz and Mrs. Helen Lin, Joe David Bellamy, Jack Davies, Andrew Tatarsky, and Leah Kreger offered vital information and encouragement over the years.

Dick was beloved by many people, and the mention of his name proved to be a passkey to history. I wish I had been able to include all the stories and insights I gleaned in the course of my research. Crucial were my conversations with Leo Castelli, Walter De Maria, Sherman Drexler, Mary Frank, Robert Frank, Arne Glimcher, Sam Green, Michael Heizer, Ivan Karp, Kasper König, Patrick Lannan Jr., George Nelson Preston, Barbara Rose, and Bagley, Virginia, and Charles Wright.

I learned an immense amount from talks and written exchanges with Doon Arbus, Adam Aronson, Richard Artschwager, Dore Ashton, Walter Darby Bannard, Timothy Baum, Bill Berkson, Lee Bontecou, Paul Brach, Robert Breer, Barbara Brown, Robert Brown, Jean Bultman, Sophie Calle, John Chamberlain, Remi Charlip, Dan Christensen, Christo and Jeanne Claude, Nancy Christopherson, Wendy Clarke, Paula Cooper, Denise Corely, Robert Creeley, Robert Crozier, Emilio Cruz, Judith Darrow Freed, Pat de Groot, Chris-

tophe di Menil, Maria Teres Capparota di Suvero, Victor di Suvero, Lois Dodd, Bob Dootson, Sally Hazelett Drummond, Everett Ellin, Patricia Patterson and Manny Farber, Richard Feigen, Rafael Ferrer, Jesse Forst, Miles Forst, Chuck Ginnever, Kristin Jones and Andrew Ginzel, Peter Goulds, Sue Grody, Red Grooms, Sally Gross, Jane Wilson and John Gruen, Fred Gutzeit, Alanna Heiss, Barbara Heizer, Pati Hill, Nancy Holt, Fredericka Hunter, John Ittmann, Neil Jenney, Lester Johnson, Jill Johnston, Joan Jonas, Emily Mason and Wolf Kahn, Allan Kaprow, Lois Karp, Klaus Kertess, Max Kozloff, Rakuko Naito and Tadaaki Kuwayama, Knight Landesman, Ronnie and Jenny Landfield, Ralph Lee, Jean Leering, Dorothy Lichtenstein, Lucy Lippard, Robert Littman, Rob Lobe, Joe LoGiudice, Marcia Marcus, James Mayor, Lowell McKegnie, Mrs. Buddy Meyer, Forrest (Frosty) Myers, Jay Milder, Patty Mucha, Grégoire Müller, Bruce Nauman, Mica Nava, Cynthia Navaretta, Kenneth Noland, Richard Nonas, David Novros, Barbara Novak and Brian O'Doherty, Claes Oldenburg, Jules Olitski, Yoko Ono, Felix Pasilis, Pauline Pasilis, Pat Passlof, Larry and Paula Poons, Emily Rauh Pulitzer, Catrina Neiman and David Rabinowitch, Yvonne Rainer, Marilyn and David Reichert, Paul Resika, Pierre Restany, Rolfe Ricke, Bettina Riedel, Dorothea Rockburne, James Rosenquist, Dorothy Rouse-Bottom, Audrey Sabol, Irving Sandler, Susie Schlesinger, Carolee Schneemann, Linda Schwartz, Sanford Schwartz, Adam Scull, Stephanie Scull, Helen Segal, Rena Segal, Peter and Carol Selz, Richard Serra, Richard Smith, Carl Solway, Keith Sonnier, Daniel Spoerri, Michael Steiner, Pat Steir, Frank Stella, John and Sheila Stoller, Allan Stone, Kunié Sugiura, Sidney Tillim, Walasse Ting, Calvin Tomkins, Selina Trieff, Richard Tuttle, Tony Vevers, June Wayne, Idelle Weber, Daniel Weinberg, Evelyn Weiss, John Wesley, Tom Wesselmann, Robert Whitman, David Whitney, Helen Miranda Wilson, Lewis Winter, Phyllis Yampolsky, Hanford Yang, Peter Young, Virginia Zabriskie, and Robert Zakanitch.

Others facilitated my research in myriad ways, including Michael Abrams, William C. Agee, Ramon Alcolea, Judith Aminoff, Mark Andrejevic, Jason Andrew, Callie Angell, Elizabeth C. Baker, Bill Barrette, Kelly Baum, Avis Berman, Michael Blackwood, Suzaan Boettger, Ruth Bowman, Carol Rose Brown, Emily and Will Brown,

Diane Burko, Sarah Burnes, Melissa Rachleff Burt, Chris Busa, James O. Clark, David R. Collens, Patricia Cruz, Carolyn Daffron, Francis Davis, Sally Dennison, Emmie Donadio, Hunter Drohojowska-Philp, Rachel Blau Duplessis, Martha Nilsson Edelheit, Peter Eleey, Nina Felshin, Natalie and Irving Foreman, Sophie Forst, Claude Gintz, Charles Giuliano, Connie Glenn, Judith Goldman, Marty Greenbaum, Jennifer Gross, Jon Hendricks, Richard Hide, Viva Hoffmann, Kathleen Housley, Caroline A. Jones, Diane Karp, Jonathan D. Katz, Brigitte Kölle, Suzanne Kreps, Joan Kron, Frances Kuehn, Gary Kuehn, Rhoda Yarbrough Lauten, Aaron Levy, Michael Lobel, Jeanie Low, Arthur Lubow, Chuck Mee, Ivana Mestrovic, Barbara L. Michaels, Barbara Moore, Lisa Mordhorst, Clive Phillpot, Katherine Porter, Marcus Ratliff, David Reed, Randy Rosen, Jeff Rosenheim, Phyllis Rosenzweig, Charles Ruas, Leslie Rubinkowski, Sid Sachs, Shinobu Sakagami, Lisa Schachner, Meryle Secrest, Willoughby Sharp, Sherry Sheffield, Stephen Soba, Barbara Solomon, Jeffrey Sturges, Elisabeth Sussman, Brian Szott, Alexander Theroux, Jan van der Donk, Ellen van Fleet, Jaap van Liere, E. J. Vaughn, Claire Wesselmann, Eleanor Wilner, Basil Yang, John Yau, Daisy Youngblood, John Zinsser, and Pavel Zoubok. Special thanks go to Dick's former schoolmates and neighbors in Wyoming—Faye Sauder Bruce, Ruth Churchill, Phyllis Hall, Ilse Hofmann Maile, Billy Marsall, Alan McAllister, Don Moore, Pauline and Ben Saunders, Cynthia Stafford Wills, Pat Lowry Wilson, Bobby Yerkes, and foremost Albert Richardson—who helped bring Dick's early history alive. Fellow biographers Michael Brenson, Cathy Curtis, and Justin Spring provided invaluable support, as did Lindsay Pollock, Sarah McFadden, and Carrie Rickey.

Of incalculable aid during all stages of my work were a Creative Capital / Andy Warhol Foundation Arts Writers Grant; an Arts Commentary Fellowship, Pennsylvania Council on the Arts; and a Pew Foundation Fellowship in the Arts, in literary nonfiction. Equally important were residencies at the I-Park Foundation, East Haddam, Connecticut; the Lannan Foundation, Marfa, Texas; the Santa Fe Art Institute, Santa Fe, New Mexico; the Ragdale Foundation, Lake Forrest, Illinois; the Millay Colony for the Arts, Austerlitz, New York; the Blue Mountain Center for the Arts, Blue Mountain, New

York; the Vermont Studio Center, Johnson, Vermont; the Rockefeller Foundation, Bellagio, Italy; and the Norman Mailer Writers Colony, Provincetown, Massachusetts. For support in countless ways, I've been serially assisted by Heather Donahue-Greene, A. Rebecca Kelly, Traci Weatherford-Brown, Joseph Hu, Mauro Zamora, Madeline Adams, Michael Bauer, Catherine Higgins, Olga Dekalo, Natalie Yoder Marasco, Natalia Vieyra, Gee Wesley, Alanna Rebbeck, and the inestimable Tiernan Alexander. My colleague Sue Spaid lent her expertise as an art gumshoe, as did Rachel Heidenry, assistant and ace picture researcher.

Agents extraordinaire Becky Sweren and Billy Kingsland at David Kuhn Projects shepherded the book into being, and my editors Ileene Smith, Courtney Hodell, and John Knight and copy editor Maxine Bartow helped transform a tubby manuscript into a shapely book. The Internet and e-mail were in their infancy when I began writing; thank heavens for them. And here's a shout-out to Joe Pilates and F. A. Alexander for setting me straight as I sat still for all those years. Jonathan Stein's love and support, tangible and intangible, made everything possible.

INDEX